BETWEEN THE IMAGE A

M000167013

Ashgate Studies in Theology, Imagination and the Arts

Series Editors:

Jeremy Begbie, Duke University and University of Cambridge, USA
Trevor Hart, St Mary's College, University of St Andrews, Scotland
Roger Lundin, Wheaton College, USA

What have imagination and the arts to do with theology? For much of the modern era, the answer has been 'not much'. It is precisely this deficit that this series seeks to redress. For, whatever role they have or have not been granted in the theological disciplines, imagination and the arts are undeniably bound up with how we as human beings think, learn and communicate, engage with and respond to our physical and social environments and, in particular, our awareness and experience of that which transcends our own creatureliness. The arts are playing an increasingly significant role in the way people come to terms with the world; at the same time, artists of many disciplines are showing a willingness to engage with religious or theological themes. A spate of publications and courses in many educational institutions has already established this field as one of fast-growing concern.

This series taps into a burgeoning intellectual concern on both sides of the Atlantic and beyond. The peculiar inter-disciplinarity of theology, and the growing interest in imagination and the arts in many different fields of human concern, afford the opportunity for a series that has its roots sunk in varied and diverse intellectual soils, while focused around a coherent theological question: How are imagination and the arts involved in the shaping and reshaping of our humanity as part of the creative and redemptive purposes of God, and what roles do they perform in the theological enterprise?

Many projects within the series have particular links to the work of the Institute for Theology, Imagination and the Arts in the University of St Andrews, and to the Duke Initiatives in Theology and the Arts at Duke University.

Art, Imagination and Christian Hope
Patterns of Promise
Edited by Trevor Hart, Gavin Hopps and Jeremy Begbie

An Introduction to Jean-Yves Lacoste
Joeri Schrijvers

Christian Theology and Tragedy
Theologians, Tragic Literature and Tragic Theory
Edited by Kevin Taylor and Giles Waller

Between the Image and the Word
Theological Engagements with Imagination, Language and Literature

TREVOR HART
University of St Andrews, UK

ASHGATE

© Trevor Hart 2013

All rights reserved. No part of this publication may be reproduced, stored in a retrieval system or transmitted in any form or by any means, electronic, mechanical, photocopying, recording or otherwise without the prior permission of the publisher.

Trevor Hart has asserted his right under the Copyright, Designs and Patents Act, 1988, to be identified as the author of this work.

Published by
Ashgate Publishing Limited
Wey Court East
Union Road
Farnham
Surrey, GU9 7PT
England

Ashgate Publishing Company
110 Cherry Street
Suite 3-1
Burlington, VT 05401-3818
USA

www.ashgate.com

British Library Cataloguing in Publication Data
A catalogue record for this book is available from the British Library

The Library of Congress has cataloged the printed edition as follows:
Hart, Trevor A.
 Between the image and the word : theological engagements with imagination, language, and literature / by Trevor Hart.
 pages cm. -- (Ashgate studies in theology, imagination, and the arts)
 Includes index.
 ISBN 978-1-4724-1369-7 -- ISBN 978-1-4724-1370-3 (pbk) -- ISBN 978-1-4724-1371-0 (ebook) 1. Incarnation. 2. Imagination--Religious aspects--Christianity. 3. Language and languages--Religious aspects--Christianity. 4. Theology in literature. I. Title.
 BT220.H24 2013
 230--dc23

 2013008987

ISBN 9781472413697 (hbk)
ISBN 9781472413703 (pbk)
ISBN 9781472413710 (ebk – PDF)
ISBN 9781472413727 (ebk – ePUB)

MIX
Paper from
responsible sources
FSC
www.fsc.org FSC® C013985

Printed in the United Kingdom by Henry Ling Limited,
at the Dorset Press, Dorchester, DT1 1HD

Contents

To my parents
Geoffrey Edward Hart and Julia Margaret Hart
and in memory of my grandmother
Winifred Elliott (1915–2007)

Provenance of Chapters

With the exception of Chapter 1, the pieces in this volume are based upon or contain some material from the following among my previous publications, though most have been rewritten or expanded and developed for the sake of their appearance here:

'Calvin and Barth on the Lord's Supper' in Neil B. MacDonald and Carl Trueman, eds, *Calvin, Barth and Reformed Theology* (Milton Keynes: Paternoster, 2008), 29–56; 'Lectio Divina' in Robert MacSwain and Taylor Worley, eds, *Theology, Aesthetics and Culture: Responses to the Work of David Brown* (Oxford: Oxford University Press, 2012), 126–40; 'Migrants Between Nominatives' in *Theology in Scotland* 6:2 (1999); 'Tolkien, creation and creativity' in Trevor Hart and Ivan Khovacs, eds, *Tree of Tales: Tolkien, Literature and Theology* (Waco, TX: Baylor University Press, 2007); 'Poetry and Theology in Milton's *Paradise Lost*' in Nathan MacDonald, Mark Elliott and Grant Macaskill, eds, *Genesis and Christian Theology* (Grand Rapids: Eerdmans, 2012), 129–39; '*Cain's* Byron: A Mystery – On the Inscrutability of Poetic Providence', *The Byron Journal* 37:1 (2009), 15–20; 'Goodly Sights and Unseemly Representations: Transcendence and the Problems of Visual Piety' in Stephen C. Barton, ed., *Idolatry: False Worship in the Bible, Early Judaism and Christianity* (London: T&T Clark, 2007), 198–212; 'The Sense of an Ending: Finitude and the Authentic Performance of Life' in Trevor A. Hart and Steven R. Guthrie, eds, *Faithful Performances: Enacting Christian Tradition* (Aldershot: Ashgate, 2007), 167–86; 'Unexpected Endings: Eucatastrophic Consolations in Literature and Theology' in Trevor Hart, Gavin Hopps and Jeremy Begbie, eds, *Patterns of Promise: Art, Imagination and Christian Hope* (Farnham: Ashgate, 2012).

Chapter 4 was previously published as 'Imagination for the Kingdom of God? Hope, promise, and the transformative power of an imagined future' in R.J. Bauckham, ed., *God will be all in all: The Eschatology of Jürgen Moltmann* (Edinburgh: T&T Clark, 1999) and is reproduced by kind permission of T&T Clark, an imprint of Bloomsbury Publishing Plc.

Introduction

The central contention of Christian faith is that in the incarnation the eternal Word or Logos of God himself has taken flesh, so becoming for us the image of the invisible God. In a wholly distinct but analogous manner our humanity itself is lived out in a constant toing and froing between the economies of materiality and immateriality. Imagination, language and literature each have a vital part to play in brokering this hypostatic union of matter and meaning within the human creature, making of the flesh more than, as flesh alone, it is or can account for. Through a series of studies approaching different aspects of these two distinct dialectical movements (in the incarnation, and in the dynamics of human existence itself) this book pursues an understanding of each which will benefit from its deliberate juxtaposition with the other, convinced that, while they are neither to be confused nor mixed, within the Trinitarian economy of creation and redemption these two occasions of 'flesh-taking' are nonetheless inseparable and indivisible.

Over the past 12 years, much of my personal research has been bound up with the activities of the Institute for Theology, Imagination and the Arts in the University of St Andrews. During that time I have found myself returning again and again to certain core issues to do with the centrality of the imaginative as a vital condition of so much in the distinctive texture of Christian faith and theology, and of the wider human world against which such faith and theology stands out for consideration. This book is the first of several that will appear in due course arising directly from this period of consolidated and sustained attention, much of it carried on in close conversation with colleagues and research students within the Institute or during its regular conferences, colloquia and other events. The focus for this particular volume is a cluster of issues arising at the intersection between Christian theology, human language and literary imagination. Although most of the pieces were originally written for and published in quite distinct contexts, I have become increasingly aware of an identifiable convergence of concerns and insights between them such that the organic whole which now exists is considerably more than the sum of its originally individual parts. The provenance of the various chapters inevitably results in occasional repetition of points, though I have sought in the process of redrafting and expanding materials to reduce these to a minimum, and to incorporate cross-references where possible to reinforce the overall unity of concern and focus.

The theological themes attended to in the book include the nature of religious language, the category of sacrament, redemption, the doctrine of creation, theological anthropology and eschatology; but the central theme that holds the entire collection together is the vital significance of the incarnation of the eternal

Son or Word as the man Jesus Christ. It is to Christology, and in particular to the classical Christology of the creeds, that I have turned again and again in this volume to provide a perspective from which to view a range of different theological, religious, linguistic and aesthetic concerns. I have done so out of a conviction that this event, which Christians hold to be the singular epiphanic point in the drama of God's dealings with humankind, affords some new and imaginative ways of approaching some rather tired and well-worn questions. The intellectual traffic, though, does not all move in one direction, as though Christian theology possessed all the answers, regardless of the provenance or natural territory of the questions. Across the volume the situation is rather that of a constructive exchange and convergence of insights, with theology having much to learn from careful work in linguistics, hermeneutics, cultural theory, literary studies and other relevant disciplines. For a Christian theologian, though, it is finally God-talk – and God-talk as shaped decisively by the doctrine of the incarnation – that lies at the heart of whatever distinctive contribution to intellectual conversation theology may have to make, and that resists its reduction to any other form of discourse. This centrality is reflected here, albeit, I hope, with appropriate generosity and intellectual humility shown towards others who think differently or have contributions of a quite different sort to offer.

Imagination, language and literature are categories woven unevenly through the entire volume, with the particular focus of concern being now on one and now on another, but all three eventually making some appearance in most if not all of the chapters. This is hardly surprising, with literature being a product of language and imagination, imagination relying upon language for its articulate expression, and the uses and development of language in its turn being dependent upon our capacity for acts of imaginative *poiesis*. Nonetheless it is the category of imagination which makes a salient appearance in one way or another in all of these pieces, and so serves to unify the collection, and it makes sense to say something about this category in particular before proceeding any further.

In his book *Poetics of Imagining* Richard Kearney suggests that part of our problem with identifying imagination may be that we are simply too close to its power, too bound up with its manifold activities, to be able easily to step back and observe it at work. 'Might we not say of imagination' he muses, 'what Augustine once said of time – we think we know what it is but when asked we realize we don't?'[1] Yet it is vitally important that we stop and ask and consider, precisely because imagination is so pervasive a feature of our existence, so close, as Kearney suggests, to the heart of our existence. In fact, a significant interest in the nature and functions of human imagination has been apparent in scholarship published over the past 50 years or so. Not all of this interest has

[1] Richard Kearney, *Poetics of Imagining: Modern to Postmodern* (Edinburgh: Edinburgh University Press, 1998), 1.

been of a theological sort of course, though some certainly has.[2] As one survey of
the relevant territory notes,[3] the topic 'sprawls promiscuously' over a wide range
of human intellectual concerns including the philosophy of mind, psychology,
aesthetics, ethics, hermeneutics, poetry and literature, and most of the natural
and social sciences, as well as theology. The teeming prodigality of allusions to
the imaginative in contexts as far apart as virology, the construction of economic
models, the interpretation of dreams and the critical appreciation of Shakespeare's
sonnets points, though, I suggest, not to a pathological carelessness in the use of
an admittedly flexible and slippery term, but to something (or more likely some
set of things related by family resemblance)[4] which, while difficult to pin down
in any definitive way, is nonetheless identifiably shot through every cell of our
distinctively human engagements with the world like so much DNA. In other
words, the quality of things or activities to refer to which we instinctively reach for
the word 'imaginative' and its cognates crops up wherever we choose to look, even
though the imaginative element may actually look quite different (or appear to be
implicated in different sorts of things) as we encounter it in different instances.

But we shouldn't exaggerate the differences, as if usage renders the
vocabulary of 'imagination' endlessly adaptable, a wax nose to be fashioned

[2] A representative selection of significant monographs focused explicitly on
aspects of human imagination as such must suffice here both to substantiate the point
and to provide the interested reader with a starting point for further study of the
subject: Paul Avis, *God and the Creative Imagination: Metaphor, Symbol and Myth
in Religion and Theology* (London: Routledge, 1999); David Brown, *Tradition and
Imagination: Revelation and Change* (Oxford: Oxford University Press, 1999); David
Brown, *Discipleship and Imagination: Christian Tradition and Truth* (Oxford: Oxford
University Press, 2000); Edward S. Casey, *Imagining: A Phenomenological Study*, 2nd
ed. (Bloomington and Indianapolis: Indiana University Press, 2000); Garrett Green,
Imagining God: Theology and the Religious Imagination (San Francisco: Harper and
Row, 1989); Mark Johnson, *The Body in the Mind* (Chicago: University of Chicago Press,
1987); Gordon Kaufman, *The Theological Imagination: Constructing the Concept of God*
(Philadelphia: Westminster Press, 1981); Richard Kearney, *The Wake of Imagination*
(London: Routledge, 1988); Richard Kearney, *Poetics of Imagining: Modern to
Postmodern* (Edinburgh: Edinburgh University Press, 1998); Daniel Nettle, *The Strong
Imagination* (Oxford: Oxford University Press, 2001); Mary Warnock, *Imagination*
(London: Faber, 1976).
[3] See Leslie Stevenson, 'Twelve Conceptions of Imagination', *British Journal of
Aesthetics*, Vol. 43, No. 3, July 2003, 238–59. See 238.
[4] The principle of the 'family resemblance' model of identification or 'likeness' is
the recognition that things can be quite closely related to other things without having any
single feature (or 'essence') in common with all of them to which the use of a common term
(e.g. in this case 'imagination') refers. Rather than seeking any single attribute, or even
specifying some set of necessary and sufficient qualities which all examples must manifest
in order to qualify as instances, this approach is willing to think instead in terms of a cluster
of attributes which can be seen to attach in different degrees and ways to different members
of the relevant 'family'.

to fit any face we choose. It doesn't, and it isn't. In fact, after a very thorough consideration of examples, Leslie Stevenson identifies just 12 discrete members of the relevant linguistic and conceptual family: 12 basic ways, that is to say, in which the term 'imagination' is typically used in day to day writing and speech, and 12 corresponding 'things' or sorts of things to which that language refers us.[5] What produces the intellectual promiscuity to which Stevenson properly refers us, therefore, is not an infinitely protean aspect of the conceptuality itself, but rather its remarkable capacity for migration from one sphere of intellectual concern to another, crossing striking distances and surviving some apparently inclement conditions in the process.

Imagination, then, seems to be a pervasive feature of our humanity, which is to say, in theological terms, of the sort of creatures God has made us and calls us to be. No matter where we slice it and put it under the microscope for observation, humanity turns out to have an imaginative element embedded in its molecular structure. So much so, in fact, that Kearney insists that 'we wouldn't be human without it. ... (B)etter to appreciate what it means to imagine' is thus, he suggests, 'better to understand what it is to be'.[6] That's a philosopher's judgement. But, if it is even close to being true (and it is based on a very thorough and careful study of the phenomenon), it clearly warrants careful theological attention to the phenomena of the imaginative.

A distinction might usefully be drawn between this broader account of the imaginative in human life which recent scholarship has produced, and much more specific and focused uses of the term 'imagination' to refer to certain creative and artistic activities of which human beings are capable. The point of drawing the

[5] Stevenson's list of 'the most influential conceptions of imagination' is as follows: (1) The ability to think of something not presently perceived, but spatio-temporally real. (2) The ability to think of whatever one acknowledges as possible in the spatio-temporal world. (3) The liability to think of something that the subject believes to be real, but which is not. (4) The ability to think of things that one conceives of as fictional. (5) The ability to entertain mental images. (6) The ability to think of anything at all. (7) The non-rational operations of the human mind, that is, those explicable in terms of causes rather than reasons. (8) The ability to form perceptual beliefs about public objects in space and time. (9) The ability to sensuously appreciate works of art or objects of natural beauty without classifying them under concepts or thinking of them as useful. (10) The ability to create works of art that encourage such sensuous appreciation. (11) The ability to appreciate things that are expressive or revelatory of the meaning of human life. (12) The ability to create works of art that express something deep about the meaning of life. See Leslie Stevenson, 'Twelve Conceptions of Imagination', 238. We need not suppose that this list is exhaustive (Stevenson himself makes no such claim) or that a different taxonomy might not be provided. But this list goes some way towards mapping the 'grammar' of imagination, and shows that there are clear patterns (and clear limits) to the circumstances of the concept's use. For a different way of carving the same joint see Trevor A. Hart, 'Transfiguring Reality: Imagination and the Re-shaping of the Human', *Theology in Scotland* 8:1 (2001).

[6] Kearney, *Poetics of Imagining*, 1.

distinction, though, is not to warrant any separation between the two, but precisely to draw attention to the fundamental connections that exist between a host of fairly mundane everyday dispositions and activities which we all participate in as human beings (expecting, planning, exploring, fearing, hoping, believing, remembering, recognising, analysing, empathising, loving, conjecturing, fantasising, pretending and so on) and more specialised activities of a self-consciously creative and imaginative sort. Judgements we make about these latter ways of thinking and acting cannot, therefore, easily be disentangled and isolated from their context within the wider jurisdiction of the imaginative.

This leads to a further clarification which may perhaps be instructive: Older discussions of our theme often proceeded in terms of a faculty psychology which spoke as though 'the imagination' were a discrete human organ or part to be set alongside others (*the* will, *the* reason, *the* conscience, and so on) each having its own distinctive sphere of responsibility. Such hypostatisation fostered the notion that the products of 'the imagination' were of a very specific sort, readily distinguishable and separable from the products of other faculties. That's not how the language of imagination is used any more, in part precisely because authoritative studies of the phenomenon have recognised just how widespread and integrated our 'imaginative' engagements with things are. Imagination is better thought of as *a way of thinking, responding and acting* across the whole spread of our experience, not some arcane 'thing' with a carefully specified and limited remit. And an *imaginectomy* would render us incapable, therefore, not just of certain artsy activities we might (or might not) make do or be better without, but of much (possibly most) of what makes us human at all. The imaginative is the psychical equivalent not of our appendix (which, when it becomes troublesome or painful, we can simply cut out and flush away without loss) but the blood supply which circulates things (both good and bad) around our entire body. The question facing us, therefore, is not so much *whether* we shall be imaginative as human beings, but *how* we shall be so.

Viewed in this light, the plea for careful theological consideration to be afforded to the imaginative appears both more substantial and more urgent. For now it occurs not as a call for theologians to take interest in and attend to something entirely proper (possibly even useful and interesting) but nonetheless peripheral to human existence as such. Instead, the plea to take imagination seriously is nothing less than a summons to reckon with something lying close to the core of what it is to be human, a feature of our humanity that shapes our essentially human responses to others, to the world and (we may reasonably suppose) to God. This being so, Christian theology can hardly afford *not* to get to grips with and afford a proper place to imagination as it attempts to make sense of what it is to be human in the world God has made. For it seems that God has made us imaginative beings, and placed us in a world which calls forth from us responses of an imaginative sort if we are to indwell it meaningfully and well. Life itself, let alone 'life in all its fullness' is from top to bottom, from beginning to end a highly imaginative affair. The sooner theologians take imagination seriously the better, then, because

anything less is a blinkered denial of what learning across the range of disciplines is telling us is a vital component of the human condition. Apart from anything else, this means that it is a central part of that 'flesh' which, according to Christian faith, the Son of God came into the world to make his own, in which he lived, suffered and died, and which he raised from death and exalted to the Father's right hand.

So, the plea to take imagination seriously, and an insistence upon hearing and getting to grips with what wider studies have to tell us about the imaginative dimensions of our own humanity, is certainly not a bid to allow the particular concerns of Christian faith and theology to be constrained or determined by some inherently 'non-theological' agenda or set of categories. It is precisely to allow the specific insights and the distinctive claims and concerns of theology to emerge more clearly as we think them together with broader patterns of understanding. In short, only when we have a clear idea of what the imaginative looks like and is capable of (as borne witness to by the best of human learning in other disciplines) shall we be able to appreciate where the distinctiveness of a Christian understanding and appreciation of it may lie, and what precise shape that might take. Continued refusal or failure to reckon with it at all in theological terms can only place unnecessary and dangerous constraints on our understanding, and thereby finally on our living and on our ministry and mission as those called to share in Christ's renewed humanity in the world. For, if imagination is indeed basic to our creatureliness and to our living as human beings, then we have reason to suspect that life in all its fullness may involve more, and not less of it.

The task of working out all the entailments of this suggestion in detail is one reserved for another volume, but hopefully the theological engagements undertaken in this book will at least break some of the relevant ground and identify questions for further investigation. The opening chapter deals with the nature and status of human language as applied to God. It begins by revisiting the discussion of analogy, engaging with Aquinas's classic treatment of the subject in the *Summa Theologiae* and more recent works such as Janet Martin Soskice's illuminating study of metaphor and its place in Christian discourse about God. The focus then moves on to consider T.F. Torrance's suggestion that theological terms should finally be stripped of their imaginative 'flesh' and drawn into an essentially 'imageless' relation with the truth of their presumed referent. The chapter argues, contrariwise, that this is neither possible nor doctrinally warranted as an ideal in Christian theology. Using Christological paradigms, it is maintained that the status of the verbal image, albeit necessarily broken and always made new by its application to the reality of God's being and life, is nonetheless such that the 'flesh' of the relevant image (in a manner analogous to the flesh of Christ – God's own 'enfleshed Word') remains securely in place and plays a far more positive and permanent role in that revelatory economy within which our knowing of God occurs than Torrance's advocacy of the 'pure concept' allows.

The category of sacrament has been appealed to variously in Christian treatments of aesthetics (for example by David Brown, Frank Burch Brown and Richard Viladesau), often as the presumed locus of a divine presence rendered

accessible through an aesthetic encounter with natural or cultural phenomena of one sort or another. Concentrating on the accounts of the Lord's Supper provided by John Calvin and Karl Barth, Chapter 2 presents an alternative vision of the category of sacrament as such, understanding it as a concrete form of divine sign-giving centred on the promises of God fulfilled and renewed in the life, death and resurrection of the incarnate Son of God. In the incarnation (and only subsequently in the eucharist) it is argued, God placed himself decisively and once and for all in the 'order of signs' (de la Taille) in a manner entailing a radical accommodation to our creaturely condition. The ambiguity of the sign, though, as well as fitting the essential mystery of an encounter with the reality of a God who remains wholly other in his self-giving, also preserves the freedom of God to give himself in a particular rather than an indiscriminate manner. Sacramental presence and action understood as an act of divine signification is thus properly earthed in the central sign of the incarnation, and to be understood within the scope of a biblical doctrine of election. Continuing the argument of chapters 1 and 2, the first part of Chapter 3 responds in a critical but constructive and appreciative manner to the contention made in the recent work of David Brown that God may be experienced through an encounter with 'mystery in words' in the poetic image. Christology, and particularly the claim that in Christ God himself has 'taken flesh' is, it is maintained, a more satisfactory theological ground than sacrament both for a theological epistemology and for a theologically informed account of poetics. The second part of the chapter picks up constructively on some of the key themes in Brown's discussion, to do with mystery and semantic slippage, and explores these further in light of the central Christian doctrines of the resurrection and ascension. The natural implication of these doctrines (according to which the Logos remains 'enfleshed' rather than resuming some putative discarnate state after 30 years 'trapped in the body'), it is argued, is that the fundamental density of the sign and its resistance to final closure or definition should be understood as a potential enrichment, intrinsic to the blessing of our creaturely condition as embodied beings, and not as a frustrating function of the fall eventually to be overcome by a divinely over-determined hermeneutics. The central 'revealed' symbolics of the Christian tradition itself, it is suggested, actually points us in a quite different direction – one in which the 'Logos asarkos' enjoys no natural privilege, in which embodiedness is a basic condition of human creatureliness as such rather than a temporary predicament to be endured, and in which ambiguity and the demand for interpretation certainly involve the willing risk of loss and self-emptying and yet, paradoxically, prove also to be the kenotic mode through which alone a world full of wonder, mystery and awe comes to us.

Chapter 4 explores the grammar of our imaginative encounters with 'otherness' in pursuit of what Jürgen Moltmann calls a 'community of difference' – i.e. one in which otherness is taken fully into account and made the object of unconditional acceptance rather than mere 'tolerance'. Drawing on a model of conversation elaborated by political philosopher Michael Oakeshott and on J.R.R. Tolkien's account of the epistemic status of 'secondary belief', the suggestion is made

that a distinctly Christian theological engagement in inter-cultural and inter-disciplinary conversation should be one which is always willing to risk itself through imaginative (and practical) strategies designed to engage with the other *as* other, to empty itself and risk its own loss or demise, trusting that only in doing so, paradoxically, can it fulfil itself and be true to its particular identity. The Christological theme of kenosis or 'self-emptying' carries forward from Chapter 4 to Chapter 5, applied now to the question of human 'creativity' understood within the context of a doctrine of divine creation and the unique prerogatives of God entailed by that doctrine. Without compromising those prerogatives in any way, the chapter nonetheless follows a tradition within Jewish and Christian theology which understands God's creative action *ad extra* as essentially and deliberately incomplete, and as soliciting or conscripting human action as part of a wider creaturely participation in God's own continuing trinitarian engagement with the world as a creative project. Drawing on Dorothy L. Sayers' play *The Zeal of Thy House* and Tolkien's Elvish creation myth *Ainulindäle*, and conversing with Jewish theological traditions such as *tikkun olam* and *zimsum,* the chapter offers a Christologically-focused argument for thinking of God's own creativity as kenotic in more than one sense, and for understanding human creativity for its part as a sharing in the dynamics of Christ's own creative human response to the Father in the power of the Holy Spirit. This, it is suggested, places human artistry on a more secure theological footing in principle than it has sometimes enjoyed; but 'creative imagination' must be understood as referring to a far wider spread of human responses to the given world, of which artistry may perhaps furnish a fitting paradigm.

The Jesuit writer Richard Viladesau has suggested that, notwithstanding the quite different expectations attaching to works of artistic imagination on the one hand and the more standard outputs of the church's acknowledged theologians on the other, works of art may nonetheless function as 'texts of' as well as 'texts for' theology. Meanwhile from a Protestant perspective, Paul Fiddes speaks instead of a constructive dialogue on territories of shared concern between Christian doctrine and works of the literary imagination, the former moving 'from mystery' towards conceptual clarity, and the latter 'towards mystery'. These claims are explored in Chapter 6 with particular reference to John Milton's poetic epic *Paradise Lost* and Byron's provocative drama *Cain: A Mystery*, concluding that literature may indeed function as a form of theology precisely as literature, and may even be better suited to deal with some theological issues than its more systematic and dogmatic counterparts. Much of the art most central to the tradition of Western Christianity prior to the Reformation was cast in the form of the visual and plastic as distinct from the verbal image. Chapter 7 explores some of the theological issues attendant upon the practice of what David Morgan refers to as 'visual piety' – i.e. the production and use of visual and plastic art in contexts of a devotional and liturgical nature. In particular, it considers the claim made forcefully by some of the Reformers, that such use either constitutes or else risks the descent into some form of idolatry in which the relationship between signifier and signified collapses

for all intents and purposes. Postmodern exaltation of the image over 'reality' may, it is suggested, suffer from a similar problem, although the post-structuralist resistance to the notion of absolute presence might also be interpreted as an echo of the apophatic impulse inherent in Christian uses of images of any and every sort. Calvin's measured response to the issue is considered, and the chapter ends by suggesting the need to go beyond Calvin to a more thoroughly Chalcedonian account of the nature and capacities of images to function in contexts of visual piety.

It is one of the features of most works of literary imagination that they re- present the often messy realities of life under the guise of some imaginative pattern or form in terms of which sense may be made of them. Works of fiction in particular have typically progressed toward some climatic point (perhaps more than one), and then found a resolution of sorts by ending in an aesthetically satisfying manner. Life, as has often been observed, is mostly quite unlike that, and although the Christian tradition and other religious patternings of life have been and are concerned with questions of living well and dying well, it remains the case that the 'end' of particular human lives in this world is only rarely a 'good' ending in this sense. All too often, the end, when it comes, comes unexpectedly, far too soon for matters to have been resolved, bearing analogy rather to vital pages having being torn from an as yet unfinished story than to the well-crafted sense of an ending. Pursuing the literary analogy a little further, the lives of too many of our fellows are more like bit parts in a drama than well developed and rounded characters, a matter of moral and eschatological rather than poetic concern. The aesthetic disquiet at unsatisfactory endings or incomplete performances, though, resonates deeply with religious and theological sensibilities, and with the desire for an adequate eschatological accounting for the 'ends' of those who pass too quickly and often cruelly from the world's stage. Chapter 8 explores this theme in constructive conversation with the theological perspectives on human endings offered respectively by John Hick, Karl Barth and Jürgen Moltmann. Maintaining the eschatological turn, Chapter 9 tackles the contested question of Christian faith's relationship to that most elevated of literary genres, the tragedy. It has been insisted, by advocates of the tragic and theologians alike, that the milieu of Christian faith is inhospitable to genuinely tragic vision. Drawing on accounts of tragedy offered by Iris Murdoch, George Steiner, Terry Eagleton and others, and on theological perspectives from Donald Mackinnon and Alan Lewis, this penultimate chapter appeals to Tolkien's notion of the literary *eucatastrophe* to argue that, within the peculiar structure of the paschal *triduum,* the insights of tragedy and the gospel hope in 'the death of death' resonate and complement one another in a vital manner, rather than constituting mutually corrosive visions. Chapter 10 closes the volume by concentrating on the peculiar nature and structure of eschatological imagination as such. Taking its point of departure from a key incident in Shusaku Endo's novel *Silence,* it explores the phenomenology of hope as an imaginative disposition helpfully mapped in secular discourses by Ernst Bloch, George Steiner and others. In light of this secular account, the chapter contrasts it with the distinctive transcendent grammar of Christian hope, entering

into a close critical dialogue with Jürgen Moltmann's sustained theological account of hope as 'imagination for the kingdom of God'.

A volume of this sort inevitably incurs a significant number of intellectual and personal debts in the writing. Scholarly work of any serious sort is always a shared enterprise as well as an individual venture, and because this book draws on material drafted over a number of years, the debts are too numerous to count, let alone mention. Most of those without whose friendship, collegiality, support and intellectual stimulus it would not have seen the light of day must therefore take their inclusion in a general, but nonetheless heartfelt, expression of gratitude as read. A few specific mentions, though, are warranted. First, I am grateful to the University of St Andrews for granting me a period of research leave in the academic session 2009–10 during which much of the work for this and a companion volume[7] was undertaken. Next, thanks are due to the University of New South Wales for inviting me to deliver the New College Lectures for 2008; to Wheaton College in Illinois, where I delivered a paper on imagination and evangelism; and to Professor Yang Huilin of the Department of Philosophy and Religion at Renmin University in Beijing for an invitation to participate in an international seminar on 'Scriptural Reasoning and the Grammar of Theological Thinking' in Beijing in August 2012, and to deliver a keynote lecture at Renmin University's Summer Institute in Souzhou during the same trip. Material originally prepared for each of these academic contexts has found its way into this book in one form or another. The taught masters and research students in the Institute for Theology, Imagination and the Arts in St Andrews have provided a constant stimulus for my reflection on issues treated here, and I have learned a great deal from supervising or examining their work, and from our conversations in the weekly Friday research seminar. Similarly, the collegiality and conversation provided by my colleagues in the Institute over the years (most notably Jeremy Begbie, David Brown, Steve Guthrie, Gavin Hopps and Michael Partridge) has been a constant source of fertile exchange and constructive criticism which has undoubtedly led to the enhancement and enrichment of the ideas developed here. No doubt I could have learned much more from them than I have, and any remaining deficits must certainly be owned as part of my individual contribution to the work. It is to be regretted that academic life generally provides far fewer opportunities for this sort of exchange today than it once did, and I count myself grateful, therefore, for the genuine sense of intellectual community afforded by the Institute and its activities since its inception in 2000. I would also like to pay tribute here to the staff at Ashgate for the usual efficiency with which they have produced the book, and their willingness to publish it quickly during a period when the demands of the current government audit of research in British universities might have delayed its appearance inordinately. Lastly, my thanks are due to the Rector and domestic staff of St Paul's School, Darjeeling, where the

[7] *Making Good: Creation, Creativity and Artistry* (Waco, TX: Baylor University Press, 2014).

final drafting and editing of several chapters was completed in January 2013, and to my fellow travellers from the Diocese of St Andrews, Dunkeld and Dunblane whose company on this trip to north India, together with the inspiring views of the Himalaya available from my temporary office, has made an otherwise stressful and irksome task altogether more bearable, and with whom I look forward to celebrating the completion of the manuscript.

<div align="right">

Trevor Hart
St Paul's School, Darjeeling
28 January 2013

</div>

Chapter 1

Between the Image and the Word

It is apt to remind ourselves at the beginning of a book bringing Christian theology into conversation with imagination, language and literature that the participants in the conversation are ones naturally rather than unnaturally yoked. This is true quite apart from questions of the peculiar content of theology itself or the theologian's responsibility to engage constructively and critically with a range of different human disciplines and practices stretching beyond the usual suspects of philosophy, history and the natural sciences. Christian theology itself, I am suggesting, by virtue of the nature of its proper and primary object (the God made known in Jesus Christ) and its own nature as an activity shaped and determined by that same object, is closely and necessarily wedded to acts of imaginative human *poiesis*.

Imagination, Meaning and Reality

Let us be quite clear about this: we are not speaking now only of those moments where faith, in its attempt to articulate and express itself most fully and clearly, finds itself compelled to burst explicitly and unashamedly into full-blown poetry, to harness the resources of story-telling, or to trespass imaginatively into other worlds the forms of which bear little direct or obvious resemblance to our own. This sort of thing is rife, of course, both in Scripture and in the tradition of the church across the centuries, and, if it is to be faithful to the witness to either of these, theology itself cannot wholly eschew self-consciously imaginative forms. But my point here embraces the whole spectrum of what theology does, rather than what might be deemed by some to be occasional and necessary lapses into more poetic and less precise and scientific modes of engagement. No doubt there are more and less poetic forms of theology, some better suited to particular subjects and contexts than others. But my claim here is that *all* theology, no matter how 'scientific' and precise its aspiration or achievement, is nonetheless also 'poetic' and contingent upon acts of deep human imagining from the outset.

The etymology of the verb *theologein* must not be permitted to mislead us at this point. Even the most rigorous and tightly defined uses of words and ideas (the usual connotations of *logos* in theology and elsewhere) that we are capable of as human beings are inseparable from and dependent upon prior and continuing acts

of imaginative *poiesis*.[1] Among Christian writers on the subject, none has seen this point more clearly than C.S. Lewis, writing now in his professional capacity as a philosophically trained literary critic rather than as Christian apologist, though his theoretical insights in the one field shaped his practice in the other from first to last.[2] Reason, Lewis observes, can only function if it has something to reason about, otherwise it is empty, and he follows Kantian precedent in ascribing to the logically prior and occult activities of imagination the responsibility for furnishing the relevant materials.[3] What imagination supplies, Lewis suggests, is not just a cornucopia of material objects to be experienced, but the webs of relationship within which these objects are situated and in terms of which we are able to 'make sense' of them. Imagination, he insists, is thus not the organ of truth but of *meaning*. And, since 'meaning is the antecedent condition both of truth and falsehood, whose antithesis is not error but nonsense',[4] imagination is evidently a necessary if not a sufficient condition of all our most carefully reasoned and rational engagements with the world. Having made this most fundamental and vital point, Lewis then proceeds to concede that imagination functions at a 'lower' level than reason, which he supposes must be appealed to finally as the arbiter of truth. This, though, hardly seems to go far enough in its efforts to rehabilitate the profile of imagination. After all, when one turns to consider some of the activities

[1] Undermining the dichotomy commonly supposed to exist between evidence-based and 'rational' procedures on the one hand and the spheres of operation of imagination on the other has been an important contribution of recent theory, reinforcing the observation made more than a century ago now by the Scots poet, novelist and preacher George MacDonald, that imagination, far from needing to be rendered subservient to reason or even maintained in a perpetual critical dialectic with it, actually furnishes the logical and linguistic conditions under which reason alone may perform even its 'coolest' tasks. See George MacDonald, *A Dish of Orts* (Whitehorn, CA: Johannesen, 1996), 11–15. (The relevant essay was first published in 1867.) Cf., e.g., Mark Johnson, *The Body in the Mind: the Bodily Basis of Meaning, Imagination and Reason* (Chicago and London: University of Chicago Press, 1987), George Lakoff and Mark Johnson, *Philosophy in the Flesh: The Embodied Mind and its Challenge to Western Thought* (New York: Basic Books, 1999).

[2] For a helpful discussion of the connection between these two strands of Lewis's literary output see Michael Ward, 'The Good Serves the Better and Both the Best: C.S. Lewis on Imagination and Reason in Apologetics', in *Imaginative Apologetics*, ed. Andrew Davison (London: SCM Press, 2011).

[3] The key text is 'Bluspels and Flalansferes' in C.S. Lewis, *Rehabilitations and Other Essays* (London: Oxford University Press, 1939), 135–58. Cf. Kant's discussion of the transcendental and empirical imagination in Immanuel Kant, *Critique of Pure Reason*, trans. Norman Kemp Smith (London: Macmillan, 1929), A115–30. Kant's concern is with the formation of the *Objekt* of knowledge in perception and its subsequent classification and retrieval, whereas Lewis concentrates specifically on the role of language in shaping and reshaping meaningful wholes for our indwelling. In other respects, though, their accounts are consonant.

[4] Lewis, 157.

typically associated with 'reasoning' of the sort Lewis clearly has in mind, a moment's reflection reveals them to be in reality themselves activities of a highly 'imaginative' sort, trespassing far beyond the immediacy of the empirically given. Devising experiments, testing, theorising, calculating and so on are clearly very different sorts of activities from daydreaming, fantasising or constructing artistic alterities (let alone the deliberate construction and perpetuation of falsehoods), but they are activities, nonetheless, which are not only contingent upon *prior* acts of an imaginative sort, but continue to rely upon our capacity for imagination at every point. Unless we choose arbitrarily to define our terms in ways that posit an artificial antithesis, it seems that we must reckon with a much more perichoretic relationship than even Lewis permits between the imaginative and what we hold to be our most reliable and 'hard-edged' encounters with reality.

This is true, we might observe, of our intellectual engagements with objects of all sorts, but – in one of the great ironies to be grappled with in these matters – it is especially true at the cutting edge of such engagements, those frontiers of knowledge where established patterns of language and conceptuality let us down (precisely because we are confronted with something genuinely new for which we possess as yet no intellectual or linguistic currency). In situations like these we are driven to acts of catachresis, bending and extending the natural range of our language through the undeniably poetic devices of analogy and metaphor, teaching our old words new tricks in order to fill the gaps in the lexicon,[5] and, by effectively adjusting or accommodating our language to the structures of the world in this way, granting ourselves enhanced epistemic access to it.[6] Thus, there are poetic fingerprints to be found all over the precise and technical vocabularies of the sciences, in talk about electromagnetic fields, sound waves, particles of light, genetic codes and pre-programmed motor responses for instance. The glow associated with poetic origination may long since have dulled with use, of course, but in each case we can see how an eye for metaphor and acts of imaginative creativity are as vital to the advancement of scientific understanding as any intellectual or practical skill. Here the poetic and the heuristic impulses appear naturally to stand and fall together rather than necessarily tugging in opposite directions.[7]

In the particular case of Christian theology the shortfall of our day-to-day utterance with respect to its putative object is even more daunting than that confronting us at the limits of empirical exploration and (much more frequently)

5 Nelson Goodman, *Languages of Art: An Approach to a Theory of Symbols* (London: Oxford University Press, 1969), 68.

6 See on this Richard Boyd, 'Metaphor and theory change: What is "metaphor" a metaphor for?', in *Metaphor and Thought*, ed. Andrew Ortony (Cambridge: Cambridge University Press, 1993).

7 See, e.g., Johnson, 98, 157 et passim, Paul Ricoeur, *The Rule of Metaphor: Multidisciplinary Studies of the Creation of Meaning in Language*, trans. R. Czerny and others (Toronto and Buffalo: Toronto University Press, 1977), 246.

the stubborn resilience of so many day-to-day realities that will not be measured, weighed or reduced to the terms of any convenient calculus (the gnawing anxiety caused by a delayed medical diagnosis; the sacramental charge of an unexpected smile; the veil of mystery that remains intact even amidst a lover's passionate embrace). Here too, therefore, we must insist upon a vital symbiosis rather than a putative opposition between the logical and the poetic, the word/idea and the image.

The poetry of R.S. Thomas is perpetually haunted by questions of God's presence and absence, and of the capacities and incapacities of human language in the face of one who is, in Kierkegaard's phrase, 'wholly other', yet closer to us than we are to ourselves. In 'The Gap', the poet imagines God himself contemplating the dictionary of human speech, the glaring blank alongside his name a convenient index of the gulf remaining between them. Rather than tolerate any attempt to scale the heights of divine mystery and place him under the arrest of lexical definition, this God chooses instead to define his own name, making 'the sign in the space/on the page, that is in all languages/and none; that is the grammarian's/torment .../... and the equation/that will not come out'.[8] When God places himself within the order of signs, the poem suggests, matters are far from straightforward, the accommodation being as much a matter of judgement as of grace, and leaving God's mystery and freedom unscathed, veiling his elusive reality even as it shows it.

When it comes to the *logos* concerning *Theos*, in fact, for reasons bound up directly with what is widely held to be true of this God, we are necessarily reliant on language of a poetic sort. This is widely acknowledged in discussions of religious language, but its implications are not always taken fully on board or kept sufficiently in view in the wider task of doing theology.

Analogy, Meaning and the Incomprehensible

One classic discussion of the status and force of human language used to speak of God is that provided by Thomas Aquinas in the opening chapters of the *Summa Theologiae*.[9] Aquinas is on the whole more positive about the wider circumstance than R.S. Thomas's poet, yet his account remains a very measured and carefully qualified one, and certainly provides little encouragement for those who would wish to pin God down on the basis of any sort of lexical logic-chopping attempted 'from below'. According to the claims of Christian faith itself, Aquinas reminds us, the uncreated and infinite reality we know as 'God' by definition transcends

[8] R.S. Thomas, *Collected Poems 1945-1990* (London: Phoenix, 1995), 324.

[9] The relevant discussion is in *Summa Theologiae*, 1a. Q. 12–13. For text see Herbert McCabe O.P., ed., *St Thomas Aquinas Summa Theologiae* (1a. 12–13), St Thomas Aquinas Summa Theologiae, vol. 3 (London: Blackfriars in conjunction with Eyre and Spottiswoode, 1964).

the created and finite world inhabited by his own creatures, and as such can, in the strictest sense, neither be comprehended by creaturely minds as such nor spoken about in terms of the meanings attaching ordinarily to our discourse. Here it becomes necessary at once to lodge a significant disclaimer, and to notice something that is perhaps not often enough noticed about Aquinas's account. God being God, he insists, it is quite impossible that any created mind should see the essence of God by its own natural powers.[10] The key phrase here, though, is 'by its own natural powers', and Aquinas proceeds to affirm at once that, when the soul is finally freed from its present entanglement with material things by death, and by virtue of an act of divine grace uniting the soul directly to God, knowledge (or 'seeing') of God's essence will indeed be possible even for creaturely intellects. This, indeed – the enjoyment of the so-called 'beatific vision' – is Aquinas's firm eschatological hope, and all that he says subsequently about what our minds and our language are capable of *in the meanwhile* is set consciously in apposition to this hope, as something by comparison 'so exiguous as to be hardly worth discussing'.[11] While ever we labour in a human 'nature' in which soul and body are inexorably intertwined, Aquinas insists, our forms of creaturely knowing and our language alike are constrained by the limits of that which also exists in close conjunction with corporeal objects and whatever can be known through a process of logical abstraction from the same. God, being infinite, clearly *cannot* be known in this way, and thus while God may from time to time grant individuals a miraculous glimpse of his 'essence' in this life, our *natural* epistemic and linguistic capacities, being hopelessly wedded to the senses, are bound to fail in any attempt to encompass it.[12]

The categories used by Aquinas in Question 12, of 'knowing' or 'seeing' God's 'essence', are ones unfamiliar to us today, and Herbert McCabe suggests helpfully that the force of his point would come across rather more clearly if he had said instead that in this life we do not actually know what 'God' (or any creaturely term applied to God) really means, and are thus compelled to use words to mean more and other than we can ever understand. We cannot get either our heads or our words around the reality of this God, because his reality is literally mind-blowing and lies well beyond the natural range of any language suited to the dealings we have as human beings with the world around us. But, Aquinas observes, that is actually the only sort of language available to us as human beings.[13] The fact that, paradoxically, notwithstanding all this we are able to speak *meaningfully* about God and thereby obtain some appropriate grasp on his reality lies in part at least,

[10] 1a. 12, 4. See McCabe O.P., ed., 15.

[11] This point is made by Herbert McCabe in an editorial appendix on 'Signifying Imperfectly', in ibid., 104.

[12] See esp. 1a. 12, 4 and 1a. 12, 11.

[13] 'Non enim possumus nominare Deum nisi ex creaturis, ut supra dictum est.' 1a. 13, 5. McCabe O.P., ed., 64.

Aquinas suggests, in the plasticity of language and its capacity to be redeployed in imaginative ways.

Words coined originally to speak of one thing can be taken up and made new, their semantic patterning modified and stretched creatively so that they come to refer fittingly to other, quite different things, enabling us to talk and therefore to think about them. If, as Aquinas readily acknowledges, this sort of thing is basic to the ways in which we expand and order our knowledge of the world itself, straddling the interstices and simultaneously plotting the (sometimes far from apparent) connections between different creaturely realities, in the case of our knowing and speaking of God who is, Aquinas reiterates, 'more distant from any creature than any two creatures are from each other', it is clearly essential to the circumstance.[14] In this case above all others, univocal predication (a particular word or phrase used more than once and bearing exactly the same sense on each occasion) is not an available option, and if we are to avoid the hermeneutic emptiness of utter equivocation, therefore, we are bound to rely instead on the imaginative stretching of our terms to bridge the gap.

God, Analogy and Metaphor

Aquinas identifies different forms of this stretching in our talk about God. In doing so he puts his finger on and seeks to account for something that most Christian readers would almost certainly concur with; some human terms, we tend naturally to suppose, apply to God more fully and properly than others, so that there is apparently less of an imaginative stretch involved in referring to God as good or wise than there is in calling him a shepherd, let alone a rock or a lion. This, Aquinas tells us, is because the former terms apply to God by way of analogy, whereas the latter are merely instances of metaphor.[15] How, then, does he account for the difference between the two?

Words that refer *analogically* to God, Aquinas argues, refer to non-material qualities ('perfections') which God actually possesses in common with his creatures (though he possesses them, Aquinas reminds us at once, in a manner befitting his own eternal and infinite nature and which thus far outstrips our intellectual and imaginative grasp). We know that these perfections are possessed by God (though not how he possesses them), Aquinas contends, because we find them present in his creatures and, he maintains, the transcendent 'first cause of all things' must itself first possess whatever perfections it duly imparts to its creaturely effects.[16]

[14] 1a. 13, 5. ibid., 63. This observation arises as the premise for one of the arguments *in contrarium*, but Aquinas's *responsio* endorses it as a ground for rejecting univocal predication, while denying that equivocation is the only logical alternative. Cf. ibid., 67.

[15] See the discussion of this difference in 1a. 13, 3 and 6.

[16] See, e.g., 1a. 13, 2: 'Any creature, in so far as it possesses any perfection, represents God and is like to him, for he, being simply and universally perfect, has pre-existing in

Presuming this to be so, of course, such qualities (being, goodness and wisdom are some of Aquinas's chosen examples) belong primarily and properly to God and only secondarily and in a derived way to creatures. Furthermore, the meaning of the relevant terms (what Janet Soskice calls their natural or proper 'domain of application')[17] is for Aquinas centred precisely on their applicability to God rather than on our more familiar uses of them.[18] In calling God 'good', therefore, he insists, we are actually involved in literal rather than figurative speech. The way in which the term applies to God (its *modus significandi*) is going to be vastly different from the sense it bears in the statement 'Thomas is good', and in this life we cannot know precisely what it means to speak of God as good; but, for reasons just indicated, it will involve no trespass beyond the term's primary and proper domain of application. So, by definition analogy is quite different from univocal predication but it is, Aquinas insists, a form of the *literal* rather than a *figurative* use of words.[19]

How, then, does all this differ from a metaphorical use? According to Aquinas, in several basic respects. Both involve the semantic stretching of terms across difference, but otherwise they are themselves quite different from one another. To begin with, Aquinas argues, the primary and proper domain of application of the words we use metaphorically of God is limited to creaturely realities,[20] so that the trajectory of meaning travels, as it were, identifiably from below to above and words are compelled to operate well beyond their natural comfort zone and to do work quite other than that for which they were designed. Here, we might say, the domain of application of the relevant terms is not only stretched, it is in effect ruptured, and words are left isolated, functioning in places where they did not expect to find themselves and do not properly belong. Secondly, therefore, Aquinas holds, human terms used to speak of God in this way do not name perfections God *actually possesses* in common with us, but, being semantically inextricable from

himself the perfections of all his creatures.' McCabe O.P., ed., 55. Cf. 1a. 12, 12. In these passages Aquinas echoes the metaphysical principle first aired in the fifth century AD by the NeoPlatonist Proclus according to whom 'Everything which by its existence bestows a character on others, itself primitively possesses that character, which it communicates to the recipient'. Proclus, *The Elements of Theology*, trans. E.R. Dodds (Oxford: Clarendon, 1953), 21. For Aquinas, though, the more significant point is that such perfections exist in creatures atypically and imperfectly, and exist in God 'in a higher way than we can understand or signify'. McCabe, O.P., ed., 55.

[17] See Janet M. Soskice, *Metaphor and Religious Language* (Oxford: Clarendon Press, 1985), 64–5.

[18] '... hoc dicendum est quod quantum ad rem significatam per nomen per prius dicuntur de Deo quam de creaturis.' 1a.13, 6. McCabe, O.P., ed., 70.

[19] See esp. 1a. 13, 3.

[20] '... omnia nomina quae metaphorice de Deo dicuntur, per prius de creaturis dicuntur quam de Deo.' 1a. 13, 6. McCabe, O.P., ed., 68.

their flesh-laden context of use,[21] only point obliquely to a 'certain likeness' or 'parallelism' (*similitudo*) suggesting itself between God and mundane realities.[22] Presumably, if such metaphor works rather than falling flat, the similitude may be taken to be appropriate rather than arbitrary, but the sense of 'fit' will nonetheless be of a wholly different order than that involved in analogical speech. We inherit lots of images of this sort from Christian Scripture itself, of course, which pictures God variously as a rock, a refreshing drink, a lion, a vintner, an artist, a husband, a woman in labour, a shepherd and many other things besides. And we might suppose (though Aquinas himself does not deal directly with the question), we reach intuitively for others on occasion in order to grasp or articulate some distinctive feature of faith's living encounter with God.

Analogy and the Apophatic Contra-indication

Despite such alleged differences, these two ways of stretching our language in order to speak of God seem to me to fall rather closer together in Aquinas's account of the matter than first appearances might suggest. To begin with, the broad structure and direction of linguistic use is the same in both cases, for, as Aquinas readily admits, even in analogy it is true that, whatever its meaning may be *sub specie aeternitatis* or from a God's-eye point of view, 'from the point of view of *our use* of the word *we apply it first* to creatures because we *know* them first',[23] and thus only secondarily to God. Aquinas's insistence that such reference is in reality 'literal' rather than figurative makes no practical or structural difference at this point. God is no more 'good' or 'wise' *in the way that we are* (and thus in any of the senses that we attach to our use of those terms in familiar human discourse) than God is a rock or a shepherd, and there thus remains a clear and considerable stretching of language and imagination moving from below to above in applying them meaningfully to him. In neither case are we able to define precisely what we mean or cash things out fully in 'literal' terms; indeed, were we able to do so, the theological resort to the poetic image with its capacity to *suggest* what cannot be grasped or stated in a categorical manner would be wholly unnecessary and, we might add, our engagement with things considerably less rich. Aquinas's own indications that some such clarity of vision is what awaits us in eternity need not detain us here, other than to observe that it need not be interpreted as the eschatological endorsement of the sort of rationalism which wants no more and no less than it says and can define exactly – as though God were a giant, hitherto unclassified species of moth to be pinned conveniently under glass and labelled

[21] 'Thus it is part of the meaning of "rock" that it has its being in a merely material way. Such words can be used of God only metaphorically.' ibid., 59.

[22] See 1a. 13, 3 and 6.

[23] 1a. 13, 6. McCabe, O.P., ed., 71. My emphasis.

at last by a nineteenth-century amateur collector,[24] rather than the ultimately unfathomable mystery, to be united with whom is to be ravaged and undone by love, and so to lose all interest in considerations of a merely intellectual sort. Indeed, as analogues for the beatific vision go, while certain acts of intellection may well fit the bill, it is more likely to be those most evidently woven together in our experience with imaginative, aesthetic, affective and moral realities (the sense of wonder and awe attendant upon some new scientific discovery; the compelling 'beauty' of a newly apprehended mathematical or logical pattern; the goodness and 'rightness' of responding in a particular way to an unexpected initiative of personal self-revealing) and not the rarefied abstractions inscribed for convenient reference and computation on the pages of the dictionary or the manual.

The other aspect of difference Aquinas identifies between analogy and metaphor as we have seen has to do with the respective levels of similarity and dissimilarity understood to pertain between predicate and object, and the relative felt sense of propriety and impropriety therefore involved in conjoining them. Appeal to something like this is also commonplace in more recent attempts to distinguish the two linguistic forms. Whereas in the one circumstance, Sallie McFague suggests, what is indicated is 'profound *similarity* beneath the surface dissimilarities', in the other we point only to the slightest 'thread of similarity between two dissimilar objects',[25] a formulation which echoes Aquinas's talk of shared qualities versus mere fleeting similitudes. Consequently, Janet Soskice suggests, from its inception analogical use 'seems appropriate' and 'fits into standard speech without imaginative strain',[26] while the relatively wayward and risqué nature of the metaphorical is captured nicely in Nelson Goodman's colourful (and highly metaphorical) description of it as 'an affair between a predicate with a past and an object that yields while protesting'.[27] Where there is metaphor, it seems, there is some evident felt sense of conflict or tension, the conjunction between two things being 'to some extent contra-indicated'.[28]

Again though, the two allegedly distinct forms evidently hold something basic in common. In each, the relevant use of words is designed to indicate some level of similitude apprehended in a relation characterised otherwise by non-identity and dissimilarity between two things or circumstances, and thus, even though the *ratios* of similarity to dissimilarity indicated may differ significantly, we have to do in both cases with a use of words designed to hold like together with unlike, and one

[24] What the reader may perhaps think an unduly extravagant and indulgent image was suggested to me both by a quick scan for biblical metaphors (see Hos 5.12 in NIV) and by stumbling inadvertently again across 'The Empty Church' in Thomas, 349.

[25] Sallie McFague, *Metaphorical Theology: Models of God in Religious Language* (Philadelphia: Fortress Press, 1982), 12, 15.

[26] Soskice, 65–6. Soskice's book remains the most thorough and helpful overall treatment of the subject available.

[27] Goodman, 69.

[28] Ibid.

which therefore, in McFague's paraphrase of Paul Ricoeur, contains the whisper 'it is, *and it is not!*'[29] The audibility of the whisper will indeed vary with the degree of difference we suppose to exist and, as we have seen, in this regard metaphor is generally located at one end of a putative scale and analogy at the other. But this, surely, is a convenient place to remind ourselves of the theological conviction that accompanies and undergirds Aquinas's ruminations about theological language from the outset; namely, his insistence that the difference between God and finite creatures is so great as to be unimaginable, and that even in the case of analogical speech about him, therefore, in the very instant that likeness of any sort is dangled tantalisingly before us, it is at once snatched away again to be offset and qualified by the equal and opposite suggestion of a profound difference remaining unscathed and unfathomed. Even here, surely, 'from the perspective of human use' there is something remarkable and striking about being willing to use the same word in both cases? God is good, we say; but being God, God is good in a way lying far beyond our intellectual and imaginative reach, so that we cannot understand the gravity of our own words even in uttering them. We may (and do) properly trust that they bear some positive relation to their several mundane uses; but precisely what that relation is, finally, we can neither know nor say.

Semantic Slippage and the Problem of Petrification

Some theologies would be inclined to widen the ontological and epistemic gap between divine and creaturely reality even further than Aquinas himself does, perhaps challenging in doing so the idea that any 'qualities' could meaningfully be supposed to be held in common between them, or at least that we could *know* them to be so by a process of logical inference. Indeed, those unwilling to follow Aquinas's metaphysic in tracing the perfections evident in creaturely effects to their pre-existent type in a divine exemplar (God), will have no abiding reason to distinguish between the analogical and the metaphorical in the precise way that he does, and will seek different grounds for choosing to deploy some terms to speak of God and resisting the use of others, or for granting some terms more priority and weight than others within the patterns of religious and theological discourse. While unlikely to collapse all our anthropomorphic images for God down to the same level (as though to call God Father, for instance, were no more and no less fitting or significant than to refer to him as a farmer, let alone a rock or maggots)[30] such theologies will nonetheless tend to insist that any and every human term *when applied to God* is, by nature of the ontological and epistemic circumstance,

[29] McFague, 13. Cf. Ricoeur, 224.
[30] Hos. 5.12, NRSV. KJV has 'as a moth'.

striking and surprising in its first use at least, and thus charged with that tension and sense of resistance generally ascribed to metaphorical utterance.[31]

Furthermore, in the case of our speech about God all this is bound to remain, properly speaking at least, a permanent rather than a temporary state of affairs. In our human dealings with creaturely things, the poetic image often petrifies, passing eventually into more prosaic and 'literal' modes, its work as a tool of exploration now successfully completed and the relevant territory if not exhausted at least now mapped to our satisfaction. Metaphors, as it is commonly put in the literature, eventually 'die', their capacity to shock or surprise (and in doing so to draw our attention to something hitherto unnoticed) having been dulled through the familiarity of sustained use. Such death, of course, far from being an indication of failure, is precisely a function of the success of the image and its ready assimilation by the wider language. So, for instance, in his discussion of this semantic slippage across time Colin Gunton reminds us of the once metaphorical status of the word *muscle* which 'when first used presumably drew upon some of the associations of the Latin *musculus*, "little mouse". No-one now thinks of those associations, but that is because it has been so successful'.[32] Gunton describes this as the passage of the relevant term from metaphorical to 'literal' status within the language, a shift which means simply that what was once a striking and unfamiliar use has now 'come to be accepted as the primary use of the term'[33] or, we might say, been adopted as a use located securely within the range of the term's primary domain of application.

Soskice, acknowledging the importance of such diachronic developments in the patterns of language use, yet preferring to follow Aquinas in differentiating literal (including analogical) from metaphorical predication on the basis of something more than usage alone, distinguishes instead between literal use and what she identifies as 'dead' and 'short-lived' metaphors respectively. The latter, she suggests, function within language in ways closely related to analogy, but native speakers of the relevant language can, on reflection, readily identify that the usage is inconsistent with the word's 'original domain of application'.[34] An analogy, Soskice suggests, has never possessed any 'modelling' or heuristic capacity, staying at home and having led rather a dull linguistic life; whereas a

[31] See helpfully on this McFague, 13. Metaphors, we ought to note, are not stable, and do not all function on the same level. Indeed, it is precisely those that prove most rich and fruitful in opening up territories of meaning that tend, eventually, to pass into 'literal' use and so surrender their metaphorical status. In linguistic terms, both 'Son' and 'rock' are metaphors as applied to God, but the profundity and semantic excess attaching to the former place it on a quite different level than the latter.

[32] Colin Gunton, *The Actuality of Atonement: A Study of Metaphor, Rationality and the Christian Tradition* (Edinburgh: T&T Clark Ltd., 1988), 34.

[33] Ibid., 35. Here Gunton draws on Ricoeur's account of the relevant distinction. See Ricoeur, 291.

[34] See Soskice, 71–4.

'dead metaphor', on the other hand, has had a colourful past, even if we find it now settled down to a quieter form of existence. It is tempting at this point to raise all manner of questions about the notion of a consistent and unchanging 'original domain of application' and its alleged non-susceptibility to the contingent fluctuations of time and place. Depending on exactly where and when one enters the relevant conversation, it might be argued, one's sense of what counts as the primary domain may be calibrated quite differently, and talk about muscles, and magnetic fields or, for that matter, God as Father, Lord, and perhaps 'good' and 'wise' too[35] might then, even on reflection, strike one as having something odd and out of place about them or as entirely unsurprising and proper.

We cannot (and fortunately need not) resolve these interesting and contested differences of understanding here. Allusion to them, though, leads us conveniently back to my main point: Where our discourse about the phenomena of creaturely existence in the world is concerned, words can and do shift in their range of applications with impunity, however we may choose to describe or theorise that shift. What was once a striking and surprising use of words becomes less so, eventually being taken for granted as part of a perfectly natural and ordinary way of speaking about things. But in the case of our talk about God, I would suggest, there is a vital sense in which this process of assimilation ought never to be allowed to happen, not entirely anyway. I say 'ought' because, of course, it does happen, and in the case of lots of human terms (Father, Lord, King and others) many Christians have long since forgotten the oddity of just what we are doing when we use them to speak of God. But we ought not to forget it. We should deliberately keep the relevant images alive, no matter how accustomed we have become to their use, because, in a unique manner and to a unique extent, God remains forever elusive and resistant to convenient classification, escaping our grasp whenever we try to tighten up our definitions or pin him down more precisely. To forget this, or to overlook it in practice, is both to run the risk of religious idolatry and to miss the power of the poetic image to transform and renew the vulgate, the breaking open of our terms on the rock of divine otherness compelling constant reconsideration and reevaluation of their familiar meanings. To call God 'King', for instance, cannot leave human models of kingship unscathed, but must be permitted to come back eventually to bite not just our political theologies but our politics, God's particular way of exemplifying 'kingship' calling its creaturely equivalents severely into question.[36] It is typical of poetic images that

[35] It is not difficult to imagine a semantic (and religious/theological) past where these two terms and other alleged instances of analogical use were ones the application of which to God had once fallen fairly clearly outside rather than comfortably within their established domain of use, and where this fact was reflected in the ability of native speakers, on reflection, to identify a certain sense of disturbance at their theological application. That they apply to God naturally or properly is a metaphysical claim, and a controvertible one at that.

[36] I am indebted to my colleague Richard Bauckham for suggesting this example.

their juxtapositions of like and unlike transform our understanding of all relevant terms in the relationship. In the case of God and God alone, though, we might properly insist, such mercurial otherness is not just *de facto* but *de jure*, a feature of who and what God himself is in his proper relationship to the world. Here, the 'split-reference', the mysterious and fluid interplay of 'it is' and 'it is not' which Ricoeur identifies as the very hallmark of the truthful poetic image[37] remains and must remain identifiably in play, our refusal to resolve or reduce it into other, more secure, 'hard-edged' and intellectually manageable forms of thought and speech having received, we might suppose, the highest possible warrant. For Christians, discourse about God and with God, in liturgy, theology or elsewhere, is bound finally to remain a matter of the image, precisely in order to be faithful to the peculiar way taken by the divine Word in God's address to us.

The Object and the Mode of Knowing

To allow the images which function at the heart of Christian theology to petrify and so subject to precise determination would in practice be unfaithful to the very nature of the object we are seeking to know and to speak of, and thus, ironically perhaps, result precisely in a highly *unscientific* approach to it. This point is made forcefully in the writings of T.F. Torrance, who reminds us repeatedly that in all properly scientific and objective procedure it is the nature of the particular object itself which must prescribe the relevant mode of knowing, and thus the form and the content of whatever knowledge arises.[38] This, he insists, is no less true of our knowledge of God than our knowledge of anything else, though its precise implications will obviously vary from field to field. Where our knowledge of God (*theo-logein*) is concerned, Torrance insists, one particular implication is that in any true statements we make our words are bound to possess and retain a fundamental density and resistance to precise determination, remaining fluid in their mode of signification. Theological language, he urges, is *paradeigmatic*, never precisely *descriptive*; it *points* beyond itself to God rather than attempting to picture him.[39]

Torrance privileges spatial metaphors in his articulation of this, picturing our words as physical tools, having a 'side' that faces us as we handle and deploy them, and a 'side' turned appropriately to make contact with the object. Theological statements, he acknowledges, must, to be sure, 'be closed on our side, for we have to formulate them as carefully and exactly as we can', but on God's side they must remain 'open (and therefore apposite) to the infinite objectivity and

37 Ricoeur, 224.

38 See, e.g., Thomas F. Torrance, *Theological Science* (London: Oxford University Press, 1969), 13f. et passim. Cf. Thomas F. Torrance, *Theology in Reconstruction* (London: SCM Press Ltd, 1965), 53–4.

39 Torrance, *Theological Science*, 20.

inexhaustible reality of the divine Being'.[40] Only thus can our words possess an appropriate transparency, enabling us to look *through* them, rather than *at* them, and permitting our minds to 'come under the compulsion of the Reality we seek to understand',[41] rather than forcing it in a Procrustean manner into verbal and intellectual boxes already conveniently at our disposal. 'It is important to see that open concepts are not irrational because they are open', Torrance writes, 'for to be open vis-à-vis the eternal God is the true mode of their rationality, prescribed for them by the nature of the divine Object of knowledge – they would in fact be most imprecise and inaccurate if they were not open in this way'.[42] To seek to over-determine our meanings at this point, then, to insist on hard and precise modes of speaking, or even to permit inadvertent hardening through the familiarity of use would be a wholly inappropriate way of proceeding, irrational rather than rational and, in theological and religious terms, tantamount to idolatry. The inadequacy of the terms we use in this context is *essential to* their truth, Torrance urges,[43] rather than compromising it.

In similar vein, Colin Gunton observes that the indirectness and elusiveness of metaphor, holding together quite explicitly the affirmation that 'it is' with the vital qualifier that, even so, 'it is not', grants it an epistemic modesty befitting 'a primary vehicle of human rationality' and superior to the hard-edged and 'pure' concepts which would, in effect, finally deny reality any abiding mystery or capacity to resist our attempts to wrestle it into submission.[44] Both Torrance and Gunton would, I think, see due intellectual humility (and hence the demand for openness, indirectness and imaginative semantic surplus in our speech and thought) as proper to all properly objective knowing, and a vital counterpoint, therefore, to whatever efforts in the direction of the precise determination and tight definition of terms may legitimately arise in our dealings with creaturely things too. Only thus can we both 'fix' meaning sufficiently to think and speak and write in a coherent manner about things at all, and yet, at the same time, allow reality to enforce constant modifications and adjustments to those meanings, rather than leaving them 'fixed' in some once and for all manner and thus blind and deaf to further insights and discoveries.[45] But it seems reasonable, nonetheless, to suggest that in the case of God in particular, and in some sense uniquely, the whisper 'it is, *and it is not*' demands to have the volume cranked up to 11 on a regular basis

[40] Thomas F. Torrance, *God and Rationality* (London: Oxford University Press, 1971), 186–7.

[41] Ibid., 187.

[42] Ibid.

[43] Ibid., 187–8.

[44] See Gunton, 39.

[45] On the metaphorical 'fixing' of meaning and its implications see ibid., 45. For the same basic point cast in other terms, cf. Torrance, *God and Rationality*, 19.

in order to prevent us from collapsing into an inappropriate, impious and irrational form of 'rationalism'.[46]

By-passing the Image in Pursuit of the Logos

Given Torrance's own inevitable reliance on figurative uses of language in writing about all this ('open' meanings which permit us to 'look through' words rather than 'looking at' them, or in which words are permitted to 'point beyond' themselves, functioning as 'tools' rather than as 'pictures', etc.) it is interesting to note his general reluctance to grant the imagination much positive place in Christian theology. Of course, he admits, at one level the use of 'images' drawn from the world of things familiar to us is inevitable in our talk about God if we are to think or say anything about him at all. As we have already seen, though, for Torrance, while such images are clearly 'adapted to' our capacities as human knowers ('closed' on our side) so that 'we may have some hold in our thought upon (God's) objective reality', they are equally certainly not 'fitted to' the reality of God himself, which remains transcendent and elusive, far beyond the reach of any attempt to picture or describe it.[47]

While agreeing with the insistence of Anglican theologian Austin Farrer that we cannot discern the reality of God 'except *through* the images', therefore, Torrance nonetheless demurs strongly from Farrer's further elucidation of the same point, according to which 'We cannot by-pass the images to seize an imageless truth'.[48] On the contrary, Torrance argues, although we certainly cannot by-pass the images, what must be recognised and underscored is the fact that in this particular context such images do not actually work by 'imaging' at all (since the God to whom they point is not capable of being imaged). In this sense, therefore, precisely what must be said is that the 'truth' we apprehend (and the way in which we apprehend it) is 'imageless', and to forget or deny this is bound to end in some form of idolatry. This leads Torrance quickly into seemingly paradoxical talk about 'images that do not actually image',[49] and although faithfulness to biblical language and practice compels him to retain the vocabulary of the image, he gladly exchanges it on a regular basis for the less potentially troublesome talk of 'concepts' which, he urges, are closely related to images, but have been stripped down and purged of any concrete pictorial content, so that they can function now in a purer, more abstract, more precise and 'imageless' manner. At this point, Torrance appeals in what he takes to be a biblical (and subsequently a Reformed) manner to the pattern

[46] On 'rationalism' in the relevant sense see Gunton, 1–25.

[47] Torrance, *Theological Science*, 20.

[48] See Austin Farrer, *The Glass of Vision* (Westminster: Dacre Press, 1948), 110. For Torrance's discussion see Torrance, *Theological Science*, 19.

[49] Torrance, *Theological Science*, 20.

of auditory rather than optical experience, and to the vital qualification of the one by the other in biblical and theological understanding of our talk about God.

> In the biblical tradition image and word belong together, and it is through word that the images are made to signify or indicate that to which they point. It is this powerful element of word that makes us look through the images and hear past them to what God has to say, and so to apprehend Him in such a way that we do not have and are not allowed to have any imaginative or pictorial representation of Him in our thought.[50]

Thus, on the one hand, in this context pictures without words are paradoxically 'blind', denying us of 'eyes to see', as it were, precisely because we lack the accompanying 'ears to hear'. But, Torrance suggests, words without pictures are *not* empty. Not always. We must not identify the conceivable (let alone the rationally compelling) with states of affairs that we can 'picture' he insists, citing Frege's work on symbolic logic in support of his case. The pure concept, stripped of all the distracting clutter of perceptibility, emancipated from the inevitable opacity of the flesh, functions 'imagelessly' to penetrate successfully into deep regions of logic lying far beyond and corresponding to nothing that we can picture for ourselves.[51]

Imagination, Reason and Rationalism

I shall suggest momentarily that these may not be either the most obvious or the most helpful terms in which either to affirm what Torrance apparently wishes to affirm or to deny what he wants to deny about the nature and functioning of our talk about God. First, though, it is worth noting the ostensible parallels existing between his chosen terms and those associated with various forms of what Gunton refers to as 'conceptual rationalism'.[52] Arising in different guises across the centuries from Plato's *Republic* to the thought of G.W.F Hegel (1770–1831), the hallmark of this philosophical tendency, Gunton observes, is its insistence 'that meaning and truth are successfully conveyed only by means of concepts of an intellectual kind which have been purified as completely as possible from all imaginative or pictorial content', resulting in an over-valuing of abstract logical connections between ideas, and a relative denigration of everything else.[53]

In his *Lectures on the Philosophy of Religion* (1821–31), Hegel presents a version of this in which he distinguishes sharply between the place of *Vorstellungen* ('representations') and *Begriffen* (concepts) in religious and theological

[50] Ibid.

[51] Cf. Torrance, *God and Rationality*, 23.

[52] See Gunton, 16ff.

[53] Ibid., 17.

engagements with the reality of God.[54] Religion is necessarily full to the brim with *Vorstellungen*, the 'sensible forms or configurations'[55] in and through which truth is clothed for us in flesh, presented under the guise of concrete particulars and the relationships between them (pictures, stories and the like) so that we may apprehend and grasp it readily. But this is a preliminary and provisional state of affairs as regards our dealings with the truth, and things cannot remain thus. Precisely because they are reliant on imagination and representation in this way, Hegel argues, religious traditions cannot themselves penetrate to the universal truth of things, but remain trapped at the level of historical and material particularity, weighed down, as it were, by their complicity in the forms of the flesh, and prevented from any ascent beyond its regions. Thus, for Hegel, precisely what must occur is for the imaginative concretions (images, stories etc.) of religious doctrine to be 'elevated and transmuted into more adequate conceptual form',[56] the imaginative flesh being in effect stripped away so as to reveal the intellectually pure and logically precise skeletal framework of *Begriffen*.

At first blush the parallels between Hegel's account and that developed by Torrance are quite striking and can hardly be overlooked, even though closer inspection will at once reveal significant differences between their respective theological concerns and projects. Hegel, for instance, participates unashamedly in that intellectual prejudice according to which whatever relies upon or is complicit in the realm of the particular (historical, material) has by definition a strained and problematic relationship to the truth of things and must, like the Platonic soul of old, finally be released or redeemed from its entanglement with the *kosmos aisthetos* in order to discover its true place in the realm of pure Ideas or Forms (*kosmos noetos*). Torrance has no truck with any such dualism, being committed in a way that Hegel is not to the fact and thus the radical particularity of the incarnation,[57] that event in which, according to Christian faith, God himself 'took flesh' and made the contingencies of historical and material existence his own in order to redeem them from within and to give himself to be known in and through

[54] See, e.g., G.W.F. Hegel, *Lectures on the Philosophy of Religion* vol. 1, trans. R.F. Brown, Peter C. Hodgson, and J.M. Stewart (Berkeley, CA: University of California Press, 1984), 396ff. For a full discussion see further Charles Taylor, *Hegel* (Cambridge: Cambridge University Press, 1975), 465–533.

[55] A more familiar term, Hegel notes, is simply *Bilder* ('images'). See Hegel, 397.

[56] Gunton, 22.

[57] For Hegel the doctrine of the incarnation is to be understood as a pictorial representation whereby the universal truth that '(t)he divine nature is the same as the human' is imaginatively mediated and grasped at a lower level than its philosophical realization. See G.W.F. Hegel, *Phenomenology of Spirit*, trans. A.V. Miller (Oxford: Clarendon Press, 1977), 459–60, 475. For a helpful account cf. Colin Gunton, *Yesterday and Today: A Study of Continuities in Christology* (London: Darton, Longman and Todd, 1983), 40–43.

them.[58] Indeed, for Torrance it is precisely the truth articulated in the Nicene doctrine of the *homoousion*, the consubstantiality of the incarnate Son with the Father, which both permits and compels us to deploy certain human terms in our thinking and speaking about God at all, grounding those same terms 'objectively' in God.[59] But when it comes to the question of the precise epistemic force of that particular flesh which the divine Son made his own (let alone any other instance of creaturely reality falling outside the hypostatic union), when he enquires, in other words, about the significance which the particular shape and substance of this flesh has for the content and shape of our thinking and speaking about God, Torrance's case leans much further in the direction of Hegel's, in phraseology at least, and generates an apparent tension in his thought.

Imagination, Imagelessness and Invisibility

For Torrance, the 'flesh' or humanity of Christ is absolutely indispensable as a starting point for theology, being precisely a vital divine accommodation to our human ways of knowing. Furthermore, Torrance insists, this flesh can never be circumvented or set aside as though it were a mere external creaturely vehicle for an inner divine content which can be grasped and held onto without it. The particular humanity of the man Jesus Christ is eternally ordained to be 'God's language to man', and we cannot, Torrance insists, know God without paying constant and careful attention to it.[60] Yet we must reckon with the paradox that even here where he makes 'flesh' his own, God is nonetheless known precisely through the signifying mediation of that which is 'not-God' (the humanity of Jesus),[61] and if we can and must not seek to 'get behind the back of' this *logos incarnatus* in order to know God in some direct and unmediated way, nor, therefore, must we ever mistake it for the proper object or final destination of theological knowing. The concrete human form upon which our knowing depends here, even though it may and must be acknowledged and confessed as God's very own 'flesh', must, in other words, like all those other creaturely forms of thought and speech which

[58] This doctrine, Torrance insists, constitutes the very 'antithesis of any radical dichotomy between intelligible and sensible worlds. It is the doctrine of the coming of God into our human existence in space and time, and his affirming of its validity in relation to himself as Creator and Redeemer. Torrance, *Theology in Reconstruction*, 52.

[59] See ibid., 39. Cf. 52.

[60] Torrance, *Theology in Reconstruction*, 129–30.

[61] Here Torrance follows Barth who puts the matter thus: 'What if God', he enquires, 'be so much God that without ceasing to be God he can also be, and is willing to be, not God as well (?)'. Karl Barth, *The Göttingen Dogmatics: Instruction in Christian Religion*, Vol. 1, trans. G.W. Bromiley (Edinburgh: T&T Clark, 1991), 136.

prepare the way for and duly follow on from it,[62] nonetheless be and remain 'open' on its far side, the side which is turned and points us towards the eternal Being of God himself.

Even within the dynamics of the hypostatic union, in other words, for Torrance the flesh of the incarnate Son cannot function in such a way as to become the logical terminus of our knowing and speaking about God but must, like any other creaturely reality, become 'transparent', functioning precisely 'signitively' rather than 'eidetically',[63] merely pointing our gaze in the right direction rather than providing any picture or mimetic approximation to the Being of God.[64] Here, scandalously perhaps, we must insist that not just our vulgar human terms but even the humanity of God himself is, *in and of itself and as such*, inadequate and possessed of a certain inevitable and vital impropriety with respect to the task of making God known.[65] In as much as Jesus' humanity is 'not God', it participates in the inherently ambiguous condition of the sign, and if it is to function thus it must, in the very process of being assumed or appropriated within the enhypostatic movement of the incarnation, also be broken open and transfigured, acquiring a tantalising surplus of meaning far beyond anything it ordinarily possesses, its very brokenness and open-endedness permitting it, within the Trinitarian dynamics of divine self-giving, to refer us beyond itself to that which it is not.[66]

Here, though, what Torrance certainly shares with Hegel – namely a deep suspicion of the intellectual contributions of human imagination and its products, and a self-conscious elevation within his theological method of the 'pure' concept

[62] Torrance speaks of Israel's history as the divinely furnished matrix for interpreting the person and work of Christ, the divine Word being here already 'on the road to becoming flesh', and providing conceptual tools for its own proper articulation. See, e.g., Thomas F. Torrance, *The Mediation of Christ*, 2nd ed. (Edinburgh: T&T Clark Ltd, 1992), 1–23.

[63] Torrance, *Theology in Reconstruction*, 19–20.

[64] For Torrance, any denial of this would amount to a serious compromising of the insights of Chalcedonian Christology, according to which the two 'natures' of the incarnate Son are *inseparabiliter* and *indivise*, but equally vitally *inconfuse* and *immutabiliter*. See ibid., 130.

[65] Ibid., 31. According to classical christology, of course, Jesus' humanity is anhypostatic, having no existence 'in and of itself and as such' but only in its 'personalising' union with the eternal Son. Thus any attempt to abstract from the particularities of its case are, strictly speaking, irrational. Precisely for this reason, even the particularities of Jesus' humanity serve as much to veil or obscure the deeper reality and meaning of the incarnation as to reveal it, if they are attended to in terms proper to empirical observation and modes of analysis proper to the human sciences alone.

[66] Torrance's account of the signitive relation thus concurs with Barth's notion of an *analogia fidei* rather than an *analogia entis*. See below, 38–9 There is also a parallel with Aquinas' insistence that terms used analogously of God merely point us toward God rather than granting us any comprehension of their meaning as it pertains to his essence; for Torrance and Barth, though, the analogy arises strictly within the context of revelation, whereas for Aquinas its source is one rooted firmly in creation and our capacity of reasoning.

and its allegedly 'imageless' and superior way of referring – generates some friction and seems finally to exist in tension with, if not to tug in a rather different direction from, the core Christian claim that the communication of divine meaning involves a radical, irreducible and (as Torrance himself is so often at pains to remind us) *permanent* act of enfleshing.[67] Visibility is, whether we like it or not, one of the characteristics of the flesh, and we cannot strip it away to the point where it ceases to be noticed without removing it altogether, thereby effectively reversing the direction and the accomplishment of incarnation. Torrance, as we have seen, is quite emphatic that the *humanitas Christi* is both the starting point and a permanent abiding condition for our knowing and speaking of God, and insists that we cannot (and must not attempt to) go behind the back of it in a bid for some unmediated encounter with divine reality. But his talk of an ideal of 'imageless' conceptuality, of 'images which do not image',[68] of words which function adequately without pictures,[69] of the purification of the image by the accompanying word so that visual content falls away to be replaced by an acoustic relation,[70] all conjures up a vision of a form of 'transparency' which may finally become difficult in practice to disentangle from *invisibility*, in which case the significance for Christology of the particular shape and content of the 'flesh' of Jesus (the specific things that he does and says and suffers in his ministry as the gospels record these for us) is at risk of being attenuated in a problematic manner.

Incarnation, Particularity and Dialectic

Richard Bauckham identifies just such relative lack of attention to the particularity of Jesus in the Christology of some of the same patristic theologians whom Torrance so admires, and contrasts it with the particularising emphasis of the New Testament writers.[71] The danger here, Bauckham suggests, is that while formally insisting upon the centrality of the 'full humanity' appropriated by the eternal Word or Son in grounding and mediating all our knowing of God, in practice what occurs is that the humanity becomes insufficiently opaque to permit any imaginative purchase upon it whatever, the mind's eye not 'going behind the back' of the *logos incarnatus* of course, but nonetheless effectively passing straight through the particulars of his story to a very high level of conceptual abstraction without encountering much resistance or interference. Unlike Hegel,

[67] The presence of Jesus' risen and ascended body (as part of his full sharing in our nature) at the right hand of the Father is basic to Torrance's theology of the Priesthood of Christ. For a full elaboration see Thomas F. Torrance, *Space, Time and Resurrection* (Edinburgh: Handsel Press, 1976), 106–58.

[68] Torrance, *Theological Science*, 20.

[69] Torrance, *God and Rationality*, 23.

[70] Torrance, *Theology in Reconstruction*, 20.

[71] See Richard Bauckham, 'Christology Today', *Scriptura* 271988: 20–28.

Bauckham insists that universal significance can be had here only *in and through* (and not despite) the concrete particulars of the incarnate economy, and that the conceptually precise doctrines of incarnation and trinity must therefore always be held closely together with the biblical stories about Jesus and not permitted in practice to become an abstract substitute for them.[72] This does not mean, of course, that the conceptual precision afforded by doctrines can be abandoned in the name of some Neo-Ritschlian eschewal of 'metaphysics'. To do this would be to fall into the precise trap from which Torrance would rescue us, collapsing everything down to the level of a set of opaque historical and creaturely meanings in which the story of Jesus refers us *to* itself but never refers us *beyond* itself in an epiphanic manner (i.e. so that it may speak to us appropriately of God). Instead, we might say, the lesson to be learned from Christology, and applied more widely by extension from what we learn there, is that the levels of image (*eikon*) and idea/concept (*logos*) must constantly be held closely together, generating meaning precisely and only as they are maintained in a dialectic where each is constantly qualified and rejuvenated by the other. The eternal Word *takes* flesh and tabernacles with us, becoming for us (by all that he is and says and does and suffers) the very *image and likeness* of the invisible God; but this is an image which functions only as faith is granted ears and eyes to penetrate beyond (without ever letting go of) the level of what is presented to it at the level of flesh and blood, and attempts to make sense of it in terms and categories proper to that level alone are therefore bound to fail. What we are dealing with here (to pursue the Christological point further) is not a stripping away or attenuation of the flesh, but a transfiguration and quickening of it in which it is appropriated by God and granted a depth and surplus of meaning which, in and of itself, it can never bear. But it is difficult to see how talk of 'imagelessness' and the elevation of the 'pure concept' (if such a thing exists) can secure this rather than risking its loss, in the Christological context or anywhere else.

Apophaticism, Images and Concepts

Are there, then, more helpful ways of saying what Torrance apparently wishes to say? It seems to me that there are, and that they will entail the redemption of the imaginative (and hence the 'image') from the purgatorial secondary state into which he typically casts it. We should remind ourselves first of Torrance's over-riding concern which, despite his direct echoing of Hegel's exaltation of the concept in theology, is in reality quite different from Hegel's own. For Hegel, Gunton suggests, the strict differentiation and disentanglement of concepts from their imaginative counterparts was to be undertaken in the conviction that the

[72] Ibid., 23–4. On the relationship between universality and particularity in theology see helpfully Colin E. Gunton, *The One, the Three and the Many: God, Creation and the Culture of Modernity* (Cambridge: Cambridge University Press, 1993), esp. Chapter 5.

former would, once purged of fleshy impurities, be capable, in principle at least, of offering up for our contemplation reality 'as it is', directly and without error.[73] For Torrance, on the other hand, it is a fundamental mistake to suppose that the reality of God could *ever* be known in this way, and the concept is to be preferred to the image precisely because it is less likely to get in the way of our knowing of God by obtruding itself as an opaque entity which we look *at* rather than looking *through*. For Torrance, we might say, there is an inherently *apophatic* impulse[74] in all our thinking and speaking about God, and concepts are precisely a means of acknowledging and preserving this circumstance rather than escaping from it in some rationalist manner. Concepts too, therefore, although they exist at a higher and 'purer' level of our intellectual engagement than 'images', are, on this account, nonetheless *kenotic* in nature, referring us beyond themselves in the very instant that they present themselves for consideration. We might put the same thing in literary rather than theological terms: for Torrance, concepts as well as images must finally be concluded under the rubric of the poetic whisper: 'it is, *and it is not …*'.

To suggest this, though, is to raise again the need for a more nuanced account of the relationship between concept and image, imagination and reason than the blunt distinction so often posited. This is something that Torrance himself would almost certainly eschew, but which seems to me to be both warranted and worthwhile. It affords us, I shall argue, a way of maintaining an appropriate apophatic humility in our theology without, in the process, compromising or attenuating in any way the significance of the claim that the Logos of God is, as far as we are concerned, always an *enfleshed* Logos and never a *logos nudus*.[75] The flesh is always present, and always significant, though its significance varies as we attend to it in different ways and for different purposes. In a directly related manner, I suggest, it is a mistake to suppose the existence of two distinct tiers of intellectual engagement, one in which the imagination is permitted to function freely (the sphere of the 'image') and another from which it can and must be excluded at all costs in the interests of some alleged 'conceptual purity'. No such purity (if by that is intended

[73] Gunton, *The Actuality of Atonement*, 22–3, 38.

[74] By 'apophatic' in this context I intend not the sort of radical undercutting of the status of theological statements which denies them any purchase whatever upon the reality of God and ends thus in a form of devout agnosticism or a mystical experience which eschews the cognitive altogether, but rather the constant acknowledgement that even the most carefully formulated and precise uses of language about God are inadequate and fall short of defining or comprehending his reality even as they are taken up and made new within the dynamic event of revelation itself.

[75] This seems to me to be the epistemic significance of the doctrines of resurrection and ascension (where the incarnation is affirmed as a permanent state of affairs in the divine economy rather than a merely temporary manifestation), and the pursuit of a Word whose flesh has been rendered practically invisible in the process of our knowing and speaking inevitably calls it into question.

precisely purity from all traces of the imaginative) is possible, as Torrance's own favourite philosopher of science, Michael Polanyi, recognises in his unashamed reference to the importance of the 'conceptual imagination' in the natural sciences, mathematics and elsewhere.[76]

What Polanyi's phrase admits is that even concepts and precisely honed logical abstractions of the sort to which Torrance aspires for theology involve us in an act of 'imagining' something, holding something in our mind's eye (though the visual connotation of this metaphor itself is misleading and demands qualification)[77] in order to look 'through' it, no matter how thin or vague that something may itself be. Indeed, the very act of 'looking through' an image, permitting layers of 'visible' content to become epistemically transparent rather than remaining opaque, is an act of a *highly* imaginative sort rather than one from which imagination has been or ever could be purged. The attempt to 'imagine nothing' is self-defeating, since in imagining 'nothing', we are inevitably *imagining* something, even though the something in question may well be 'nothing' (which we generally picture in terms of absence, empty space, a vacuum, or whatever). Rather than mistakenly seeking to escape from the imaginative (and the 'images' it produces) into some putative imagination-free zone populated by 'pure concepts' (defined precisely by their 'imageless' nature), therefore, we should reckon instead both with its inescapable presence and with the remarkable variety of ways and levels in and at which it performs its given tasks, and thus the wide variety of its products, all legitimately, but in certain respects unhelpfully, concluded under the rubric of 'the image'. The image, it turns out, is no one trick pony, but can be and do very different sorts of things, sometimes even managing more than one at once.

Pictures and Images of Other Sorts

Despite his broad-brush disparagement of the image in relative terms, Torrance's position leaves scope for accommodating this important recognition, since, even though he often overstates his case, it is in fact to particular *sorts* of imaging relation that he directs his approbrium. In particular, it is to that sort of imaginative activity in which we 'picture' something in quite concrete terms, or allow one

[76] Michael Polanyi, *Personal Knowledge: Towards a Post-Critical Philosophy* (London: Routledge and Kegan Paul, 1958), 46.

[77] A mental 'image' (if we take this now to refer to any product of acts of imagination) may not be visual at all, but aural, or related to others of our five senses. I can imagine a taste or a sound just as readily as something 'seen'. In this sense, of course, appeal to experiences of audition (in relation to the theological category of a 'Word' which speaks to us) may equally be an appeal to an 'image', albeit one of a distinct sort to those which Torrance refers using the term.

thing to serve as 'a picture of' something else.[78] A physical picture, of course, is precisely something that we are intended to look at and attend to in its own right, even when doing so is meant precisely to stimulate our thinking about something or someone or somewhere else (e.g. in the case of a representational painting or drawing or a photograph). The relation 'x is a picture of y', then, brings with it certain attendant experiences and expectations, among which we might list a high degree of visual stability (the picture is generally relatively static, and its content does not change), an expectation that it contains a high rather than a low level of representational force (in some identifiable and proper sense we expect it to 'look like' that which it pictures for us, though this may not always be via any straightforward attempt at visual simulation), and a capacity to be attended to as an object in its own right (its 'kenotic' aspirations are limited ones; we are expected to look *at* it, and can do so, indeed, for purposes wholly other than attending to it as 'a picture of' something else). We can see at once how these expectations are hugely problematic if transferred into the context of theological imagining, resisting any notion of transparency or openness of the sort which Torrance insists is so vital, clamouring for our undivided attention, and accompanied by a strident and deafening declaration that 'it is' which all but drowns out any remembrance of the fact that 'it is not'.

But not all 'images' are of this sort. Mental images, for example, even when they are vivid and as concrete as we can possibly make them (when, for instance, we are trying recall precisely how something looked or picture (sic) how it might look) are far more fluid and prone to spontaneous modification than we should often like; and, as Gilbert Ryle points out, despite the way in which we speak of it, the 'mental image' is in any case not really a thing in its own right at all, not something we can 'look at', but precisely a *way of thinking about* something else.[79] Mental images, we might say, even when we want them to perform a 'picturing' function, have a built-in (and sometimes frankly infuriating) openness and transparency, resisting our attempts to firm them up and close them down. Unlike their physical counterparts, therefore, they are by nature suited to precisely the sort of breaking and chastening which Torrance advocates, though such breaking and chastening depends precisely upon their place as imaginative constructs rather than betraying it.[80] They do not, if we treat them in this manner, cease to be images, but become images of a different sort, functioning now in a quite different way, enabling us to *think about* things in a quite different way and at a wholly different level. Indeed,

[78] See, e.g., his insistence that in theology, as in mathematics, we must not identify 'the conceivable with the picturable'. Torrance, *God and Rationality*, 23. Cf. his allusion to 'the fatal mistake of treating … images as pictorial representations or reproductions' in theology. Torrance, *Theology in Reconstruction*, 51.

[79] Gilbert Ryle, *The Concept of Mind* (London: Penguin, 1963), Chapter VIII. Cf. the discussion in Jean-Paul Sartre, *The Psychology of Imagination* (London: Methuen, 1972).

[80] On the differences between mental, verbal and physical images, and their significance vis-à-vis the danger of 'idolatry' see further Chapter 7 below.

if Ryle is correct, we cannot ever prescind wholly from the territory of the image without ceasing to 'think about' anything at all. We need something, no matter how 'thin' or transparent or chastened, to latch onto and work with if we are to apprehend anything at all. In Torrance's chosen terms, concepts must be 'closed' on our side, even if they are radically broken open on God's side. The 'flesh' assumed by the divine Word may and must indeed be chastened, transfigured and made anew if it is to be epiphanic, but it cannot be stripped away or rendered completely invisible. Crucifixion is followed not by the absence of the flesh, but by its resurrection and ascension to the Father's right hand, where it abides in its vital mediating and priestly role.

Certain sorts of verbal image, too, contain an inbuilt resistance to being dragooned inappropriately into a 'picturing' role. Thus, as we have already seen, it is part of the nature of metaphor to function obliquely rather than directly, speaking of one thing in terms *suggestive of* another,[81] but with a high quotient of 'contra-indication' kept constantly in play,[82] and a flickering interplay sustained between the tantalising suggestion that 'it is', and the sober and equally vital acknowledgement that 'it is not'. Again, we might say, such images are already broken and chastened by nature, and lend themselves well to further acts of imaginative asceticism where appropriate. Here again, though, it is not by the absence of 'images' that the relevant theological concerns are safeguarded, but through acts of *responsible theological imagining* in which images themselves are modified and (if we prefer) 'purified' so as to fulfill a particular epistemic purpose. If it is one (widely acknowledged) function of imagination to set us free from the given constraints of the empirical, it is certainly another of its functions (though much less widely recognised) to liberate us from pictures by which we might otherwise, as Wittgenstein puts it in a closely related discussion, be 'held captive' in inappropriate and damaging ways.[83] In theology, as elsewhere in our dealings with reality, it is precisely the broken or chastened image which, Colin Gunton suggests, opens us to the world and permits the world in its turn to enforce changes in the meanings that our words bear. Thereby, in a manner that has nothing whatever to do with a precise 'picturing' relation, our speech and thought becomes appropriately and adequately 'world-shaped' (or in the case of theology, 'God-shaped').[84]

[81] Soskice, 15.

[82] Goodman, 69.

[83] Ludwig Wittgenstein, *Philosophical Investigations: The German Text with a Revised English Translation*, trans. G.E.M. Anscombe, 3rd ed. (Oxford: Blackwell Publishing, 2001), 1. §115. Wittgenstein's point has to do with one particularly unhelpful 'picture' of how language itself is related to reality, i.e. as though it in its turn in some sense *pictured* the things it speaks of.

[84] See, e.g., Gunton, *The Actuality of Atonement*, 45–7.

That all this occurs in the case of our God-talk only by virtue of what Karl Barth calls an 'analogy of faith' rather than an 'analogy of being'[85] may readily be conceded (though doubtless not all readers will feel the need to go this far). Barth's point is that a correspondence between the act of God's knowing and speaking of himself and human knowing of him arises only within the event of revelation itself, and only thus (and within this dynamic relational context for as long as it perdures)[86] is any human language granted the capacity to bear witness to the reality of God's own life and being and action. Put more simply, God himself must speak in, with and through our human speech-acts about him if the relevant terms are actually to speak truthfully, and only within a personal relationship of faith and obedience can we begin to grasp dimly what these terms now come to mean. Otherwise they remain opaque, veiling the divine reality rather than revealing it, and leaving us only with the natural and mundane capacities of human language, with its established trajectories of vocabulary and syntax. Lest all this seem unduly technical and complex, it might be observed that some such supposition lies behind the fairly common Christian practice of praying and invoking the Spirit before embarking upon readings of Scripture (or, for some, the task of theological interpretation or construction). Were it simply a matter of matching biblical words to the patterns readily traced in the best lexicons and grammars, no such deliberate petition would be thought necessary (as distinct from a mere habit or polite formality). Bruce McCormack suggests that it was Barth's adoption of 'the ancient anhypostatic-enhypostatic model of Christology' in 1924 that undergirded this new emphasis in his understanding of theological language.[87] Human terms used of God (like the humanity of Jesus itself) lack any independent *hypostasis* or substance apart from the act in which God supplies this lack by appropriating them and taking them up into his own speaking. Quite apart from the historical point, the conceptual links between the two circumstances remains illuminating. The greater the emphasis upon divine otherness with respect to the creature, the more needful some such consideration seems to be. Nevertheless, if genuine analogy or signification of any sort (rather than sheer equivocation) is to be admitted, then the fleshly term in that analogy (the flesh of the signifier) must remain within our grasp and clearly within our sights rather than being erased.[88]

[85] See Karl Barth, *Church Dogmatics* Vol. 1/1, trans. Geoffrey Bromiley (Edinburgh: T&T Clark, 1975), 243–7. For a helpful brief elucidation of the idea see Bruce McCormack, *Karl Barth's Critically Realistic Dialectical Theology, Its Genesis and Development 1909–1936* (Oxford: Clarendon Press, 1995), 16–19.

[86] For Barth the relevant analogy never passes over into human hands or control, but depends continually upon the gracious action of divine self-giving. It is thus a function of revelation as a particular Trinitarian event.

[87] McCormack, 19.

[88] An issue which we cannot consider fully here but which merits mention, is that of the nature and scale of the relevant transformation of our terms in the 'analogy of faith'. Barth's tendency is to suggest that, prior to the divine appropriation of our language, no

Image, Iconoclasm and Revelation

Two further points demand our attention before we draw this opening chapter to a close. First, the rehabilitation of the category of the image proposed here does nothing to compromise the concerns lying behind that ancient biblical injunction which, admittedly, sought the wholesale removal and subsequent avoidance of 'graven images' rather than their redemption.[89] To begin with, this radical surgery in the tissue of the Hebrew cult was occasioned by the selfsame theological impulses we have sought carefully to preserve, elevating the wider biblical account of God's relationship to the world for which God is and remains radically other than whatever he has created, and uncircumscribed by any of its forms or processes.[90] Yet the same Old Testament which at this defining moment of Israel's history urged the abandonment of *material* representations of God, elsewhere encourages and fuels an abundant and diverse poetic 'imaging' of him on more or less every page (as king, shepherd, warrior, rock, lion, strength and shield, light, and so on).[91] So, the notion of a blanket biblical prohibition on all images in our dealings with God makes no sense at all. And both verbal and mental images too, we have seen, are susceptible to treatments which quickly render them unfit for religious and theological service. But images of this sort, of course, are not so easily expelled from the sanctuary or, I have suggested, from that systematic reflection which begins and remains securely earthed in what happens there. Indeed, the pervasive and central role played by verbal images, and their inextricability not only from the substance of Scripture itself but from the life of faith and the encounters of prayer and worship, seem to me sufficient to render the banishment of the image from theology inherently undesirable as well as impossible. If theology is in any sense to be held accountable to all this, then some such images at least seem bound to accompany it in some form no matter how far theology travels out from its biblical/liturgical starting point, or how often those images may have to be

such analogy exists (rather than claiming that our language in and of itself lacks any created capacity to point us to God). If, though, this emphasis is pushed too far, it seems to entail the idea that the relationship between the meanings attaching ordinarily to our terms and images and those which they acquire through their chastening and making anew in the analogy of faith is *equivocal* rather than analogical or metaphorical, which presents its own set of serious theological concerns. If what we ordinarily mean by 'goodness', 'love' etc. has no proper relationship to the meanings obtaining when such terms are taken up into the act of revelation, then we quickly find ourselves in a quite peculiar theological territory. It would seem more satisfactory to indicate that such terms bear a particular surplus of meaning which cannot be apprehended by the creature apart from the context of divine speaking and the response of faith and obedience.

[89] Exodus 20:3–5; Deuteronomy 27:15.

[90] So, e.g., Gerhard von Rad, *Old Testament Theology. Vol 1. The Theology of Israel's Historical Traditions*, trans. D.M.G. Stalker (Edinburgh: Oliver and Boyd, 1962), 212–19.

[91] Cf. Tryggve N.D. Mettinger, *No Graven Image? Israelite Aniconism in its Ancient Near Eastern Context* (Stockholm: Almqvist and Wiksell International, 1995), 15.

broken and made anew on the journey. Again, despite the superficial attractions of expulsion (and notwithstanding apparent biblical precedent for the same), what really matters here is best secured, I would contend, not by the absence of images, but by their continual imaginative chastening and 'making new' within the dynamics of divine self-revealing and prayerful response.

Mention of the rich stock of images supplied by Scripture and their abiding importance for theology leads conveniently to my final point in this preliminary discussion of the relationship between word and image in theology, one which, for many readers, has no doubt haunted much of our discussion to this point and must now be flushed out and tackled directly. All this talk of Christian theology as bound up irrevocably with acts of imaginative *poiesis*, as being in large measure, indeed, an image-constituted and image-constitutive set of activities will, for some readers, seem to carry with it the implication that the substance of the faith is in some sense 'made up', that it begins and ends in acts of sheer human construction and invention rather than acts of divine revelation, as if the God of which theology speaks were, in large measure at least, as we would tend to say, a mere 'figment of our imagination'. There are, of course, theologians and theologies for whom this is indeed both a basic supposition and a positive rather than a negative judgement, and to whose names the explicit appeal to imagination in theology is often tethered in an unfortunate manner. So, for example, Gordon Kaufman[92] presents revelation and imagination as logically opposed sources for theological endeavour, and urges the latter as the only honest strategy for an age in which (he suggests) the idea of God stepping in to make himself known is no longer tenable.[93] Thus the God of our religious and theological utterance is, in the words of another writer on the subject, the 'primary human Artifact',[94] a projection of our inner reality onto the clouds rather than in any sense an objective reality breaking in from 'beyond' them.

There is much in Kaufman's analysis of the structure of theological engagement that I find both persuasive and compelling, but this fundamental dichotomy between imagination and revelation is misleading and wholly unnecessary, and those who are less confident than Kaufman himself about the absence of God from the sphere of human knowing may safely choose to ignore it, premised, as it is, on a culturally familiar but entirely unwarranted identification of the *imaginative* with the purely *imaginary*. It is not my purpose here to argue the case for the abiding importance of revelation as a theological category, but simply to insist unequivocally on something which others have argued persuasively and at much

[92] See Gordon D. Kaufman, *The Theological Imagination: Constructing the Concept of God* (Philadelphia: Westminster Press, 1981), esp. 21–57, 263–79. An essentially similar approach is found in McFague.

[93] Kaufman, 30.

[94] Elaine Scarry, *The Body in Pain: The Making and Unmaking of the World* (Oxford: Oxford University Press, 1985), 181–243.

greater length,[95] namely, that *an account of religious and theological engagement cast in terms of the categories of the imaginative is entirely compatible with an appeal to the dynamics of revelation,* having to do chiefly with questions about the forms our knowing takes and must take, and not its ultimate source or epistemic warrant. This is a simple point, but one well worth making because of the unhelpful connotations still clinging to the word 'imagination' and its cognates.

I have already spoken of the need for human images of God to be laid hold of and broken open and transfigured by their appropriation by God, and their being drawn into a wholly new semantic context (to 'mean' now with respect to a divine rather than any creaturely object) sustained by the act or event of revelation. We might put the same point another way. God, we may reasonably suppose, is just as capable of taking our imaginations captive as he is of engaging our 'hearts', 'minds' and 'wills' (in so far as these may legitimately be disentangled from the texture of imagination itself), and may give himself to be known by appropriating human activities and outputs of a highly imaginative (as well as a relatively unimaginative) sort. Indeed, if our account of revelation is informed at all by the actual forms which Christian Scripture takes and the sorts of reading it most naturally demands of us, then we appear to have good reason for insisting that this is precisely what God has done and continues to do, engaging us through texts and practices explicitly and unashamedly imaginative in nature, as well as demanding further acts of tacit but genuine *poiesis* in our more systematic theological reflections and constructions. For the sake of consistency we may refer to Torrance again at this point, according to whom, 'In all theological knowledge, a proper balance must be maintained between the divine Subject and the human subject' since theological knowledge 'is after all a human activity' and '(i)f the human factor is eliminated, then the whole is reduced to nonsense' but, he adds, 'unless the divine element is dominant, then man is in the last resort thrown back upon his own resources, and an impossible burden is laid upon him'.[96]

If we maintain a precisely balanced and carefully ordered account of this sort in which both the fully divine and the fully human aspects of revelation are taken fully seriously, but the parabolic dynamic of revelatory action is understood to move first 'from above to below' and only then 'from below to above', we may in a perfectly proper sense speak of theology as a human practice of 'imaginative construction'[97] and even of God as 'an imagined object',[98] without for one moment abandoning the vital claim that such imagining properly arises from and is informed, constrained and constantly reshaped by a reality lying beyond

[95] See, e.g., Tony Clark, *Divine Revelation and Human Practice: Responsive and Imaginative Participation* (Eugene, OR: Cascade, 2008), Bruce McCormack, 'Divine revelation and human imagination: must we choose between the two?', *Scottish Journal of Theology* 37, no. 41984, 431–55.

[96] Torrance, *Theology in Reconstruction*, 27.

[97] Kaufman, 263f.

[98] Scarry, 184.

ourselves, one our continued engagements with whom break open and 'force new meanings' upon the very words and images he has himself given to us as appropriate ways in which to think and speak of him. In this sense, it seems to me, Austin Farrer's claim that '(D)ivine truth is supernaturally communicated to men in an act of inspired thinking which falls into the shape of certain images'[99] is basically correct, however we may wish to gloss it and whatever we may wish to add by way of disclaimers. It follows, of course, that appeals to 'revelation' therefore provide no easy escape (should anyone desire it) from the particular challenges and demands of the sort of 'poetic logic' with which, I have argued in this chapter, theology, in its dealings with a God who is wholly other and thus can only be spoken and thought of under the guise of things that he is not, must grapple from beginning to end. Whether we attend to the divinely furnished images of Scripture, the concrete self-imaging of God in the flesh, or the myriad ways in which these have been taken up and responded to in the varied forms and patterns of Christian tradition across the centuries, theology is intrinsically and necessarily a 'poetic' set of practices in the proper sense, and one in which the imagination is and must be kept constantly and identifiably in play.

[99] Farrer, 57. Not all biblical images, of course, carry equal weight within Christian tradition, and some serve within the canonical pattern and subsequently in the work of theological interpretation and construction to inform our understanding of others.

Chapter 2

The Promise and the Sign

Embodiment and Meaning

The previous chapter dealt with aspects of the relationship between the image and the word/idea in theology, or, more precisely, with different ways of using words in religious and theological contexts – the more identifiably 'poetic' uses of the concrete verbal image on the one hand, and the more precise, hard-edged and carefully defined use of concepts on the other. Words, though, are not the only sorts of things laden with significance for us as human beings. Indeed, words typically have their meanings bound up inextricably with their use in particular contexts of intention and action, and in association with material objects of one sort or another; and, while objects and actions, for their part, generally have significance bestowed upon them by some linguistic context, their significance cannot often be cashed out at the level of verbal meaning alone. We need not concern ourselves greatly with precise claims about the percentages of communication relying on paralinguistic cues to recognise the validity of the basic point. That the same words are capable of meaning quite different things depending on the context or the precise inflection of their utterance is something we are only too aware of. And we know, too, that there are some bodily performances which transform verbal meaning, and others – the pat on the back, the embrace, the smile, the grimace – the significance of which seems more or less independent of words, no matter how remotely situated. Conversely, as Elaine Scarry notes, our bodies are also capable of shutting down our capacity for and receptivity to meaning altogether, certain thresholds of pain serving effectively to close down the circuits of signification and compel our curvation in upon ourselves.[1] This might be thought to be ironic for Christians, given that the object and action held to be most significant of all by Christian faith is an instrument of torture, and the immolation upon it of a human body in excruciating pain. Be that as it may, Christian theologians are also bound to reflect upon the peculiar significance of our circumstance as creatures whose existence more broadly holds together within itself the bodily and that sphere of meanings and values which transcends materiality alone, and constantly mediates the realities of the one to and through the other. As C.S. Lewis's Screwtape expresses the matter to his diabolic nephew, 'Humans are amphibians – half spirit and half animal. ... As spirits they belong to the eternal world, but as animals

[1] See Elaine Scarry, *The Body in Pain: The Making and Unmaking of the World* (Oxford: Oxford University Press, 1985), 45–69.

they inhabit time' and, we might add, space.[2] Artist and poet David Jones puts the matter less colourfully, but with equal force, referring to the human creature as a 'sapiential mammal', uniquely fitted within creation for acts of sign-making and sign-giving, and disposed towards the gratuity and intransitivity of Ars.[3] We may wish to dispute the slightly dualistic categories in which Lewis and Jones respectively unpack their descriptions, but the basic point is clear enough: when it comes to meaning, matter matters, even though it is not all. That it should be thus ought hardly to surprise the Christian whose faith centres around the claim that God's own Logos communicated himself finally and fully by becoming flesh and, in the resurrection and ascension to the right hand of the Father, remaining enfleshed for our sakes.

The point at which this is most explicitly and fully acknowledged in Christian theology, perhaps, is in its doctrine of the sacraments, held by almost all Christian traditions to involve dominically sanctioned embodied actions charged with a peculiar significance in relation to union of the believer with the crucified, risen and ascended humanity of Christ. While sacramental theologies may sometimes understand the ritual elements and actions themselves as little more than a helpful visual aid for realities more conveniently and efficiently captured in verbal terms alone, it seems more fitting to a Christian theological anthropology rooted in the doctrine of the incarnation – and, additionally, more in accordance with what many secular accounts have to teach us about the complexity of our human circumstance as makers of and participants in meaningful constructs of one sort or another – to suppose that this provision of explicitly material and kinetic means of signification is both a form and a convenient index of the full extent of God's gracious accommodation to our distinctly human modes of knowing. In this chapter, I will explore this claim by focusing on just one (though arguably the most obvious one) of the catholic sacraments, considering and comparing the eucharistic theologies of two Reformed theologians, John Calvin and Karl Barth, each of whom construes the fundamental circumstance in the Lord's Supper[4] as one of divine sign-giving. Calvin's views on the subject are easily accessed, but Barth's less easily so, since his developed account was to have formed part of the incomplete and fragmentary fourth volume of *Church Dogmatics* (henceforth CD) extant at the point of his death in 1968. Furthermore, as is well known, Barth's views on the sacraments had undergone a significant shift late on in his career as a result of the influence of his son Markus's exegetical work on the doctrine of

2 C.S. Lewis, *The Screwtape Letters* (London: Geoffrey Bles, 1941), 44

3 See the essay 'Art and Sacrament' in David Jones, *Epoch and Artist* (London: Faber and Faber, 1959), esp. 143–51.

4 In this chapter I shall refer variously to the 'Lord's Supper' and the 'Eucharist', partly to conform to the use of the writers being studied. I shall, though, use Eucharist and its cognates as my default, not to indicate any specific theological agenda or liturgical preference, but simply in order to benefit from its convenient possession of an adjectival form.

baptism.[5] Barth recognised the problem facing his readers, but in the preface to the published 'fragment' of CD 4/4 (in its extant form on baptism, but his treatment of the Lord's Supper was to have formed 'a conclusion and a crown' to this chapter) surmises that – on the basis of what the fragment actually contains – 'intelligent readers may deduce ... how I would finally have presented the doctrine of the Lord's Supper'.[6] The task is less simple, though, than Barth himself suggests, and the results of such reconstruction, even when accompanied by the author's own mandate, must inevitably be tentative. There are, to be sure, scattered and suggestive references to the Supper to be attended to in earlier volumes, and a handful in the posthumously published 'lecture fragments' on the Christian life[7] (which would have found their way eventually into the text of CD 4/4 had Barth survived). But of Barth's developed view there is no substantial version available. To ascertain its contours we shall thus be forced precisely to rely on imaginative inferences and extrapolations from the late direction of his wider thinking about the sacraments, and his decision to situate his discussion of them within a part-volume on Christian ethics as 'the free and active answer of man to the divine work and word of grace'.[8]

Issues in Eucharistic Theology

Before embarking on a reading of Calvin and Barth, it may be helpful first perhaps to provide a theological framework to guide and inform the task, by attending to some issues central to eucharistic theologies as such rather than any eucharistic theology in particular.

The Presence and Action of God

Rowan Williams observes that the Eucharist is fundamentally an event of meaning-making which involves both God and human beings in activity of one sort or another.[9] There is nothing contentious about such a claim. Whatever else we may wish to say about the nature of what happens here, it is clear enough that it involves the use of symbolic objects and actions. This is acknowledged in the

[5] Markus Barth, *Die Taufe ein Sakrament?* (Zollikon, Zurich: Evangelischer Verlag, 1951).

[6] Karl Barth, *Church Dogmatics IV/4 (The Christian Life, Fragment)*, ed. Geoffrey W. Bromiley and Thomas F. Torrance, trans. Geoffrey Bromiley (Edinburgh: T&T Clark, 1969), ix.

[7] Eventually published as Karl Barth, *The Christian Life, Church Dogmatics IV/4 Lecture Fragments*, trans. Geoffrey Bromiley (Grand Rapids, MI: Eerdmans, 1981).

[8] Barth, *CD IV/4*, ix.

[9] See 'The Nature of a Sacrament' in Rowan Williams, *On Christian Theology* (Oxford: Blackwell, 2000), 197–208.

ancient description of the bread and the wine as 'signs'. But very different things have been made of and intended by this, not least since the Reformation when talk of the Supper as essentially 'symbolic' came to be associated in particular with a reductionist account of its significance. The most basic question in eucharistic theology, therefore, concerns whether, where and how in this event God himself is held to be present and active under, with and through empirically observable human activities.

At one level these activities lend themselves perfectly well to analysis in terms proper to what today we number among the 'human sciences' (especially semiotics, ritual theory, dramaturgy and the sociology of knowledge). Considered thus, the Eucharist is a ritual performed with specific material objects – bread and wine – in which those same objects are symbolically re-ordered through a distinctive act of human meaning-making. The precise actions performed in this ritual may vary (sometimes significantly) in their particulars and they are interpreted in a variety of ways; but the actions and the understandings of them conform broadly to an identifiable template modelled on the words and actions of Jesus at the supper he shared with his disciples on the night before his death. 'In these acts', writes Williams, 'the Church "makes sense" of itself, as other groups may do, and as individuals do'.[10] Having said this, the question which remains to be answered is whether there are other levels at which an account of the Eucharist's reality must be given in order to appreciate its full significance? Is there, that is to say, something more than a human act of meaning making occurring in its midst, something which transcends the reach of day-to-day empirical or theoretical description and demands a properly theological vocabulary? In short, is God involved here, and if so how?

Perhaps, though, we need to reformulate and sharpen our question further still, and ask instead about the *peculiar mode* of God's presence and activity in the Eucharist.[11] Few theologians are likely to concede that God is absent or inactive altogether from any human context or activity in the world he has made. Thus Williams insists that 'the meaning of our acts and relations rests, moment by moment, on God's creative grace'.[12] There is at least a general presence of God to be reckoned with at all times and in all places, holding the created cosmos in being and drawing it towards its creaturely goal. If the psalmist discovered God present even in the depths of Sheol (Ps. 139:8), then it is surely unlikely that we shall find him to be absent from eucharistic worship. Furthermore, Williams continues, 'the sacraments are performed, in obedience to Christ, by those already caught up in God's work, those who have received and live by God's promise'.[13] The meaning of the Eucharist, in other words, whatever theological view of it is entertained,

[10] Ibid., 205.

[11] See on this, helpfully, Donald M. Baillie, *The Theology of the Sacraments and Other Papers* (London: Faber, 1957), 97f.

[12] Williams, 205.

[13] Ibid.

could never be *ex opere operato* in the strictest of senses. On the contrary, the significance of what is done here is essentially contingent and 'kenotic', referring us away from itself to that which it signifies; namely, the prior and promised redemptive work of God in Christ and the Spirit. Apart from this wider pattern of divine presence and action in the world, what is done makes no sense – or at best *arbitrary* sense which is no longer really Eucharist at all.

But we must press the matter further and more precisely. Is there, we must ask, a peculiar and distinctive mode of God's presence and activity to be identified within the Eucharist? Does God promise to do something *special* as and when bread and wine are taken within the Church and certain things done with them (as for example, it might be supposed that God does when Scripture is read and the Word is preached)? And, if so, what is this special something, and where does it occur? It is at this stage of the discussion that some views of the Supper have parted company with the mainstream.

Some theologians have been eager to draw the line after an affirmation of God's wider presence and activity, preferring to construe the Eucharist itself as constituted by a series of distinctly human actions and dispositions. Acknowledging that God is present and active as Creator here as everywhere, and that the meaning of what happens here is utterly contingent upon God's prior and promised work in which we are caught up (so that the Supper certainly cannot be seen as an autonomous act), such a view nonetheless understands the Supper as such as something that we do rather than something that God does (albeit something that we do *in response* to God or as an expression of *faith in* God). So, for example, the Swiss reformer Zwingli[14] interpreted the Lord's Supper precisely as an activity of human meaning-making, in which bread and wine (following Jesus' lead at the Last Supper) are invested by faith with symbolic value as signifying Jesus' body and blood, and the wider eucharistic action signifies or expresses the faith of the believing community in Jesus' redeeming sacrifice on the cross. The essential meaning of the Supper, on this view, lies in its nature as a symbolic response of *eucharistia* (thanksgiving) for what God has done in Christ, an act of human faith and obedience.

Most traditions, though, have understood things rather differently than this, even if they have sometimes struggled to say precisely how. Something happens here, they have held, which cannot finally be accounted for in human terms alone. To make sense of it, talk of human symbolising requires to be supplemented by recognition of an accompanying divine sign-giving and -making. This alone grants the eucharistic objects and actions the significance which they have but could never otherwise acquire, as the symbolic means of our sharing more fully and more deeply in Christ, in his offering of himself to God in his life and his death on the cross. Beyond this baseline of agreement, particular interpretations of how all this should be thought of or expressed again part company and travel in radically different directions. But there is concurrence at least that the 'all this' to be made sense of involves a special, and not just a general, presence and action of God,

[14] See, e.g., his *Commentary Concerning True and False Religion* (1525).

and that this special presence and action is in some way focused upon the physical elements of bread and wine, and what is done with these – taking, breaking, eating, drinking, and so on.

It is important to keep this talk of divine action central, since theological discussions of 'sacramentality' sometimes proceed as if their proper concern were with the intrinsic capacity of certain material realities to put us in touch with 'spiritual' realities, or with 'the divine', or 'the transcendent', or God. Quite apart from the problems involved in presuming easy or natural identification between any of these latter terms, there is already a *prima facie* problem in thinking and speaking as though creaturely realities (material or otherwise), being finite and fallen, could have any natural capacity in and of themselves to be the bearers of divine meaning. That they may themselves be *granted* such a capacity by God's acting upon and through them (and upon and through *us* in our correlative activity of response) is, of course, another matter. Indeed, this is the only basis upon which faith and theology could be possible at all. But even then, we must reckon with the claim that such capacity is not bestowed upon these objects in isolation or as a permanent endowment, but only within the particular actions into which they are assimilated. We must therefore be rather more careful how we speak of such things than theological talk about 'sacramental' this, that and the other (or about the 'sacramental principle' in Christian theology) sometimes appears to be.

The Presence of Christ and the Elements

Discussions of 'eucharistic presence' have in fact generally spoken not so much about *God's* presence, but about the presence of *Christ* in relation to the bread and wine. We may note several things about this: (1) The two names are not simply synonymous in the eucharistic context, since it is the risen and ascended *humanity* of Christ that is in view here; (2) despite this, the pattern of orthodox Christology does permit the substitution of the name 'Christ' for the name 'God' (since in Christ it is God with whom we have to do), and talk about the presence of Christ may therefore legitimately perform more than one function in this context; (3) Christ's humanity is, therefore, the humanity of God and a further mode of God's own presence in the world; (4) For the humanity of Christ to be 'really' present in the eucharist, a special presence and activity of God as such must be presupposed; (5) Christians also believe that Christ is 'really' present in other contexts[15] – in the preaching of the Word for example, indeed 'wherever two or more are gathered' in his name – but while these various modes of his presence are clearly analogous to one another, it has generally been considered important to differentiate them, thereby recognising the peculiar modes of presence and activity of God proper to different contexts; (6) different ways of thinking about the relationship between God's mode of presence 'in' or 'to' the humanity of Christ in the incarnation and

[15] See, helpfully, Edward Schillebeeckx, *The Eucharist* (London: Sheed and Ward, 1968), 43.

'in' the eucharistic elements and actions[16] result in quite different accounts of what is effected through the sign.

In the above I have made a particular point of twinning the terms 'presence' and 'activity' whenever speaking of God's involvement in the Eucharist (or anywhere else). This seems to be important for a number of reasons. First, it reflects a fundamental biblical concentration upon God's activity as the way in which God's character (the Bible does not really deal in anything equivalent to the later philosophical categories of 'being' or 'nature') is apprehended. Second, it encourages us to recognise that when God is active, he is also 'present' in the midst of his own action, and not functioning via remote control from some distant 'place' (and therefore, in effect, absent); and correspondingly whenever God is present he is active and not to be thought of as a static 'substance', exposure or proximity to which he alone is in some sense transformative of human existence. Thus, if we suppose that the Eucharist is a context in which we are granted 'communion with' or (as some traditions have expressed it) 'participation in' God, then this is not by virtue of God simply 'being' in the same place as us (or 'in' the physical elements which we ingest), but because God is himself *doing* something distinctive to bring such communion about, acting upon us, and with us and through us. As Schillebeeckx notes,[17] the ancient church adhered to a model of God's relationship to this-worldly realities which was inherently dynamic and made sense of the Eucharist in these terms; but this tended to be obscured later by the borrowing of philosophical terms concentrating attention upon the abstract and the inert.

Whatever terms we choose, though, it may help us to think of what occurs in the Eucharist (unless we opt for a purely human account of its meaning) as a dynamic *appropriation* by God of the elements of bread and wine and the actions which we perform with them, lifting them up beyond the level of their own intrinsic capacities and charging them with new significance. Thinking about the eucharistic presence of God in this dynamic way evokes obvious parallels with God's appropriation of human flesh in the incarnation itself and his appropriation of human language in preaching and other contexts in which Scripture is read and interpreted. It may thus offer a more congenial model for Protestant sensibilities than is suggested by the language of bare 'presence' alone. Another benefit of insisting upon a dynamic conception of presence is that it reminds us that it is precisely in *actions* (God's and ours) that the bread and wine are symbolically re-ordered. To think and speak of God's presence in the 'elements' as if they remained inert on the table throughout, therefore, is to misplace the centre of

[16] For a helpful discussion of the problems associated with the preposition 'in', and its association with an Aristotelian 'container' notion of space, see Thomas F. Torrance, *Space, Time and Incarnation* (Oxford: Oxford University Press, 1969). For a full treatment of modes of divine presence and absence in Christian theology see Infolf U. Dalferth, *Becoming Present: An Inquiry into the Christian Sense of the Presence of God* (Leuven: Peeters, 2006).

[17] Schillebeeckx, 67–8.

symbolic gravity. At its best, eucharistic theology has always insisted that it is the bread and wine *as they are set apart, taken, broken, poured out, received and consumed* which are the focus of what God does here. Again, a suggestive parallel lies in understandings of the incarnation which treat it as an essentially timeless conjoining of two natures rather than a history of struggle, filial obedience and self-offering, or the sort of bibliolatry which treats the Bible almost as an object to be venerated, forgetting that its meaning for faith is tied to the human activity in which it is read and made sense of. Eucharist, like incarnation and proclamation, is a dynamic event on God's part and on ours.

Eucharistic Modification

A further question to be faced concerns the implications of all this for the creaturely realities involved. After all, many eucharistic liturgies refer unashamedly to the bread 'becoming' Christ's body, and the wine his blood, so that, in some sense, in receiving the creaturely elements we are at the same time 'receiving' Christ and him crucified. Does this mean that the bread and wine are somehow changed, that the reality which confronts us in them is different in the midst of the eucharistic celebration than it was before it? From very early in the church's history, it seems that theologians have felt compelled to insist that some such change must be recognised. Schillebeeckx cites the fifth century bishop Theodore of Mopsuestia (c.350–428) who, on the basis of Christ's words of institution, insists: 'Christ did not say "This is the *symbolum* of my blood", but "This *is* my blood", a *change* of the wine takes place.'[18] Many have followed in this basic insistence, and for essentially similar reasons. Hence debates about the Eucharist over the centuries have tended to centre on analysis of the words Jesus used in referring to the bread and the wine, and the precise implications of those words.

While, though, consideration of a 'change' in the bread and wine may begin here, it cannot end here, as if only on the basis of a crudely literal and pedantic interpretation of Jesus' words can the notion of change be made sense of and taken seriously. If we ask whether, in the context of the eucharistic celebration, what confronts us in the bread we take and eat and the wine we drink is 'merely' bread and wine any longer, then any who subscribe to some notion of God's presence and activity here are bound to resist this suggestion, and to admit at least that there is now, and for the moment, 'something different' or 'more' to be said of the bread and wine than this. They may well wish to insist that there is nothing *less* than bread and wine here, but they will accept that there is something more. For, they will recognise that, when something is appropriated by God and taken up into his activity and purposes in a manner that was not true of it before, we can and must say that its 'reality' (that which is true of it) has in some way been modified and enlarged. Again, we may note that directly parallel issues have arisen in discussion about the humanity which the Son of God assumed in the

[18] Cited in ibid., 67.

incarnation. This humanity, it has traditionally been insisted, is certainly not *less* than fully human by virtue of its assumption, but its 'reality' is unique by virtue of its unique relationship to God, and if we overlook this difference and insist that it is 'mere' humanity like any other, then we miss all that matters most about it. Analogously, human words (written and spoken) are, in being laid hold of by God when Scripture is read and the gospel preached, no less human than they were before; yet we attend to them expecting to hear the Word of God in and through them. So, whether or not we get hung up on particular terminology, the recognition of a particular and peculiar presence and action of God in relation to the eucharistic elements does seem to compel an acknowledgement that there is now something other and more to be said about them, and hence that something about them has indeed changed.

As the Western Church sought to underwrite this acknowledgement in the Middle Ages it did so by borrowing terms from Aristotelian philosophy. We can see easily enough how its application of these terms was intended to safeguard both the profundity of the change that occurs to mere bread and wine and the fact that these things remain (perceptually at least) the same as they were before in the midst of the divine action. The medievals expressed all this, though, by saying that the 'substance' (the underlying essence of the thing) of the elements had changed, while the 'species' or 'accidents' (the particular qualities manifest to our senses) remained the same. Since, in terms of the philosophy upon which they were drawing, a given thing could only *be one sort of thing* (possess one substance or nature) at once, theologians were driven to suggest that that which had once been bread *was actually now bread no longer*, but had been changed into the substance of the body of Christ, and the 'substance' which had been wine was correspondingly now the blood of Christ.[19] As well as focusing attention unhelpfully on the physical elements as such (rather than their situation within a symbolic *action*) these technical claims travelled far beyond the simple profession of faith that the Eucharistic bread and wine are transfigured by their assimilation into God's purposes. Rather than their creaturely 'reality' being *enhanced*, the medieval doctrine effectively displaces that reality altogether, transmogrifying it into something else which now confronts us in its place.

[19] Cf., e.g., Aquinas' insistence: 'Now, what is changed into something else is no longer there after the change. The reality of Christ's body in this sacrament demands, then, that the substance of the bread be no longer there after the consecration' (*Summa Theologiae*, 3a., Q.75, Art. 2). The same point is reaffirmed in an anathema approved by the Council of Trent on 11 October 1551: 'Should anyone maintain that, in the most holy sacrament of the Eucharist, the substance of bread and wine remains (in existence) together with the body and blood of our Lord Jesus Christ and should deny this wonderful and unique changing of the whole substance of bread into the body and of the whole substance of wine into the blood, while the species of bread and wine nonetheless remain, which change the Catholic Church very suitably calls transubstantiation, let him be excommunicated' (cited in Schillebeeckx, 38).

The intentions of this notion of 'transubstantiation' (which was adopted by the Fourth Lateran Council in 1215, endorsed and clarified by major medieval theologians such as Thomas Aquinas, and duly reaffirmed in the sixteenth century by the Council of Trent and again in the 1960s by Vatican Council II)[20] may have been commendable, but its way of articulating things was clearly highly problematic. In particular, its language, inevitably suggesting to the theologically unsophisticated that Christ's actual flesh was now physically present on the altar, and about to be bitten by human teeth and swallowed, reinforced all manner of popular misperceptions and superstitions concerning what was taking place.[21]

If, though, we return to the theological concerns lying behind the doctrinal formulation, Schillebeeckx is surely correct to claim that the gap between Catholic and mainstream Protestant understanding is less wide than first appearances suggest? Most traditions, following such clues as exist in the New Testament, have wanted to insist that when God appropriates bread and wine in the Eucharist what he does with it (and with us as we take and bless and share it) involves 'uniting us to Christ' in some redemptive way.[22] This being so, it seems reasonable to say – along the lines indicated above – that to the 'reality' of the bread and wine is added now a new determination in relation to Christ's body and blood (effective metonymy for his humanity in its entirety),[23] even though this is not visible

[20] See Austin Flannery, ed., *Vatican Council 2: The Conciliar and Post-Conciliar Documents* (Grand Rapids: Eerdmans, 1992), 104.

[21] The doctrine was not responsible for introducing this crude realism. It was already extant in the eleventh century as the case of Berangarius of Tours shows. Forced to recant his original adherence to a careful distinction between the physical 'signs' of bread and wine and the 'spiritual' reality of sharing in the body and blood of Christ, in 1059 Berangarius signed a statement including the words 'the true body and blood of our Lord Jesus Christ ... are sensibly ... handled by the hands of the priests and broken and crushed by the teeth of the faithful'. See on this, Alasdair Heron, *Table and Tradition: Towards an Ecumenical Understanding of the Eucharist* (Edinburgh: The Handsel Press, 1983), 94–5. While his own view of the matter was anything but crude, even Aquinas endorsed the rejection of Berangarius' original distinction as heretical (*Summa Theologiae* 3a., Q.75, Art. 1) and the doctrine of transubstantiation did nothing to qualify more unfortunate and macabre interpretations among the masses of the 'physical' handling and chewing of Christ's actual body in the sacrament.

[22] The New Testament does not contain a developed theology of the Eucharist, but it is clear that both Paul and John understand the eating and drinking which occurs there within the context of a theology of the union of the believer with Christ. Each understands union with Christ's humanity as central to human salvation, and sees the eucharist as a vital (if not absolutely necessary) means whereby our active sharing in Christ is sustained and deepened. See, for example, 1 Cor. 10–11 and John 6:47–58, and Heron's commentary on these passages in ibid., 34–53.

[23] Heron, following Betz, notes a tension in the New Testament's emphasis, observing Luke's and Paul's form of the 'words of institution' : 'This is my body, ... This cup ... is the new covenant in my blood' (see Luke 22:19–20; 1 Cor. 1124–25). This formulation, Heron

and leaves their physical reality unscathed. Were we to set the specific terms of Aristotelian metaphysics aside, and take the word 'substance' simply in its more ancient, non-technical sense of 'the underlying reality' (*sub-stantia* = 'that which stands beneath') which confronts us in a thing, then as Schillebeeckx indicates, talk of a 'change of substance' is no more or less problematic as such than our talk of a 'change of reality' or, if preferred, an enhancement or enlargement of it.[24] But 'substance' talk is probably too heavily stained by its history of use to be helpful in constructive eucharistic theology today. It is, in any case, the language of another era, and it generally makes sense for theologians to seek contemporary ways of articulating the basic issues at stake. When we turn, shortly, to consider Calvin we shall see that he recasts the terms of the discussion, setting substance largely aside and accounting for what occurs in the Supper instead in terms of the alternative category of figuration.

Summary

To recapitulate, then, we have seen in this section that central to historic discussions about the Eucharist are questions: (1) about God's dynamic presence in the midst of the event; (2) about the outcomes of this divine activity (uniting participants with Christ); (3) about Christ's own 'presence' by virtue of this union; and (4) about the nature of the reality which confronts us in the bread and the wine as they are appropriated by God's action. These are by no means the only issues, and we shall see that Calvin and Barth attend to others also; but these are the chief issues which have preoccupied the Church's discussion, and our rehearsal and clarification of them should furnish a helpful background against which now to set their particular accounts.

Calvin – Bread and Wine Trans-figured

Calvin follows Augustine and Aquinas in linking the sacraments to our propensity, as embodied creatures, for sign-making. This, he recognises, is central to our attempts to make sense of and to represent for ourselves the reality confronting us in the world, and in particular those aspects of it which transcend the limits of

suggests, points to the whole humanity of Christ in its history from birth to resurrection as the content of that 'new covenant' with which faith is effectively united in the sacrament. The versions in Matthew and Mark, with their disentangling of body and blood, draw attention rather to the death of Jesus on the cross as such. Both emphases, Heron notes, should be permitted to resonate through our liturgies and our theology, and it is important to remember that 'body and blood' do indeed refer not just to the sacrificial death of Jesus, but to his whole life offered in obedience to his Father for our sakes. See ibid., 13.

[24] See Schillebeeckx, 73–4.

sense perception as such. Hence Aquinas writes, 'it is connatural to man to arrive at a knowledge of intelligible realities through sensible ones, and a sign is something through which a person arrives at knowledge of some further thing beyond itself. Moreover', he continues, 'the sacred realities signified by the sacraments are certain spiritual and intelligible goods by which man is sanctified'.[25] If, then, we are to 'know' or engage with these same realities, it will inevitably be through the mediation of physical signs such as the water of baptism and the bread and wine of the Eucharist. Calvin concurs, drawing attention to the fact that the 'signs' in question are not just the material objects themselves, but the wider 'ceremonies' or actions in which these objects are taken up.[26] 'Here', he writes, 'our merciful Lord, according to his infinite kindness, so tempers himself to our capacity that, since we are creatures who always creep on the ground, cleave to the flesh, and, do not think about or even conceive of anything spiritual, he condescends to lead us to himself even by these earthly elements, and to set before us in the flesh a mirror of spiritual blessings. ... because we have souls engrafted in bodies, he imparts spiritual things under visible ones. Not that the gifts set before us in the sacraments are bestowed with the natures of the things, but that they have been marked with this signification by God'.[27]

Divine Sign-giving

From this, though, it emerges at once that while the sacraments may be understood at one level in terms of a wider semiotics, the fundamental thing about this particular sign-giving or -making is that it is a matter of God's own gracious action in accommodating himself to our condition. Calvin insists that the relation of signification, through which in the handling of material things 'spiritual realities' are genuinely bestowed and received, is in an important sense arbitrary rather than natural: the bread and the wine have no intrinsic relationship to that which, in this context alone, is offered and received through them. It is a matter of convention peculiar to their use within the Christian community.[28] But this is, as it

[25] *Summa Theologiae*, 3a., Q. 60, Art. 4.

[26] *Institutes* IV.xiv.19 in John T. McNeill, ed., *Calvin: Institutes of the Christian Religion*, ed. John Baillie, John T. McNeill, and Henry P. Van Dusen, The Library of Christian Classics, vol. XXI (Philadelphia: Westminster Press, 1960), 1295–6.

[27] IV.xiv.3, ibid., 1278.

[28] It is true, of course, that bread and wine as such do have a certain natural correspondence to 'flesh' and 'blood' in their simple physical properties, and Calvin acknowledges that it is through 'a sort of analogy' that we are led from the physical to the 'spiritual' things involved in the eucharistic action. See IV.xvii.3, ibid., 1363. So the association between these 'signifiers' and that which they signify is not 'arbitrary' in quite the sense ascribed in modern semiotics by Saussure to the linguistic sign (Ferdinand De Saussure, *Course in General Linguistics* (London: Peter Owen Ltd, 1959), 68). But the relationship of these everyday realities to the *particular* body and blood of *Christ* (and

were, a divine rather than a merely human convention, resting firmly upon God's determination of the signs rather than the 'symbolific'[29] activity of the Church alone. The signs, we might say, are more securely spoken of in this particular context as given and received rather than 'made';[30] given by God, not just once in the dominical 'institution' of the Supper, but again and again wherever it is celebrated, the efficacy of the signs being contingent on the 'miracle' of God's repeated renewal of the signifying relation. What happens in the Supper, therefore, is no mere sociological phenomenon, but the gracious approach of a holy God to sinful creatures, condescending to furnish the symbolic means of their reciprocal approach to him.

Calvin does not deny the importance of human activity in the ceremony, but he does set it decisively within the context of a logically prior divine action which under-girds ours and makes it meaningful. Thus, a sacrament may helpfully be defined as 'an outward sign by which the Lord seals on our consciences the promises of his good will toward us in order to sustain the weakness of our faith; and we in turn attest our piety towards him'.[31] 'In one place Chrysostom therefore has appropriately called (the sacraments) "covenants", by which God leagues himself with us, and we pledge ourselves to purity and holiness of life, since there is interposed here a mutual agreement between God and ourselves'.[32] There is a dual dynamic of activity in the 'sign' (which, therefore, is complex, signifying more than one thing), but God is finally responsible for all that happens, and the preponderance of 'doing' is in any case located by Calvin in the God-humanward direction rather than the reciprocal response elicited from the human side. Thus God manifests himself through the signs,[33] draws us to himself,[34] increases, nourishes and deepens faith,[35] grants assurance,[36] and confirms or seals the content

therefore their further analogical correspondence as 'food for the body' under which 'food for the soul' is actually given and received in the Supper) is arbitrary inasmuch as it rests wholly on the decision and action of God.

[29] The term coined by Susanne Langer to refer to the peculiarly human mode of meaning making through symbols of one sort or another. See Susanne K. Langer, *Philosophy in a New Key: A Study in the Symbolism of Reason, Rite, and Art*, 3rd ed. (Cambridge, MA: Harvard University Press, 1956).

[30] This is not to deny that, in an important sense, human 'making' of meaning is essential to what occurs. It is simply a way of insisting, as Calvin does, that the priority of action lies with God, into whose activity humans are duly drawn as responsible participants, but apart from whose activity no sense can be made of the eucharistic sign and what it effects.

[31] IV.xiv.1, McNeill, ed., 1277.

[32] IV.xiv.19, ibid., 1296.

[33] IV.xiv.6, ibid., 1281.

[34] IV.xiv.13, ibid., 1288.

[35] IV.xiv.7, ibid., 1282.

[36] IV.xiv.1, ibid., 1360.

of his promise pertaining to our redemption.[37] There are other, more specific things which Calvin holds are 'shown' and 'executed' in the sign of the Supper, and we shall consider these duly. But this list is sufficient to indicate already the nature of the event as one in which God is definitely and pre-eminently involved from first to last, and any 'power' attaching to the eucharistic signs is God's own power through his presence and activity in the Spirit, appropriating the bread and wine as his 'instruments'.[38] Indeed, 'the sacraments properly fulfil their office only when the Spirit, that inward teacher, comes to them, by whose power alone hearts are penetrated and affections moved and our souls opened for the sacraments to enter in. If the Spirit be lacking, the sacraments can accomplish nothing more in our minds than the splendour of the sun shining upon blind eyes, or a voice sounding in deaf ears'.[39]

Faith Alone Participates in the Sign

The appropriate mode of apprehension of and correspondence to the Spirit's work, here as elsewhere for Calvin, is faith. Thus, he insists, only those who eat and drink in faith truly receive what is offered to them. While the offer is indiscriminate and the table open, unbelief stops short at the level of a merely physical participation, the bread and the wine being for it 'cold and empty figures',[40] opaque rather than transparent, and devoid of that divine signification which, for faith, renders sharing in them an actual sharing in the body and blood of Christ. Where faith is lacking, therefore, bread and wine remain merely bread and wine, and Calvin is emphatic that a careful distinction be drawn at every point between the physical signs and that which, under God's appropriation, they signify for faith. In a manner directly parallel to orthodox prescriptions concerning talk about the incarnation, he insists that while there is indeed a real union between signifier and signified (or the 'matter') whereby the latter is genuinely shown and genuinely 'present' to be received in faith, nonetheless, 'they are not so linked that they cannot be separated; and ... even in the union itself the matter must always be distinguished from the sign, that we may not transfer to the one what belongs to the other'.[41]

There are twin errors to be avoided here Calvin urges, following Augustine.[42] First, we may confuse what is proper only to the matter with what is proper to the physical sign, and thereby ascribe to the signs in and of themselves some beneficial power to be availed in the mere act of physical eating and drinking. This extols the signs immoderately, and obscures the 'mysteries' to which they properly refer us, missing what is really important. The other danger, though, is that we shall

[37] IV.xiv.1, ibid., 1277.

[38] IV.xiv.17, ibid., 1293. IV.xiv.12, ibid., 1287.

[39] IV.xiv.9, ibid., 1284.

[40] IV.xiv.7, ibid., 1282.

[41] IV.xiv.15, ibid., 1290.

[42] IV.xvii.5, ibid., 1364–5.

separate the sign from the matter, breaking the relation of signification, and failing to appreciate that 'by the showing of the symbol the thing itself is also shown' and received.[43] One is, as it were, a form of eucharistic Eutychianism, and the other its Nestorian equivalent.[44] Both result in a damaging of the proper relation of 'union in distinction' and 'distinction in union' between sign and matter, and both end up in a fascination with the signs as such, prohibiting them from performing their essential figurative function of lifting our hearts up to heaven[45] to apprehend Christ who is, nonetheless, truly exhibited in them, truly 'present', and truly given and received when we eat and drink in faith. Accordingly, Calvin rejects the theology of transubstantiation and the associated practices of venerating and reserving the sacramental elements.[46] This robs the bread of its integrity as bread, confuses the two realities within the signifying relation with one another, and effectively denies the need for faith (since Christ is de facto present *as* the bread and wine which are physically consumed).[47] He is equally concerned, though, to reject accounts of the Supper which turn the bread and wine into the stage props of a merely human symbolising of faith in Christ.[48] Of course what is said and done in the Supper *is* a profession of faith, but this aspect must be acknowledged as secondary to faith's place as the mode in which we receive from the hand of God all that he offers to us through the mediation of the bread and wine; that is, Christ and all his benefits.[49] For it is indeed Christ (and not our faith), Calvin insists, who is the true 'matter' or 'substance' signified in the Supper, and while figuration is necessarily involved in the ceremony, we should not suppose that Christ is offered or received 'only' figuratively. Thus 'the godly ought by all means to keep this rule: whenever they see symbols appointed by the Lord, to think and be persuaded that the truth of the thing signified is surely present there'.[50] Otherwise, we accuse God of being a deceiver, offering to us only 'empty symbols'.

Signs and Words

Before exploring further Calvin's understanding of the presence of Christ in the Supper, we should note again the importance which he ascribes to the event of the Supper as a whole (and not just the bread and the wine) in this regard. It is the 'ceremony' as such which constitutes the wider 'sign' within which the particular signifying power of bread and wine is located. And the ceremony is, of course, a

[43] IV.xvii.10, ibid., 1371.

[44] Calvin does not draw out these Christological analogies, but he can hardly have been unaware of them.

[45] IV.xiv.5, McNeill, ed., 1280; IV.xvii.36, ibid., 1412.

[46] See IV.xvii.13–15, ibid., 1373–8.

[47] IV.xvii.33, ibid., 1406.

[48] See IV.xiv.13, ibid., 1288–9.

[49] IV.xvii.5, ibid., 1364.

[50] IV.xvii.10, ibid., 1371.

synthesis in which objects, actions and words are juxtaposed and related to one another. So, while Calvin insists that the material signs are vital, he also refuses to detach their meaning from the accompanying immaterial symbolics of narrative.[51] The bread and wine are 'seals' and 'confirmations' of a promise already given, and make sense only when faith apprehends them as such. There must therefore always be some preaching or form of words which interprets the 'bare signs' and enables us to make sense of them, and the 'faith' which apprehends them, while not mere intellectual assent, has nonetheless a vital cognitive dimension.[52] 'Augustine calls a sacrament "a visible word" for the reason that it represents God's promises as painted in a picture and sets them before our sight, portrayed graphically and in the manner of images'.[53] This does not, it should be noted, reduce the elements to dispensable visual aids, as if the essential meaning of the Supper could be conveyed equally well in their absence. Calvin's choice of similes is helpful here. Certain sorts of images (in our day we might cite photographic as well as painted images) may well require some verbal context before we can make appropriate sense of them,[54] yet when viewed in this context they undoubtedly possess a power or force of their own which transcends the limits of meaning to which words alone may take us. So, too, Calvin insists (exchanging images) 'as a building stands and rests upon its own foundation but is more surely established by columns placed underneath, so faith rests upon the Word of God as a foundation; but when the sacraments are added, it rests more firmly upon them as upon columns'.[55] Faith, then, is more surely established, more firmly founded through God's appropriation of tangible things as bearers of his meaning, and by them he 'attests his good will and love toward us more expressly than by word'.[56] Again, this seems to be due not just to a certain 'dullness' on our part, but to our very nature as embodied beings in a world where meaning is finally bound up with physicality. 'Because we are of flesh' these things 'are shown us under things of flesh',[57] there being a surplus of meaning which supervenes upon the narrative and is available only through these accompanying physical signs. Calvin, like many other commentators, terminates his consideration here, stopping short of potentially fruitful reflection on the further dimension of the 'drama' of the Supper, that is, the equally symbolic *actions* in the performance into which the bread and the wine are taken up.[58]

[51] See IV.xiv.3–4, ibid., 1278–9. Cf. Aquinas, *Summa Theologiae*, 3a. Q.60. Art. 6–8.

[52] IV.xvii.39, ibid., 1416.

[53] IV.xiv.6, ibid., 1281.

[54] In viewing the photographic image, Susan Sontag suggests, 'Only that which narrates can make us understand'. Susan Sontag, *On Photography* (London: Penguin, 1979), 23.

[55] IV.xiv.6, McNeill, ed., 1281.

[56] IV.xiv.6, ibid.

[57] IV.xiv.6, ibid.

[58] See IV.xvii.43, ibid., 1420–21.

Signification, Metonymy and the Presence of Christ

As we have been seeing, at the heart of Calvin's understanding of the sacrament of the Supper there lies a careful account of the working of signs, and it is these same terms that he develops in his theology of eucharistic presence. There are, he tells us, three factors to be taken into consideration in the Supper: 'the signification, the matter that depends upon it, and the power or effect that follows from both.'[59] The 'signification' is the physical sign, together with its narrative context ('the promises, which are, so to speak, implicit in' it). The 'effect' is redemption, the continuing transformation of our lives through the communication to them of Christ's own life lived before his Father. The 'matter' is that which the signs signify, that beyond themselves to which they refer and 'unite' us as we follow or indwell the signifying relation. And the matter of these particular signs is Christ's own humanity together with all its 'benefits'. Here it becomes apparent that Calvin's understanding of the Supper in Book IV of the *Institutes* is founded firmly on the Christology and soteriology already expounded in Books II and III, especially his echoing of the biblical and patristic insistence that incarnation and atonement are organically united, and Christ's whole incarnate history from conception to ascension part of that which he offered for us once for all and now offers to us as the 'substance' of our salvation.[60] It is clear that Calvin understands the 'body and blood' of eucharistic symbolism in this way as metonymic reference to the whole Christ, and while he certainly follows the Western tradition in placing due weight on the death of Jesus he does not limit the significance of what is signified to this. What is set before us in the eucharistic signs is the truth of the union of our own humanity with Christ's whereby all that he has and is becomes the root and source of our redemption. 'This', Calvin writes, 'is the wonderful exchange which, out of his measureless benevolence, he has made with us; that, becoming Son of man with us, he has made us sons of God with him; that, by his descent to earth, he has prepared an ascent to heaven for us; that, by taking on our mortality, he has conferred his immortality upon us; that, accepting our weakness, he has strengthened us by his power; that, receiving our poverty unto himself, he has transferred his wealth to us; that, taking the weight of our iniquity upon himself (which oppressed us), he has clothed us with his righteousness'.[61]

For Calvin, then, the eucharistic signs refer us away from themselves to Christ. Our participation in their symbolic meaning, though, is no mere 'calling to mind' of Christ's saving significance. By virtue of the Spirit's action and of our response in faith, it is itself a mode of sharing in that significance and being transformed by it. As we eat and drink, so, under the symbols, Christ 'really' offers his 'body'

[59] IV.xvii.11, ibid., 1371.

[60] See further Trevor Hart, 'Humankind in Christ and Christ in Humankind: Salvation as Participation in Our Substitute in the Theology of John Calvin', *Scottish Journal of Theology* 42, no. 1 (1989).

[61] IV.xvii.2, McNeill, ed., 1362.

and 'blood' to us and we receive and are 'fed' by them.[62] In other words, the mysterious organic union of believers with the humanity of Christ is actually realised and deepened through this ritual performance, and the sanctification of our sinful and weak humanity duly furthered. This 'flesh and blood' communion with Christ in the present moment presupposes that Christ is himself 'present' to us in some sense, and Calvin insists that it will not suffice to suggest that this presence is of the same sort as his wider presence in the Spirit.[63] Something more and specific is going on here which compels us to speak of a distinctive eucharistic mode of Christ's presence to us and ours to him. Calvin is emphatic, though, in his rejection of various medieval attempts to account for this in terms of a local physical presence in the elements of bread and wine.[64] This is not because he thinks such an account too incredible to take seriously, but because it compromises a proper understanding of the incarnation and the nature of Christ's risen and ascended humanity. Christ's body, he argues, remains in its risen and ascended state finite and subject to 'the laws of common nature';[65] to predicate of it some capacity for eucharistic ubiquity contradicts this truth, and effectively loses sight of the difference between Christ's deity and his humanity, resulting in a form of post-resurrection docetism.[66] If we take Scripture seriously, we find that Christ's humanity is 'in heaven' at the right hand of the Father, from where we are to await his return in glory and for judgement.[67] It cannot, therefore, also be physically present in the bread and wine of the Supper. This being so, we must make sense of the 'presence' of Christ in such a way that it acknowledges his simultaneous 'absence' (located spatially in heaven). This, Calvin admits, is in its way no less remarkable a claim than that entailed in the doctrine of transubstantiation, and entertains a 'miracle' no less challenging to the bounds of day-to-day common sense. The difference, he suggests, is that it is a miracle consonant with and even required by the witness of Scripture concerning what occurs in the Supper.

The eucharistic union of believers with the humanity of Christ is, Calvin insists, a mystery which the mind cannot comprehend,[68] something to be experienced rather than understood or analysed.[69] It is for this very reason that God accommodates himself to the limits of our reasoning, and furnishes an essentially imaginative mode in which we may approach and partake of it, showing the 'figure and image' of a mystery 'by nature incomprehensible' in visible signs.[70] The signs function to assure us of the reality of Christ's body and blood once offered for us and now

62 IV.xvii.10, ibid., 1371; IV.xvii.32, ibid., 1403–4.

63 IV.xvii.7, ibid., 1367.

64 See IV.xvii.12f., ibid., 1372f.

65 IV.xvii.29, ibid., 1398.

66 IV.xvii.29, ibid., 1399.

67 IV.xvii.26–9, ibid., 1393–40.

68 IV.xvii.7, ibid., 1367.

69 IV.xvii.32, ibid., 1403.

70 IV.xvii.1, ibid., 1361.

offered afresh to us, 'as if we had seen it with our own eyes',[71] though of course we have not, and the mode of presence remains elusive. This though is no mere token of something in reality absent, like a tattered photograph of a loved one kept in a wallet. For, Calvin insists, the signs are themselves the mode of Christ's actual presence to us, the 'truth' or reality of what is signified being 'inseparable from the sign'.[72] The symbols 'represent' Christ to us,[73] but they do so because they are themselves as it were, the form of Christ's own presence in absence, so that as we share in the sign we actually share in Christ himself. Thus Calvin expounds the meaning of Jesus' words at the Supper, 'This *is* my body', precisely through an appeal to linguistic trope. It is, he argues, metonymy, the substitution of a part to represent a larger whole (as 'the White House' is used in news bulletins to refer to the machinery of American government) to which the part properly belongs.[74] In the Supper, the bread (and wine) 'not only symbolizes the thing that it has been consecrated to represent as a bare and empty token, but also truly exhibits it' by virtue of a divine determination uniting it, and us through it, to Christ's humanity. The appropriateness of the metonymy lies, therefore, not in any natural relation between bread and the humanity of Jesus, but in a miracle by which the Spirit 'truly unites things separated in space' and 'Christ's flesh, separated from us by such great distance, penetrates to us' as we take and eat and drink.[75]

The Incarnation and Imaginative Trans-figuration

It is vitally important to note, though, that Calvin does not understand the believer's union with Christ as *established* by the Supper and its signifying relation alone. On the contrary, this union (the 'fraternal alliance of the flesh' as Calvin calls it) rests on the sharing of the Son in our humanity by virtue of the incarnation, and it is on this basis that he is 'truly' for us the 'bread of life' and we partakers of his 'flesh'.[76] But his objective 'once for all' healing of this same 'flesh' through obedience and sacrifice remains to be applied to us in the course of our Christian living, and the Supper is a central mode (though by no means the only mode) of this existential participation. 'Therefore, the sacrament does not cause Christ to begin to be the bread of life; but when it reminds us that he was made the bread of life, which we continually eat, and which gives us a relish and savour of that bread, it causes us to feel the power of that bread.'[77] The other thing to note here is that for Calvin the union established between the eucharistic signs (and thereby believers who partake in the wider 'sign' of the ceremony) is precisely with the *humanity*

[71] IV.xvii.1, ibid.
[72] IV.xvii.16, ibid., 1379.
[73] IV.xvii.1, ibid., 1360.
[74] IV.xvii.21, ibid., 1385.
[75] IV.xvii.10, ibid., 1370.
[76] See IV.xvii.4, ibid., 1363.
[77] IV.xvii.5, ibid., 1364.

of Christ. For Calvin this is vitally important, for to deny it, and to posit some direct rather than indirect relation between the signs and God, would effectively be to short-circuit Christ's role as mediator, and thus himself a signifier whose significance cannot be grasped immediately nor cashed out in the terms of any symbolics, but only indwelt by the divinely engendered fragility of faith. Instead, Calvin's understanding reinforces this theology of Christ's continuing priesthood, since the Supper is precisely a means of its being realised in practice, uniting us to his 'flesh' through which alone we may approach the Father with a confidence that has little to do with intellectual certainty. While, therefore, there is a clear analogy between the 'materiality' of God's dealing with us in the Supper and in the incarnation, the analogy needs to be handled very carefully indeed. The mode of God's presence in the bread and wine is different, more indirect even than his presence in Christ, and the sacrament, therefore, should not (for Calvin at least) be thought of as 'extending' the incarnation in any way. It does not 'extend' it (as if the bread now performed the same role as Christ's flesh once did) but is a symbolic form whereby the incarnate Christ himself, risen and ascended at the right hand of the Father, makes himself present to us and grants us a participation in his own redeemed humanity.[78] The 'presence' of Christ, therefore, is realised through an appropriation by God's Spirit of the sign's capacity to trespass beyond the boundaries of actual physical presence, and while Calvin is careful to avoid any suggestion that faith partakes of Christ 'only by … imagination'[79] (we might better render this 'in a merely imaginary way') it is clear that his understanding of what occurs in the Supper is, from first to last, articulated in terms of 'poetic' logic and God's active appeal to our nature as imaginative creatures.

Barth – Signification, Revelation and Response

As James Buckley has noted, during the 1930s when Karl Barth was writing his *Protestant Theology in the Nineteenth Century*, he expressed profound disquiet about the tendency in modern theology to found theological description upon general, non-theological discourses, seeking the meaning of the Church and its practices (for instance) in some accidental modification of normative human community, its rituals and symbols.[80] The key phrase here, though, is '*found theological description upon*'. For in this same period Barth was working on the first volume of his *Church Dogmatics*, and here he was entirely happy to cast his fleeting account of the Lord's Supper in the terms of a wider model of signification. In doing so, though, he did not permit secular discourse to lay down the rules for or determine the limits of his description, let alone appeal to it for external intellectual

[78] On the Eucharist as an extension of the hypostatic union see Schillebeeckx, 68.

[79] IV.xvii.11, McNeill, ed., 1372.

[80] Buckley, 'Community, baptism and Lord's Supper' in John Webster, ed., *Cambridge Companion to Karl Barth* (Cambridge: Cambridge University Press, 2000), 197.

warrant. Instead, he borrowed such aspects of it as lay usefully to hand in order to articulate something about the structure of God's engagement with humankind, an engagement which, Barth asserted unashamedly, begins and ends unambiguously with God himself. The Lord's Supper, he insisted, is one example of the wider pattern of that *divine sign-giving* in which the dynamic of *revelation* consists.[81]

Signification and Analogy

Like Calvin before him, therefore, in his writings prior to the late 1950s Barth appeals to the logic of signification as a way of thinking about what occurs in the Lord's Supper. More explicitly than Calvin, though, Barth employs this same scheme in order to make sense of the wider pattern of God's revelatory dealings with the world, of which the sacraments are a part. When the God who is wholly other than the world gives himself to be known in the world, Barth argues, it is through the appropriation of this-worldly objects, events, relations and orders, all of which are wholly other than himself, but all of which are duly drawn into a new relationship with him whereby they are granted the capacity to 'mean' something radically new and unexpected. These creaturely phenomena are granted a 'special determination' whereby 'along with what they are and mean within this world ... they also have another nature and meaning from the side of the objective reality of revelation'.[82] The physical entities are in and of themselves incapable of such signification, but are laid hold of by the Word of God in his speaking to the world. The essential *arbitrariness* of the signs is thus a vital correlate of Barth's denial of any *analogia entis* between God and his creatures.[83] For their part, the 'signifiers' (the things appropriated) must be set in a new, transcendent relation in order to function as 'signs'; and in order to apprehend and follow their new meaning we, too, must be lifted up beyond our natural capacity as knowers to behold them now 'from the standpoint ... of transcendence'.[84] Furthermore, neither of these occurrences (which are not once for all, but, in God's faithfulness, constantly repeated and renewed) grants either the signifiers or ourselves any enduring capacity apart from God's gracious appropriation and activity. Revelation is always, for Barth, an event (*Ereignis*), a happening. Thus 'the activity of the sign is, directly, the activity of God Himself'.[85] 'The given-ness of these signs does not mean that God manifest has Himself as it were become a bit of the world' or

[81] Karl Barth, *Church Dogmatics I/2*, ed. Geoffrey W. Bromiley and Thomas F. Torrance, trans. George Thomas Thomson and Harold Knight (Edinburgh: T&T Clark, 1956), 229.

[82] Ibid., 223.

[83] On the relationship between Barth's account of the Supper and his doctrine of analogy see Paul D. Molnar, *Karl Barth and the Theology of the Lord's Supper* (New York: Peter Lang, 1996).

[84] Barth, *CD I/2*, 223.

[85] Ibid., 224.

placed himself at general human disposal.[86] The Church is bound by these signs, called to return again and again to these particular words, events and things as she seeks an encounter with the living God who has met her in them before. But God, Barth insists, is not bound by them.[87] They are no magic lamp which we have only to rub in order to conjure up his presence. God remains free in his Lordship, and the signification of his presence and action remains elusive should we try to pin it down for inspection. Yet he has graciously committed himself to these signs and promised to renew his communion with us as we seek him here in faith and obedience.

Hypostatic and Sacramental Union

At the very heart of this economy of divine sign-giving, of course, lies the history of the man Jesus Christ whose humanity is in its entirety 'taken up' by God as the ultimate 'sign' of his own reality. Here, most obviously and most vitally, God lays hold of creaturely reality and makes it his own, establishing it in a new and unprecedented relationship whereby it serves as a marker of God's own presence with us, Immanuel. The structure of the incarnation, as it were, parallels and adapts itself to the structure of signification: that which is 'not God' is reordered within the scheme of things and becomes for us a sign (for those granted eyes to see and ears to hear) of God present in our midst. Thus, Barth admits, 'the humanity of Jesus Christ as such is the first sacrament'.[88] But Barth already knows that he is on dangerous ground here, lest the nature of the relationship between God and the humanity of Christ in the incarnation be *confused* with other divine 'appropriations' of worldly phenomena.[89] There is a radical difference which renders the incarnation unique, and relegates all other divine sign-giving in comparison to a secondary and derivative status. For here, as nowhere else in human history, God relates to creaturely reality by *becoming* it, establishing an absolute hypostatic identification between himself and the creature. Jesus' humanity functions as a sign (in the strictest sense *the* sign) of God in the world because Jesus himself *is* the form which God takes humanly in history, the Word who has 'become flesh' for our sakes. But this relationship of 'hypostatic union' is unique, and does not pertain to any other God-given sign. 'It happened only once. It is not therefore

[86] Ibid., 227.

[87] Ibid., 224.

[88] Karl Barth, *Church Dogmatics II/1*, ed. Geoffrey W. Bromiley and Thomas F. Torrance, trans. T.H.L. Parker et al. (Edinburgh: T&T Clark, 1957), 54.

[89] See, e.g., his discussion in 1955 of the 'temptation' of drawing this comparison. ET Karl Barth, *Church Dogmatics IV/2*, ed. Geoffrey W. Bromiley and Thomas F. Torrance, trans. Geoffrey Bromiley (Edinburgh: T&T Clark, 1958), 54–5. By the end of the decade the cautious and almost grudging acknowledgement that the parallel may nonetheless be an illuminating one for understanding the Supper had given way to an abandonment of it.

the starting-point for a general concept of incarnation.'[90] Yet this act of 'primary objectification' on God's part is itself the basis and meaning of all other divine signifying (acts of 'secondary objectification' as Barth refers to them). The content of this particular and unique sign, we might say, becomes the substance or 'matter' (to use Calvin's term) of all the other signs through which revelation occurs. As such, it both calls into question any assumption that other creaturely realities are in themselves capable of directly bearing 'divine meaning' (and thus contradicts rather than offers warrant for general 'principles' of sacramentality in Christian theology) and nonetheless offers hope that, in God's gracious accommodation of himself to our capacities, they might come to serve as secondary and indirect signs. 'He and no other creature is taken up into unity with God. Here we have something which cannot be repeated. But the existence of this creature in his unity with God does mean the promise that other creatures may attest in their objectivity what is real only in this creature, that is to say, God's own objectivity – so that to that extent they are the temple, instrument and sign of God as He is.'[91]

When, 25 years or so after writing these words, Barth began to espouse a very different notion of Baptism and Lord's Supper, the change in his thinking may in part have been due to a deepening conviction that this (for him vital) distinction was too easily and too often overlooked and these 'so-called sacraments' mistakenly vested with attributes and propensities proper only to the humanity of Jesus. That the *unio hypostatica* and the *unio sacramentalis* must be carefully differentiated was something he insisted upon from the outset (the man Jesus Christ, he notes bluntly, is identical with God whereas the bread and wine of the Supper are not),[92] but he came eventually, as we shall see, to deny the *unio sacramentalis* altogether. For the later Barth the Lord's Supper was no longer to be identified as a place where God appropriates creaturely realities to serve extraordinarily as bearers of divine meaning, lifting us up to know him more fully through our participation in the signifying relation. It is certainly an event of signification, and a divinely 'given' one since Jesus himself instituted it. But the signification requires no peculiar divine action to establish or sustain it, and its 'matter' (that which is signified by it) is to be identified elsewhere than in Christ as such. Before shifting our attention to this late version of things, though, we must first trace more of the pattern of Barth's earlier thought about the Lord's Supper. The evidence for this is patchy and fragmented, and will involve us in making occasional inferences on the basis of things he has to say about 'the sacraments' more generally.

The Word Takes Flesh

As we have seen, for Barth the Lord's Supper is to be understood in terms of a wider pattern of divine sign-giving whereby God grants us knowledge of and

[90] Barth, *CD II/1*, 54.
[91] Ibid.
[92] Barth, *CD I/2*, 162.

communion with himself. Chief among the phenomena appropriated by God to serve as signs is human language in both its written and spoken forms, but in the Supper and in Baptism we are confronted with *elementa*, 'elements of a spatially extended, corporeal nature' which duly become the bearers of divine significance.[93] Barth plays down any suggestion that we are dealing with an essentially different mode of divine engagement here though, insisting upon the parallels between the various sorts of signs[94] and avoiding the notion that the bread and wine in the Supper are significant in their inert physicality. That they are tangible signs is certainly important, but Barth reminds us that 'the spiritual, historical and moral being of man is also steeped in the elemental sphere, in the cosmos of corporeality, in an ultimately inextricable unity with his natural being, of which it is the counterpart'.[95] Furthermore, the signifying force of these *elementa* resides not in their physical manifestation as such, but in their deployment within the context of an *actio sacra*, an action in which body, soul, spirit, mind and will are all engaged. So, while Barth does not make the point explicitly, we cannot doubt that he sees the accompanying words of the Supper (which are, he reminds us, themselves part of an action, and though not tangible nonetheless sensible signs, *audible* in nature)[96] as inseparable from the physical elements as part of the wider liturgical drama in which meaning is realized. Following Heinrich Vogel, though, he acknowledges that the supra-linguistic dimensions of this dramatic sign do have their own irreplaceable force, asserting clearly, 'and with relatively greater eloquence than the word in the narrower sense can ever do, that the *iustificatio* or *sanctificatio hominis*, which is the meaning of all divine sign-giving, does not rest upon an idea but upon reality, upon an event'.[97] The physical and active dimensions of the Supper, therefore, are not incidental but vital, for they go further than words can in driving home the truth which lies at the centre of the Christian gospel – *Et incarnatus est*.

In the Lord's Supper, just as in preaching, Barth maintains, mundane realities are laid hold of by God in such a way that while at one level they are 'simply and visibly there', at another they receive a new 'form' from the Word of God, and can no longer be regarded as 'mere' bread and wine. In the eucharistic context they acquire a new designation as *nota a verbo Dei insculpta* (a sign inscribed by the Word of God),[98] a designation accompanied by a new capacity alien to their nature as such, but leaving it intact. This new capacity has to do with their role as instruments of God's purpose to justify and sanctify human beings, applying what

[93] Ibid., 230.

[94] See, e.g., Karl Barth, *Church Dogmatics IV/3/2*, ed. Geoffrey W. Bromiley and Thomas F. Torrance, trans. Geoffrey W. Bromiley (Edinburgh: T&T Clark, 1961), 737f.

[95] Barth, *CD I/2*, 230.

[96] Ibid., 229–30.

[97] Ibid., 230.

[98] Karl Barth, *Church Dogmatics I/1*, ed. Geoffrey W. Bromiley and Thomas F. Torrance, trans. Geoffrey Bromiley (Edinburgh: T&T Clark, 1975), 88–9.

was done once for all in Christ to believers in the here and now. This much they have in common with all divinely ordained signs,[99] but the four-dimensionality of the Supper does this in its own way. 'It is ... a question of (believers') nourishment by Him. It takes place in the fact that, as often as they here eat and drink together, He proffers and gives Himself to them as the One He is, as the One who is absolutely theirs; and conversely, that He continually makes them what they are, absolutely His.'[100] Of course one might also speak analogously of Christ 'offering' himself to us whenever the Gospel is proclaimed; but again, the 'eating and drinking' of the bread and wine do this in their own peculiar way which outstrips the reach that words alone possess.

The Presence of Christ and the Supper

This brings us to the question of 'presence'. While he rejects the Roman Catholic doctrine of transubstantiation and variations upon it, Barth insists that the 'becoming' in which bread and wine are appropriated as signs is no less 'realistic' than what was intended by that doctrine.[101] The action of the Supper is therefore no merely human action, but one over which Christ himself presides, to which he invites us, and in which he 'proffers and gives Himself' to us anew for our conscious reception.[102] Indeed, the Supper makes no sense, Barth suggests, apart from the presupposition that 'the One whom we remember is Himself in action now, to-day and here'.[103] Whereas for Calvin the Spirit mysteriously transgresses the boundaries of space, uniting the eucharistic signifiers to the humanity of Christ which is in heaven, Barth indicates rather that the Christ who is present and active is the Christ of the gospel accounts, the one who 'overcomes the barrier of his own time and therefore historical distance'; and the 'action' in which he is present is 'His then action' which, though historically particular, transcends the limits of its own time and breaks into our present.[104] Barth too, though, appeals to spatial metaphor in his theology of presence, not in relation to the eucharistic event specifically, but in his account of the wider Pauline claim that Christians are 'in Christ' and Christ reciprocally 'in' them. This language, he suggests, while having an extended metaphorical range (Christians live their lives after the pattern of Christ's humanity, and that pattern is duly formed in them) has a logically prior and determinative 'local' sense in which 'the spatial distance between Christ and Christians disappears', 'Christ is spatially present where Christians are, and ... Christians are spatially present where Christ is, ... not merely alongside

99 Barth, *CD I/2*, 230.
100 Barth, *CD IV/2*, 703.
101 Barth, *CD I/1*, 89.
102 Barth, *CD IV/2*, 703.
103 Ibid., 112.
104 Ibid.

but in exactly the same spot'.[105] Such talk, Barth insists, suggestive as it is of a perichoretic transgression not just of the boundaries of time and space but also the boundaries separating Christ's particular humanity from ours (without breaching the integrity of that particularity) must not be demythologised.

This strong, 'realistic' notion of Christ's wider presence in the Church helps us to make sense of Barth's passing observation about the Supper that in it Christ is in some sense 'present without needing to be made present'.[106] This acknowledgement sets the Supper in a wider context and relativises the emphasis laid upon it as such (the union of Christ with the believer is certainly not dependent upon eucharistic participation). But Barth traces a link between the two, and seems content to admit that there is nonetheless a special or peculiar moment to be identified in this God-given sign in which the wider 'presence of' or 'union with' Christ is, by virtue of a distinctive divine activity perceptible only to faith, realised and reinforced in particular lives and in the Christian community. Here, 'In the work of the Holy Spirit there takes place … in a way which typifies all that may happen in the life of this people, that which is indicated by the great *touto estin*, namely, that unity with its heavenly Lord, and the imparting and receiving of His body and blood, are enacted in and with their human fellowship as realised in the common distribution and reception of bread and wine'.[107] This realisation of the believer's union with Christ through the sign of the Supper is 'impossible' from the human side, but 'on God's side it is not only possible but actual', taking place 'in the gracious act of the gracious power of the Holy Spirit which co-ordinates the different elements and constitutes and guarantees their unity'.[108] While, therefore, Christ's union with and indwelling of the believer is a wider phenomenon pertaining to the whole Christian life, Barth indicates here that the Supper plays a distinctive and central role in realising it,[109] and that what occurs has to do with the Spirit's 'co-ordinating' or 'uniting' of the earthly and the heavenly, so that the one may serve appropriately as a sign and mediator of the other.

The Supper as a Sign of Response

In the last two decades of his life Barth's views on Baptism and the Lord's Supper underwent a profound shift. The roots of this shift lay primarily in considerations of exegesis, most notably the influence of a book on Baptism published by Barth's own son, Markus.[110] Barth was persuaded by the argument of this work that the notion of 'sacrament' as it had arisen in the early centuries of Christian

[105] Barth, *CD IV/3/2*, 547.

[106] Barth, *CD IV/2*, 113.

[107] Barth, *CD IV/3/2*, 761.

[108] Ibid., 762.

[109] See, e.g., ibid., 901 where he refers to it as a 'repeated and conscious' appropriation by the Church of that which is offered.

[110] Barth, *Die Taufe ein Sakrament?*

history was lacking in adequate biblical basis. Linking the New Testament's occasional use of *mysterion* in an unwarranted manner to the events of Baptism and the Supper, it resulted in a decisive relocation of the centre of gravity in the Church's understanding of them. *Mysterion* (*sacramentum*), Barth tells us in his own eventual account of the matter, in the New Testament 'denotes an event in the world of time and space which is directly initiated and brought to pass by God alone, so that in distinction from all other events it is basically a mystery to human cognition in respect of its origin and possibility'.[111] In the sub-apostolic Church an understanding developed of Baptism and the Lord's Supper in these terms, as ritual participations in an activity of God which in themselves afford a share in salvation to participants. 'Baptism and the Lord's Supper now (for the first time) began to be regarded as cultic re-presentations of the act and revelation of God in the history of Jesus Christ, and consequently as the granting of a share in His grace.'[112] This idea, Barth argues, was borrowed from parallel rituals in the religions of Asia Minor and, more importantly, obscures rather than illuminates the Bible's teaching about the Christian rites, a case which he then argues at length in relation to Baptism.

As we have already noted, no parallel argument was ever developed concerning the Lord's Supper, and very few positive statements indicating the shape of Barth's revised view of it are extant. Those that are, though, indicate clearly enough that the same basic concerns that mark his account of Baptism pertain here too, and it is therefore legitimate to extrapolate from them the broad shape his developed account would likely have taken had he survived to produce it. The things that are not true of Baptism, he indicates clearly enough, are not true of the Supper either. Thus, he writes, 'Baptism and the Lord's Supper are not events, institutions, mediations or revelations of salvation. They are not representations and actualizations, emanations, repetitions, or extensions, nor indeed guarantees and seals of the work and word of God; nor are they instruments, vehicles, channels, or means of God's reconciling grace. They are not what they have been called since the second century, namely, mysteries or sacraments'.[113]

Central to Barth's theological concern about wider sacramental understanding and practice (concern which the new exegesis enabled him now to resolve in relation to Baptism) was an unhealthy emphasis upon the rites themselves as if human performance of and participation in them was essential to and guarantee of the benefits of salvation.[114] This both detaches the signs from their proper relation to what God has done for us in Christ and neglects the need for a wider and radical discipleship as the form of the outworking of that same redemption. As we have seen above, his earlier appeal to the category of the sign sought precisely to avoid the former error. The Supper refers the believer beyond itself, empties itself out

[111] Barth, *CD IV/4*, 109.

[112] Ibid.

[113] Barth, *CD IV/4 Lecture Fragments*, 46.

[114] See, on Baptism in this regard, Barth, *CD IV/4*, 71.

in the interests of directing faith to Christ, the real and only source of salvation. To collapse the structure of the sign, thereby confusing the signifiers of the rite with that which they signify, is effectively a form of idolatry. But if the Supper is nonetheless spoken and thought of as a time and place where God himself is active in applying to us the benefits of what he has done objectively and once for all in Christ, and if the signifying force or 'meaning' of the event (the 'matter of the sign' in Calvin's phrase) lies in our being united to Christ, then there is always the danger of such misunderstanding occurring. If God 'does something redemptive' here, then an *ex opere operato* view of the rite will no doubt always be lurking in the shadows waiting for an opportunity to emerge.

What Barth's rejection of the category of 'sacrament' did was effectively to liberate his understanding of the Supper from any such danger. For now he bluntly denied that God was at work in this event mediating or applying the benefits of salvation. Furthermore, the meaning of the Supper, while certainly related to the objective fashioning of salvation for us in the humanity of Christ and its day-to-day application to us through our mysterious 'union' with him, did not lie in divine action as such, but elsewhere. 'With all that the community of Jesus Christ and its members are and say and do, (Baptism and the Lord's Supper) belong to something that God has permitted and entrusted and commanded to Christians, namely, the answering, attesting, and proclaiming of the one act and revelation of salvation that has taken place in the one Mediator between God and man, … they are actions of human obedience for which Jesus Christ makes his people free and responsible. They refer themselves to God's own work and word, and they correspond to his grace and commands.'[115] In other words, there is not a dual dynamic in the sign of the Supper, as Calvin had insisted, and as Barth had himself earlier accepted, but only a single movement. The meaning of the sign lies not in God's movement towards us in his Son, but in our reciprocal and corresponding movement towards God in faith and obedience. Instead of being secondary, this human movement now becomes primary and, indeed, the sole meaning of the rite. Of course it presumes the prior and subsequent activity of God, without which it would not be possible or meaningful, since here faith looks both backward and forward and offers thanks for God's grace and faithfulness, centred upon the death of Christ to which the bread and wine testify.[116] But their role is precisely to serve as *signs of our testimony and response* to this self-offering, and not as divinely given signs of the offering in which faith is laid hold of by God, united to the offering and thereby nourished. Such 'union' occurs, but it occurs elsewhere, in the wider pattern of Christian living and the communication of Christ to the believer by the Holy Spirit. While there is a 'strict correlation' between this divine action and the human action of the Supper, there is also a 'no less strict distinction' to be observed which locates the meaning of the Supper decisively in the latter

[115] Barth, *CD IV/4 Lecture Fragments*, 46.

[116] See, on Baptism in this regard, Barth, *CD IV/4*, 134.

rather than the former. The Lord's Supper is a 'distinctly human action',[117] an ethical event, and not a mystery in which God gives himself to be known. It is, as Barth tells us in one of the few positive statements on the subject dating from this period, 'the thanksgiving which responds to the presence of Jesus Christ in His self-sacrifice and which looks forward to His future'.[118]

Of course Barth does not deny the presence and activity of God in the Supper in any absolute way. But he limits it to that general presence and activity which undergirds all human action and which alone sets faith free to make a responsible response of thanksgiving.[119] Here his second concern about sacramental practice, its tendency to encourage an antinomian reliance upon mechanistic ritualism detached from a life of faith and obedience, comes to the fore. The human action of the Supper is not merely the outward form of some secret, mysterious thing that God does, but a fully responsible moral act, corresponding to God's prior and promised activity in Christ and the Spirit. Indeed, Barth suggests that if the Supper is 'basically a divine action' then it becomes difficult for us to take it seriously as a human action at all.[120] This does not seem to follow at all, not least given some of Barth's own earlier statements about the Spirit's work in co-ordinating divine and human activities.[121] What he is seeking to avoid, though, is any notion of eucharistic action as a *merely* mechanistic human performance by and under the guise of which God is compelled to do something for our benefit. That wholly misses the significance of its ethical dimension. Again, this danger too is circumvented if, on other grounds, the claim that God is present and active in some special eucharistic manner is set aside, and the Supper seen instead as *essentially* and *distinctively* a human action, significant of human response and only indirectly of the divine initiative which calls it forth and renders it possible. This view, of course, risks falling prey to a different danger – that of Pelagianism and perfectionism. But, Barth observed, perfectionism was not the problem confronting the Church in the context in which he wrote, an acknowledgement that it was not exegesis alone which lay behind his ready and relieved embrace of a new view of the 'so-called sacraments'.

Indeed, the main issue attaching to Barth's late view of the Lord's Supper is that he did not yet appear to have engaged in the sort of careful exegetical work that would enable him to sustain it. The impression one gains is that, under the influence of Markus Barth's exegesis he arrived at a new understanding of the nature of Baptism and the way God works in and through it. This duly led him to reject its status as a 'sacrament' in the traditional sense, and to revise his understanding of (effectively to abandon) the category of sacraments as such. On the basis of this revised understanding, he posited (but never developed) a parallel

[117] See, on Baptism in this regard, ibid., 143.

[118] Ibid., ix.

[119] See, on Baptism in this regard, ibid., 105–6.

[120] See, on Baptism in this regard, ibid., 106.

[121] See, e.g., Barth, *CD IV/3/2*, 762.

revised understanding of the Lord's Supper, as yet lacking the sustained exegetical base which would grant it support.

By Way of Conclusion

There would seem, though, in principle to be no reason to make such a lateral move from Baptism to the Supper. In his reflection on the subject Alasdair Heron argues that 'the sacraments' ought never to become an independent subject of theological interest. Otherwise we may proceed from some generic definition of what a 'sacrament' is (about which the New Testament knows nothing whatever) and then proceed to 'squeeze the Eucharist, baptism, and perhaps other things as well into that framework'.[122] Barth's suggestion that one might deduce 'the sorts of things' he would have wanted to say about the Eucharist from the things he actually said about baptism (and understand both in terms of his rejection of a presumed notion of 'sacraments') suggests that he fell into this very trap. There seems to be no reason why one might not in theory hold quite radically differing views of the nature of God's involvement in Baptism and the Lord's Supper respectively, especially if one were to begin, as Heron insists we must, not with an *a priori* notion of what a sacrament is, but with the New Testament's distinctive account of each. The only satisfactory basis for a revised account of the nature of the sign of the Lord's Supper, that is to say, will be precisely an *exegetical* one, akin to that which led Barth to a new view of Baptism. A theology of 'the sacraments' ought not to be permitted the sort of *a priori* role which he appears to have granted it.

In due course, but long after his father's death, Markus Barth published another work which offered just such an exegetical basis.[123] The focus of his consideration was John 6, and Jesus' discourse on the 'bread of life'. This passage does, indeed, seem to lie close to the exegetical heart of the matter, and to be central, therefore, to any attempt to weigh the relative merits of Calvin's and Barth's (later) view of the Supper.

To go back to where we began this chapter, the central question at issue in eucharistic theology concerns whether, and if so where and how, God is peculiarly present and active in the Supper's midst. Historic debates have centred (perhaps unhelpfully) around Jesus' words at the last supper with his disciples. Taken in themselves, though, these words hardly bear the weight that has traditionally been placed upon them. Only one of the three synoptic accounts of the supper[124] indicates that this was a practice which Jesus expected his disciples to repeat, and 'do this in remembrance of me' might suggest that what was intended was simply a symbolic way for the community regularly to call to mind Jesus and

[122] Heron, 56.

[123] Markus Barth, *Rediscovering the Lord's Supper* (Eugene, OR: Wipf and Stock, 2006).

[124] Luke 22:19.

the significance of his death for others. Nothing in the passage (or its parallels in Matthew and Mark) warrants an insistence that this is to be a locus of peculiar divine activity, let alone some of the things claimed over the centuries concerning what happens to the bread and the wine. The earliest New Testament testimony to the supper is 1 Cor. 11:23f. which supports Luke's account of Jesus instituting a normative practice for the community, but describes its purpose in a way which initially seems to support Barth's rather than Calvin's account. 'For as often as you eat this bread and drink the cup, you proclaim the Lord's death until he comes.' The emphasis here, that is to say, is ostensibly upon human rather than divine action, and more specifically faith's testimony, keeping the cross-centred identity of the community clearly in its own view and that of the world.

In the wider context of chapters 10 and 11, though, Paul introduces notes of caution about the Supper which at the very least indicate that the early Church took its approach to it very seriously indeed.[125] There is a certain sense of 'sacrality' about it which means that one may approach it 'unworthily' (11:27), and by doing so 'provoke the Lord to jealousy' (see 10:22). Such sentiments are not incompatible with an interpretation of the Supper as an occasion on which the Church symbolically represents and reflects upon its identity as a community rooted in its unity with Christ. They are perhaps more likely, though, if this same unity is understood as being somehow at stake in the event itself. The latter suggestion is reinforced by Paul's specific claim that 'whoever … eats the bread or drinks the cup of the Lord in an unworthy manner *will be answerable for* the body and the blood of the Lord' (11:27, my italics), a statement which duly urges a more rather than less 'realistic' reading of 10:16, 'The cup of blessing that we bless, is it not a sharing in the blood of Christ? The bread which we break is it not a sharing in the body of Christ?' Such words, like Jesus' own in the synoptic accounts, *can* be read as 'merely poetic', indicating a purely human act of signification; but the wider context raises questions about the adequacy of reading them in this way.

It is John 6:32–59, though, that arguably furnishes the most awkward material for the sort of 'neo-Zwinglian' view advocated by Barth. If one subscribes to an interpretation of the chapter which sees no deliberate eucharistic allusion, then the awkwardness here dissolves. But if one accepts that Jesus' words in this passage constitute a Johannine reflection on the Supper, then what emerges is a more solid biblical base for a view of it as a place where God is active in nourishing and deepening believers' union with Christ, *as well as* believers being active in receiving Christ in faith and obedience. 'Unless you eat of my flesh and drink my blood, you have no life in you. Those who eat my flesh and drink my blood have eternal life, and I will raise them up on the last day; for my flesh is true food and my blood is true drink. Those who eat my flesh and drink my blood abide in me, and I in them' (6:53–7). When read as commentary upon the Supper these words situate our understanding of it firmly within John's wider theology of union with Christ, and appear to indicate that the eating and drinking entailed by it is of

[125] I am indebted to my colleague Richard Bauckham for this observation.

peculiar significance for the believer's day to day 'remaining' in that union. Faith itself has no control over this; the bread from heaven is given by the Father (6:32), and it is Jesus himself, the divine Word who has been 'made flesh' (1:14), who now offers (as he once offered) his flesh and blood for our participation via the sign of eucharistic eating and drinking (6:51–2).

Approaching Scripture as canon, such a reading provides warrant for a more 'realistic' interpretation of Jesus' words at the last supper and Paul's statement that our eating and drinking *are* a participation in the body and blood of Christ. If we adopt such readings, then we shall understand the Eucharist as a divine, and not merely a human act of meaning-making, and thus be inclined towards Calvin's rather than Barth's final account of the matter, seeing in the sacraments more widely a further gracious accommodation by God to the condition of creatures who, called to dwell simultaneously in the perichoretic spheres of body and soul, can know and enjoy fellowship with God only by his active participation in the order of signs.

Chapter 3

The Economy of the Flesh

Thus far I have argued that Christian theology is inexorably wedded to the economy of the image due to the nature of its proper object, and that God's revelatory engagement with us takes place through acts of gracious accommodation in which God enters the material 'order of signs' within which our distinctly human creaturely existence and response are played out. In the present chapter my concern will remain with this theme of the flesh, and its capacity to bear significance and thus become more than whatever, as flesh alone, it is or has. In particular, I return to the subject of language (not explicitly 'religious' language alone, but language as such), and the claims made in the recent work of my colleague David Brown[1] regarding the 'sacramental' power of the poetic image as such to draw us – through a sustained dialectic of mystery and meaning – into an encounter with the God who lies at the heart and the root of all creaturely mystery and meaning. I trust that readers will be able readily to discern the respect and esteem in which I hold Brown's work; but, notwithstanding a fruitful sharing of theological concerns, we do differ on some questions of method and substance, and I hope that an attempt here carefully to expound and respond to some of his arguments will provide an opportunity to point to some alternative ways of addressing those concerns, and thus perpetuate a fruitful and enjoyable conversation. Towards the end of the chapter, following on from Brown's concentration on the inherent depth and mysteriousness attaching to certain uses of words, I will offer some theological reflections on linguistic indeterminacy, and its relationship to the divine 'flesh-taking' in the incarnation and our place in the world as embodied (and fallen) creatures. First, though, to Christology itself.

The Word Which Always Takes Flesh

According to the testimony of the fourth evangelist, the Word which was in the beginning 'with God and ... was God', in the fullness of time 'became flesh' and dwelt in our midst, thereby giving himself up, as the author of 1 John has it, to be 'seen with our eyes ... and touched with our hands' as well as heard.[2] The fact of the incarnation, it appears, eschews any neat or convenient bifurcation between word

[1] See especially David Brown, *God and Mystery in Words: Experience through Metaphor and Drama* (Oxford: Oxford University Press, 2008).

[2] See Jn. 1:18; 1 Jn. 1:1.

and image, and furnishes *prima facie* theological warrant at least for exploring the claim that the verbal image (words which, in David Brown's phrase, are 'nearest to the visual' in their way of working)[3] might bear particular significance in our encounters with this same God through the mediations of language, wherever and however such encounters may be understood as occurring.

Indeed, the encounters with God to which Christian faith testifies, focused supremely here in the inhomination of the eternal Son, but identified also in the reading and interpretation of Scripture, in sacraments and other liturgical action, and more widely amidst our multiple engagements with the phenomena of a shared world, are always mediated at some point and in some manner by a concomitant presentation of 'flesh'. This is part and parcel of what poet and painter David Jones refers to as a 'predicament of being human',[4] the fact that our distinctive creaturely circumstance is one straddling the spheres of the material and the non-material,[5] holding them together and mediating the realities of the one to and through the forms of the other. For creatures of this sort, in other words, matter matters. It is not incidental, but modifies and shapes and grants distinctive texture to our engagements with non-material realities (whether these be creaturely, or divine). The flesh, far from constituting an inconvenient conduit for the transmission of essentially 'fleshless' ideas or feelings from A to B (ideally without either significant loss or pollution),[6] is itself complicit in and contributory to the meanings we discern and make and share together in the world as God has created it, and as the sort of creatures he has made and calls us to be.

The wider claim here is not a peculiarly Christian or even a peculiarly theological one of course; but it assumes particular significance and gains far deeper resonance when situated adjacent to Christian faith's most fundamental and distinctive claim – namely that God's own Word addressed to humankind is never a *logos asarkos*, but from first to last an *enfleshed* word, a claim which I take the doctrines of the resurrection and ascension to be intended emphatically to underline.[7] The incarnation is no mere expediency or temporary theophany, but

[3] Brown, 132, cf. 20.

[4] David Jones, *Epoch and Artist* (London: Faber and Faber, 1959), 166.

[5] For reasons bound up directly with issues raised by Brown and treated in this chapter, I prefer 'non-material' or 'non-corporeal' here over 'spiritual', popular use of the latter term nowadays tending to blur the distinction between that which has identifiably to do with manifestations of God's Spirit (i.e. *pneumatikos* in the Pauline sense) and realities of other sorts. See Gordon D. Fee, *God's Empowering Presence: The Holy Spirit in the Letters of Paul* (Peabody, MA: Hendrickson, 1994), 28–32.

[6] As, for instance, in some forms of modern idealism, and aesthetic theories shaped by them. See further Trevor Hart, 'Through the Arts: Hearing, Seeing and Touching the Truth', in *Beholding the Glory*, ed. Jeremy S. Begbie (London: Darton, Longman and Todd, 2000), 8–15.

[7] In light of the patristic distinction between a *logos endiathētos* and a *logos prophorikos* in the divine life, questions about the inseparability of thought from language

an abiding reality within the triune life of God, flesh situated now at the Father's right hand for all time, and mediating any and every approach we care or dare to make to the throne of grace.

The cross-over between distinctly theological claims of this sort and wider theories about human language and its workings seems to me to be potentially very rich. Such cross-over lies at the heart of the volume with which we are concerned in this chapter, though direct treatment of the doctrine of the incarnation as such is rather more slender there than one might expect. There is, I shall suggest duly, a clear Christology in the book, but the incarnation is not its primary focus. Consistent with Brown's approach in the two preceding volumes, it is the category of 'sacrament' instead (in its by now familiar extended sense) that for the most part structures and informs the exploration undertaken.

It is true of our human words too that they cannot eschew the flesh but must ever assume it and remain incarnate within it, whether that be the actual material substance of acts and outputs of utterance and inscription, or the mental images which present themselves (mostly unbidden) to the mind's eye, as words bear meanings reaching beyond their own immediate sensory form and location. At one level Brown's concern is identifiably with the 'sacramentality' of words in this wider sense, quite apart from any specifically religious or theological consideration – viz., with their nature as signs marrying the material and the non-material dimensions of creation (what the creed refers to as 'things visible and invisible'). But, as in earlier volumes, his concern is finally always with questions of a more ultimate sort, and with a definition of 'sacrament' which lies closer, at least, to its more precise ecclesial domain of use, tracing a positive organic connection between the two. Could it be, he asks, that the phenomena of speech and writing *as such* (words uttered and written, heard and read), or certain sorts of things done with words, might themselves (i.e. quite apart from and prior to questions or claims about their appropriation by divine acts of revelation) be or become the occasion for or constitutive of experiences of a distinctly 'religious' sort or – less anonymously and impersonally phrased – an encounter with the generous God who is everywhere present and always desirous of being known?[8] Brown's answer to the question is, as by now we might expect, a positive one. In particular, he argues, the power of acts of verbal *poiesis* to make mystery and meaning 'rhyme' in our engagements with the world[9] puts us in a place experientially where such

and the entanglements of language itself in the world of matter compel further reflection, perhaps, on the coherence of the image of a *logos asarkos* as such – i.e. a divine word or thought formulated already within the immanent dynamics of the divine life (remaining as yet to be expressed 'externally') not thoroughly implicated, at least by way of anticipation, in the creaturely and historical order. See G.L. Prestige, *God in Patristic Thought* (London: S.P.C.K., 1952), 123.

[8] Brown, 110.

[9] 'Metaphors do after all both affirm something to be the case and yet refuse complete identification and closure.' ibid., 22.

an encounter is at least far more likely, albeit not inevitable. Thus, consistent with his broader conviction that 'revealed religion builds on natural religion rather than wholly subverts it',[10] Brown attends to wider insights from the side of poetics to help the Church understand both how those outside its boundaries may yet be granted an experience of God without necessarily ever darkening its doors and, equally importantly, how its own peculiar uses of and engagements with words (especially *poetic* words) in liturgy, preaching, prayer, the reading of Scripture, hymnody and so forth, might be rendered more fully fit for purpose than they so often are.

Metaphor, Modesty and Mystery

As the title of his book proclaims, it is with '*mystery* in words' that Brown's proposals concerning the sacramental capacities of language are most closely bound up. As he acknowledges, *all* words have a charge of mystery clinging to them, though we often forget or choose to ignore the fact.[11] In so far as words have to do with reality, not remaining trapped within self-defining and tautological systems of meaning (as 'some form of internal play'),[12] but pointing to and suggesting that which transcends and resists capture or containment by them, they experience what can be construed either as a shortfall or a surplus in semantic terms, depending on the perspective adopted. Thus, even our most prosaic and precise use of words is haunted in some measure by an inability to speak the world fully into presence for us.

The religious overtones of the language of semantic 'presence' are familiar and anything but accidental. 'The age of the sign', Derrida claims, 'is essentially theological'.[13] For its part the strategy of 'reading without end', of abjuring finalities of meaning is, George Steiner reminds us, a defining feature of the religion of Judaism, and he traces deconstruction's 'crisis of the word' directly back to a religious (and in itself wholly proper) impulse to venerate the transcendent and inviolable status of the 'holy text'.[14] Mistaking elusiveness for absence, though, or perhaps secretly preferring the narcotic of the textually secondary and semantically penultimate to 'the often harsh, imperious radiance of sheer presence',[15] deconstruction 'dances in front of the ancient Ark' in a manner that is 'at once playful … and in its subtler practitioners … instinct with sadness. For the

[10] Ibid., 1.

[11] Ibid., 44, 66.

[12] Ibid., 46.

[13] Cited in George Steiner, *Real Presences: Is There Anything In What We Say?* (London: Faber and Faber, 1989), 120.

[14] See ibid., 40–49.

[15] Ibid., 49.

dancers know that the Ark is empty'.[16] Steiner's own response to the putative crisis is to revisit the mystery in words, finding here instead precisely an index of a deep, complex and rich reality lying beyond us, irreducibly 'other' than ourselves, and eluding the reach of our language. The most appropriate (indeed the only possible) way forward for those who would continue to use and to interpret words, he urges, is a disposition of trust, respect, and risk-taking – wagering on the capacity of language to put us in touch with and so disclose aspects of a world which yet remains transcendent and ultimately mysterious.[17] This wager on 'real presences', he argues, is itself viable only on the basis of another – the supposition (equally unsusceptible to demonstration) of God's own intrinsically elusive presence in, with and underwriting it all,[18] a claim distinct from but wholly consonant with Brown's own case in which the trajectories of significance are traced, as it were, contrariwise – from meaning (and mystery) as we find them evident in words, in the direction of God.

If, properly speaking, mystery attaches to any and every use of words, nonetheless the quotient of mystery varies significantly with different uses of them. And it is in more explicitly and self-consciously poetic uses, such as metaphor and catachresis, where words find themselves compelled to function beyond the borders of what Janet Soskice calls their ordinary 'domain of application'[19] and doing work other than that for which they are ordinarily considered fit, that the quotient of mystery is set at its highest. Such words strike us precisely as something out of the ordinary, at first glance even improper, though (if the metaphor is a good one rather than the mere arbitrary redistribution of predicates) the sense of impropriety is short-lived, giving way sooner rather than later to what Ricoeur refers to as 'the air of *rightness* that certain more fortunate instances of language ... seem to exude' despite their evident peculiarity at first blush.[20] Yet the putative fit is indeed an unfamiliar one, and we generally have to live and work with it for some time before its deeper reaches open themselves up, gradually modifying our sense of what counts as 'ordinary' in the first place. The more profound and striking

[16] Ibid., 122.

[17] Cf. Brown, 66.

[18] See, e.g., Steiner, 3, 229. For a critical response to this latter claim see Infolf U. Dalferth, *Becoming Present: An Inquiry into the Christian Sense of the Presence of God* (Leuven: Peeters, 2006), 43–8. The step in Steiner's argument here is aided (though hardly required) by a use of the term 'transcendence' to refer variously to God's distinction from the world and the distinction of the world in its turn from human users of language and from language itself. The elusiveness of the relevant presence in each case is apparently understood in terms of analogy rather than any more direct relation.

[19] Janet M. Soskice, *Metaphor and Religious Language* (Oxford: Clarendon Press, 1985), 64–5.

[20] Paul Ricoeur, *The Rule of Metaphor: Multidisciplinary Studies of the Creation of Meaning in Language*, trans. R. Czerny and others (Toronto and Buffalo: Toronto University Press, 1977), 239.

the image, the longer it takes for familiarity to harden its surface,[21] obscuring the depths of mystery that it continues to suggest, exploration of which may well 'reorganize our habitation in reality'.[22]

The words of the poet, Brown suggests, are deliberately and unashamedly dense and open-ended, resistant to over-determination or premature closure of meaning.[23] They are so, of course, not because poets are bloody-minded or cussed individuals, but because the texture of reality as the poetic eye grasps it is at once deeper and more complicated than our workaday modes of apprehension and speech ever acknowledge. The poet jolts us, causing us to 'stand and stare' at the world,[24] to pause and look again, and again, rather than moving quickly on, content that we have seen all and understood all. Thus, as Ricoeur observes, the heuristic and the creative often stand and fall together in our engagements with the world, rather than being found at opposite ends of the epistemic spectrum.[25]

We cannot handle such words quickly and easily. They force us to tarry with them, to linger over them, to 'chew on' them,[26] returning to them again and again, and even then remaining unsatisfied, convinced that there is more yet to be had.[27] Meanings, Rowan Williams reminds us, do not happen all at once but take time,[28] a circumstance which the poet's image makes palpable. The very oddness of the poetic image draws attention to itself (to its 'flesh') in a manner which at first blush may seem ostentatious, even self-important, but finally is not so. The initial invocation to 'look at me' gives way *precisely as we do so* to a self-emptying, pointing beyond itself to a rich surplus of meaning which is by no means its own and which it makes no claim to fathom. The mystery at the heart of words, we might say, is contingent on the mystery at the heart of *things*, on the poet's glimpsing it, and on the power of his image to suggest it.

This 'kenotic' disposition of the image, though, and its deliberate wandering in the borderlands of mystery ought not to lead us to underestimate its epistemic

[21] E.g., in the process whereby it may become 'lexicalized', accepted as the 'literal' or primary use of the term. See ibid., 290–91.

[22] George Steiner, *After Babel: Aspects of Language and Translation*, 2nd ed. (Oxford: Oxford University Press, 1992), 23.

[23] The poetic image, of course, comes in forms other than metaphor. Brown, though, concentrates on metaphorical uses of words in particular, and we follow him in this concentration.

[24] Cf. W.H. Davies' poem 'Leisure': 'What is this life if full of care/We have no time to stand and stare?'

[25] See, e.g., Ricoeur, 239, et passim. Cf. also the account developed in Mark Johnson, *The Body in the Mind: The Bodily Basis of Meaning, Imagination and Reason* (Chicago and London: University of Chicago Press, 1987).

[26] Brown, 72.

[27] A potentially 'inexhaustible presence'. See ibid., 60–61.

[28] Rowan Williams, *Grace and Necessity: Reflections on Art and Love* (Harrisburg, PA: Morehouse, 2005), 137.

capacities. Intelligibility and mystery, Brown insists again, belong together, and arise together most fully and obviously in the well-crafted metaphor.[29] Such images provide us with a language in terms of which to speak and make sense of newly glimpsed realities, new ways of experiencing the world, new ways of 'modelling' it. But they do so in a manner which is entirely honest about just how little, as well as how much, it knows and can say, refusing any simple identification of its statements with states of affairs, and complicating the kataphatic suggestion that 'it is' with the implicit apophatic reminder that 'it is not'.[30] In this sense, as Colin Gunton suggests, the indirectness of metaphor is perfectly suited to the sort of epistemic modesty that befits any 'realist' account of the world and our knowing of it.[31]

For Brown, though, the importance of the verbal image lies not just in its fusion of intelligibility and mystery, but in its power to provoke a *sense* of mystery or to draw us into an experience of mystery in which heart and will, as well as intellect, are fully involved.[32] The mysteries to hand may themselves be purely creaturely ones but, as we have already noted, for Brown even *such* experiences, mediated through poetry, may render us in turn more receptive to or open out onto mysteries of a more ultimate sort, the mystery from which all earthly mysteries take their name.

The tragedy of Christianity, Brown argues, lies in its failure so often to recognise this, overlooking the intrinsic power of the verbal images shot undeniably through its own Scriptures, liturgies and hymns, and rushing instead to pin definitive meanings down. In a well-intentioned but misguided effort to get its head fully around the realities with which faith must reckon, the Church has so often committed the sin of reductionism, missing the semantic excess with which such words are naturally and deliberately freighted by their human and, we might presume in relevant cases, their divine author. As a consequence, rather than furnishing a rich imaginative *habitus* for faith's indwelling and exploration, a wooden literalism renders the images flat (insisting that 'this is that'), their meanings killed, shrink-wrapped and labelled for easy classification. In the words of one Protestant poet, 'the Word made flesh is here made word again', and all sense of mystery 'impaled and bent' on a 'logical hook'.[33]

If this is at one level a malaise bound up with the intellectual dispositions of modernity, Brown insists that, despite the congruence between mystery and semantic indeterminacy, those postmodern initiatives which seem to want to

[29] Brown, 8.

[30] See Ricoeur, 255.

[31] See Colin Gunton, *The Actuality of Atonement: A Study of Metaphor, Rationality and the Christian Tradition* (Edinburgh: T&T Clark Ltd., 1988), 39. Cf. Chapter 1 above, 18–25

[32] See, e.g., Brown, 6–7, cf. 55.

[33] From 'The Incarnate One' in Edwin Muir, *Edwin Muir: Collected Poems* (London: Faber and Faber, 1960), 228.

confine us finally within the endless labyrinthine play of language are likely to serve us little better, allowing all sense of genuine presence effectively to evaporate or haemorrhage away instead of (with modernism) murdering in order to dissect.[34] Brown's prescription, therefore, is a deliberate rediscovery and recovery of the power of acts of verbal poiesis within the Church, refusing to rein the imagination in too soon, being willing to trespass beyond familiar meanings and even familiar images, pushing further down the semantic trails to see where they may lead us, and willing to be surprised and discomfited as often as we are affirmed and encouraged by where we end up.[35]

Mystery, Order and the Logos

As we have already had reason to observe, far from being incompatible with order or present only in inverse proportion to it (so that concern for either would inevitably be involved in a constant tug of war with concern for the other), for Brown a sense of the mystery of things belongs properly together with order and each must be permitted to *qualify* our concern with the other. Too much mystery or too much explanation, without this vital qualifying counterpoint, is something to be avoided at all costs, ending up inevitably in one of the twin sand traps of reductionism and sheer obscurantism.[36] So, a due sense of mystery has to do not with the *absence* of order, but perhaps with recognition of a certain *complexity* of order which eludes our capacity to plot or fathom it completely, or else the simultaneous possibility of more than one meaningful way of ordering things within the field of perception. A dialectic may and must be maintained between explanation (the way of affirmation) and the modesty of the way of negation. And again the structure of metaphor, with its deliberate interplay between elements of *kataphasis* and *apophasis*, provides a fitting medium, meaningfulness and mystery being glimpsed together in the same moment. There is an intriguing resonance here, too, with Kant's account of the experience of beauty as something generated by a dynamic 'play' between the understanding and the imagination which remain locked in a sort of unresolved but intensely pleasurable tango: a sense of genuine 'orderliness' glimpsed in the artefact, but one the seductive particularity of which remains finally mysterious, resisting any and every attempt to subsume it under any concept.[37]

[34] Brown, 66. On modernism's rationalistic subjugation of the imaginative and poetic in favour of literal and allegedly more reliable modes of thought and speech see helpfully Gunton, 1–25.

[35] Cf. esp. the penetrating and at times provocative discussion of Christian hymnody in Brown, 73–109.

[36] Ibid., 33.

[37] 'Beauty is an object's form of *purposiveness* insofar as it is perceived in the object *without the presentation of a purpose.*' Immanuel Kant, *Critique of Judgment*, trans. Werner

The mystery attaching to the poetic image, Brown suggests, in fact has two dimensions, being capable simultaneously of deepening and broadening our experience, suggesting both an inexhaustibility and a deep underlying interconnectivity as facets of the shared reality we indwell.[38] The *inexhaustibility* of the image has to do first with the fact we have already noted, that any image can only take us so far and no further into that reality, always suggesting more than it can show; but it also has to do with the polyvalence of many images, which are capable of drawing our imagination fruitfully in more than one direction at the same time.[39] On the other hand, the image's distinctive *modus operandi* is one that points to and evokes an underlying *interconnectivity* between things, unifying experience by associating the apparently unlike,[40] generating new wholes where we had never perceived them before, and thereby modifying the contours of what we take reality itself to be. In Mark Johnson's phrase, the poet's metaphor so often discloses a 'novel order ... which yet makes sense', fusing the creative impulse with the heuristic.[41] In related vein, Owen Barfield speaks of an original semantic unity familiar to the ancients, but which *homo analyticus* has long since forgotten in his passion to classify and define, today's acts of *poesis* (linguistic and other sorts) thus being tantamount to the *rediscovery* of that deeper order which binds the cosmos together.[42] Such moments and experiences of recognition, Brown argues significantly, may initiate and be taken up into experiences of a properly religious sort, opening out onto (and opening us up to) the divine reality from which this deep order ultimately proceeds.[43]

At this point, Brown's insistence on the immanence of God not just in the world, but in 'the mystery at the heart of words', is undergirded by an appeal to Christian appropriation of the Stoic logos doctrine, and thus (his wider preference for the category of 'sacrament' not withstanding) to Christology, albeit a Christology as yet unmodified by any particular reference to the incarnation. Thus it is 'the Logos that permeates all of creation and so provides the foundation for things unlike to be illuminatingly compared, as well as things like',[44] holding intelligibility and mystery closely together. Furthermore, the poet's play with words, by drawing us into a sense of the *world's* residual mystery draws us more fully too into that

S. Pluhar (Indianapolis and Cambridge: Hackett, 1987), 84. Cf. also the discussion in the Translator's Introduction on liv–lix.

[38] Brown, 46ff.

[39] Ibid., 7, 49.

[40] '(P)oetry's truth comes from the perception of a unity underlying and relating all phenomena.' C. Day Lewis, *The Poetic Image* (London: Jonathan Cape, 1947), 34.

[41] See Johnson, 162. Cf. Ricoeur's observation that metaphors 'are "appropriate" ... to the extent that they join fittingness to novelty, obviousness to surprise'. Ricoeur, 238.

[42] Owen Barfield, *Poetic Diction: A Study in Meaning*, 2nd ed. (London: Faber and Faber, 1952), 85–9.

[43] Brown, 46–7.

[44] Ibid., 72.

'larger mystery' of which it is part, the same 'inexhaustible presence' who was in the beginning with God and was God. If we would but recognise the fact, the Logos may still be seen 'permeating logoi rather than being quite separate and distinct',[45] so that 'metaphor can itself provide us with an experience of divine presence'.[46]

The assumption in all this appears to be not just that God is mysteriously present, but that his peculiar mode of presence here *as Logos* (in the mysterious intelligibility of things grasped by the poet and evoked in his images) is *fundamentally continuous* (part of a continuum) with that created mystery and with our experiences of the same, so that to have experienced the mystery lying 'at the heart of words' is in some direct sense *already to have had* an experience of the divine Logos, or at the very least to have been drawn to the threshold of such an experience, the one being in effect a natural extension or concomitant of the other. But can and should we envisage any such continuity between aspects of the creaturely and the uncreated source of all things? Certainly, theologies wishing to emphasise the radical otherness of God with respect to the world, not construing God as *absent*, but as, in Samuel Terrien's phrase, an intrinsically 'elusive presence' in the world's midst unless and until he chooses to disclose himself,[47] are likely to find any such suggestion highly problematic. The greater the emphasis placed on God's presence-as-radically-other, the more problematic the putative step up or on from an encounter with 'mystery in words' to the mystery of the creative *dabhar* of the LORD seems to become, related though they undeniably are and must be.

Brown's central concern in this book is to commend to us the essential openness and mystery of the verbal image. But if, as Aquinas insists in the *Summa*, God is 'more distant from any creature than any two creatures are from each other',[48] then surely in using any of our terms to speak of this God we must reckon with a stretching of them across difference on a scale to which even the most striking and surprising and penetrating of mundane metaphors cannot aspire? The image of 'mystery' itself, though, cannot be exempt from this consideration. If God is indeed properly referred to as 'mysterious', then presumably he is so in a sense which precisely ruptures and breaks open our more familiar uses of that term, rather than lying comfortably within its ordinary 'domain of application'. To suppose that creaturely mystery is of a sort fundamentally like or continuous (let alone identical) with divine mystery, so that our experience of the one (as it arises in the use of words or elsewhere) naturally entails or provokes or opens out onto experience of the other, not only raises some deep theological questions, it also seems to risk a prescription with respect to the term's meaning (rendering

[45] Ibid., 43.

[46] Ibid., 55.

[47] Samuel Terrien, *The Elusive Presence: Toward a New Biblical Theology* (San Francisco: Harper & Row, 1978).

[48] *Summa Theologiae* 1a.13, 5. As noted in Chapter 1, while this statement occurs in the case *in contrarium*, Aquinas's *responsio* endorses it as a ground for rejecting univocal predication, while denying that equivocation is the only logical alternative.

'mystery' itself less mysterious as it were) of a sort which Brown elsewhere counsels us forcefully against.

Earthing the Order of Signs

In the trio of volumes beginning with *God and Enchantment of Place*, Brown's major concern is to reckon with 'a God who is engaged with the whole of life', and not shackled within the boundaries of the Church.[49] It is to this end that he urges upon us the 'reinvigorated sense of the sacramental'[50] as a 'major, perhaps even the primary way of exploring God's relationship to our world',[51] and repeatedly expresses resistance to the idea that the substance of Christian revelation should be appealed to in order to set the appropriate standards of consideration and measurement.[52] Here, though, I want to suggest that in making the case he wishes to make about the nature and importance of the verbal image for Christian worship in particular, a more sustained engagement with the biblical and classical doctrine of the incarnation would actually reap considerable dividends, affording insights, perhaps, for a wider poetics, and leaving the Church, wherever it lapses into the sort of bloodless literalism Brown describes so well, with little excuse and nowhere to hide – hoist clearly at the last with its own doctrinal petard.

At the close of his essay on 'Art and Sacrament', David Jones cites the suggestion of Maurice de la Taille that, in the events of the Upper Room on Maunday Thursday, Good Friday's Victim 'placed Himself in the order of signs'.[53] But should we not say precisely this of that logically prior act in which God himself took flesh and in the very act of taking it transformed it, investing it with significance stretching inexhaustibly beyond the limits of its creaturely form? Was it not here, in the conception by the Spirit in the womb of the Virgin, in other words, that God placed himself first and most decisively in the order of signs, a gratuitous act of flesh-taking and meaning-making beginning with the annunciation and opening out through all the particulars of a life lived, through cross, resurrection and ascension, onto eternity at the Father's right hand? Such a claim – that the incarnation itself sees God entering the order of signs – is not of course incompatible with talk of the Logos indwelling certain of our human *logoi*, but it is a different sort of claim and, for Christians, a different order of claim with some far-reaching implications.

[49] David Brown, *God and Enchantment of Place: Reclaiming Human Experience* (Oxford: Oxford University Press, 2004), 2.

[50] Ibid.

[51] Ibid., 6.

[52] See, e.g., the criticism of von Balthasar and Frei in Brown, *God and Mystery in Words*, 2–3.

[53] Jones, 179.

Unless we suppose the circumstance of the incarnation to be not just unique (which, I take it, is basic to the Christian understanding of what happens here) but wholly anomalous, it seems reasonable to enquire whether this putative act of divine sign-giving – God becoming 'incarnate' as it were not just in the stuff of human nature but thereby in the stuff of human culture too – might itself have something important to contribute to our understanding of that which it appropriates (and thus must presuppose) but also transforms in doing so. Just as we must allow our understanding of our own humanity to be informed by consideration of what it amounts to here, so, *mutatis mutandis*, might we not learn something too about the nature of words and their relation to the flesh precisely by pausing to take stock of what occurs in this singular act of divine *poiesis*? I realise that this could be construed as an act of intellectual imperialism, theology wading in arrogantly with the answers to questions no one (even within the Church, let alone outside it) is asking. That's not the intention here at all. I take fully on board Brown's insistence that Christian theology may have much to learn about all manner of things from wider and more general discourses, and should take the trouble to shut up and listen to find out what they are saying. But given the suggestive overlap of categories operating here (divine and human sign-giving, words which assume flesh) it seems to me incumbent upon Christian theology at least to ask the question and see whether, from the resources of its own distinctive tradition, it may have something to contribute to the conversation, if a conversation is indeed what it is.

In her discussion of the trope of metaphor, Janet Soskice describes it as conjoining a plurality of associative networks (ones typically held to be wholly distinct and even mutually exclusive, so that the conjunction is always striking and surprising) through the unity of a common grammatical subject.[54] What are we to make, I wonder, of the fact that the structure of the poetic image thus described draws tantalisingly close to the logic of hypostatic union as the Church has traditionally articulated it, where God, for all his overwhelming otherness, is nonetheless conjoined strikingly and surprisingly with our humanity through the posited unity of a common grammatical subject?[55] In related vein, Brown refers us to Frances Young's account of the way in which the apostle Paul 'overlays' texts and images from the Old Testament's distinctive witness to God with references to Jesus, so that 'they are all seen at once and so are seen differently',[56] both

[54] See Soskice, 49–51, 64–6.

[55] According to the formulary of the Council of Chalcedon (451) Christ is to be 'recognized in two natures, without confusion, without change, without division, without separation ... coming together to form one person and subsistence'. See Henry Bettenson, *Documents of the Christian Church* (London: Oxford University Press, 1947), 73. On 'person' (hypostasis) as 'grammatical subject' see Rowan Williams, "'Person' and 'personality' in Christology ', *Downside Review*, no. 941976.

[56] Frances Young, 'From Analysis to Overlay: A Sacramental Approach to Christology', in *Christ: The Sacramental Word*, ed. David Brown and Ann Loades (London: SPCK, 1996), 50.

now 'occupying the single space that is Christ'.[57] In the resultant metaphorical synthesis, Young observes, 'distinctions are not removed, but a union which is a sort of coinherence is perceived'.[58] In each circumstance, unity and distinction are understood to be maintained without loss, as one reality accommodates itself in giving another, strikingly different, reality to be known, and our understanding of both terms in the relationship is modified in the process. Metaphor, it would seem, is a peculiarly apt tool for approaching the mystery of divine flesh-taking. What, then, if anything, may be learned about the poetic image if now we shift our perspective, and attend to Christology as such?

Whether we think in terms proper to the later, philosophically informed account of a shared being (*homoousia*) between God the Father and the incarnate Son, or follow the New Testament's suggestion that, as Richard Bauckham puts it, Jesus 'shares in the identity' of the God of Israel,[59] the demands of the incarnational claim seem to be essentially the same ones. First, there must be no Ebionite reduction of what confronts us here to the wooden 'letter' of Jesus' humanity in its empirical aspect.[60] Otherwise, its true meaning dies in our hands, ceasing to refer us beyond itself and so draw us into the rich mystery of God's own life and being, 'reorganizing our habitation in reality' in the process by transforming our understanding of the God who gives himself to be known in this way. Of course we may not (and may never) fully *understand* what it means to insist that God himself is here present doing and saying and suffering these things, but to fail to grasp the nettle of this insistence, settling instead for an account at once more secure and less disturbing in intellectual terms, is precisely to miss its point and, by surrendering the 'inexhaustibility' of the sign, to render Christology itself and as such (i.e. as a discourse that presumes and insists that there is something here over and above the ordinary creaturely circumstance to be reckoned with and accounted for) otiose. Yet, in our bids to respect the deeper significance of Christ's humanity, opening ourselves to the trajectories of its kenotic reference beyond itself, there can nonetheless be no letting go or losing sight of the particular shape which the history of divine flesh-taking assumes. Rather, we must linger with it, return to it again and again, seeking its universal and divine significance only in and through the mediations of its particular concrete presentations (the actual things Jesus is presented as doing and saying and suffering in the gospel accounts), and not in spite of these. We must refuse to succumb to the temptation if not to abandon the flesh altogether, nevertheless to move far too quickly to very high levels of

[57] Brown, *God and Mystery in Words*, 56.

[58] Young, 50.

[59] See Richard Bauckham, *Jesus and the God of Israel: God Crucified and Other Studies on the New Testament's Christology of Divine Identity* (Grand Rapids: Eerdmans, 2008), 1–59, 182–253, et passim.

[60] For a discussion see the essay by Stephen Sykes in J.P. Clayton and S.W. Sykes, eds, *Christ, Faith and History: Cambridge Studies in Christology* (London: Cambridge University Press, 1972).

abstraction in our reckoning with it.[61] As in the order of signs more generally, so here, supremely so, in Rowan Williams words, 'the flesh is more than it is, gives more than it (as flesh) has'.[62] But, as I argued in Chapter 1, we shall not discover the 'more' either by dealing with its surface aspect alone, or by treating it merely as a convenient stepping-stone onto something else altogether.

The verbal image, Brown suggests, is that use of words 'nearest to the visual' in its mode. For its part, the economy of the divine Word in the incarnation, we might say, is more like a verbal image than any other form of utterance, a 'showing' as much as a 'saying', and one the intractable 'fleshiness' of which is essential to its functioning. It holds mystery and meaning together in a constant creative tension, affording multiple concrete presentations that we can grasp and work with imaginatively, while yet resisting every attempt to determine it completely, remaining forever 'open-ended' on its God-ward side.[63] In these respects (and perhaps in many others remaining to be elucidated) a 'semiotics' of the incarnation reinforces precisely the sorts of points Brown himself wishes to make and to urge upon Christian readers in particular. Brown acknowledges this in passing, but in practice makes surprisingly little of it, preferring to rely instead on the category of sacrament to provide his theological ballast (and in doing so, inclining unhelpfully in the direction of an account of the Word's incarnational presence itself grounded in terms of a notion of 'sacrament' rather than *vice versa*).[64]

Let me be clear. I am not here positing the need for or even the possibility of a wider poetics founded decisively on the contingencies of divine sign-giving in the incarnation. That is an intriguing suggestion deserving of further consideration, but it lies beyond the scope of my particular purpose here.[65] Nonetheless, for the

[61] See Richard Bauckham, 'Christology Today', *Scriptura* 27 (1988): 20–28.

[62] Williams, *Grace and Necessity*, 61.

[63] So, e.g., Thomas F. Torrance, *God and Rationality* (London: Oxford University Press, 1971), 186–7. See above, 25–7

[64] See, e.g., Brown, *God and Mystery in Words*, 52. The relation is explicitly suggested in this form in the rationale for the aforementioned collection of essays *Christ: The Sacramental Word*, edited by Brown and Ann Loades. My own inclination is to suppose that, while analogies between incarnational and sacramental presence are certainly appropriate and helpful, they can also be misleading. The modes of divine presence alluded to in each case remain quite distinct, and the relevant order of priority is significant. 'Sacrament', at least as used to refer to Christian Baptism and Eucharist, denotes something wholly secondary to and contingent on the reality of the incarnation itself, sacramental 'presence' being a communication of Christ's humanity to the believer by faith, and only thus a sharing in his own intimate communion with the Father in the Spirit. See above, 47–51

[65] Clearly, to treat the incarnation merely as an instance (albeit a singular instance) of a wider species of lexical phenomena would be intrinsically problematic, overlooking all that is unique to it and makes it what it is. Perhaps, though, the act of divine flesh-taking might be held to entail a sanctification of the peculiar structure and intrinsically under-determined nature of the economy of sign-giving, and thus be of wider significance precisely in the radical uniqueness of its circumstance. See below, 89–96 The greatest

Christian, it seems to me, the urgent imperative for exploring further the peculiar way of the image and for reckoning with the likelihood that doing so may enhance rather than detract from the quality of our engagements with God in worship, preaching, liturgy and so on, lies finally not in any general human poetics (whether understood 'sacramentally' or not) but unequivocally and uncomfortably here, in the Church's central claim that at the centre of our dealings with God we have to do precisely and only with an *enfleshed* Word and not some other sort (if any other sort be supposed finally to exist). That God deals with us *thus* when he deals with us most centrally and decisively, that is to say, encourages faith to take more seriously the presence (indeed the proliferation) of other 'enfleshed words' within the wider economy of Christ and the Spirit, and to respect their proper nature instead of demonstrating what Barth condemns as a 'chronic lack of imagination' in its reception and appropriation of them.[66]

Whether this encourages or provides warrant for the supposition that, apart from such acts of divine sign-giving, something about the structure and nature of the poetic sign itself and as such may instigate an encounter with this God, or that 'the experience of the divine in ordinary poetry' might be 'not fundamentally different from the experience of Christ in the words of the liturgy'[67] is, of course, a very different sort of question. It is one which itself compels an ever deeper grappling with the question precisely why the Logos who in the beginning spoke the world into being and was henceforth ever present in its midst, nonetheless saw fit in the fullness of time to enter it again, this time in a radically new way, taking his place on the stage of history for an embodied performance the like of which the world had and has otherwise never seen.

Words, Bodies and Mystery

I want in the remainder of this chapter to reckon with some rather different (though related) theological considerations attendant upon the nature and interpretation of language. In some clear sense language itself, as well as its particular uses, arises within the world not just as a peculiarly human phenomenon but as the direct outcome of human acts of making. Older theology, to be sure, speculated about a prelapsarian Edenic *Ursprache*, a symbolics possessed of 'direct divine etymology', given to Adam so that he might re-enact the divine mechanism of

theological obstacle to developing such a case seems likely to be the disputed issue of the so-called *analogia entis*, but this must be reckoned with sooner or later in any serious theological venture. See above, 38, 63.

[66] '(Einer) krankhaften Phantasielosigkeit'. See Karl Barth, *Die kirchliche Dogmatik III/1* (Zollikon-Zürich: Evangelischer Verlag, 1945), 87.

[67] Brown, *God and Mystery in Words*, 3.

creation.[68] In the tradition preserved by Dante, for instance, having spoken the world into existence, God then helpfully supplies humankind with the lexicon and grammar in terms of which sense must subsequently be made of it, a linguistic circumstance obtaining globally down to the building of the Tower of Babel, and surviving in some manner in the tongue of the ancient Hebrews.[69] In its own rather different way – obviously without appeal to any such divine inception of language, and with a very different set of implications – contemporary social and linguistic theory, too, draws our attention to a fundamental 'givenness' of language for any particular participant in it, emphasising its function as an all-embracing symbolic *habitus* into which we are born (we do not choose it or make it for ourselves), and which serves in significant measure to construct and shape not just our sense of the world as a reality external to ourselves but (since even self-consciousness is shot through with language) our sense of 'self' too.[70] Rather than consisting in a tool box from which tools may freely be selected by a pre-linguistic self to express pre-linguistic meanings, there is thus an important sense in which we are always already in the hands of language rather than *vice versa*.

Nonetheless, there is more and other to be said than this. One might reasonably offer a reading of Gen. 2 in which the responsibility invested in Adam by God is not as the first user of a divinely donated dictionary (matching each signifier appropriately to its pre-ordained signified), but as one invited to *give* a name to each creaturely form and presence, an act of *onomatothesia* in which human language itself is forged and extended – and with it culture as a distinctly human dimension – and the process of creation extended rather than merely re-enacted.[71] Be that as it may, and notwithstanding the insights of theory concerning culture's role as a given heritage and matrix with and within which we must each live and work, viewed from another angle it is in any event clearly the case that, as they arise and develop in history's midst, languages and cultures are indeed themselves the products of human action, and our participation in them is of a deliberate (and thus responsible) as well as a tacit sort. We do things within and with and to the order of signs, even if the things we can choose to do are themselves constrained by that order, and may in turn escape the limits of whatever intentions we may have in acting as we do. Our linguistic responses to the world, in other words, are subject

[68] See Steiner, *After Babel*, 60–61. See further James H. Stam, *Inquiries into the Origin of Language: The Fate of a Question* (New York: Harper and Row, 1976), Graham Ward, *Barth, Derrida and the Language of Theology* (Cambridge: Cambridge University Press, 1995), 35–52.

[69] See Ward, 35.

[70] See Terry Eagleton, *Literary Theory: An Introduction* (Oxford: Blackwell, 1983), 130.

[71] This is the reading offered in the eighteenth century, for instance, by Vico, according to whom Adam was granted both the capacity and the responsibility of naming things poetically in accordance with their natures. See Giambattista Vico, *New Science*, trans. David Marsh (London: Penguin, 2001), 158.

to the dictates of human will in a way that our bodily responses generally are not. This is not, of course, incompatible with the suggestion that language (i.e. language as such, not just some putative long-lost primal tongue) is part of God's own 'giving' of a world to his human creatures. As the eighteenth-century philosopher Hamann observes in a classic treatment of the question, within the context of a theology of creation everything is *ultimately* of divine origin, and divine and creaturely agency ought not in any case to be treated as alternative explanations, but understood frequently as coinherent and concurrent.[72] Thus, language may be acknowledged as a fully human product without compromising the claim that, precisely as such, both its ultimate provenance and its continuing development and unfolding fall within the dynamics of God's creative action. Nonetheless, such acknowledgement introduces a distinctive new theme – viz., that this particular gift (the human capacity for acts of signification and culture) cannot possibly be received passively, but implicates us in conditions of responsible use apart from which it may be experienced not as blessing but as something else altogether.

The picture is complicated further by the fact that, whatever may be imagined to have pertained in the instance of the Edenic vernacular, we find ourselves situated now in any case in a very different economy – one lying both east of Eden and after Babel. The order of signs as we indwell and participate in it in history's midst, we discover upon reflection, is a remarkably fragile structure, being at once indirect, unstable and plural. Semiotic theory has often cast these features of language in an essentially negative light, identifying them as a function of human fallenness rather than human creatureliness as such, and thus something (from a theological perspective) to be struggled with, overcome and finally redeemed from, rather than something to be celebrated, enjoyed and redeemed in promised new creation of God.[73] That there are direct and illuminating parallels to be drawn here with attitudes towards the body is no accident, since it is precisely the *materiality* of the sign (the necessary embeddedness of language itself in our embodied existence) around which much of the perceived fragility clusters. An account of the mediation (and construction) of reality as proper to the human condition rather than accidental to it, though, points us in a rather different direction.

George Steiner observes that it follows logically from the appeal to a primal divine donation of language that originally all linguistic signs applied 'naturally', directly and easily to their referents, rather than arbitrarily as semiotics after

[72] See 'The Last Will and Testament of the Knight of the Rose-Cross' (1772) in Johann Georg Hamann, *Writings on Philosophy and Language*, trans. Kenneth Haynes (Cambridge: Cambridge University Press, 2007), 96–110.

[73] Thus, Derrida observes, for the tradition of 'metaphysics' 'The sign is always a sign of the Fall'. Jacques Derrida, *Of grammatology*, trans. Gayatri Chakravorty Spivak (Baltimore: Johns Hopkins University Press, 1976), 283. See further Kevin Hart, *The Trespass of the Sign: Deconstruction, Theology and Philosophy* (Cambridge: Cambridge University Press, 1989), 3–21.

Saussure typically insists.[74] Thus '(t)he tongue of Eden was like a flawless glass; a light of total understanding streamed through it'.[75] Whatever we make of this suggestion, it is apparent that our own linguistic circumstance is rather different, language, as it were, interposing itself across the board 'between apprehension and truth',[76] and denying us the opportunity to step momentarily altogether outside its framework in order to judge the authenticity of its mediations, any more than we can step outside our bodies to validate theirs. At this point, then, a parallelism between sense and sensibility holds good, each mediating reality to us in a version shaped and edited decisively by its own capacities and categories. Perpetuating the parallelism momentarily, the only total leap out of language, Steiner insists, is death[77] (though those who hope for the resurrection of the flesh, of course, may properly complain that even this is to presume too much). Such indirectness of access, though, may be construed in different ways. It may be judged negatively and as a problem (and thus a distinguishing feature of any symbolics situated 'after Babel'),[78] breaking our relation and preventing our immediate access to 'reality', or distorting and warping such access as we have, 'trapping' or 'imprisoning' us in its own systems. (Compare the familiar post-Cartesian suggestion that we are in some sense 'trapped' in our own bodies, and cannot be sure that anything exists beyond the testimony furnished by them.) But again, we have to enquire about the meaningfulness of such talk (and again the parallelism of our sensory responses to the world is instructive). Exactly what sort of reality would it be, we might ask, that was not 'significant' for us in one way or another in our encounter with it? But if significance is bound up by definition with signification – that is, with systems of meaning-making – then a world bereft of the mediations of language is just as impossible for us to imagine as one from which the constructive contributions of our bodies and brains had been entirely erased. In either case, what would remain would not be a humanly recognisable world at all. Viewed in this light, language is what makes human experience of the world possible at all, enabling us to inhabit reality as a meaningful environment, to extend ourselves out into reality and 'make sense' of it.

That language is itself also a *product* of responsible human activity certainly has serious implications for reckoning with this 'covenant' between word and

[74] Steiner, *After Babel*, 61. For a helpful summary of Saussure's central positions see Eagleton, 96–7.

[75] Steiner, *After Babel*, 61.

[76] Ibid.

[77] Ibid., 116. So, again, 'Only death is outside discourse'. Steiner, *Real Presences*, 88.

[78] So Steiner: 'Babel was a second Fall, in some regards as desolate as the first.' Steiner, *After Babel*, 61. The punishment of Babel, though, was that of the fragmentation and subsequent plurality of human language. There is no biblical suggestion that I am aware of that an immediate relation to the world through a wholly transparent language was ever part of 'unfallen' human existence. The suggestion rather presupposes that indirectness is a problem (a function of sin) rather than a necessary part of the human condition as such.

world, but it does not of itself undercut or fatally compromise it. On the contrary, Colin Gunton, as we have seen, suggests that the indirectness of the linguistic relation (as distinct from the odd notion that language somehow 'mirrors' reality or provides a 1:1 mapping of its coordinates) tends in itself to engender an appropriate humility in the face of reality, respecting its mystery and otherness rather than squeezing it into the particular set of containers we happen to have available to us. Here we notice the flip-side of the important recognition that language shapes reality; reality, for its part, returns the compliment, reshaping and 'making new' our language as we find ourselves compelled to modify it so as better to fit new insights, new intuitions, new thoughts. Metaphor, Gunton suggests – the most indirect of all linguistic devices – far from distancing us from reality, is thus in actual fact the most natural and fitting tool for a realist epistemology to wield, 'cutting the world at its joints' to gain epistemic access, while at the same time maintaining a disposition (*habitus*) of openness, receptivity and humility in the face of it, eschewing the idolatrous identification of statements with states of affairs.[79] The point is a wider epistemological one, but we can hardly fail to notice in passing that such a disposition is exactly what we might suppose fitting for creatures in a world received consciously as a gift from God's hand.

As well as being indirect in their relation to reality, signs are also an inherently unstable medium of engagement with it. Far from being fixed and secure, their meanings are slippery, difficult to pin down precisely, and prone to constant change. Language, Steiner avers, is in reality 'the most salient model of Heraclitean flux'.[80] If, as linguistic theory after Saussure insists, meaning is not mysteriously immanent within signs (the particular material markers inscribed on paper or uttered aloud have no *necessary* connection with what they are taken to signify) but largely a matter of cultural and historical convention (quite different signifiers may and do evoke the selfsame 'signified' – *horse, cheval, Pferd, equus,* ἵππος, and so forth), then the meanings of signs are in significant measure a function of their distinction from and particular relation to all other signs within the synchronic system. (Saussure appeals to the analogy of the 'meaning' a piece on the chessboard has at a particular point in a game, something determined wholly by its relation to other pieces on the board as identified within the given rules of the game.) Thus the meaning of 'horse' is bound up with the fact that it is not 'house' or 'morse'. But the concentric circles of differentiation involved here spread out in principle to the thresholds of the system itself, each sign in turn defining itself in terms of its difference from those aurally or graphically proximate to it, the buck of meaning

[79] See Colin Gunton, *The Actuality of Atonement: A Study of Metaphor, Rationality and the Christian Tradition* (Edinburgh: T&T Clark Ltd., 1988), 27–52. The image of 'cutting the world at its joints' (among other things in Gunton's account) is borrowed helpfully from Richard Boyd, "Metaphor and theory change: What is 'metaphor' a metaphor for?", in *Metaphor and Thought*, ed. Andrew Ortony (Cambridge: Cambridge University Press, 1993).

[80] Steiner, *After Babel*, 18.

never quite stopping or settling anywhere, being 'the spin-off of a potentially endless play of signifiers'.[81] And, if we turn to a dictionary in order to help us define the meaning of a particular word within a given language, what we are confronted with are more words of the same sort, words, that is to say, which themselves come laden with questions about their own (potentially diverse) meanings. We can look these up in the dictionary too, of course, but, absent our capacity to step outside language as a medium, the process is a potentially endless one.[82] At this point we might naturally suppose speech to have the advantage over writing, appealing to the speaker to clarify precisely what they mean by their words; but this is to overlook the fact that thought itself is already mediated to consciousness by language, and all the complicating elements of the materiality and ambiguity of the sign (its difference from that which it ostensibly represents) are thus already present in the speaker's 'inner' formulation of utterance. Meaning, it seems, is never fully present, never 'pure' or 'immediate', but always incarnate in the flesh of language, and hence necessarily 'deferred', unarrestable in principle, flickering ever further down the corridors of signification whenever we seek to put our finger on it, and no matter how far we choose to pursue it.

Diachronically, too, meaning refuses to stand still for observation and classification. Here, too, meaning is a function of 'difference', of the permeation of 'presence' by that which is absent from or other than the sign itself and as such.[83] Language is a temporal process (the meaning of words is always 'in a state of being constituted',[84] constantly unfolding rather than something fixed in amber), the sense of every word in a sentence, and each sentence in a paragraph or a conversation being held in suspense, deferred, to be modified by what is yet to come.[85] 'For the words to compose some relatively coherent meaning at all', Eagleton suggests, 'each one of them must, so to speak, contain the trace of the ones which have gone before, and hold itself open to the trace of those which are coming after'.[86] Furthermore, it belongs to the nature of signs as such that they must be capable of repetition. In order to function as signs at all, they cannot be the linguistic equivalent of the 'single-pad' codes employed by military cryptographers (the point of which is precisely to resist decipherment in absolute terms).[87] Yet this very capacity for 'iterability' and empirical resituation, combined with the sign's material difference from that of which it is a sign, renders it intrinsically vulnerable to an uncontrollable shifting and slippage in its meaning.[88] Each fresh

[81] Eagleton, 127.

[82] See Jonathan Culler, *On Deconstruction: Theory and Criticism after Structuralism* (London: Routledge and Kegan Paul, 1983), 95.

[83] Ibid., 94–5.

[84] Hart, *The Trespass of the Sign*, 26.

[85] Eagleton, 128.

[86] Ibid.

[87] Cf. Steiner, *Real Presences*, 54.

[88] See Hart, *The Trespass of the Sign*, 12.

use of a word or a phrase in language is haunted by the history of its previous uses, so that in the strict sense the same words can never mean *exactly* the same thing twice.[89] But the precise context of inscription or utterance modifies the sense of signs in other ways too, Steiner observes, each contingent circumstance invoking a distinctive set of associations, both public and private in nature (we speak 'at the surface' of ourselves, he observes, beneath which lies a wealth of subconscious associations 'so extensive and intricate that they probably equal the sum and uniqueness of our status as an individual person').[90] In this sense, no particular context of utterance or writing, hearing or reading can completely circumscribe or 'totalise' the meaning of signs; by virtue of their nature as signs, they are *always* open to change (susceptible to what 'befalls' them as Derrida puts it),[91] and a surplus or 'remainder' of potential meaning thus haunts their every use.

For all these reasons, language is a medium shot through with levels of 'undecidability' or 'alterity', making it an unstable and in some ways a risky rather than a secure environment in which to dwell. And the 'hermeneutic motion'[92] of interpretation, therefore, is as vital to our indwelling of the world as the systole and diastole of cardiac function, or the rhythm of inhalation and exhalation in respiration. The latter, of course, are themselves signs of organic health rather than pathological, and, although the instability of signs may bring its obvious problems and challenges (we may wish it were otherwise), it, too, might be viewed as a natural feature of what it means to be human in the world, and cast in a positive rather than a negative light. In other words, the absence of any pure congruence between the material sign and that which it signifies (and the consequent need for us constantly to interpret and explore possibilities of alternative meaning), rather than being construed as a distinctly postlapsarian circumstance, might instead be understood as part of what it means to be embodied beings in a world which refuses reduction to materiality alone – part of the 'predicament of being human' as David Jones has it. As Kevin Hart notes, this is really Derrida's fundamental point: 'full presence' (a meaning unmediated by signs and hence determinable in an absolute manner) is neither a prelapsarian ideal nor an eschatological hope, but an illusory goal.[93] Presence is always elusive, yet this is not a matter of the *failure* of signs to do their work (of signs in a 'fallen' economy), but rather a structural feature built into language as such by virtue of its materiality. On this view, we should no more bewail the constraints attendant upon our indwelling of systems of signs (and hope for their eventual removal) than we should bewail those arising from our circumstance as embodied beings situated at particular points in time and space. The parallels are precise, and more than accidental, and those who espouse a theology centred on the incarnation have good reason at least to applaud

[89] Steiner, *After Babel*, 18, 24.
[90] Ibid., 181.
[91] See Hart, *The Trespass of the Sign,* 19.
[92] See Steiner, *After Babel*, Chapter 5.
[93] Hart, *The Trespass of the Sign,* 14.

the challenge Derrida presents to the residual Platonism of some accounts of our relationship to language (many of which would apparently prefer to strip it of its 'flesh' altogether in pursuit of an immediate engagement with a pre-existent *logos asarkos*, a move challengeable on Christological grounds alone).

In any case, we must not overstate the negative aspects of the circumstance. The simple fact of our ability to communicate meaning more or less effectively across and within languages in a plethora of everyday life contexts bears witness to the fact that, for the most part, we have more than sufficient determinacy to work with.[94] On the other hand, again, the fact that meaning is ultimately (but only ultimately) unfathomable, and frequently less determinate than we should like, demands of us not just the hard work involved in acts of interpretation, but a sense of respect, mystery and humility in the face of reality, rather than the arrogant assumption that, with a set of state-of-the-art precision linguistic tools at our disposal, we can capture it and pin it down definitively for inspection and analysis. And, what from one angle appears as instability, of course, may, from another, be construed instead as potential richness, flexibility and adaptability, the protean capacity of language to accommodate itself to a reality which is itself constantly on the move, permitting words, texts and utterances to speak to ever new contexts, rather than remaining shackled to one precise circumstance of use, again holding out the promise of an as yet unborn surplus of meaning to be had in a world still brimming with unrealized possibility.[95] Again, such richness, depth and mystery attendant upon things is precisely what we might expect, perhaps, in a world received as a gift from God's hand, and not 'givenness' of a precise, literal and wooden sort, a world patient in the final analysis of only one 'reading'. It is precisely the religious and theological significance of richness and depth of this sort that David Brown is concerned to draw our attention to, and to this extent at least, despite the significant differences of outlook and the critical responses articulated earlier in this chapter, I find myself wholly in agreement, and grateful for the signal challenges and suggestions to be found in his work.

[94] As Eagleton notes, it is *absolute* grounds for our habitual uses of words that Derrida and his followers are concerned to deconstruct, not determinate meaning of any sort and at any level. (Eagleton, 144, 148.) Clearly, in practice the levels and sorts of certainty necessitated by and available in different existential circumstances are in any case very varied.

[95] Cf. Steiner, *Real Presences*, 42. See further Trevor A. Hart, *Faith Thinking: The Dynamics of Christian Theology* (London/Grand Rapids: SPCK/Eerdmans, 1999), 107–62.

Chapter 4

The Grammar of Conversation[1]

In this chapter my concern will be with the role of imagination in fostering and enhancing community in the midst of difference. I shall also be tracing some theological models for understanding and underpinning the ethical migration of the particular 'self' into the territories of otherness, to the end of a respectful and loving co-existence. I use the word 'loving' quite deliberately here, as it seems to me that it is this notion, properly understood, that sets Christian identity decisively apart, being itself set apart from its sickly and altogether less costly cousin, 'tolerance'. To *tolerate* one's neighbour, let alone the alien in the midst or the enemy, is something altogether different from loving them, though the differences would need to be spelled out in each particular instance rather than in the abstract. And it is unconditional love for the other, rather than mere tolerance, to which Christians are committed as the basis of human community, for they worship a God whose very nature is love, and who draws us unconditionally into a communion in which we love because we discover ourselves already to be loved by him.

That initiatives fitted to furnish community in the midst of difference are desperately required in a world which, as well as being 'global' and 'globalised' in many respects, is also paradoxically at once more plural in intellectual, cultural and religious terms, hardly needs saying. What may need saying is that Christianity has resources to offer precisely out of its own particularity as a tradition of belief and practice, a tradition springing from the news of a radical transgression of the biggest and most daunting boundary of all – that between God and the world. These resources, I shall argue, are consonant (or at least resonate) with wider insights concerning the nature of what Martha Nussbaum dubs the 'moral imagination', and the particular merits of literature in forming and enriching our capacity for this. Furthermore, they suggest that knowledge and communion are best fostered and sustained not by eliding or marginalising difference or particularity, as in some forms of pluralism or dialogue between those allied to different 'identities',[2] but precisely by allowing difference in all its fullness and integrity to be maintained, shared and (within the appropriate constraints of law) practiced.

Of course, difference obtains at various levels of personal existence – between individuals, between social and economic groups, between nations, between ethnic

[1] This chapter has been reproduced by kind permission of T&T Clark, an imprint of Bloomsbury Publishing Plc.

[2] On the nature of 'identity' and the origins of the contemporary concern with it see, helpfully, Zygmunt Bauman, *Identity: Conversations with Benedetto Vecchi* (Cambridge: Polity Press, 2004).

groups, between religions, between civilizations, and so on. It all depends where we choose to draw the relevant boundaries. And we must avoid reifying or absolutising difference in unhealthy or dangerous ways. The idea of that which is 'other' is susceptible to all manner of abuse socially and politically. As a social construct, 'otherness' has much to answer for in the long history of man's inhumanity to man, being grist to the mill of every form of tribalism. So acknowledgement of the genuine and significant differences that do exist must always take place within the context of a countervailing recognition of what is held in common (even when that cannot always easily be specified), and the recognition of the 'other' first and foremost as a fellow human being made (according to Christians) in the image and likeness of God and heir to the covenant promises of God. Properly speaking, of course, the category of 'otherness' (like that of 'identity') arises only against such a backdrop, being dependent upon the logically prior apprehension of that which is the same. The human other is identifiable as such only because the relevant difference is shot through something easily recognisable as humanity. This chapter was drafted during a trip to India, amidst a set of linguistic, religious, social, economic (and culinary) circumstances utterly remote in all sorts of ways from that of St Andrews in Scotland, despite the lingering heritage evident here and there of its colonial past. Even in the thick of all this difference and otherness at its most intense, bewildering and potentially threatening, though, glimpses of a shared humanity would show through repeatedly, often in the most unexpected and surprising ways, making the hard work of seeking a shared space within which to coexist and cooperate and flourish both possible and intrinsically worthwhile. Yet respect and love for others, Iris Murdoch suggests, are rooted not merely in the affirmation of self by discovering what corresponds to it, but finally in *curiosity* about what is other than ourselves, and in a healthy imaginative engagement with and response to that otherness.[3] A literary allusion already suggests itself as appropriate here: in reading a novel, we find that we can only understand it because what it tells us about are things that in some sense we already know and can grasp or relate to, while we only want to read it because it tells us about things we do not already know, and which we thus find interesting and worthwhile engaging with in a bid to enlarge the scope of our inner world.

If we are to engage concretely and constructively with 'the alien in our midst', then questions arise about how best this might be facilitated. Complicating the picture further, of course, is the extent to which difference arises already within the limits of the individual self, such that each of us is aware of being 'other' to ourselves, or of having a fragmented series of 'identities' which, within the substance of our inner experience, refuse to add up to a neat, coherent and convenient single 'I'. For the purposes of this chapter, though, I am compelled to pass over that discussion as one to be attempted on another occasion. Here I

[3] See, e.g., Iris Murdoch, *Metaphysics as a Guide to Morals* (London: Vintage, 2003), 214f.; Cf. her discussions of 'attention' and an 'other-centred' conception of truth in 'On "God" and "Good"' and 'Against Dryness', *Existentialists and Mystics: Writings on Philosophy and Literature* (London: Penguin, 1999), 287–95, 337–62.

shall concentrate instead on the relationship between whatever 'self' we take to be identified and bounded by (though not confined to) the particular human body in its extension through time, and that which exists beyond those bounds and must be engaged with courtesy of the body's complex mediations.[4] Later in this chapter I shall suggest one model to facilitate a constructive, curiosity driven encounter, especially between adherents of different religious groups, but first we must deal further with some of the categories already touched upon.

Otherness, Curiosity and Community

In his essay 'The knowing of the other and the community of the different',[5] Jürgen Moltmann first suggests that 'without knowledge there is no community, and without community no knowledge',[6] and then proceeds to identify two distinct and opposing principles regarding the challenge presented by this circumstance. First there is the principle that 'like is only known by like', which Moltmann traces back to Aristotle's *Metaphysics* (II, 4, 1000b) and dubs the principle of analogy. In this case, he observes, what is genuinely other cannot be known at all, and our acquisition of knowledge about the world, the other person, or God himself amounts only to 'the continually reiterated self-endorsement of what is already known'.[7] As regards knowledge of God, this principle supposes that the human self is already 'divine', otherwise it could not recognise that divine reality which transcends it.[8] Thus, an epistemology founded on this principle reflects a monistic ontology, whether this leads in the direction of the deification of the human knower or the reduction of God to a projection of the creaturely imagination. In personal, social and political terms, the conviction that 'like is only known by like' tends either to be indifferent towards or anxious about that which is different (and thus forever alien) in the other, rather than curious about or fascinated by it. It typically seeks to neutralise and domesticate otherness, either by force (some version of exclusion, colonialism or globalisation), or by the more humane but equally disrespectful mechanisms of a 'dialogue' intended to establish a shared denominator of 'human' experience and outlook, and secure homogeneous cultural expressions of the same, thus marginalising and belittling the very things that grant particular identities their value and colour.[9]

[4] On identity and selfhood see Paul Ricoeur, *Oneself as Another* (Chicago: University of Chicago Press, 1992).

[5] See Jürgen Moltmann, *God for a Secular Society: The Public Relevance of Theology* (Minneapolis: Fortress Press, 1999), 135–52.

[6] Moltmann, 135.

[7] Ibid., 139.

[8] Ibid., 140.

[9] It might also be noted that such putative 'shared' perspectives frequently end up looking very much like an assemblage of fundamental and particular convictions held by the dominant party or power group within the plural exchange, and thus amount in

The second principle Moltmann identifies is that according to which 'other is only known by other' (the principle of dialectic), a model which he also credits to Greek philosophy (Euripides, Anaxagoras), but for which he finds theological grounds in the dialectical relationship which occurs in communion between ourselves and the Wholly Other God. We might add, though Moltmann does not in this context, the distinctly Christian conviction that in God himself there is eternal communion between three persons constituted as much by their difference from one another as by their sharing of a single nature. Triunity, in other words, is at one level an exemplification of communion evinced in diversity, albeit one only analogously related to the creaturely circumstance (no two creatures are consubstantial in the manner that Father, Son and Holy Spirit are properly confessed to be). Where creatures (and fallen creatures at that) are concerned, Moltmann notes, our initial experience of that which is different, strange or new is one of resistance to the self and attendant pain or suffering caused. Genuine otherness is discerned by way of contradiction and contrast rather than correspondence, and we quickly sense 'the claim of the new' and our need to accommodate it or adjust ourselves accordingly.[10] The point here, of course, is precisely that knowledge of difference and knowledge of self/same arise together and dialectically. Knowing ourselves, we are able readily to identify that which differs from and resists ourselves, and become curious and wonder about the contours of its otherness. 'In the others', Moltmann writes, 'I do not look at what is like myself, but at what is different in them, and try to understand it. I can only understand it by changing myself, and adjusting myself to the other. In my perception of others I subject myself to the pains and joys of my own alteration, not in order to adapt myself to the other, but in order to enter into it'.[11] It is by way of such willing subjection and the imaginative transcendence of the established boundaries of 'self' that genuine community rather than artificial homogeneity can be established and sustained.

Exploring related intellectual territory, but carving the conceptual joint rather differently, Richard Sennett distinguishes between two modes of human conversation, each of which he holds to be necessary to securing an appropriate coinherence of knowledge and community. Each begins with careful listening to the other, since '(people) who do not observe, cannot converse'.[12] From this attentive beginning, a 'dialectic' approach, Sennett argues, sets up a verbal play

reality to a form of colonialism by stealth. Genuinely shared territories of meaning can only be established or identified when all the differences which divide are taken fully into consideration and allowed full play, and not despite these.

[10] Ibid., 144.

[11] Ibid., 145.

[12] Richard Sennett, *Together: The Rituals, Pleasures and Politics of Cooperation* (London: Allen Lane, 2012), 14, citing Balfour Browne, KC.

of opposites in the interests of a higher synthesis establishing common ground.[13] Here, sameness and shared agreements are achieved, but through a process which attempts first to allow each party to articulate its particular distinctive convictions. The imaginative disposition demanded of participants is essentially *sympathetic*, stepping into the standpoint of the other in so far as this is possible, and identifying with the other's perspective, viewing the world for the first time through the other's eyes. Only thus, Sennett's account indicates, will areas of genuinely shared concern and conviction be identifiable in the midst of difference. Other life circumstances, though, demand of us a rather different imaginative capacity and disposition in our relationship with otherness. This Sennett calls the 'dialogic' approach, in which difference is approached and explored and mapped not by acts of imaginative mimesis or 'identification with', but precisely by the self remaining true to itself and its centre of gravity, and viewing the other from within that familiar perspective precisely as other than ourselves.[14] This imaginative disposition Sennett calls *empathic*, being the approach demanded of the interviewer, the doctor called upon to make a diagnosis, or the man standing on the river bank while another is drowning in the rapidly flowing waters. In each case it is not by stepping into the other's shoes that a relevant understanding and response is achieved, but precisely in the self's *difference* from the other. In most circumstances, though, these prove to be not so much wholly distinct imaginative performances as overlapping and conjoint ones both of which are needed in some measure, and which must be maintained in the relevant proportion in a dialectical interplay in which each informs the other.

Richard Bauckham notes the Christological parallels and resonances with all this in his illuminating discussion of particularity and universality in the incarnation.[15] On the one hand, in taking flesh and sharing humanity with us, the Son of God held in common with us all that is shared in our human 'nature' and existence, thus identifying himself with us. Yet, since humanity does not exist as an abstraction but only in the form of particular human lives lived, this same Son of God embraced to the full the particularity and contingency of historical existence, becoming the man Jesus. We would be mistaken, though, Bauckham argues, to suppose that the redemptive significance of Jesus for each of us consists only in whatever we happen to hold in common with him and he with us (the basis on which feminist theology, for example, has sometimes struggled with a 'male saviour'). Instead, it is by virtue of a complex interplay of sameness and otherness that Jesus' redemptive being and action is realised, his 'universal' saving significance being bound up just as thoroughly with the particular and peculiar things he is reported to have said and done and suffered as it is with his assumption of 'humanity' and sharing of 'the human condition'. Thus it is precisely the shape of his particular

[13] Ibid.,18–19. Readers will notice (and need to bear in mind) the rather different meanings attaching to 'dialectic' in Moltmann's and in Sennett's accounts respectively.

[14] Ibid., 21.

[15] Richard Bauckham, 'Christology Today', *Scriptura* 27, 1988.

character and personhood (whether encountered in first century Palestine or through the narration of his story in the Church today) which, as it interacts with others, transforms them redemptively; and the form of his identification with some (the poor and the downtrodden for instance) differs significantly from his identification with others (the pharisees and teachers of the law) because their particularity demands a wholly different response and relationship.

Hermeneutics and the Form of the Personal

Theological and philosophical anthropologies in recent decades have urged upon us an understanding of human personhood as constituted in relation. So, for example, philosopher John Macmurray writes: 'The personal is constituted by personal relatedness. The unit of the personal is not the "I", but the "You and I".'[16] For Macmurray, then, as human beings we are not isolated units who, subsequent to some absolute given 'existence' and 'identity', choose to enter into relationships with others. Rather, our existence and our identity is given and shaped *in* the complex networks of relationships which we inhere in life, some of which are obviously closer than others (since the networks may presumably be supposed to extend as widely as the category 'humanity' itself), and some of which are 'given' to us at birth by virtue of biological accident, or by virtue of our immediate social location, and others we choose to enter into, thereby modifying who we are. Two brief quotations from theologian David Ford reinforce Macmurray's point: 'People are all around us, but they are also inside us. ... Some of them are so much part of our identity that they are woven into the texture of our thinking and feeling. Their voices in us may not be distinguishable from what we habitually say to ourselves. ... To ask "Who am I?" leads straight to the other people who are part of me. Is there any layer of self where there are no others?'[17] And then: 'We live before the faces of others. Some are there physically, others in memory or anticipation. We have been formed face to face from our earliest days, deeper than conscious memory.'[18] Not all relationships with others are as close as this of course, but they are nonetheless part of who we are and exercise an impact, however slight, upon the shape of our being.

 While others shape our identity in this way, however, Paul Ricoeur reminds us of the irreducible particularity of each human person, a particularity rendered in part by the unique combination of relationships, experiences, choices and actions (for identity, he insists, is formed through time in a narrative sequence), memories, hopes and the rest which contribute to a unique centre of perspective on the world which is 'me' and 'you'. No one else can occupy this same centre of perspective

[16] John Macmurray, *Persons in Relation* (London: Faber and Faber, 1961), 61.

[17] David Ford, *The Shape of Living* (London: Fount, 1997), 1–3.

[18] David Ford, *Self and Salvation: Being Transformed* (Cambridge: Cambridge University Press, 1999), 17.

as their own. It is ours. In a sense it *is* that which, in active relation to other unique selves, constitutes our 'self'. And, because identity is constituted and emerges in a narrative, it is constantly being modified and emerging.[19]

In his writing on hermeneutics Friedrich Schleiermacher insists that 'the art of interpretation' is necessary not only in the case of ancient or culturally remote texts, but equally in the case of an encounter with the living voice of the other, for here, too, the otherness of the other means precisely that the possibility of misreading or misunderstanding (and thus inappropriate modes of relationship or response) is universal. 'In interpretation', therefore, he writes, 'it is essential that one be able to step out of one's own frame of mind into that of the author'[20] or, we might say, the other. And, whether we are dealing with texts or living voices, Schleiermacher suggests, the initial mode of procedure must always be the same: that of a respectful, attentive listening.[21] Of course the goal of stepping into the frame of mind (or in more contemporary terms the 'horizon') of the other is, as Schleiermacher acknowledges, a goal which can never be achieved perfectly by any human interpreter; it can at best be approximated to. To achieve it completely would be in effect to *become* the other and to lose one's own particularity in the process, an achievement which, as we have seen, even were we able to manage it, would be of mixed benefit at best. But the point is that the goal *can be approximated to*, and such approximation is the responsibility laid upon ethical imagination. If we are to understand the others' perspective, and thereby relate to them in constructive and life-giving ways, then we must make the relevant effort required of us to do so. In some cases that effort may be relatively little; in others it will be quite substantial.

If the sort of imaginative self-transcendence of which I have been speaking begins with a respectful and receptive listening, this means in the first instance that it will not allow any ready-made categories or types, or carefully prepared responses immediately to be brought to bear. Such categories are inevitably based on generalities and, useful though they may be in due course, can actually prevent us from hearing what someone is saying to us if we attend to them in the first instance. Those of us in the Christian Church know all about these ready-made boxes. We have a whole host of them which we apply to one another, often on the basis of a relatively short and shallow impression: Evangelical, liberal, catholic, charismatic, fundamentalist, and so on. Even when others present themselves to us in terms of such neat labels we have a responsibility to refuse to allow these, or any combination of them and others, to be determinative of our response and relationship to them as other. We have to listen (to 'observe'), and in listening to try to hear who they are and where they are coming from, to enter as far as we can into the unique complex of relationships, events, memories, hopes and desires

[19] See, e.g., Ricoeur, 113–51.

[20] F.D.E. Schleiermacher, *Hermeneutics: The Handwritten Manuscripts* (Missoula: Scholars Press, 1977), 42.

[21] Ibid., 109.

as well as identifications-with (i.e. the larger groups or sets of values which they identify with) which shapes who they are. And to do this will involve an effort of imagination in which we transit out from our own way of seeing things, and attempt to see things for a while from a quite different vantage point, not in order to *become* the person who stands over against us as other, but in order to *know them* more fully, through such sympathetic identification with them as it is possible to achieve, and by the way of empathic detachment, attending to their otherness as it appears to us from our perspective, in order thereby to understand what it might mean for us, being ourselves, to love them as our neighbour.

In his book *Aspects of the Novel,* E.M. Forster draws a distinction between what he calls 'flat' and 'rounded' characters in a novel.[22] Flat characters are those whom the novelist forms around a single basic idea or trait, or two or three at most. In effect their reality extends no further than their identification with these simple ideas, and need not do so for the purposes of the plot. Round characters on the other hand are much more complex; we know much more about them, and their narrative identity is such that they could never be summed up in a single phrase. There is development, inner-conflict, genuine struggle with the messiness of human life. We feel that they might surprise us at any moment as we learn more about them. They resist quick and easy classification. And, of course, they are what makes most novels worth reading. Well, novels, as Forster suggests, need their share of flat characters in order to make them readable. If all characters were rounded out, the novel would rapidly lose touch with its main story line. But life is not a novel, and no human being is simple. No one can fit neatly into a simple category, even though we often treat people as if they could and did. To treat them thus is to pigeon-hole them, to ignore their particularity, their genuine otherness. It is to fail to treat them as neighbour, and a dangerous failure of moral imagination. Of course life is too short for us to treat all the people we meet as rounded characters; but we should never forget that they *are* rounded characters, and we should beware of 'flattening' those with whom we *do* have to deal with, just because it is often easier to do so. As Anthony Thiselton points out, such reductionism and failure of imagination results in depersonalising modes of relationship (we treat the other as an object to be classified and 'explained' rather than a person with a complex identity and set of needs to be understood) and in pastoral contexts results only in superficial and inadequate therapies.[23]

There is, then, in every act of moral imagining, every attempt to practice the art of interpretation, a fundamental need for *particularity* to be respected and attended to. Both our own particularity and that of the complex 'text' or other whom we are seeking to understand, to whom we are relating, must be taken fully seriously. It is in the interweaving of the two unique perspectives which are our respective 'selves', and the narratives which have shaped these, that a genuine meeting of

[22] E.M. Forster, *Aspects of the Novel* (London: Pelikan, 1962), 75f.

[23] A.C. Thiselton, *Interpreting God and the Postmodern Self* (Edinburgh: T&T Clark, 1995), 54, 75.

persons and the mutuality in which genuine love consists, occurs. In the words of Ernst Fuchs, in interpretation 'The texts must translate us before we can translate them'.[24] In other words, the other must draw us out, translate us from where we are to where he or she is, in order that we may return to our own particular standpoint bearing understanding with us. But this does not mean that universality or generality is either unimportant or dispensable. The opposite is the case. Although we must begin by seeking particularity, and by listening rather than classifying, it remains true that the effort to attend to the other in its otherness (rather than in its sameness to us or to others whom we know) presupposes and depends utterly upon a mesh of common, shared human experience shot through the difference. Only by appeal to *this* are we able to travel out from our own particularity at all, making contact with the other because there is something in common between us to grant us some footholds on the otherwise slippery and inhospitable slope of particularity. The extent to which we can already identify with the other, we might say, is the extent to which we are able to go further and discover the wholly unfamiliar. The typical post-modern denial of anything called 'human nature' or of commensurable spheres of common human experience thus paralyses every attempt at imaginative self-transcendence and risks leaving us trapped within the isolation of our own ways of seeing and doing things.

This does not mean beginning with the general and only subsequently moving on to particularity (not, at least, in *temporal* terms: the *logical* order may actually be like this since, as we have already seen, the apprehension of difference depends upon a sense of sameness). This is because in reality universality and particularity are woven together in the texture of the human. Universal or shared dimensions of experience and behaviour are nonetheless incarnated in radically particular moments and aspects of complex lives, and we cannot separate the two out without tearing those lives apart in unnatural ways. It is this perichoretic intermingling of universality and particularity alone which grants us access to the life of the other as humanly significant. Thus, if we return again briefly to Schleiermacher, we discover that he finds it necessary to identify two distinct but inseparable movements in the bid to understand the other. In addition to the dialectic between 'self' and 'other', there is another to be maintained between what Schleiermacher calls the methods of 'divination' and 'comparison'. 'Each method', he writes, refers back to the other. The divinatory is based on the assumption that each person is not only a unique individual in his own right, but that he *has a receptivity to the uniqueness of every other* person. This assumption in turn seems to presuppose that *each person contains a minimum of everyone else*, and so divination is aroused by comparison with oneself'.[25] Generality and particularity, then, far from being opposed to one another, are mixed together and require one another, being mutually self-constitutive and self-defining. Understanding, an ethical

24　Cited in A.C. Thiselton, *New Horizons in Biblical Hermeneutics* (Peabody, MA.: Hendricksen, 1992), 64.

25　Schleiermacher, 150.

imagination, thereby involves a constant toing and froing between these two poles, the shared and the particular, the familiar and the alien. The general or 'shared' is necessary as a familiar backdrop in order for us to identify particular versions of or departures from it; while particularity requires a certain sort of generality in order to be significant and meaningful to others. It is because we 'contain a minimum of the other' (even though we cannot abstract that 'minimum' out from particular events and experiences, and cannot always specify what it is) that the imaginative motion out into the realms of the unfamiliar is possible. Moral imagining, we might say, is inherently metaphorical. In discovering the like in the very midst of the unlike, it is able to resonate with it, to speak of it, and thereby to begin to plot its very otherness.

In his poem 'Swallows'[26] R.S. Thomas offers us a suggestive image for what George Steiner refers to as the 'hermeneutic motion'.[27] Our encounters with otherness are pictured as endless migrations out from our particular 'perches of bone' only to return, eventually, with our own particularity somehow modified and enhanced, identifiably the same and yet somehow different. Steiner's preferred metaphor is that of a voyage of discovery and invasion of the world of the other, a voyage from which, like the imperial armies of old, we return bearing exotic trophies of our success, importing into our own world cargo which may infect it with alien and uncomfortable ideas and ways of seeing things, and telling colourful tales of the remarkable things we have seen and experienced so far from home. Such images draw attention to the nature of every bid for understanding of the other as essentially a journey of imagination in which we are granted the capacity to transcend the boundaries of our own particularity and to engage with otherness in ways which plot something of its difference, before finally returning to ourselves with our horizons broadened and our 'self' in some sense more rounded and complete through the venture.

For this reason it might be argued that a training in the 'art of understanding' ought always to incorporate engagement with imaginative literature of one sort or another as a means to the cultivation of a disciplined imagination. For, what a great novel or poem does, in effect, is precisely to take the reader on journeys of imaginative self-transcendence, to lift us out of ourselves and relocate us temporarily somewhere else; to show us things we had not seen before, or familiar things now looking quite different because viewed from an unfamiliar perspective. The poet (using the term for the moment inclusively for all creative writers) enlarges our vision, tracing patterns, threads and connexions which stretch out beyond the horizons of our known world, and leading us out (as we trace them with him) into the complex structure of things until, at last, we find ourselves in quite unfamiliar territory, our imagination stretched, sometimes to breaking

26 R.S. Thomas, *No Truce with the Furies* (Newcastle-upon-Tyne: Bloodaxe Books, 1995), 49.

27 George Steiner, *After Babel: Aspects of Language and Translation*, 2nd ed. (Oxford: Oxford University Press, 1992), 312f.

point.[28] Upon our return we discover that, while we are the same person we were, our personhood has nonetheless been transfigured in some way by the experience. We have seen and tasted more of reality than we had previously, and the texture and colour of our own world presents itself differently as a result.

Literature is, according to Ricoeur, 'a vast laboratory for thought experiments' in which, under carefully controlled conditions, we are subjected to all manner of possible (and sometimes impossible) variations on human experience and outlook.[29] As we read, we effectively leave our 'selves' behind in suspended animation and move out to become, in our imagination, someone other than ourselves. Sometimes we 'become' the central character about whom we are reading, identifying ourselves with their actions and experiences. The form of the novel facilitates this more fully than any other because (especially through the assumption of the voice of the grammatical first person) its narrative is able to put us inside the heads of its characters until we know them as well as – and occasionally better than – they know themselves. The author can achieve this imaginative transition in her readers because she is the creator of her characters and responsible for fashioning their identity. She can fill out the picture from her position of authorial omniscience and omnipotence vis-à-vis the world of the text, granting us opportunities for indwelling alien particularities to a degree which could never arise in our real-life encounters with otherness.

C.S. Lewis, reflecting on the benefits of such imaginary migration between nominatives concludes that in and through it we seek and are granted 'an enlargement of our being. We want to be more than ourselves. … We want to see with other eyes, to imagine with other imaginations, to feel with other hearts, as well as with our own. … The man who is contented only to be himself, and therefore less a self, is in prison. My own eyes are not enough for me, I will see through those of others. … Literary experience heals the wound, without undermining the privilege, of individuality. … in reading great literature I become a thousand men and yet remain myself. Here, as in worship, in love, in moral action, and in knowing, I transcend myself; and am never more myself than when I do'.[30] Of course our being is enlarged more, and we are rendered more fully ourselves, by encounters with a real rather than an imaginary other or others. Furthermore, we must tread carefully in pursuing the parallel; literary migration is undertaken in order to secure pleasures and benefits directed towards the self who reads, whereas the exercise of moral imagination in real life is, if not entirely selfless, nonetheless concerned for the good of the other as well as the self. The vital point, though, is that both are encounters which occur through an *imaginative* engagement, and the *imaginary* or fictional, by virtue of its controlled and deliberate nature and the possibilities of a more intimate becoming which the narrator's omniscience

[28] See C. Day Lewis, *The Poetic Image* (London: Jonathan Cape, 1947), 85f.

[29] Ricoeur, 148.

[30] C.S. Lewis, *An Experiment in Criticism* (Cambridge: Cambridge University Press, 1961), 139–41.

affords, can equip and train us better to handle our engagements with the actual others who face us daily in our living.

Culture and Conversation

Given all this, my concern in the rest of this chapter will be with a number of different frontiers along which engagement or exchange between distinct territories of meaning may arise or reasonably be sought. If, for the sake of convenience (but more than convenience alone) we shift our ground from the domain of one metaphor to another, and speak instead of distinct 'voices' and the sorts of exchange which may arise or be sought between them (argument, interrogation, testimony, 'small talk', or whatever), the potential sites for such exchange are identifiable at various levels of our personal encounter with that which is other than ourselves – i.e. as those possessed of 'voice' and called upon variously to speak. For our purposes here we might think most immediately of different voices (and exchanges between them) arising within and between literary texts, within and between different intellectual disciplines, and within and between distinct human cultures. So far as mapping the complex web of relations between self (or same) and other is concerned this is, of course, merely to scratch the surface, but doing so will provide us with plenty to reflect upon in the space available to us. My particular concern in what follows is with the sort (or sorts) of exchange that may prove beneficial in inter-disciplinary and cross-cultural or cross-religious exchanges in particular, and the tone or register of voice most befitting constructive participation in these.

What, though, of theology? In Western treatments of our subject (even thoroughly 'secular' ones) it is still commonplace to be reminded that all human utterance arises 'after Babel'. The allusion, of course, is to the prehistoric occasion when, according to the canons of Jewish and Christian scriptures, God deliberately scrambled the signals of human speech (in a calculated act of judgement and grace) to prevent the completion of an essentially Promethean technological project and its potentially disastrous outcomes. The consequent fracturing of discourse and 'scattering' of linguistically mediated perspectives is variously weighed, but pious Christian readings of the Pentecost story and technical manuals of hermeneutics alike tend mostly to view it *eschatologically*, i.e. as a 'fall' into language the redemption of which (whether divinely or philosophically accomplished) will see diversity and plurality duly displaced by a Utopian immediacy and concordance of meaning.

Towards the end of the chapter I shall suggest that from the standpoint of Christian faith there are good theological grounds for supposing otherwise, resisting the idea that the effoliation and enrichment of human speech lies in the direction of any effective reduction of it to a monoglot, monotonous semantic singularity. Since, in any case, we do not find ourselves as yet unambiguously in the kingdom or even on its threshold, our imaginative attempts to 'make sense

of' others, venturing across boundaries of one sort or another, are for the time being bound to involve acts of translation and interpretation, and vulnerable to all the fragility and indeterminacy typically attendant upon these (constraints of which those who have kindly undertaken to translate this chapter are no doubt already and painfully all too aware!). Again, I shall suggest duly that there are grounds within the grammar not just of theology but of *Christology* in particular for supposing that this circumstance ought not to be construed in wholly negative terms, and for reimagining Pentecost, therefore, as a symbol not of the erasure of otherness but of the transcendence and fulfilment of the self/same as it risks itself in relationship with the other and for the other's sake.

In a 1959 essay the English philosopher and political theorist Michael Oakeshott observed (against the grain of the linguistic philosophy of the day) that not all human utterance is cast in (or should be measured by virtue of its capacity to imitate) the tones of one privileged mode, that is, the mode of practical activity or argumentative discourse.[31] Significant human speech, he insists, may be found in other modes less immediately concerned with the exigencies of survival, and more suited, therefore, to a descriptive, reflective or even a playful exploration of the realities and possibilities of the human world as we find it. Among such 'authentic' yet strictly speaking non-combative and impractical (technically 'useless') idioms of speech Oakeshott lists 'science', history and 'poetry' (the latter here a metonym for literature and creative writing more widely), and we might add other distinct voices participant in the speech of human cultures including, no doubt, 'theology' as and when it arises. And, Oakeshott suggests, the place where all these voices (and others within or alongside them) come together and engage with one another is itself most helpfully pictured and approached not as 'an inquiry or debate among inquirers, about ourselves and the world we inhabit', but as a *conversation*, a quite different sort of linguistic and semantic context, and one in which different conventions, expectations and rules of engagement apply.

What sort of thing is it, then, that makes a conversation a *conversation*, as distinct from any other sort of 'language game' or thing done with words? An extended account lies beyond the scope of this chapter, and in the interests both of clarity of expression and economy of words, therefore, I will resort here to citing Oakeshott himself at greater length than I might otherwise be inclined to:

> In a conversation the participants are not engaged in an inquiry or a debate; there is no "truth" to be discovered, no proposition to be proved no conclusion sought. They are not concerned to inform, to persuade, or to refute one another, and therefore the cogency of their utterances does not depend upon their all speaking in the same idiom; they may differ without disagreeing. Of course,

[31] See 'The voice of poetry in the conversation of mankind' in Michael Oakeshott, *Rationalism in Politics and Other Essays* (Indianapolis: Liberty Fund, 1991), 488–541. The essay was originally a Ludwig Mond Lecture delivered in the University of Manchester.

a conversation may have passages of argument and a speaker is not forbidden to be demonstrative; but reasoning is neither sovereign nor alone, and the conversation itself does not compose an argument. ... In conversation, "facts" appear only to be resolved once more into the possibilities from which they were made; "certainties" are shown to be combustible, not by being brought in contact with other "certainties" or with doubt, but by being kindled by the presence of ideas of another order; approximations are revealed between notions normally remote from one another. Thoughts of different species take wing and play round one another, responding to each other's movements and provoking one another to fresh exertions. ... (I)n it different universes of discourse meet, acknowledge each other and enjoy an oblique relationship which neither requires nor forecasts their being assimilated to one another.[32]

The central point, then, is that a conversation of the sort Oakeshott intends, is essentially plural, open-ended and in a proper sense playful; we join it for the sake of participating in it rather than to secure some predetermined (economically or politically driven) goal or output, and any benefit we gain from doing so (besides the enjoyment of the conversation itself and as such) arises serendipitously, from the unpredictable interplay or collision of difference. Anyone may speak, and may do so on their own terms, the relevance of their utterance being measured not by some external standard but by the course of the conversation itself alone, an 'unrehearsed intellectual adventure'.[33] There is no arbiter, no hierarchy of voices, and strictly speaking no conclusion; conversations do not 'conclude' anything as such, and nor do they have an obvious terminus, instead being in effect put on hold, capable of resumption on another occasion. As civilised human beings, Oakeshott argues, we are heirs to just such conversations of which, in their public guise, 'cultures' are the natural bearers and sustainers from one time and place to another. But conversations of this same sort go on unnoticed, too, within each of us as voices (some identifiably our own, others infused and metabolised, others still coming from who knows where) each say their piece in a lively internal exchange that generally looks nothing like a scripted or carefully marshalled dialogue, and frequently moves in unpredictable and sometimes disconcerting directions. And, of course, conversations can be deliberately hosted, bringing voices from different orders of discourse into the same space in order to see what happens, where the exchange will go and what might arise out of it.

This model of a conversation between voices offers a quite distinct mode of engagement from that of the sort of 'dialogue' so often pursued between groups or traditions, familiar not least (and the preferred model of encounter) in the sphere of inter-faith or inter-religious relations. While there are clear similarities, the key differences seem to me to be very significant, and to resist any easy reduction of the one to the other. A dialogue generally has some clearly specified goal or

32 Ibid., 489–90.
33 Ibid., 494.

outcome (even if that is something as vague and general as 'enhanced mutual understanding'), and very often is directed specifically towards establishing increased levels of shared agreement around core issues. Furthermore, those involved in dialogue of this sort are generally mandated with representing their own tradition and its perspectives, charged with responsibility for not compromising the official party line on fundamental issues on the one hand, while seeking to determine the highest common denominator on the other (often a task demanding a high level of diplomatic skill). The dialogues themselves tend to be staged and carefully structured rather than open-ended and spontaneous, and are far from 'unrehearsed' – on the contrary, to a certain extent they are necessarily pieces of more or less scripted theatre. As we saw in our brief discussion of Sennett's notion of 'dialectic' above, exchanges such as these are quite capable of taking into consideration and respecting the particularity of respective traditions, though it must be admitted that within the theology of religions they have often tended tacitly to relegate such particularity to secondary and marginal status in the interests of some supposed generic 'religion' or 'religious experience'. But it is at the level of the group or the tradition that particularity of perspectives is mostly handled in dialogue, rather than the individuals involved in such exchanges feeling free to be themselves (the much more complicated and fluid 'composite of sentiments, affiliations and behaviours'[34] that makes each one who he or she 'is' at a given point in time) or to sit loose in a playful manner to the expectations of whatever group(s) he or she generally identifies with. I am not suggesting that 'conversation' of the sort that Oakeshott proposes should displace this more familiar model of 'dialogue'; I suggest simply that it may furnish a vital complement to it, and one which might bear its own distinctive fruit in the knowing of 'the other by the other', and the establishment of the 'community of the different'. Additionally, they entail a form of personal vulnerability in the face of otherness (which is yet not wholly without power and authority of its own) which seems to me to be rather closer to the heart of Christian identity than either the 'fetish of assertion'[35] which would drive home its own case at all costs as though that were itself the highest form of good, or else the slightly insipid models of pluralist essentialism for which the particular is always inherently soluble in the underlying acids of shared consensus, and thus 'identity' a category finally surplus to requirements.[36]

[34] Sennett, 8.

[35] Bernard Williams, cited in Sennett, 18.

[36] As Bauman observes, the question of 'identity' only arises where 'belonging' is no longer taken to be a simple matter of fate and fact, and where there exist alongside one another numerous 'communities of believers', so that 'one has to compare, to make choices, to make these repeatedly, to revise choices already made on another occasion, to try to reconcile contradictory and often incompatible demands'. Bauman, 11. Pluralism of the sort I have in mind here seeks to reverse the processes of history and cultural cross-fertilisation, and finds it difficult to cope constructively with the idea of abiding contradictions or incompatibilities which must be held onto despite the desire for harmonious co-existence.

I have used the term 'playful' of conversations understood in this way, and in so far as that term severs the connection with considerations of immediate practical utility or calculable pay-off, it performs an important function. But such playfulness has nothing to do with mere frivolity, as Oakeshott himself is concerned to insist. On the contrary, it can be deadly serious; indeed, in a certain sense it always is, for in order to 'play the game' at all we are obliged to put ourselves in a vulnerable place, a place where risk (to self, and the things we generally take to be most defining of it) is par for the course, and to pursue defensive strategies is to spoil the game or at the very least to exclude ourselves from it by default. For the risk has to do precisely with exposing ourselves to otherness and (for the sake and the duration of the game at least), sitting loose to the various markers and security blankets of our own identity, that unique coincidence of perspectives, images, experiences, associations and dispositions that marks out the particular space in the cosmos that is 'me' or 'you'. The risk (or danger) of conversation thus has at least two aspects – first, that we shall fail in our bids to transcend the limits of selfhood, remaining trapped, as it were, behind the boundaries of our own particularity, unable to make contact with the other (saying what we mean, being heard and understood, and hearing and understanding what is being said to us); and second (perhaps even more disconcerting), that we might actually succeed. Let's consider these in reverse order.

Meaning, Reality and Literature

In various writings on the subject, C.S. Lewis (best known to the reading public as an apologist for Christian faith, but more relevant here as a philosophically-trained critic of literary romance and mythology) observes that the power of literary or poetic imagination has in the first instance to do with meaning rather than reality.[37] Put succinctly, the fact that we can imagine some state of affairs (that it holds together or coheres in our mind's eye) certainly does not lead us to conclude that any such state of affairs is true, or has some real exemplar in the world. Indeed, insofar as art is precisely artifice, an 'aesthetic' disposition will always be one in which we remain aware at some level of the difference between the 'world' of the work (novel, poem, painting or whatever) summoned forth by the artistic imagination and the world of our day to day affairs. To do otherwise is to commit a category error which ruins the effect of the piece for us *as art*, like the fabled man who, seeing a dastardly murder about to be committed, leapt from his seat in the theatre and rushed onto the stage, determined to prevent it. Of course there is a proper mode of 'believing in' which characterises our enjoyment of the artifice, but it is not the same sort of belief as that which we invest in what we take to be real, and we are mostly well aware of the distinction between them. The former (what

[37] See, for instance, the essay 'Bluspels and Flalansferes' in Lewis, *Rehabilitations and Other Essays*, 135–58.

Coleridge refers to as a 'willing suspension of disbelief', and J.R.R. Tolkien, more positively, as 'secondary belief) is an enjoyment of meaning without any moral commitment to the truth or falsehood of the circumstance represented. The skill of the poet or artist lies precisely in showing us something which, by the manner of its showing, draws us in and thereby takes our imagination captive, suggesting a larger 'world' or state of affairs in which the particular thing shown (no matter how outrageous or improbable when measured by other canons of 'reality') makes sense and does not cause us to stumble imaginatively. Of a particularly clumsy translation of a work of literary fantasy to the stage Tolkien once complained that it demanded of the viewer not so much that his disbelief be suspended as that it be hung, drawn and quartered! It is precisely this that, by its skilled suggestion and evocation of meaning, the successful work of artistic imagination avoids.

Meaning, then, is as such (and as a product of imaginative construction) *separable* from questions of reality and truth. And imagination is more concerned to suggest playfully *What if it were thus?* than to convince us that in fact it *is* (even though it may in fact be). To enjoy a story or a play as such, therefore, is not to demand that it be consonant with what (on other grounds entirely) one believes to be true of the material, moral or spiritual orders beyond its borders, but simply to enjoy the architecture of its meaningfulness, and the experience of being granted temporary citizenship in its imaginative world. Since he takes reality to be meaningful in its own way rather than a chaos, Lewis also insists that imagination is a necessary *condition* of 'truth' just as it is of falsehood. We must, after all, be able to make a certain amount of sense of something to believe it to be true or false, otherwise such profession would itself be meaningless.

It seems to me that in the sort of 'conversation' described for us by Oakeshott, the various participant voices are (for the purposes and duration of the conversation) epistemically resituated in a manner that renders them subject to analysis in essentially similar terms. They are temporarily shorn of their relationship to questions of truth or falsity (which, for the purposes of the conversation may not be presumed, nor demonstrated by appeal to considerations lying beyond the borders of the conversation itself, placing every voice, as it were, on a level playing field) and must be attended to at the level of their *meaning* alone. As those who speak, what we are in effect saying is *What if it were thus?*, inviting among our hearers and interlocutors an imaginative assent which as yet leaves questions of actual truthfulness bracketed out of consideration. And as those who hear the voices of others, we are called for our part to exercise imagination, to imagine that it might be otherwise than we have typically supposed it to be, to open ourselves to new possibilities of meaning, and to see whether they unfold themselves before us in a convincing and compelling manner. We must, to pick up a telling phrase of Lewis, 'risk being taken in'.[38]

There is that word again – risk. For secondary belief is not quite so innocuous as first appearances might suggest. And while questions about reality and truth have

[38] Lewis, *An Experiment in Criticism*, 94.

no formal part to play in its operations, they will not be held at bay indefinitely, and often sneak in under the radar to harry us, compelling reconsideration and re-evaluation of cherished assumptions and perspectives. We may, as it were, only have velcroed our convictions to the mast for the purposes of imaginative indwelling, but we sometimes find them stubbornly resistant to our attempts to detach them again before moving on. The entertainment of meaning, afforded us by the imagination's constructive and reconstructive labours, is powerful, and can be persuasive. This is hardly surprising, given the centrality of the imaginative in all our efforts to 'make sense' of things, including the most serious and 'hard headed' approaches to reality that we are humanly capable of (as we have already noted, science is nothing if it is not imaginative first),[39] and those vague and indeterminate yet profoundly influential metaphysical constructs to one or other of which each of us subscribes – albeit often tacitly – in order to identify, situate and orientate ourselves in the world, and to which Charles Taylor has helpfully granted the label 'social' and 'cosmic imaginaries'.[40] The lines between the real, the imaginative and the purely imaginary, in other words, are not able to be drawn quite so precisely or with such a thick pencil as we might suppose, the undertow of the imaginative towards conviction sometimes proving impossible to resist.

And this, no doubt, is precisely why we find art and literature so compelling and so valuable; because they will not be isolated in some hermetically-sealed 'alterity' set in apposition to our lived reality, but continually break in (or break out) to modify our ways of experiencing that same reality, for good or ill. The self who returns from the imaginative migrations afforded by literary artifice is never precisely the same self, but a self expanded, adapted and changed (and who knows how much?) by what it has experienced. The value – and so too the risk – of our participation in conversation is surely of an essentially similar sort. Sitting loose to our own particular identity and commitments for the while, we gain the blessing of seeing and tasting the world through other eyes; but with that blessing comes the danger of 'being drawn in', having our being enlarged, and in ways that may return us to the fray of living with our eyes and ears opened to quite new and compelling ways of experiencing it – the boundaries of our particular 'self' or identity transcended and fulfilled only at the risk of its radical reconstruction.

The Slippage of the Sign

The second risk we take in conversation is failure to make contact, failure to communicate with the other precisely because of its otherness from ourselves and because the currency of linguistic exchange itself is intrinsically unstable and

[39] See above, 13–16.

[40] See, e.g., Charles Taylor, *Modern Social Imaginaries* (Durham, NC: Duke University Press, 2004); and Charles Taylor, *A Secular Age* (Cambridge, MA: Harvard University Press, 2007).

constantly shifting in value. Otherness, as we have observed, comes in various degrees, shapes and sizes, but it is present even in the most straightforward and everyday utterances or inscriptions. The risk of misunderstanding, or of being misunderstood is a constant of human ventures in communication.

We have already taken note of Schleiermacher's appeal to a form of hermeneutics in our dealings with living voices as well as those inscribed in historical or culturally remote texts. Hermeneutics, though, can only go so far in its attempts to salve the wounds of cultural plurality attendant upon our primeval 'fall' into language itself. The gap between the sign and that of which it is a sign, between the 'flesh' of meaning incarnate in language and that which transcends its mere flesh alone, remains in place and will not be circumvented. As has been observed before, there is thus a kenotic aspect (a loss, a slippage, a self-effacement, a vulnerability) involved in any and every linguistic venture, any attempt to bring reality satisfactorily to expression in language. Our efforts to share ourselves, our perspectives, our deepest convictions are all broken on the rack of signification, and the more significant and cherished among them seem necessarily to be the most fragile in this regard. We cannot say what we mean, even to ourselves, since what we mean – while inexorably wedded to language – is never simply identical with what we say. When we say it to others, utter it aloud or inscribe it, it quickly slips even the leash of formulation on which we supposed we had it temporarily secured, escaping down the labyrinthine corridors of possible meaning which open out in every direction from the sign, frustrating our attempts to pin it down neatly for inspection, or to present it, neatly trussed and prepared for consumption. Immediacy of meaning, without loss, distortion or remainder, may be entertained by some as an image of the redeemed state; but as those in whose very being the realms of material and immaterial reality ('flesh' and 'spirit' if we prefer) meet and interpenetrate, no such immediacy or certainty lies within our grasp, crave and seek it as we may. To embark upon significant exchange is thus *always* to submit oneself to the inevitability of failure at some level and to some extent – to risk misunderstanding and being misunderstood, unable to convince and convict others through the power of the word alone. In conversation, where the rules of the game forbid easy appeal to external authorities or demonstrations, this risk is, we might suppose, all the more apparent.

Perhaps, though, this messy circumstance, this promiscuous chain of fleeting engagements between meaning and materiality is best understood in theological terms not as a curse, but as a blessing and a benefit, or at least as the condition which makes both blessing and curse possible, and as bound up with what it means to be human rather than something from which we should seek deliverance. There are, I think, reasons arising from within the particular horizons of Christian doctrine itself to suggest this, as well as reasons of a more general hermeneutical sort.

On the general front, we might note simply that the uncertainty and indeterminacy attaching to all discourse can all too easily (and ironically) be overstated. Despite the challenges of otherness, the systole and diastole of the hermeneutic motion does yield results; we communicate with one another, and

often to a degree perfectly adequate to our practical needs. Complacency on the one hand and despair on the other are, it seems, evils to be avoided equally. And what can be presented negatively as the 'loss' or 'slippage' of meaning, of course, can be turned on its head and redescribed in terms of semantic 'excess' or 'surplus', pointing us to the endless capacity of the world to outstretch our language, a rich, mysterious and seemingly inexhaustible source from which ever more meaning may be quarried and enjoyed. By comparison, the urgent demand for immediacy and determinacy where it arises seems bound to an arid rationalism which has (and rests content with) precisely what it has, no more, and no less.

For the Christian, though, there are reasons for resisting this demand which issue naturally from the heart of a Christian symbolics itself, and thus ought to carry particular weight. For, as we observed in Chapter 3,[41] according to the testimony of Christian tradition, God has placed himself variously not just within the world and its history but thereby also *within the order of signs*,[42] tabernacling, as it were, within the 'flesh' of the semiotic economy itself – in inspired Scripture, in the symbolics of sacraments and preaching, and supremely and definitively by clothing himself with our nature and dwelling amongst us as the man Jesus Christ. This divine assumption and appropriation of language, though, is precisely a kenotic accommodation to the human condition (including its linguistic condition), and not a 'transcendental' abrogation or overriding of it. By nature of the case, therefore, it cannot and does not involve any sheer 'givenness' or donation of absolute and unchallengeable meaning. The humanity of Christ is and remains always 'other' than God, or 'not-God' as the Swiss theologian Karl Barth puts it; in and of itself, therefore, it has no necessary or proper reference to that which, here, it signifies. Precisely here, therefore, at the point where faith certainly apprehends the glory of God himself, Godhead is and remains nonetheless paradoxically 'veiled in flesh' as Charles Wesley's lyric reminds us.[43] There is no direct, unmediated encounter with the naked 'presence' of God facilitated by this sign. Instead we are called to attend unceasingly to the flesh of the sign itself, to the presentation of Jesus' humanity, borne witness to and made sense of within that wider dynamic web or matrix of signs that is Christian Scripture and tradition. Indeed, it would be supremely ironic if, here of all places, the flesh of the sign ceased either to mean more than, as flesh alone, it means, or else to fade into insignificance, becoming the wholly transparent conduit to a pure (fleshless) 'transcendental signified'.

'Transcendental signified' is Jacques Derrida's term for a putative point outside the system of language, and hence existing (and known) in a manner free from the constraints and vicissitudes of language as a medium. Kevin Hart suggests that, for Derrida, 'since Christ is God, what He signifies is signified in and of itself',

[41] See above, 43–73.

[42] Cf. David Jones, *Epoch and Artist* (London: Faber and Faber, 1959), 179.

[43] In the hymn 'Hark, the Herald Angels Sing'.

and thus Christ (as God) is a transcendental signified in this sense.[44] My suggestion here is that, on the contrary, the logic of incarnation as understood by the classic doctrine of hypostatic union can be taken to prohibit any such conclusion, the relationship between Christ's 'deity' and his humanity being paradigmatic of the wider semiotic economy rather than rupturing or abrogating it.[45]

This incarnation of meaning at the heart of Christian faith is kenotic in another sense, too, of course; for in giving itself in this form it also risks its own demise, eschewing the way of power and coercion, and 'triumphing' finally only by remaining true to the way of an unconditional, risky and selfless love for the other. Christ returns to the Father as the victim of human rejection and crucifixion, the embodiment of foolishness rather than the victorious champion of a 'Logocentrism' that has successfully obliterated all perspectives but its own. This is the peculiar logic of Christian logos, and a distinctly Christian participation in conversation with the other (inter-personal, inter-cultural, inter-disciplinary or whatever sort) ought thus always to be one which is willing to risk itself through imaginative strategies designed to engage unconditionally with the other as other, to empty itself of power and even risk its own loss or demise, trusting that only in doing so – paradoxically – can it truly fulfil itself and be faithful to its particular identity.

[44] See Kevin Hart, *The Trespass of the Sign: Deconstruction, Theology and Philosophy* (Cambridge: Cambridge Univesity Press, 1989), 8.

[45] For related (and more substantial) discussions see further Graham Ward, *Barth, Derrida and the Language of Theology* (Cambridge: Cambridge University Press, 1995), 31–41, 235–51.

Chapter 5
Cosmos, Kenosis and Creativity

Unfinished Business

On 7 October 1936 Dorothy L. Sayers, a writer as yet acknowledged primarily for a string of successful murder mysteries, had received a letter from the organisers of the Canterbury Festival, inviting her to write a play for their forthcoming 1937 event. The invitation came both as a surprise and an honour. A surprise because, although she was in fact just about to take her first dramatic production to the stage (*Busman's Honeymoon*, co-written with Muriel St Clare Byrne, was cast and rehearsed in that same month, and had its opening night in mid November),[1] this venture was not widely known about and Sayers' talent as a playwright was still effectively untried. An honour, because her immediate predecessors in writing for the Festival were anything but up-and-coming, let alone unknown and untested. In 1935 the event had been graced by T.S. Eliot's *Murder in the Cathedral*, and in 1936 by Charles Williams' *Thomas Cranmer of Canterbury*.[2] No wonder her response expressed initial caution on the grounds that the project was 'rather out of my usual line'.[3] Notwithstanding this fact, Sayers accepted the challenge.

In accordance with the Festival's theme that year (the celebration of artists and craftsmen), but wishing also to maintain its focus on the history of the Cathedral, Sayers selected for the plot of her drama events surrounding the rebuilding of the church's choir in the late twelfth century.[4] Her protagonist was William of Sens, the French architect duly chosen by the Cathedral Chapter to undertake this

[1] See Barbara Reynolds, ed., *The Letters of Dorothy L. Sayers, 1899–1936, The Making of a Detective Novelist* (New York: St Martin's Press, 1995), 401 (10 October 1936, to L.C. Kempson); 405 (14 November 1936, to Margaret Babington).

[2] Williams appears to have suggested Sayers' name as his successor. According to Reynolds' biography, the two had certainly been in contact since 1935, and possibly earlier. As Reynolds notes earlier in her work, Sayers had in fact tried her hand at drama before, incorporating a short mystery play (*The Mocking of Christ*) in her collection *Catholic Tales and Christian Songs* (Oxford: Blackwell, 1918), and a letter written to *The New Witness* in January 1919 reveals that Williams had read this. See Barbara Reynolds, *Dorothy L. Sayers: Her Life and Soul* (London: Hodder and Stoughton, 1993), 98–101; 310.

[3] Reynolds, *Letters*, Vol. 1, 401 (7 October 1936, to Margaret Babington).

[4] The original choir had burned down in 1174. For the history see Roslin Mair, 'The Choir Capitals of Canterbury Cathedral 1174–84' in *The British Archaelogical Association Conference Transactions for the year 1979*, Vol. V, Medieval Art and Architecture at Canterbury before 1220 (British Archaeological Association and Kent Archaeological Society, 1982), 56–66.

work. Four years into an expensive but thus far successful renovation project, the historical William was seriously injured, falling from a cradle he himself had designed to facilitate installation of the keystone to the great arch. His body broken, the master craftsman was compelled to resign his commission, leaving his work unfinished, to be completed by others. Sayers locates the circumstances of this accident at the heart of her play, using it to explore some fundamental questions about the place of human 'making' in God's scheme of things. Picking up on fragments of evidence provided by the contemporary chronicler, she characterises William at first as a man whose spiritual qualifications for building the Lord's house are at best questionable. If, as the Cathedral Prior suggests, William's avarice, promiscuity and generous disregard for truth are at least offset by his evident skill and his passion to use it well, it is nonetheless *this* that is the occasion of his quite literal downfall. Immediately before the ascent which will maim him, Sayers places the following words on William's lips:

> We are the master-craftsmen, God and I –
> We understand one another. None, as I can,
> Can creep under the ribs of God, and feel
> His heart beat through those Six Days of Creation.
> … since all Heaven was not enough
> To share that triumph, He made His masterpiece,
> Man, that like God can call beauty from dust,
> Order from chaos, and create new worlds
> To praise their maker. Oh, but in making man
> God over-reached Himself and gave away
> His Godhead. He must now depend on man
> For what man's brain, creative and divine
> Can give Him. Man stands equal with Him now,
> Partner and rival.[5]

In theological terms, this is a convenient summary of Promethean excess at its worst, and William compounds the tragic hubris further when, to the warning that such blasphemous sentiments may tempt God to strike him down, he responds: 'He will not dare;/He knows that I am indispensable/To His work here.'[6] This is, of course, a misplaced confidence, and only moments later the sword of the Archangel Michael cuts the rope on which William dangles precariously above the flagstones of the Cathedral floor, sending him plunging to his physical ruin, but (as it turns out) his spiritual redemption.

[5] Dorothy L. Sayers, *The Zeal of Thy House* (London: Victor Gollancz Ltd, 1937), 69–70.

[6] Sayers, 70. On William's 'blasphemy' cf. Reynolds, *Letters*, Vol. 2, 14 (26 February 1937, to Laurence Irving).

Having depicted the folly and outrage of William's theologically informed 'aesthetic' and the nature of its outcomes, though, the drama does not proceed, as we might reasonably expect, to eschew the analogy and proposed correlation between divine and human modes of creativity which lies at the heart of it. Instead, it suggests provocatively that God, the great Master Architect of the cosmos (and so William's divine exemplar), has indeed placed himself in a circumstance where he needs human agents to complete the work begun in creation, albeit not quite in the manner that William self-importantly supposes. This, indeed, is the spiritual lesson that William is to learn through his fall and his subsequent inability to complete the masterwork he has begun. His initial proud refusal to relinquish a micro-managing, hands-on oversight of the precise shape 'his' work will now take is redeemed when he finally grasps a theological truth lying at the heart of the doctrine of the incarnation – in becoming one of his own creatures, God himself has embraced humiliation, suffering, failure and death, leaving others behind to pick up his work and carry it forward.[7] Though it is not articulated in the dialogue, close at hand lies the idea that, far from being the first moment of *kenosis* identifiable in God's dealings with the world, the incarnation should be understood as the most acute instance of a wider pattern beginning with the divine decision to create as such.[8] If God himself does not jealously exclude but actively conscripts the agency of others in the realisation and redemption of his creative project, the drama enquires, how can any human maker be prepared to do less?

There is, of course, another story to be told about the incarnation, and one that it would be very dangerous to lose sight of. According to a soteriological tradition stretching from Irenaeus of Lyons to Karl Barth and beyond, God has, precisely by taking flesh (and thereby simultaneously earthing the Trinitarian dynamics of the life of God within the patterns of human history and drawing our humanity redemptively within the penumbra of his own existence), reversed the impact of sin and alienation upon our nature and so established a place within the creaturely sphere where already he dwells together with us in fellowship, so fulfilling by way of prolepsis the purpose of creation itself.[9] Put differently,

[7] See Sayers, 99–100: 'Not God Himself was indispensable,/For lo! God died – and still His work goes on.'

[8] The notion of creation entailing a voluntary self-limitation on God's part is especially prominent in forms of Kabbalistic mysticism influenced by Isaac Luria (1534–72), especially in the distinctive doctrine of *Tsimtsum* or divine concentration/ contraction. See Gershom Scholem, *Major Trends in Jewish Mysticism* (New York: Schocken Books, 1941), 260–64. The idea also finds emphasis in strands of the Christian tradition, most recently in the work of Jürgen Moltmann. See, e.g., Jürgen Moltmann, *God in Creation* (London: SCM Press Ltd, 1985), 72–93.

[9] This is the central idea of Barth's twofold insistence that the covenant between God and Israel fulfilled once for all in Jesus Christ is the internal basis of creation, and creation the external basis of the covenant. See Karl Barth, *Church Dogmatics* III/1 (Edinburgh: T&T Clark,1958), 94–329.

in Christ God substitutes his own humanity for ours, and thus himself provides the free creaturely response in which creation comes to its intended goal and fulfilment. Nonetheless, the logic of this divine self-substitution is not to displace creaturely action altogether, but precisely to create a context in which, understood as a participation in Christ's own action through the Spirit, it may be undertaken freely and without fear of failure or falling short. In the peculiar 'already – not yet' modality of human existence situated between the incarnation and the eschatological consummation of all things, what has been achieved by God for us remains as yet to be worked out in, and with, and through us, and within this context there is much for us still to do, and no compromising of the integrity of our actions in doing it.

While, therefore, in William's hubris Sayers shows us the worst and most problematic aspects of the Humanism which emerged from the Renaissance, as Nicholas Wolterstorff notes, she does so finally not to damn the project but to seek its redemption by re-situating elements of it within a quite different religious and theological perspective.[10] In place of autonomous man, struggling nobly for artistic liberation amidst a rivalry with God, Sayers offers an alternative vision, of human artistry and craftsmanship – understood now in explicitly Christian theological terms – as at the very least a 'spiritual' vocation equivalent to others ('William's devoted craftsmanship' she tells a correspondent, has 'more of the true spirit of prayer than … self-righteous litanies'), and at best as something much more besides. The play closes with a speech to the audience by the Archangel Michael, and in his words we find the first inkling of a theme to which Sayers would return and which she would work out more fully in her own mind over the next several years. Human making and craftsmanship, it suggests, is not a breach of divine copyright or set in deliberate counterpoise to God's own creative activity; rather, the basic structure of our human ways of engaging with the world 'creatively' should be identified as a concrete vestige of and participation in God's own triune being, and as such the proper locus of that 'image and likeness' of God in which our humanity is itself made: 'For every work of creation is threefold, an earthly trinity/to match the heavenly.'[11]

Grammars of Creation

Putative analogies between divine and human modes of making are all well and good; but, it might reasonably be objected, in Christian theology across the centuries the doctrine of creation has more typically been linked to the

[10] See Nicholas Wolterstorff, *Art in Action* (Carlisle: Solway, 1997), 67–9.

[11] Sayers, 110. The play closes with this speech which, although cut from the 1937 production to meet the strictures of prescribed length, was restored in subsequent performances and can be seen in retrospect to be pregnant with the seed which would grow into *The Mind of the Maker* (London: Methuen & Co., 1941).

apprehension of God's radical ontological *otherness* from the world, and appealed to, indeed, in a manner taken as definitive of this vital gap. What differentiates 'the heavens and the earth' or 'all things, visible and invisible' from God most sharply in other words is precisely the fact of their *creatureliness*. God alone is 'uncreated'; nothing else is or ever could be. Thus we find the categories of the doctrine of creation cross-fertilising naturally and properly with those of Trinitarian and incarnational theology in biblical and patristic thought. For those whose theological understanding was shaped by Second Temple Jewish monotheism, Richard Bauckham has recently argued, to speak of Christ in Pauline or Johannine fashion as participating directly in the creation of the cosmos (e.g., Col. 1.15–16; cf. Jn 1.3) was without further ado to include him scandalously within the 'unique identity of the God of Israel'.[12] Meanwhile, in the fourth century dispute over the precise status of the person of the Son of God, the creedal identification of Christ as the one by whom 'all things were made' and the concomitant insistence that, being of one substance with the Father, he himself is 'begotten, not made', was taken to be a clinching argument against the Arians. In each case, the relevant theological premise taken for granted is that God alone is uncreated, and God alone creates in the relevant sense.

What, then, is the relevant sense? What is it that only God has done and is capable of doing? Most fundamentally, in this context the term refers to the divine donation of existence as such where otherwise there was neither scope nor possibility for it, an act of absolute origination necessarily unparalleled within the creaturely order itself. Thus, for Aquinas, 'God's proper effect in creating is … existence *tout court*'.[13] Here, the philosopher's 'interrogation of the ontological'[14] – 'Why is there not nothing?' – finds a response reaching beyond the categories of philosophical ontology alone and drawing explicitly on the resources of a theology of grace. There is 'not nothing' because God freely grants something *esse* alongside himself and invites it to 'be with him'; in doing so, furthermore, God establishes a 'primordial plenitude'[15] of meaning and possibility, an orderly habitation fit for human (and other sentient creaturely) indwelling and flourishing. All this, of course, bespeaks the radical transcendence of God with respect to the cosmos, and its concomitant dependence on him not just for its inception but for its continuing moment-to-moment existence. Furthermore, what distinguishes 'creation proper', Colin Gunton argues, is its status as something done and dusted 'in the beginning', the necessary presupposition of historical existence rather than

[12] Richard Bauckham, *Jesus and the God of Israel* (Grand Rapids: Eerdmans, 2008), 18; cf. 26f.

[13] *Summa Theologiae*, 1a.45, 4.

[14] George Steiner, *Grammars of Creation* (London: Faber and Faber, 2001), 32.

[15] I owe this phrase to Michael Northcott.

a feature of it. What remains, he insists, is not 'more creation, but simply what creator and creature alike and together make of what has been made'.[16]

All this being so, it is unsurprising that the linguistic trespass whereby Renaissance humanists transplanted *creare, creator* and *creatio* from the hallowed ground of Christian liturgy and doctrine (which hitherto had been their sole preserve) onto the soils of art historical and art theoretical description in the sixteenth century – to refer now not to divine but to fully human activities and accomplishments – occasioned considerable nervousness at the time, and has ever since aroused protest in some theological quarters. The semantic fields of 'creation', George Steiner notes, overlap and interfere,[17] and those who borrow and try the term on for size in whatever human context situate themselves and their actions of 'making', whether knowingly or not, in relation to divine precedent. Even in the past fifty years or so, when the metaphor has spread well beyond the reach of aesthetics into fields as varied as hairstyling, pedagogy, economics, technology and the media,[18] and fully aware that the lexical genie cannot now be put back in the bottle, some Christian authors have advocated a strategy of counter-cultural resistance, refusing in principle to sanction use of the term 'creation' for anything other than a particular sort of 'act of God' and its outputs, or at least interjecting whenever occasion permits (and we remember to do so) that, in the strict and proper sense, 'finite agents do not create'[19] (they merely 'make', or 'invent', or whatever).

While such theological concerns and emphases are important, though, there is more yet to be said about 'creating' and the 'presumption of affinity'[20] involved in wider uses of the relevant vocabulary. As Gunton himself admits, if divine creating is indeed an action situated properly within the grammar of the perfect tense (God always *has* created), there is nonetheless a vital sense in which 'creation' itself (the output of that action)[21] remains incomplete and a work very much still in progress.[22] In the Genesis narrative the advent of the seventh day marks a fire-break in the characterisation of the divine action, a point in time by which certain things are already established and 'given', and beyond which they need not be

[16] Colin Gunton, *The Triune Creator: A Historical and Systematic Study* (Grand Rapids: Eerdmans, 1998), 89. Gunton draws directly here on the account of Oliver O'Donovan, *Resurrection and Moral Order. An Outline for Evangelical Ethics* (Leicester: IVP, 1986), chapters 2–3.

[17] Steiner, 17.

[18] See, e.g., Richard Florida, *The Rise of the Creative Class* (New York: Basic Books, 2002).

[19] Gunton, 1, n.2.

[20] Steiner, 18.

[21] Gunton reminds us that the term 'creation', whether applied to God or human agents, tends to be used in a dual sense, to refer both to the action of 'creating' and the thing duly 'created'. Gunton, 1.

[22] Ibid., 88–9.

repeated or modified. The world is now 'finished' (Gen. 2:1) inasmuch as it is ready for immediate occupation, and after this, Pannenberg suggests, in a fundamental sense, God 'does not bring forth any new creatures'.[23] Wherever in pre-history we imagine this point in time to have arisen, though (in the text it is only with the appearance on the scene of human beings), it is clear that in another equally fundamental sense all this is as yet only the beginning of 'God's project',[24] not its divinely intended end. The fulfilment of God's 'creative' labours, shaping and reshaping a world fit for human and divine cohabitation (see, e.g., Rev. 21.3–5), must therefore be traced not in protology, but in an eschatology christologically and soteriologically determined and orientated.[25] While we may still wish to insist upon reserving talk of 'creation proper' for a particular set of precise and technical theological uses, therefore, it is nonetheless clear that the term has a penumbra already gesturing towards the possibility of a wider and extended set of uses, even within the grammar of theology itself.

The shape of the biblical witness to creation is entirely consonant with this semantic overspill. Hebrew possesses no single term covering the range of meanings of the English 'creation', and while the Hebrew poets certainly take trouble to demarcate some lexical holy ground which must never be trespassed upon (the singular verb *bārā'* being set apart from the wider imaginative field to name a unique and non-transferable activity of 'creation proper'),[26] their witness to God's primordial performance equally resists reduction to any 'single or simple articulation' of the matter.[27] Instead, the writers deploy a string of different verbal images to describe some, at least, of what occurs 'creatively' during the first six days (shaping, making, forming, commanding, etc.), these being by definition suggestive of human or other creaturely analogy. Moreover, recent work by Brown, Fretheim, Levenson and Welker has urged that, if we would be faithful to the imaginative logic of the biblical text here and elsewhere, we must recognise arising within it quite naturally the suggestion that aspects of God's fashioning of the cosmos are not only analogous to but actually conscript and demand the

[23] Wolfhart Pannenberg, *Systematic Theology. Vol. 2.* (Edinburgh: T&T Clark Ltd., 1994), 36. Cf. Barth, 182.

[24] Gunton, 202.

[25] It is on these grounds that Barth interprets the divine judgment in Gen 1.31 not as a valediction but as an ordination. All that God has made is pronounced 'very good' for the accomplishment of creation's intended goal in the fulfilment of the covenant in Christ. See Barth, 212–13. See below, 131–2.

[26] So Walter Brueggemann, *Theology of the Old Testament: Testimony, Dispute, Advocacy* (Minneapolis: Fortress Press, 1997), 148–9. For instances see W. Bernhardt, 'bara', in *Theological Dictionary of the Old Testament*, ed. G. Johannes Botterweck and Helmer Ringgren (Grand Rapids: Eerdmans, 1990), 246; Ludwig Koehler and Walter Baumgartner, eds, *The Hebrew and Aramaic Lexicon of the Old Testament*, trans. M.E.J. Richardson et al., Revised ed. (Leiden: Brill, 1994), 153–4.

[27] Brueggemann, 149.

participation of creaturely forces and agencies as such.[28] The God of Scripture, Brown suggests provocatively, is no jealous guardian of his own 'creative' prerogatives, but one whose work as Creator is – by virtue of his own choosing and self-limiting – ultimately achieved *per collaborationi*.[29]

Such poetic suggestion concurs, of course, with what we now understand of the shaping of the material cosmos, an understanding no longer tolerating imaginative confinement of it to a single working week situated 'in the beginning'. Whatever we may suppose about the temporal status of the primal act of incipience granting *esse* charged with meaning and potential to all things (including, Augustine reminds us, the structuring function of creaturely time itself),[30] several centuries of learning in physics, geology and biology serve to assure us that the work of forming a physical cosmos fit for human indwelling is one which, precisely insofar as it harnesses and involves the created capacities embedded within the cosmos itself, cannot be hurried but takes a long time. Again, wherever we locate the advent of creation's seventh day, to the best of our knowledge those same creaturely forces and processes are ones that rumble on beyond it, possessed of an abiding remit, a temporal future as well as a murky pre-historic past. Correspondingly, many of the biblical images used to picture God's ancient forming of the cosmos are extended perfectly naturally to picture his hand still at work, shaping the world's history and moving it towards its promised future.[31]

If Brown's further argument, that in the 'creation traditions' of Scripture itself, God's activity of generating and ordering a physical *cosmos* is understood to be of a piece with – and not properly separable from – his calling forth an accompanying *ethos* to render an integral material-spiritual-social 'world',[32] then acknowledgement of the *enhypostatic* inclusion of creaturely agency in the

[28] See, e.g., William P. Brown, *The Ethos of the Cosmos: The Genesis of Moral Imagination in the Bible* (Grand Rapids: Eerdmans, 1999), 36–52; Terence E. Fretheim, *God and World in the Old Testament: A Relational Theology of Creation* (Nashville: Abingdon Press, 2005), passim; Michael Welker, *Creation and Reality* (Minneapolis: Fortress Press, 1999), 6–20. Brueggemann, too, refers to a 'transactional' quality in the OT's description of the relationship between Creator and creation. See Brueggemann, 528.

[29] Brown, 41.

[30] Augustine, *City of God*, 11.6.

[31] Thus, for instance, the image of God as a *yotser* (potter) fashioning humanity from the clay is deployed quite naturally both in the narrative account of Gen 2.7–8 and in Jeremiah's poetic engagement with Israel's political history, fortunes and prospects (Jer 18.1–11; cf. Isa 29.16, Wis 15.7), and Paul's imaginative redescription of all this in the light of Christ (Rom 9.14–26; cf. 1 Tim 2.13, where the only other NT use of the Gk verb *plassein* refers back to God's fashioning of Adam from the earth, thus completing the exegetical circle). Cf. C.E.B. Cranfield, *A Critical and Exegetical Commentary on the Epistle to the Romans*, Vol. 2 (Edinburgh: T&T Clark, 1979); James Dunn, *Romans 9–16*, Word Biblical Commentary (Dallas, TX: Word Books, 1988); William McKane, *A Critical and Exegetical Commentary on Jeremiah*, Vol 1 (Edinburgh: T&T Clark, 1986).

[32] Brown, 1–33, passim.

relevant processes by which this same world is 'made' becomes inevitable (there can be no cultivation or culture without human activity), as does the concomitant insistence that its making continues beyond the threshold of the day of divine rest. Of course Adam's divinely mandated naming of the animals must be situated on a wholly different plane from God's own earlier 'creative' speech acts; but, if Brown's appeal to a biblical 'cosmopolis'[33] is correct, as a symbol of the birth and flowering of human 'culture' Adam's act of linguistic *poiesis* is nonetheless part and parcel of God's project to *establish* a world (which in this sense comes 'unfinished' from his hand), and not merely concerned with preserving or yet (since it arises in the narrative prior to sin's appearance) with redeeming one. Currents in the psychology of perception ever since Kant, and others in contemporary cultural theory point to the likelihood that categories such as 'object' and 'subject', 'nature' and 'culture' (cosmos and ethos) themselves are more closely entangled than we typically suppose, the boundaries between them permeable rather than absolute; however much may stand authoritatively over against us as something already divinely 'given', therefore, it seems that the reality of the 'human world' (the world as experienced humanly)[34] is in any case always one mediated by some relevant human activity of making – whether individual or social, explicit or occult. 'The world,' Iris Murdoch insists, 'is not given to us "on a plate," it is given to us as a creative task. ... We *work*, ... and "make something of it". We help it to be.'[35] If so, Steiner avers, the hermeneutics of 'reception theory' offers us a vital aesthetic analogue for the creation of a 'world' which comes to us thus deliberately (and wonderfully) incomplete and full of promise, implicating us directly and dynamically in the processes by which the 'work' takes shape, realising (and doing so only gradually) some if not all of the plenitude of potential meaning invested in it by the divine artist.[36]

Again, therefore, while for perfectly good theological reasons we may still wish to reserve talk of 'creation proper' for something that God and God alone does, and does during creation's first 'six days' alone, it seems artificial and perhaps even theologically unhelpful to draw the relevant lines with too thick a pencil. The biblical texts associated naturally with a doctrine of 'creation', it seems, flag continuities as well as discontinuities both between patterns of divine and creaturely action and between what precedes and follows the divine 'Sabbath' on the seventh day. Taken together with other considerations drawn from theological and 'non-theological' sources, this suggests that 'what creator and creature alike and together make of what has been made'[37] might even yet helpfully be viewed under the aegis of a creation theology, rather than being subsumed rigorously and

[33] See ibid., 13–14.

[34] Cf. Anthony O' Hear, *The Element of Fire: Science, Art and the Human World* (London and New York: Routledge, 1988).

[35] Iris Murdoch, *Metaphysics as a Guide to Morals* (London: Vintage, 2003), 215.

[36] Steiner, 53.

[37] Gunton, 89.

without further ado instead under the alternative rubrics afforded by doctrines of 'preservation', 'providence' or 'redemption'.

Making Good

The idea that God grants humankind a responsible participation in his own creative project is central to the Jewish notion of *tikkun olam*, the mending or perfecting of the world. As Jonathan Sacks notes, this notion has very ancient roots in strands of biblical and Mishnaic teaching, but receives its definitive synthesis in the kabbalism of the sixteenth century mystical rabbi Isaac Luria.[38] The central theme of the doctrine in its various forms is that the world that we inhabit as God's creatures is as yet imperfect (and in this sense God's creative vision remains unfulfilled or incomplete), and that every Jew, in the radical particularity of his or her circumstance, is called to share actively in the process of 'mending', 'perfecting' or completing the harmonious whole which God intends his creation to become and to be.[39] In its Lurianic version, as Sacks is at pains to point out, this participation is understood to be through particular concrete acts of piety and spirituality (and thus chiefly a matter of the soul) rather than by engagement in political initiatives for social justice or efforts to adjust the human impact on our created environment; but in the last hundred years or so the phrase has acquired a more inclusive connotation, all acts designed to avoid evil and do good, specifically religious or otherwise, being understood as a manifestation of *tikkun*.[40] The gist of this participatory vision is summed up neatly by Rabbi Joseph Soloveitchik:

> When God created the world, He provided an opportunity for the work of his hands – man – to participate in His creation. The Creator, as it were, impaired reality in order that mortal man could repair its flaws and perfect it.[41]

[38] See Jonathan Sacks, *To Heal a Fractured World: The Ethics of Responsibility* (London: Continuum, 2005), 72–8. For a more extended discussion of the idea see Scholem, 244–86 and Gershom Scholem, *The Messianic Idea in Judaism and Other Essays on Jewish Spirituality* (New York: Schocken Books, 1995 [1971]), 78–141, 203–27.

[39] De Lange notes that in Lurianic kabbalism the despoiling of the world occurs not in a prehistoric fall contingent on human freedom, but before or during the act of creation itself. The world is thus always a fractured, imperfect or incomplete project within which humans are called to act to secure the good. Nicholas De Lange, *An Introduction to Judaism* (Cambridge: Cambridge University Press, 2000), 206. Cf. Sacks, 74–5.

[40] See Sacks, 78; cf. De Lange, 206–8.

[41] Joseph B. Soloveitchik, *Halakhic Man*, trans. Lawrence Kaplan (Philadelphia: Jewish Publication Society of America, 1983), 101, cited in Sacks, 71.

Christians are likely to have some legitimate theological concerns and questions about elements of this religious narrative, and its linking of divine and human agency so directly in an account of the completion and redemption of the created order. Two concerns in particular stand out and demand some response. First, there is the suggestion that the world was from its inception already flawed or fractured, and received from God's hand, therefore, in a state needful of repair by (among other things) the work of human hands. Any such suggestion compromises the doctrine of creation's primal goodness, and flirts dangerously with gnostic notions of a world created not by God himself, but by an incompetent demiurge. Christian orthodoxy has always resisted such ideas, insisting that the world is from first to last the work of a Creator the hallmarks of whose character are infinite goodness, wisdom and love, and accounting for the brokenness and alienation of historical existence by appealing to the radical misuse of freedom and a consequent 'fall' of humankind into a condition of sin and death.[42] As Paul Fiddes observes, however, the theological notion of 'fall' is not inexorably wedded to a U-shaped narrative in which primal perfection is compromised and lost, to be restored again in due course by a divine salvage operation.[43] The primal goodness of creation can be understood otherwise than this. So, for example, Karl Barth interprets the divine pronouncement of creation's goodness in Gen 1.31 not as a valediction, but instead as an ordination, proleptic and eschatological in its vision: all that God has made is indeed 'very good', given its promised end in the fulfilment of the eternal covenant.[44] And it is true, surely, that the goodness with which Christian faith is finally concerned is not one speculatively posited in a remote prehistoric past, but one as yet to come, anticipated decisively in history's midst in the humanity of Jesus, but realised only in the promised future of God when all things shall be made new, and God himself will dwell amongst us as 'all in all'. Thus Fiddes outlines an understanding of fall not as a temporally situated once for all departure from an original perfection, but rather as the continual outcome of a human creatureliness as yet incomplete and imperfect, and therefore caught up in a dialectic between the possibilities of freedom and the limits of finitude, a dialectic constantly resolving itself either in trust and obedience or (more typically) anxiety and 'idolatry'.[45] Such a view does not, of course, view creatureliness and fallenness as the same thing, or ascribe the origination of evil and death to the Creator himself. Sin, and its consequences, remain the result of the creature's free choices. But this sort of view does face squarely the fact that sin arises due to a

[42] See, among patristic rejoinders to the idea, Irenaeus, *Against Heresies*, and Augustine, *City of God* XI.17; XI.23; XIII.1–3. For discussion see helpfully John Hick, *Evil and the God of Love* (London: Macmillan, 1966).

[43] Paul Fiddes, *Freedom and Limit: A Dialogue Between Literature and Christian Doctrine* (Basingstoke: Macmillan, 1991), Chapter 3.

[44] Barth, 212–13.

[45] i.e. seeking security in finite objects and goals, and granting these a worth properly due only to God.

vulnerability and weakness built into the structure of our finite existence, at least potentially. Doctrines of the fall of an Augustinian sort, which prefer to posit an original human perfection, face a number of significant difficulties of their own. They are, of course, entirely remote from anything in our experience of what it is to be human, and find it notoriously difficult to account for how or why it was that creatures enjoying unalloyed felicitude and imperturbability should choose to set it aside.[46] And such doctrines do not finally succeed in their aim of exonerating God of all responsibility for the presence of sin and evil in his world. To the extent that they ascribe ultimate sovereignty to God in creation and in redemption, they are at least compelled to acknowledge that he called into being a world which was, in Milton's phrase, 'free to fall'[47] and perhaps even bound finally to do so. Neither understanding of fallenness involves predicating sin and evil as functions of creation itself, or as necessary components of human existence as such; but each in its way finally admits that the *possibility* of sin and evil is given in the nature of the world as it comes to us from God's hand. The difference between them, finally, is that one seeks to 'justify the ways of God to men' by directing our imaginative gaze backwards to a primordial creaturely perfection, whereas the other (granting that the creation itself comes to us as yet incomplete and empirically 'imperfect') prefers to direct us to Christ, and to the fulfilment of God's promise in the future of Christ.

The other theological concern likely to trouble Christians in the notion of *tikkun olam* outlined above is the ascription of what is apparently too high a premium to the significance of human actions vis-à-vis the completion or perfection of the world, putting at risk an adequate account of divine transcendence and a theology of grace as the sole source of both our creation and redemption. That this is indeed a problematic inference of the Lurianic doctrine is suggested by Gershom Scholem, who notes the way in which an organic unity and continuity 'between the state of redemption and the state preceding it' tends to characterise some kabbalistic visions, so that redemption 'now appears … as the logical consequence of the historical process',[48] with God and humankind functioning effectively as partners (albeit unequal partners) in the enterprise. The specious wedding of process and progress that haunts our culture courtesy of the remaining vestiges of modernity grants such ideas a seductive allure even at the outset of the twenty-first century, and makes it all the more urgent that theologians speak clearly and unashamedly of the transcendent nature of Christian hope, vested as it is in God's sovereign otherness and Lordship, and not in any possibilities or potentialities latent within the creaturely (and fallen) order as such.[49] Any

[46] See the discussion of this same problem as it arises in Milton's *Paradise Lost* in Chapter 6.

[47] See John Milton, *Paradise Lost*, 3.99. See below, 155–8.

[48] Scholem, *The Messianic Idea in Judaism*, 47–8.

[49] See the critical rejoinder to the so-called 'myth of progress' in Richard Bauckham

indication that the world's redemption might be contingent in some way upon the nature of the actions we perform in the eschatological interim may well seem to compromise this transcendent commitment, and to constitute a pernicious form of 'works righteousness' inimical to the logic of the Christian Evangel.

As Sacks observes, in Judaism itself there is an unresolved tension at this point, *tikkun olam* functioning both as a principle for ordering human action in the midst of history and as an object of daily prayer and eschatological expectation.[50] It is, paradoxically, *both* something that God will do and must be implored to do (since we cannot), *and* something that we must do in the here and now and in the nitty-gritty of everyday decisions and actions. The achievement of cosmic harmony thus comes both 'from above' and 'from below' – from the side of the creature in faithful response to the Creator's calling and approach. Within the religious vision of Judaism, this dual insistence is bound either to remain an unresolved dialectic or else resolve itself in some form of religious and ethical synergism likely to place a crushing burden of responsibility on human shoulders. As we have already had occasion to notice, though, Christianity has a different framework to offer respectfully for consideration, one within which such seemingly contradictory claims may legitimately be situated and made sense of, without any confusion arising between them or any loss of integrity or force attaching to either as a result. In the messianic, priestly humanity of Christ, the Church discerns and proclaims a fully human action of *tikkun* corresponding directly to the creative and redemptive purposes and activity of God the Father and energised from first to last by the activity of the Holy Spirit. Furthermore – and decisively – this same human action is that undertaken by God himself, substituting his own humanity for ours at the heart of the covenant he has made with creation, not in such a manner as to exclude our due response, but rather to provide a context within which the partial and faltering nature of that response no longer has the power to crush us, being relativised in significance (though not rendered wholly insignificant) by the response of Christ made on our behalf.

Within a Trinitarian and incarnational account of atonement, and a corresponding understanding of human action as a participation in the priestly human action of Christ, in other words, the 'from above' and 'from below' dimensions of *tikkun olam* are able to be correlated and held together, and their whole dynamic situated within the overall triune pattern of God's activity and life. Only God can finally heal the world and bring it to completion. But he has chosen to do so not *without* a corresponding human action, but precisely in, with and through such action, concluded once and for all in the humanity of his own Son, but participated in and replicated ever and again in the Spirit-filled lives of others until the time when God will be all in all. Only God can

and Trevor Hart, *Hope Against Hope: Christian Eschatology at the Turn of the Millennium* (Grand Rapids, MI: Eerdmans, 1999).

[50] It arises at the heart of *Alenu*, the closing prayer of each daily liturgy. See Sacks, 75–6.

bring about the 'new creation' to which the apostles and prophets bear poetic witness; but in the meanwhile, we are called already to live in ways that declare this new creation to be a hidden reality, performing parables of it in the midst of history, and so conforming historical existence, piece by piece, more fully to its promised destiny in God's hands. It is this emphasis upon the significance of the piecemeal and the seemingly inconsequential that is one of the attractions of the notion of *tikkun olam*. Too often Christians are driven by a utilitarian ethic which supposes things worth doing only if some return can be identified on the investment, rather than understanding that good actions are worth doing precisely and only because it is good to do them, and that the world is in some sense made better thereby even when no grand strategy is advanced or outcome accomplished in the process. At one level, indeed, acknowledgement of the self-substitution of God's humanity for ours in Christ renders *every* other human action inconsequential; and yet, paradoxically, it simultaneously charges every action with a new significance by situating it within the sphere of action undertaken in union with Christ, and thus rendering it either a witness to or a denial of its reality as such. That the healing and completion of the world will not depend finally on my actions or yours is a vital inference of this theological vision; but that we are called, commanded even, to immerse ourselves fully in our own small part of the world and to do all that we can in every sphere of it to 'make good' the peculiar claims of faith concerning the world's origin and promised end, is an equally vital entailment. And it is, we should recall, precisely *this* world, and not some other, that will be taken up and made new by God in the fullness of time. And in that sense, nothing that we do, no choice that we make or action that we undertake in life, is wholly without eschatological consequence. For it is itself the object of God's redemptive promise.

The Liturgy of the Arts

One of the gains of an adequate theology of the priesthood of Christ is that it liberates us to acknowledge the potential liturgical significance of parts of our identity and action we have hitherto held back or supposed relatively 'secular' and lacking in religious merit. The news that the Son of God has laid hold of our humanity in its entirety and offered it back, crucified and risen, to his Father in the power of the Spirit for our sakes, compels us in our turn now to offer back to God in joyful thanks nothing less than all that we personally and communally are, and have and may yet become. As Jonathan Sacks notes, in biblical thought *homo sapiens* is the one creature which is itself identifiably 'creative', capable not just of adapting to its created environment, but of making more of that environment than is initially given in it;[51] enhancing, or adding value to it. Indeed, in as much as the world is apprehended as meaningful, it constitutes a distinctly human environment,

[51] Sacks, 79.

shot through with significance which transcends its materiality alone, a union of material being and semiotic excess in which 'a thing is not just what it is', and its reality takes time to unfold.[52] A distinctly human engagement with or indwelling of the world is thus inevitably and always one in which we 'make something of' the world rather than functioning as mere passive observers or consumers of it. To live responsibly in this sense, Rowan Williams suggests, is to draw out what is not yet seen or heard in the material environment itself, to 'uncover what is generative in the world',[53] and so, working with the grain of the cosmos, to aid and assist in the imaginative effoliation by which the world approaches more fully what it is capable of being and becoming. In offering our humanity back to God, therefore, we offer back to the world in which we are embedded bodily and culturally, and what we have made of it for good or ill.

The sort of creative imagination involved in human artistry, Williams submits, is thus not an eccentric or exclusive sort, but precisely an acute form of our wider human engagement with the world, with its distinctive dialectic of imaginative give and take.[54] The premise of artistry is that perception is always incomplete, that truthfulness unfolds as we continue to explore it, that there is always an excess of meaning in what is given to us for consideration.[55] Yet artistry, considered thus, is no mere cataloguing of the world's given forms, no 'mimetic' inventory of the extant. Art brings new things into existence, and, precisely in doing so, discovers that which it makes. Precisely because significance has no purchase apart from the actions and responses of those who indwell the order of signs, because human acts of signification and sense-making are already factored into our apprehension of an orderly and value-laden world (one in which 'cosmos' and 'ethos' are, as it were, perichoretically related), every act of discovery, of the uncovering or disclosure of new meaning, necessarily entails acts of making too, and every act of making lays bare some latent but hitherto unrecognised semiotic possibility. In art, as in life more generally, our calling is thus, paradoxically, to 'change the world into itself',[56] but we can do so precisely and only by means of imaginative responses which help to make of it more and other than it is as yet. Again, therefore, the necessary supposition is that the world is in fact not yet 'itself', but in some sense unfinished, with much more still to be drawn out of its primordial plenitude and fashioned in accordance with the 'generative pulsions' divinely invested and humanly intuited in it.[57] This is not 'creativity' of a sort that craves trespass on the soil of divine prerogatives, but it is nonetheless a participation in the unfolding

[52] Rowan Williams, *Grace and Necessity: Reflections on Art and Love* (Harrisburg, PA: Morehouse, 2005), 26.

[53] Williams, 162.

[54] Ibid., 140.

[55] Ibid., 135–9.

[56] Ibid., 18.

[57] Ibid., 27. Williams borrows the word 'pulsions' from Maritain. See Jacques Maritain, *Creative Intuition in Art and Poetry* (London: Harvill Press, 1953), 302–6.

of 'creation', and in God's making of new things and making all things new. It is precisely by means of our imaginative and 'creative' responses to the given world in the arts and elsewhere, therefore, that the world approaches that fullness of which it is capable (or, conversely, is held back from it).[58]

Having opened this chapter with a discussion of the work of Dorothy L. Sayers, it seems fitting to draw it to a close by referring to the thought of her direct contemporary and compeer J.R.R. Tolkien.[59] Looking back over his already lengthy career in 1954, Tolkien suggested to a correspondent that the whole of his literary output, imaginative and critical, had from the first really been concerned with exploring a single question; namely, the relationship between divine Creation and acts of human making or 'sub-creation' as he preferred to call it.[60] Two poetic texts in particular tackle the issue head-on, and in a manner which points to single abiding insight present from his very earliest ruminations on the subject: Primary and Secondary Reality, the world received from God's hand and 'what we make of it' in various acts of human *ars* are not to be too sharply distinguished, since they are both 'ultimately of the same stuff',[61] and our creaturely participation in each demands of us further acts of imaginative response and making. Creation, in other words, always solicits and enables further acts of a 'creative' sort rather than jealously guarding its own prerogatives.

The Elvish creation myth 'Ainulindalë' was cast in its final form in the 1950s and published only after Tolkien's death more than 20 years later, but its earliest

[58] Williams, 154.

[59] They were hardly colleagues, despite the popular association of Sayers' name with those of Lewis, Tolkien, Williams and others. In a letter to his son Christopher, Tolkien professed a 'loathing' for Lord Peter Wimsey and his creatrix! See J.R.R. Tolkien, *The Letters of J.R.R. Tolkien*, ed. Humphrey Carpenter (Boston: Houghton Mifflin, 1981), 82 [71, to Christopher Tolkien, 25 May 1944]. Doubtless the hyperbole can be taken precisely as such; but while they shared some common theological and aesthetic concerns, and despite the identifiable kinship between some of their ideas, Tolkien thought Sayers' detective fiction vulgar.

[60] Tolkien, 188 [153, draft, to Peter Hastings]. The letter was seemingly never sent. A related suggestion is contained in an earlier letter to Milton Waldman written in 1951: 'all this stuff', Tolkien writes (alluding to his entire mythological enterprise), 'is mainly concerned with Fall, Mortality, and the Machine' (Tolkien, 145 [131, undated, to Milton Waldman]). A footnote to the text reads 'It is, I suppose, fundamentally concerned with the problem of the relation of Art (and Sub-creation) and Primary Reality'.

[61] J.R.R. Tolkien, *Tree and Leaf, Including the Poem Mythopoeia & The Homecoming of Beorhtnoth* (London: HarperCollins, 2001), 30. The citation is from the essay 'On Fairy Stories' first published in 1947. Given the consonance of the idea with those expressed in earlier works, and its place in the argument of the essay as a whole, it seems likely that it dates back to the lost original (presumably much shorter) text of the lecture 'Fairy Stories' delivered in the University of St Andrews on 8 March 1939. On the history see Rachel Hart, 'Tolkien, St Andrews, and Dragons' in Trevor Hart and Ivan Khovacs, eds, *Tree of Tales: Tolkien, Literature and Theology* (Waco, TX: Baylor University Press, 2007), 1–11.

version belongs to the imaginative genesis of Middle-earth itself in the years immediately following the First World War.[62] It concerns Eru, or Ilúvatar, and his creation of the cosmos, not by solo virtuoso performance, but by calling into existence creatures themselves capable of sharing in the joyful task of bringing a world to completion. The metaphor in terms of which the myth pictures this creative interplay is itself, appropriately, an artistic one. Ilúvatar propounds a great musical theme, and invites the Ainur or Valar (the angelic first-created) to join in the music-making, each adorning the main theme with his own, to the end of a great and glorious harmony sounding forth. The creativity of the Ainur, therefore, is at once wholly unlike Ilúvatar's own creative act, while yet constituting an extension, development of and participation in it. While each of the angelic creatures is free to fashion his own individual melody, the skill or 'art' of the matter lies not in any sheer creativity *ex nihilo*, but precisely in the harmonious development of a theme which Ilúvatar himself has already propounded and which determines, as it were, the form of the overall work. The core image, then, is that of harmonising by free and spontaneous ornamentation. For his part, we are told, Ilúvatar will 'sit and hearken, and be glad that through you great beauty has been wakened into song'.[63] Creaturely acts of sub-creation, therefore, are here contingent on a divine self-limitation which, paradoxically, creates the conditions for that which pleases God's heart and satisfies his desire the most – reciprocal acts of a 'creative' sort, taking what God has given and offering it back enriched and enhanced in accordance with its original God-given store of possibility. Of course, such kenotic sharing of responsibility opens the emergent cosmos to malign influence, and Tolkien's myth, while hardly a *calque* on its biblical equivalent, has its own Miltonic Satan figure in Melkor, the most gifted angel of all, in whom sub-creative desire falls away from its proper orientation and manifests itself in the reality-denying wish 'to be Lord and God of his own private creation'.[64] Melkor's capacity for weaving discord and ruin amidst the primal harmony of the divine design is considerable, and it calls forth from Ilúvatar a deeper and superior artistry in order to redeem it, not (unlike the God of at least one Christian hymn) drowning out 'all music but his own',[65] but rather taking the offending and destructive noise up skilfully into the pattern of his own music-making in such a way that its significance is finally transfigured and made good. The bringing of the creative vision to fulfilment and completion, therefore, is by no means automatic or straightforward; but it *is* contingent on creaturely as well as divine action and response and, in God's

[62] See J.R.R. Tolkien, *The Silmarillion*, ed. Christopher Tolkien (London: George Allen & Unwin, 1977), 15–22. On the different rescensions of the myth see Trevor Hart, 'Tolkien, Creation and Creativity' in Hart and Khovacs, 39–53.

[63] Tolkien, *The Silmarillion*, 15.

[64] Tolkien, *Letters*, 145 [131, undated (1951), to Milton Waldman].

[65] 'Crown Him with Many Crowns' by Matthew Bridges (1800–94) and Godfrey Thring (1823–1903). The full text may be found in *The Methodist Hymn Book* (London: Methodist Conference Office, 1933), No. 271.

hands, it is finally secure rather than uncertain. In earlier versions of the myth, Tolkien was much more bold in his suggestion of a world given by God only in what amounts to outline form, with empty spaces deliberately left unfilled and adornments unrealised, looking to the 'eucharistic' artistry of the Ainur for their due enrichment and completion. Later editions tone this down slightly, as Tolkien perhaps increasingly realised the danger of theological misunderstanding, and felt the need to indicate more clearly the distinction he believed must indeed be drawn between that creating which God alone does and is capable of doing, and creaturely 'sub-creating' as he had by now dubbed it. For, while the myth is first and foremost a work of the literary imagination, making no obvious claim as such to a truth beyond its own borders, it is also an exploration and daring sketch of the contours of a theological aesthetic – an account not of primordial angelic sub-creating, but that 'artistry' to which human beings find themselves called in the very midst of Primary Reality.

The poem 'Mythopoeia' had its origins in a now legendary after-dinner conversation between Tolkien, C.S. Lewis and Hugo Dyson conducted in the grounds of Magdalen College on the evening of 19 September 1931.[66] Among other things, the substance of the conversation touched upon the capacity of myth (and by extension other imaginative and poetic forms) to deal in the stuff of reality and truth, rather than being (in the reported words of Lewis,[67] the 'Misomythus' of the poem's cryptic inscription) lies 'breathed through silver'. In his verse Tolkien playfully drives home his polemical point, that poetry may indeed be a sharp instrument in the hands of truth, helping us to cut the world at its joints, and he decries by comparison the sort of arid rationalism and literalism for which everything is exactly what its label says it is, and nothing is ever found to be more or other than it is. The poetic eye, the poem itself suggests, is thus the one best fitted to explore a world believed to be chock full of deep connections and hidden meanings, rather than exhausted in our measured consideration of its mere surface appearances. Furthermore, such acts of *poesis* are fundamental to the roots of human language and perception themselves ('trees are not "trees", until so named and seen – /and never were so named till those had been/who speech's involuted breath unfurled ...'),[68] and whatever world of meanings and significances we apprehend around us is therefore already in part a product of prior poetic responses to what is divinely given from beyond ourselves – a 'refracted light' which has been splintered from its pure white into a glorious array of colours only by being passed first through the prism of our humanity. We experience the world in accordance with the capacities invested in our nature, and far from being

[66] See Humphrey Carpenter, *J.R.R. Tolkien: A Biography* (London: HarperCollins, 2002), 196–9.

[67] The occasion was prior to Lewis's return to Christian faith from the atheism of his early adult years, and a significant moment in the narrative of that return. See Carpenter, 197–8.

[68] Tolkien, *Tree and Leaf*, 86.

essentially passive and receptive, those capacities turn out to involve us necessarily in acts of construction, interpretation and 'sense making' from the very first. There is, of course, a distinction to be drawn between Primary and Secondary Reality, but again it must not be drawn with too thick a pencil, since both are bound up with our peculiar poetic disposition towards things, and the boundaries between them are flexible and permeable:[69] we make, as Tolkien puts it 'in our measure and in our derivative mode', by the law in which we're made – 'and not only made, but made in the image and likeness of a Maker'.[70] To be participant 'in our measure and ... derivative mode' in God's own continuing creative engagement with the world and its possibilities of meaning, drawing it closer by constant small scale acts of 'guerrilla theatre'[71] to what, in God's creative vision, it was always intended to be, and what, through the work of his own hands, it will yet become and be, this, Tolkien suggests, is not just our right, but our distinctive creaturely calling and charge, whether used or misused.[72] And it is for acts of imaginative sub-creating that God looks and longs in his human creatures, craving nothing more than the glimpse of his own creative heart having found purchase and offered back in joyful thanks from the side of the creature. If, as Williams suggests, artistry is indeed but an acute and paradigmatic case of our wider human disposition to the world, then here the arts, holiness and worship promise to fuse in a manner as yet to be fully reckoned with in most of our churches, and with some potentially fruitful implications, perhaps, for a newly cast Christology. 'Dis-graced' we may well be, Tolkien avers; but neither the right nor the responsibility invested in us at our creation has decayed. 'We make still by the law in which we're made.'[73]

[69] Thus, artistic imagination may grant us 'Recovery ... a re-gaining – regaining of a clear view. I do not say "seeing things as they are" and involve myself with the philosophers, though I might venture to say "seeing things as we are (or were) meant to see them"'. ibid., 57–8. The concession, albeit made in passing, is significant, both including human response already within any accounting of the 'real', and suggesting the latter's susceptibility to modification by poetic redescription.

[70] Ibid., 56; cf. 87.

[71] Amos Wilder, *Theopoetic: Theology and the Religious Imagination* (Philadelphia: Fortress Press, 1976).

[72] Tolkien, *Tree and Leaf*, 87.

[73] Ibid., 87.

Chapter 6

Unauthorised Texts

Theology, Faith and Fictions

In the previous chapter we saw how works of the literary imagination (drama, poetry, myth) can engage fruitfully with religious and theological themes, and how explicitly poetic modes, contrary to popular presumption, may function perfectly well as efficient instruments in the hands of those concerned either to commend or to reckon further with aspects of reality as it is taken to be. My concern in this chapter is with the related suggestion that certain works of literature may properly function as texts of theology – texts, that is to say, that engage and wrestle with, and deepen our grasp upon the realities with which religion (and doctrine in its own distinctive mode) has properly and inevitably to do.[1] It is possible that this suggestion will be met with stiff resistance from certain quarters, and we must consider some possible objections to it.

First, there is the intellectual hangover from the specious dichotomy posited in the nineteenth century by Feuerbach and rejuvenated more recently by Gordon Kaufman between revelation and imagination.[2] Theology of a traditional sort, Kaufman notes, supposed itself to have received an authoritative revelation from God, and to be charged with re-presenting the gist of this in terms familiar and accessible to contemporary understanding. Kaufman himself, though, believes that revelation is no longer available to us as a meaningful category in the modern age, and that the reality of 'God' is one that in fact remains forever hidden and inaccessible to us.[3] Theological and religious language, therefore, must be understood rather differently, as the product of the constructive human imagination working up a concept or symbol of 'God' 'that gathers up into itself and focuses for us all those cosmic forces working toward the fully humane existence for which we long'.[4] In short, whereas 'revelation' comes down authoritatively from above as

[1] Cf. Richard Viladesau, *Theology and the Arts: Encountering God through Music, Art and Rhetoric* (New York: Paulist Press, 2000), 123–53. Viladesau's concern, though, is chiefly with pictorial art as such, and in particular its capacity to function theologically 'without the necessity of accompanying words' (123–4).

[2] See Ludwig Feuerbach, *The Essence of Christianity*, translated by George Eliot (New York: Harper Torchbooks, 1957); Gordon Kaufman, *The Theological Imagination: Constructing the Concept of God* (Philadelphia: Westminster Press, 1981). See above, 40–41.

[3] Kaufman, 21.

[4] Kaufman, 50.

the putative product of divine action, 'imagination' is the projection upwards from below of an image produced by the human imagination alone, thus possessing only whatever authority the Church or other human institutions choose to vest it with.[5] The theological task, therefore, is precisely one of poetic construction ('making things up' as popular parlance might put it), albeit one constrained by social and linguistic considerations of various sorts.

It is not my purpose here to respond to Kaufman's arguments, which demand more space and more careful dissection than my present task permits.[6] It will be clear from earlier chapters that I share to the full his conviction that theology is from first to last a highly imaginative enterprise. As David Bryant notes, however, what Kaufman gets quite wrong in articulating his case is his apparent assumption that the products of human imagining are, without exception, the products of imagination alone – that is, that the imagination is essentially and always *constructive* in its working, and has no significant *receptive* capacity whatever.[7] This is an odd supposition, since even a moment's reflection on various workings of the imagination in human life will compel the recognition that imagination can never work *ex nihilo* (despite the aspirations of some Romantic accounts of the matter), but always works with and transforms more or less significantly something given to it, by empirical experience or by some human tradition of language, belief and practice. Curiously, Kaufman's own account of how various images for God arise and are to be weighed and evaluated itself acknowledges precisely this, but what impresses itself on the reader's memory is the sharp polarity he presents between an essentially receptive disposition towards revelation and the essentially constructive nature of theology as an imaginative venture, and his proposal that theology must finally choose between the two. It is this – and the consequent elision of the distinction between the imaginative and the purely *imaginary* – that needs to be dismissed, in the theological context and elsewhere.

Imagination, as we have already seen, is the organ of meaning and, as such, furnishes the necessary conditions both for the construction of artifice and the intelligent statement of truth – and, indeed, for a whole range of meaningful constructs in which these coexist and coalesce in a fruitful manner.[8] Imagination,

[5] It is important to note that Kaufman wrestles long and hard with issues of authority, and is certainly not advocating an individualistic free-for-all. He does, though, shift the authoritative centre of gravity decisively away from the received heritage of ecclesial tradition to the perceived needs of a contemporary context.

[6] For helpful responses see Tony Clark, *Divine Revelation and Human Practice: Responsive and Imaginative Participation* (Eugene, OR: Cascade, 2008), 197–222; Bruce McCormack, 'Divine revelation and human imagination: must we choose between the two?', *Scottish Journal of Theology* 37(4) (1984): 431–55.

[7] David Bryant, *Faith and the Play of Imagination: On the Role of Imagination in Religion* (Macon, GA: Mercer University Press, 1989), 54–5.

[8] See above, 13–16.

too, precisely in its capacity for the deliberate construction of 'heuristic fictions'[9] of one sort or another, is a vital tool for the extension of our knowledge of the world and whatever lies beyond it. So, we cannot simply dismiss the imaginative as such and suppose that by doing so we secure the interests of authoritative knowledge and its intelligent ordering. Furthermore, once it has been conceded – as it must be – that even the most radical imaginative departures from the texture of reality are nonetheless compelled to begin and to work with materials given to them from beyond the scope of their own generative powers, the question of how much is given and of its ultimate provenance becomes an open one, and the suggestion that God might give himself to be known not in ways that are exclusive of acts of human imagining (a sort of divine 'download' of data inviting a purely passive disposition), but precisely in ways that solicit, demand and undergird responses of a highly imaginative sort is put back in play.[10] When we consider the texts that lie at the centre of any Christian talk about revelation, of course, the substance of what we find certainly encourages rather than discourages the supposition that this is so. Not only is the literary genre of much of the Christian canon of a sort that makes explicit appeal to our imagination first – parable, story, poetry, saga, apocalypse, proverbs and so on – and only thereby to our powers of intellectual judgement and affective and moral response, Jesus' own ministry of teaching and preaching and healing and sign-giving was, from all that we know of it, one that drew men and women into discipleship (and left others cold) via a continual and sustained appeal to their powers of imagination. 'How, then, shall we picture the kingdom of God?' is perhaps sufficient dominical mandate for taking the religious and theological importance of imagination thoroughly seriously, and for considering an understanding of revelation as a continual divine bid by the Holy Spirit to take our imagination captive, compelling us to see, hear, feel and taste the world in a wholly new manner and to respond accordingly. And I have already argued above that theology (which is predicated upon and part of that same response) is always and necessarily engaged with images of one sort or another, and thus with the operations and outputs of imagination.[11] So, the suspicion that acknowledgement of the role of imagination as such is corrosive of theological claims to be grounded in a knowledge revealed, God-given and authoritative is ill-founded, and can safely be set aside, whatever more remains still to be said.

[9] Paul Ricoeur, *The Rule of Metaphor: Multidisciplinary Studies of the Creation of Meaning in Language*, trans. R Czerny and others (Toronto and Buffalo: Toronto University Press, 1977), 239.

[10] Kaufman, as we have noted, believes revelatory acts as such to be impossible, or at least non-actual; but we need feel no obligation whatever to share this assumption, which is one held on quite independent grounds, and which has no necessary connection whatever with the alleged presence or absence of an imaginative component in religious and theological knowing.

[11] See above, 33–8.

It remains true nonetheless, that imagination works in different ways and produces quite different sorts of outputs, and this observation might occasion a second, rather different objection to the claim that works of literary imagination may function as texts of theology. Surely, it might be argued, the nature of literature is playful and open ended, eschewing the moral demand to provide an authentic or 'true' account of any circumstance, and prone thereby to muddy the waters of reality rather than lending itself naturally to a clear and concise analysis and accounting of the sort that theology, in the interest of helping faith better to understand its object, typically seeks? This criticism though, can and should be turned promptly on its head. Just as imagination can and does do more than one sort of thing, so too theology, in its turn, is patient of more than one mode of working and one sort of outcome. And, far from the open-textured and technically uncommitted nature of literary imagining being a fatal flaw, for some theological purposes, we might insist, it presents itself rather as a potential virtue.

Perhaps it may help if we differentiate at this point between theology and doctrine. For convenience, let's define doctrine as the attempt to clarify and to offer a cogent statement of what the Church believes and has classically believed across the centuries. This is a vital intellectual task, and while (for all the reasons rehearsed above) it can and will hardly be one entirely free from the contributions of imagination, its *modus operandi* will typically be one that seeks to delimit and define, closing down the available options in the interests of clarification and the establishment of a core of consensual confession. Of course, there may still be differences of perspective to be had and even disagreements to be lived with (different 'doctrines' of the person of Christ, of the Spirit, of the Church, and so on); but in so far as each is concerned with formulating – as clearly as the intrinsic mystery of faith's object permits – what can and should be confessed in relation to various articles of faith, each shares the doctrinal imperative of *stating* that mystery and doing so in a manner that equips Christian preaching and teaching in its faithful rendering of the story of God's dealings with the world.

Understood thus, doctrine is obviously a form of theology, of thinking and speaking about God. But it is not the only form. Theology needs to be willing, too, to interrogate, open up and explore the entailments of what is given to it in revelation, to consider different possibilities, and to ask uncomfortable questions and adopt alien standpoints, precisely in order better to understand its own perspectives. It needs to do this continually, returning afresh to hear the Word spoken to it from beyond, rather than resting content with the mere transmission and translation of an agreed set of formulae. Furthermore, precisely in faithfulness to what it believes itself to know of the God who has given himself to be known – viz., that this God is ultimate mystery, otherwise unknowable, and remaining veiled even in the midst of being revealed[12] – theology must reckon with the semantic shortfall and excess of all its statements, and never rest content that it has its object pinned down, and trussed up for easy inspection. Paul Fiddes puts the matter very

[12] See above, 63–4.

helpfully.[13] There is, he suggests, on the one hand a vital movement '*from* Mystery to us' in revelation as God seizes our language,[14] and this places us under an obligation to speak in our turn, and to speak as clearly as possible what we believe has been said to us. But there is also a perfectly proper and theologically important movement from the side of human reflection '*towards* Mystery', as our response to revelation takes the form not just of fixing and determining meaning, but forever seeking to interrogate and immerse ourselves imaginatively in its fertile excess afresh, unafraid of becoming lost, precisely because we trust the one who holds us and will not let us go. As Fiddes suggests, both of these impulses are necessary, and must be sustained in a constant and constructive dialogue if theology is not either to lapse into an amorphous flux of images, uncertain what it believes or why, or, on the other hand, to wither into an arid dogmatism long since drained of vital contact with the living Mystery of faith itself.

There are, of course, numerous forms which the human move towards mystery may take. Here, it suffices to note that all are necessarily highly imaginative, and that the literary imagination affords a number of such forms for consideration. Furthermore, as Fiddes observes, since 'all creative writing ... is concerned with human experience', it 'is occupied with themes that also occupy Christian faith and theology'.[15] This being so, most such writing may serve to provoke and stimulate theological imagining of a sort which, drawn into creative conversation with the distinctive voice of doctrine, holds out possibilities of renewal and regeneration, and a strengthening rather than any weakening or dilution of doctrinal reformulation of the tradition. It is precisely such a dialogue which Fiddes hosts fruitfully in *Freedom and Limit*, and it furnishes a worthy model. My concern here, though, is with works of literary imagination which, beyond furnishing an imaginative stimulus for theological reflection, might themselves reasonably be claimed as 'theological' texts, albeit ones quite different in form and tone to works of doctrine. Identifying such texts (and so excluding others) is itself a task rendered complex in the post-Christian context, with the social imaginary still populated by (albeit often unawares) and indebted to the symbols, images and narratives of its Christian heritage. Determining what may sensibly count as situating itself imaginatively within the horizons of Christian faith and practice, and thus concerned to move us towards and deeper into the Mystery (rather than merely into 'mystery') is often far from straightforward. Fortunately, my concern in the remainder of this chapter is with two literary texts each of which situates us as readers or audience (one is a drama) identifiably, quickly and fully within the world of biblical story, and is concerned in one way or another to explore and unfold the substance of that world and its possible theological entailments from

[13] See the discussion in Paul Fiddes, *Freedom and Limit: A Dialogue* (London: Macmillan, 1991), 8–15.

[14] See Karl Barth, *Church Dogmatics* I/1, 2nd ed., trans. G.W. Bromiley and T.F. Torrance (Edinburgh: T&T Clark, 1975), 430.

[15] Fiddes, 33.

within. Each, I shall suggest, offers a serious engagement with the Mystery of faith which, precisely by its open-endedness and imaginative detachment from the constraints of accepted doctrinal orthodoxies or 'authorised' perspectives, develops 'heuristic fictions' intended to enhance rather than distract or detract from the interests of theology in the wider sense, and thus, through a creative dialectic, of doctrine as such.

Byron's *Cain: A Mystery*

The observation that Lord Byron's *Cain: A Mystery*[16] keeps company with some of the thornier issues of theodicy is hardly a new one. But the play does so, it seems, on two quite distinct levels. First, the problem of 'justifying' God in the face of the often horrendous evils confronting us in God's world is woven explicitly into the dialogue and the action of the drama itself. The so-called logical form of the problem (in which definitions of goodness and omnipotence are triangulated with the surd fact of evil in order to generate an atheistic reductio ad absurdum) is alluded to directly at least twice by the eponymous anti-hero. So, for instance, in an early soliloquy, dismissive of the piety and comfortable religious certainties of his parents and siblings, Cain complains:

> They have but
> One answer to all questions, "'twas [God's] will,
> And *he* is good". How know I that? Because
> He is all-powerful must all-good, too, follow?
> I judge but by the fruits – and they are bitter. (I, i, 74–8)[17]

Secondly, though, in a peculiar parallel to this natural theological move from below to above (from the evidence of the world to disputed inferences concerning the intent and character of its creator) we find, in the criticism on the play, a literary-critical version of the same move. Now it is the 'world' of Byron's drama that is under close scrutiny (what happens in it and, chiefly, what is said in it), and the intent and character of *its* maker that is being either confidently 'read off', or anguished over, on the basis of the available evidence.

In her own sustained essay tracing parallels between the God–world relation and the artist's relationship to his text, Dorothy L. Sayers noted that for some reason 'we are continually tempted to confine the mind of the writer to its expression within his creation, especially if it suits our purposes to do so. We try to identify him with this or that part of his works, as though it contained his whole

[16] For the text, see Jerome J. McGann and Barry Weller, eds, *Lord Byron: The Complete Poetical Works*, Vol. VI (Oxford: Clarendon Press, 1991), 228–95.

[17] Cf. 2.ii.284–5. '... my sire says he's omnipotent:/Then why is evil – he being good?'

mind'.[18] In fact, of course, the mind of the maker transcends his work. And, even though in the strictest sense it must be true that 'a writer cannot create a character or express a thought or emotion which is not within his own mind',[19] the relation of transcendence remains vital. Authors create through acts of imagination, calling into being realities that are genuinely other than themselves as well as firmly tied to their creative energy and vision. Indeed, 'if a character becomes merely a mouthpiece of an author, he ceases to be a character, and is no longer a living creation' with an integrity of his own.[20] Literary ventriloquism, in other words, is tantamount to pantheism, and the genuinely creative relation breaks down completely at that point.

Furthermore, whatever standpoint we may adopt within the larger critical problem of authors and their intentions, we need to reckon with the fact that, as C.S. Lewis puts it, our chief concern in reading literature should not be utilitarian, any more than the author's was in writing it, but with allowing our imaginative capacities (and through them our emotions, moral sensibilities and spiritual awareness) to be stimulated by the imaginary pattern created by the artist. There is, we might say, an intrinsic and deliberate moral distance between the imaginary worlds of art and the real world. Even in the most realistic of fiction, Lewis argues, we are not being told 'this is what the world is like' (or even may possibly be like), but given an imaginary 'as if' for aesthetic enjoyment.[21] The point can be overstated, of course; but it does need to be taken seriously. Too many theologies would have us treat the world – in all its complexity – as a stepping stone to an encounter with its maker, rather than something to be reckoned with and 'enjoyed' in its own right. Yet a theology of creation as 'gift' is bound to insist that we linger at the level of the world itself, treating it in some proper sense as an end, and not merely as a means to some ultimate or spiritual goal.

Creation, Transcendence and the Mind of the Maker

The equivalent literary point has often been made in relation to the world of *Cain*, not least by its maker himself. Thus, in a letter to John Murray dated 3 November 1821, Byron notes that for the sake of dramatic consistency (and, one might say, permitting his key characters the sort of creaturely 'freedom' appropriate to the world he has summoned into being): 'I was obliged to make Cain and Lucifer talk [in the manner they] – and surely this has always been permitted to poesy?'[22]

[18] Dorothy L. Sayers, *The Mind of the Maker* (London: Methuen, 1941), 39.

[19] Ibid.

[20] Ibid., 41.

[21] C.S. Lewis, *An Experiment in Criticism* (Cambridge: Cambridge University Press, 1961), 88.

[22] Leslie A. Marchand, ed., *'In the Wind's Eye'. Byron's Letters and Journals*, vol. 9 (London: John Murray, 1979), 53.

A similar case is urged by Byron's most ardent advocate in the spat that ensued over the publication of *Cain* by John Murray in December 1821. Addressing himself to the charge of the anonymous 'Oxoniensis' – that the play was an organ of sedition and blasphemy, its author at best a sacrilegious mischief maker out to make a fast buck, and, at worst, to be numbered among the party of Lucifer himself[23] – the self-styled 'Harroviensis' concentrates on showing how the poet John Milton, when measured by the same standards, permits his own diabolic characters sentiments every bit as heterodox and irreligious as anything to which Byron's imagination has given voice. Yet Milton's name is held in 'highest honour and applause'. The demoniacal opprobrium granted existence in each case is, he suggests, precisely a matter of the poet being true to the world and the characters he has chosen to make, and is to be treated as such in the first instance. After all, what self-respecting fiend would speak the pious language of angels, or encourage his human protégé to do so? Is hateful blasphemy not precisely what we should expect, and therefore its presence part and parcel of the creative skill whereby a secondary world is called forth, and our belief in it secured?[24]

Finally, though, Harroviensis compromises the real force of his own argument. So determined is he to acquit Byron of the charge of being the author of the evil that stalks his dramatic world, that he mounts an alternative 'natural theological' case, stacking up the evidence of the text as a whole in a bid to construe the poet instead as a great moralist and the champion of a spiritually edifying orthodoxy. But Byron himself was probably innocent of this charge too, his own insistence that the play is 'as orthodox as the thirty nine articles' positively dripping with irony.[25] The point is, surely, that to make either move is to miss the point. There is something about the nature of the creative relationship itself which means that the creator always remains veiled behind as much as being revealed in and through his or her work, and consideration of the content of the work in itself can generally do little to help us to discern where the relevant continuities and discontinuities lie.

Cain *as a Theological Text?*

This cannot mean, of course, that 'poesy' can have no very serious moral or spiritual purpose and effect, as though it were a mere playful trifling with imaginative 'as ifs', a matter of entertainment only, titillation, and never transformation. Byron's plea that '*Cain* is nothing more than a drama – not a piece of argument' does nothing to exculpate him from the charge of doing theology in this sense.[26] It

23 Oxoniensis, *A Remonstrance Addressed to Mr. John Murray Respecting a Recent Publication* (London: Francis and Charles Rivington, 1822),

24 See Harroviensis, *A Letter to Sir Walter Scott, Bart. in Answer to the Remonstrance of Oxoniensis on the Publication of Cain, A Mystery, by Lord Byron* (London: Rodwell and Martin, 1822), 7–8.

25 Letter to Douglas Kinnaird of 4 November 1821. See Marchand, 56.

26 Letter to John Murray of 8 February 1822. See Marchand, 103.

merely draws our attention to the fact that by choosing to write a drama (and nothing less than a drama), rather than a religious pamphlet, any theology that he does will be of a quite distinctive sort, one that spoils all expectations of rigorous argument and compels us to view such, should it arise in the dialogue, with due suspicion, refusing to be persuaded unless and until the work as a whole has been reckoned with, and happy to suppose that closure in any guise, even the closure of 'an overall point of view', as Wolf Z. Hirst puts it,[27] may actually be something more and other than the writer intends to convey. The poet's description of the play's subject as 'A Mystery' is, it seems, not wholly a gesture of tribute to earlier dramatic traditions,[28] but equally an announcement that we should expect a piece concerned more to explore and chart the contours (emotional and spiritual as well as intellectual) of difficult and uncomfortable territory than to furnish any confident – let alone easy – answers. The drama creates a self-contained reality in which unpalatable possibilities can be contemplated, conflicting voices heard in all their strength, and contradictory perspectives indwelt. It is in this way that the drama's distinctive excess or surplus of meaning is brought to bear. It can make us feel (and thus 'know' in the fullest sense) the force of the painful questions that life often thrusts cruelly upon us but single-mindedly refuses to answer. Here reality is understood by being 'tasted' rather than reflected upon, even though our tasting of it is through the skilled artifice of the poet's pen rather than direct and raw as in life itself. But for that very reason, we can risk lingering awhile in those places where, in life, we might not dare to linger, the distance between the imagined world and our own being just sufficient to have, as it were, the best of both without losing touch with either. The outcome can often be a more full-orbed and emotionally adequate grasp on our own reality, refusing to endorse any view (theological or otherwise) that achieves its answers too easily or only by suffocating the most important questions before they are properly born.

Despite the preferences of theologians for tidying things up into packages altogether neater and more certain than the texture of reality typically is, we should at least note that the Bible regularly adopts this same imaginative strategy. So, as the Old Testament scholar Walter Brueggemann notes, alongside the 'core testimony' to God's character and actions that furnishes the 'overall point of view' of the Scriptural witness, there are elements of vibrant and vital 'counter-testimony' in which serious questions are asked of God, and in which he is construed on occasion as 'devious, ambiguous, irascible and unstable'.[29] That such perspectives are aired, and such questions asked, Brueggemann suggests, is an important part of the health of the text, giving vent to feelings that, far from being sacrilegious

[27] 'Byron's Lapse into Orthodoxy: an Unorthodox Reading of *Cain*', in *The Plays of Lord Byron: Critical Essays*, ed. by Robert Gleckner and Bernard Beatty (Liverpool: Liverpool University Press, 1997), 253–72 (270).

[28] See Byron's Preface to the play, McGann and Weller, 228.

[29] Walter Brueggemann, *Theology of the Old Testament: Testimony, Dispute, Advocacy* (Minneapolis: Fortress Press, 1997), 359.

or blasphemous, constitute an important and natural part of faith's response to the messy and painful eventualities that divine providence encompasses. God, we may suppose, is big enough to handle any possible offence caused.

Hope Baffled, but Not Lost

In the entry dated 28 January 1821 in his 'Ravenna Journal', Byron notes that he has been pondering 'the subjects of four tragedies to be written (life and circumstances permitting)'. Among these projects is 'Cain, a metaphysical subject, […] in five *acts*, perhaps, with the chorus'. Later in the same entry, among some 'memoranda', we find the following reflection:

> Why, at the very height of desire and human pleasure […] does there mingle a certain sense of doubt and sorrow – a fear of what is to come – a fear of what is […] Why is this? […] I know not, except that on a pinnacle we are most susceptible of giddiness and that we never fear falling except from a precipice – the higher the more awful, and the more sublime; and, therefore, I am not sure that Fear is not a pleasurable sensation; at least, *Hope* is; and *what Hope* is there without a deep leaven of Fear? and what sensation is so delightful as Hope? and, if it were not for Hope, where would the Future be? – in hell.

And then:

> Thought for a Speech of Lucifer, in the Tragedy of Cain: –
> Were *Death* an *evil*, would *I* let thee *live*?[30]

While Byron's creative purposes must finally be permitted some appropriate level of apophatic inscrutability, it seems reasonable to suggest that here, at least, we are given a glimpse of the germinal thought, feeling or question which duly grows and takes form in *Cain: A Mystery*. If '*Death*' (understood now as synechdoche for all that opposes, pollutes and finally prevents human life and flourishing) is indeed an evil (as it certainly seems to be), and if (as a vision conjured up by Lucifer in the play of the whole history of creaturely suffering suggests) death has a stranglehold on life from first to last, then why the hell (as it were) does God grant us life in the first place? What is he playing at? Is this not a strange 'gift' indeed, that inflicts pain on us even as we enjoy it, and that will, in any case, finally be wrenched from our grasp just as we have become used to it? Would it not be better for Cain's infant son Enoch to be dashed horribly against the rocks before his innocence rather than his skull is shattered? Are all dreams, desires and aspirations not thwarted from the outset by the fact that, as Cain's wife Zillah proclaims towards the play's end, 'Death is in the world' (III, i, 370)? It is this fact, and its significance, that haunts

[30] Leslie A. Marchand, ed., *'Born for Opposition'. Byron's Letters and Journals*, vol. 8 (London: John Murray, 1978), 36–7, 38, 39.

Cain throughout the play. It is death that he is preoccupied with, death that he seeks knowledge of, a vision of death that he is granted, and death that, ironically, he himself grants entrance on to the world stage. 'Death is in the world.' What are we to make of that? It is first Cain's questioning, and then the despair born of the 'knowledge' bestowed by Lucifer's vision, that occasion some of the play's most impassioned utterances:

> Thoughts unspeakable
> Crowd in my breast to burning, when I hear
> Of this almighty Death who is, it seems,
> Inevitable. (I, i, 256–9)

Thoughts unspeakable – yet thoughts, and feelings, that must be spoken, that must be aired, that we must be allowed to air. Which of us has not known the reality of such thoughts and feelings? To feel less would be to be less fully human, not more. But Cain's perspective, whether his early incredulity or his later wretched hopelessness, is not the drama as such. And the play leaves hanging to the end questions about the inevitability, the finality of death, about death's hold over life as a matter of 'seeming'. To be sure, it 'seems' to be thus. All the available evidence, when weighed in the balance, points us in that direction. Yet the drama suggests (nothing more) that even yet it may prove not to *be* thus. As Harold Fisch has observed, the closing scene contains a beginning as well as an ending,[31] with Cain and Adah cast out towards the East, bearing their children with them rather than putting them out of their misery. There is a hint here, then, of promise, of new possibilities, and finally, perhaps, even of an 'omnipotent benevolence –/ Inscrutable, but still to be fulfill'd' (III, i, 235–6). The evidence of the play itself cannot *show* us this, any more than that of our lives in the world can; but it leaves us, at the last, when all the rage and anguish have been vented and allowed to subside, with a hope that may, indeed, often be 'baffled' by the mystery of it all, but that is not yet lost.

Poetry and Theology in *Paradise Lost*

In his 1925 study *Milton: Man and Thinker* Denis Saurat urged upon his readers the importance of the attempt to 'disentangle from theological rubbish the permanent and human interest of (Milton's) thought'.[32] The thought is the familiar modern one that what really matters in poetry, as elsewhere, transcends the accidents of time and place (and particular theological commitment), and may only be had by a painstaking process of stripping these away. In his *Preface to Paradise Lost* (1942)

[31] 'Byron's Cain as Sacred Executioner', in Wolf Z. Hirst, ed., *Byron, the Bible, and Religion* (Newark, NJ: University of Delaware Press, 1991), 25–38 (25).

[32] Denis Saurat, *Milton: Man and Thinker* (New York: The Dial Press, 1925), 111.

C.S. Lewis responded, in typically forthright and colourful fashion, that this was somewhat like 'asking us to study ... centipedes when free of their irrelevant legs, or Gothic architecture without the pointed arches'.[33] Somehow the very point of the matter has been missed, or at least wantonly denied. 'Milton's thought,' Lewis insists, 'when purged of its theology, does not exist'. Much more recently, Theo Hobson has laid an analogous charge at the door of post-Romantic approaches to Milton's poetry as 'Literature' which regularly laud him as a great poet, yet assess his worth as such without reference to those ideas which, on another view of the matter, appear to be the very life-blood of his poetry itself. This, Hobson suggests, is like celebrating Jesus as a 'great moral teacher'; the judgement is not itself false, but it hardly scratches the surface of what really matters about his teachings.[34]

As a pre-Romantic, Milton himself would not have recognised the point of a tribute to his or anyone else's poetry in terms of its aesthetic and 'literary' aspects alone. Of course he understood perfectly well that poetry was gratuitous beyond any utility it might also possess. Indeed, as Frank Kermode notes, 'From all that Milton says about the way poetry works, it is clear that he asks of it not that it should *immediately* instruct, but that it should immediately delight'.[35] It is also true enough that 'Milton wrote a theological treatise; but *Paradise Lost* is not it'.[36] *De Doctrina Christiana*, in effect a work of systematic theology, was composed over several decades and probably completed at the end of the 1650s, just seven years before the publication of *Paradise Lost*.[37] But the aestheticist notion of an art produced 'for art's sake' was unknown in Milton's day, and the words of poetry mattered for much more than their music alone. In an early anti-prelatical tract[38] Milton himself articulates a vision of the poet as one uniquely gifted by the Spirit to gauge the verities of human life under God and, by showing these forth in ways sufficient to capture the popular imagination, transform the conditions of personal and public life alike. Instruction and delight, he clearly believed, could

[33] C.S. Lewis, *A Preface to Paradise Lost* (London: Oxford University Press, 1942), 65.

[34] Theo Hobson, *Milton's Vision: The Birth of Christian Liberty* (London and New York: Continuum, 2008), 164. Phillip Donnelly's recent work also insists upon holding Milton's theology closely together with his poetry if we are properly to understand the latter. See Phillip J. Donnelly, *Milton's Scriptural Reasoning: Narrative and Protestant Toleration* (Cambridge: Cambridge University Press, 2009), esp. 73–165.

[35] Frank Kermode, 'Adam Unparadised', in *The Living Milton*, ed. Frank Kermode (London: Routledge & Kegan Paul, 1960), 92.

[36] Ibid., 91.

[37] On this text and the circumstances surrounding its composition see Gordon Campbell and Thomas N. Corns, *John Milton: Life, Work, and Thought* (Oxford: Oxford University Press, 2008), 271ff.

[38] 'The Reason of Church Government Urg'd Against Prelaty' (1641). For the relevant passage see Frank Allen Patterson, ed., *The Works of John Milton*, vol. 3.1 (New York: Columbia University Press, 1931), 238.

and should interpenetrate, and in this sense the poet could and must properly be a 'theologian' too.

Milton's poetry issues from (and situates itself explicitly within) the intellectual, practical and affective world of Christian faith in the early-modern period. This was, William Poole observes, a period when the narrative centre of gravity of *Paradise Lost* (in Genesis 3) and doctrinal constructs attendant upon it were at the forefront of theological conversation.[39] Among Protestant variations on Augustinianism, differing perspectives on the doctrines of grace, freedom, foreknowledge, the divine decree and the state of human nature before and after the 'Fall' were bandied around as convenient markers of party allegiance, and all came to a head conveniently in contested readings of this particular biblical text. Why *did* Adam do what he did? This, of course, is an interesting religious and theological question. But in an age when religious and political visions were more difficult to disentangle than they sometimes are (in theory at least) today, the exegesis of biblical texts both informed and was in turn informed directly by the realities of public life, and a question about the conditions of Adam's fall was naturally understood to be a question about what human beings are really like when push comes to shove and, consequently, how human societies might most appropriately be ordered for the common good. For Milton and his contemporaries, the true context for human action could really only be understood through an imaginative grasp on a profoundly theological vision of reality, a vision of the precise sort Milton himself offers in *Paradise Lost*.

Certain questions in particular exercised Milton throughout his life, especially those to do with human liberty and the conditions under which it may meaningfully be exercised in a moral way. Thus in *Areopagitica* (1644), attacking Parliament's efforts to curb the freedom of the press, we find the following:

> If every action which is good, or evill in man at ripe years, were to be under pittance, and prescription, and compulsion, what were vertue but a name, what praise could be then due to well-doing, what grammercy to be sober, just or continent? many there be that complain of divin Providence for suffering Adam to transgresse, foolish tongues! when God gave him reason he gave him freedom to choose, for reason is but choosing; he had been else a meer artificiall Adam, such an Adam as he is in the motions. ... Assuredly we bring not innocence into the world, we bring impurity much rather: that which purifies us is triall, and triall is by what is contrary.[40]

Temptation, in other words, is the necessary condition not only for sin, but for its opposite too, obedience and the cultivation of true virtue. Goodness which

[39] See William Poole, *Milton and the Idea of the Fall* (Cambridge: Cambridge University Press, 2005), esp. chapters 3–4.

[40] See Frank Allen Patterson, ed., *The Works of John Milton*, vol. 4 (New York: Columbia University Press, 1931), 319, 311.

never has to grapple with evil (either because its choices are coerced, or because the opportunities for evil are carefully airbrushed out of its world in advance) is bound only to be a shallow and morally sickly thing; and the establishment of good in place of evil impulses in human lives lies only through victories in battle rather than strategies of constant retreat. If, then, we would truly be delivered from evil, Milton is suggesting, it can only be because we have first been led into (or exposed to) temptation. And it is this, he muses, that 'justifies the high providence of God, who though he command us temperance, justice, continence, yet powrs out before us ev'n to a profuseness all desirable things, and gives us minds that can wander beyond all limit and satiety'.[41] Another two decades would pass before the publication of Milton's more famous attempt to 'justify the ways of God to men', yet the theological and political themes explored poetically in *Paradise Lost* are here already on the table.

Milton, then, was immersed to the hilt in the political theology of his day, and we cannot glibly brush this practical, fiduciary and intellectual context aside in the pursuit of 'purely aesthetic' considerations. The beliefs, the ideas, are absolutely essential to the way the poem works *as a poem*, fusing the concerns of heart and mind and will together in an imaginative vision which challenges and reshapes not just our thinking, but in Lewis's phrase our 'total response to the world'.[42]

'Forewarn'd', or 'seduc'd to foul revolt'?

If, as I have suggested, it is important to approach *Paradise Lost* as a text which is concerned to instruct as well as to delight its readers, it is equally important to ask about the precise manner in which this instruction is duly delivered. By its very nature, as we have already noted, the voice of poetry is generally more elusive, more indirect than that of manuals of doctrine, demanding a far higher level of interpretation. To misidentify or mishear the 'voice' of the poem is (even in cases where higher rather than lower levels of reader reception must be acknowledged as essential to the event of poetic meaning) to jeopardise the broad shape of the learning and teaching process which the poet hoped to set in motion.

How, then, in *Paradise Lost* should we think of Milton placing himself (or rather the voice of his poem) and his readers vis-à-vis the received theological orthodoxies of his day? His poem contains many voices, and in the nature of the case they articulate many different perspectives, perspectives which often stand in stark contradiction to one another. The poem could hardly contain the drama that it does otherwise, drama being largely a matter of the careful generation and subsequent resolution of conflicts. But where, amidst all this complicated play of locution are we to identify the singular 'word' of the poem itself speaking to us and – since Milton deliberately casts his epic within the context of prayer,

[41] Ibid., 320.

[42] Lewis, *A Preface to Paradise Lost*, 54.

transforming Homer and Virgil's appeal to the Muse into an invocation to the Spirit – for the poetically mediated Word of God?[43]

I want next briefly to identify four literary-critical answers to this question, before turning to a theological issue that lies at the very core of the poem's treatment of Genesis 3, and considering it in the light of them. On the basis of that, I shall end by proposing that a fifth alternative may need to be entertained.

1. According to one tradition, notoriously pioneered by Blake and Shelley, and subsequently developed by William Empson and others, Milton's poetry must finally be judged heterodox in its theological achievements, whether he intended it that way or not. So, in Plate 6 of *The Marriage of Heaven and Hell* (c.1790), William Blake suggests that 'Milton wrote in fetters when he wrote of Angels & God, and at liberty when of Devils and Hell, … because he was a true Poet and of the Devil's party without knowing it'.[44] In brief, according to this reading the character of Satan comes out of the thing on the whole rather better than God in moral terms, and the reader quickly finds himself imaginatively and sympathetically identifying with him and with the rebellion which constitutes the first 'Fall' in the poem. Of course the 'official' voice of the poetic narrator, and some other voices (those of God himself, of course, and of the Archangel Raphael) offer a damning perspective on all this (as Milton realized, perhaps, that his poetic creation was rather running away with him, and sought to turn things around), but it is too late; the damage has been done, and we, together with our poetic recruiting agent, find ourselves too to be 'of Satan's party'.

2. A directly opposed view to this is championed by C.S. Lewis, according to whom Milton's account of the Fall and all that surrounds it is straightforward (for those with eyes to see), and 'substantially that of St Augustine, which is that of the Church as a whole'.[45] Like most other pre-Romantic poets, Lewis suggests, Milton was perfectly content to give a clear lead on matters of spiritual and moral concern, evoking 'stock responses' among his readers (in this case responses tutored by a Vincentian catholic consensus stretching back over the centuries),[46] and thus contributing directly to the formation and preparation of human character to meet life's various challenges and opportunities in a fitting manner. Of course there are conflicting voices in the poem, but the discerning reader sees quickly through the boo characters, and takes a stand with the 'overwhelmingly

[43] See, e.g., 1.17f.; 3.51f.

[44] The suggestion is duly endorsed in Shelley's *A Defence of Poetry* (1840). Empson insists that the main virtue of *Paradise Lost* is precisely that it unwittingly 'makes God so bad'. See William Empson, *Milton's God* (London: Chatto and Windus, 1961), 275.

[45] Lewis, *A Preface to Paradise Lost*, 66.

[46] See ibid., 82.

Christian' perspective of the poetic consensus. Milton, Lewis suggests, 'manipulates' his readers unashamedly rather than allowing them to make up their own minds or wander too far off the beaten track;[47] and he does so in the unashamed interest of Christian formation.

3. In *Surprised by Sin*,[48] Stanley Fish builds on Lewis's identification of a subtle manipulation of the reader by Milton, but takes it in a rather different direction. Rather than holding the reader by the hand, as it were, what Milton does, according to Fish, is to dump the reader down unceremoniously in the world of his poetic creation itself, and leave him there, withdrawing the benefit of narratorial omniscience, and setting him up to be seduced by the very same voices and alluring options that duly lead Eve and Adam themselves into disobedience. So yes, we do find ourselves seduced by Satan's allure, at least at first. And, when Adam falls, we are sympathetic to his choice, and would follow him. But in the moment that we 'fall' the authoritative voice of the poem rebukes us and calls us to account. The intent of all this, Fish suggests, is not sheer sadism or harassment of the reader. *Caught up in* the poetic action rather than simply *taught by* it, we discover the dark truth about ourselves, and emerge from the encounter (which occurs more than once in the poem as we fail to learn the relevant lesson) chastened, and penitent. In a sense, Fish's Milton is a supralapsarian deity who leads his readers into temptation precisely in order to deliver them from evil, a suggestion which echoes ideas we have already identified in Milton's earlier musings and which is relevant to the poem's own larger theological understanding as we shall see.

4. In *Milton and the Idea of the Fall* William Poole suggests that a compromising of dogmatic orthodoxy occurs in the poem, together with an unresolved conflict of perspectives, all due to the demands of the narrative genre itself. Precisely by seeking to do what Genesis 3 itself never seeks to do, namely, to offer a convincing (i.e. psychologically, emotionally and humanly convincing) narrative account of the commission of the first sin, Milton finds himself compelled to break company with the mainstream dogmatic tradition. For this tradition Adam and Eve were, in their pre-lapsarian state, regal and exalted creatures unperturbed by anything and easily able to send Satan packing had they chosen to do so. Milton's poem, Poole observes, offers *just such a vision* with one hand, but then withdraws it with the other, portraying the paradisal couple at various points as frail and vulnerable, easy prey to Satan's machinations. Such inconsistency, he argues, albeit theologically problematic, is *poetically* vital, since in

[47] Ibid., 41.

[48] Stanley Fish, *Surprised by Sin: The Reader in Paradise Lost*, 2nd ed. (Cambridge, MA: Harvard University Press, 1997).

narrative terms there must be a struggle before a capitulation, and thus some indeterminate state leading up to and *accounting for* the 'bad action' which follows. Narrative is, after all, a matter of situating events in some meaningful and persuasive order, and the sheer anomaly or surd occurrence sits ill with its aesthetic demands.

Poole's observation provokes an important question. Might the existence of conflicting and unresolved voices here in Milton's poem in fact be driven not (as Poole suggests) by poetic and dramatic considerations alone, but by distinctly theological considerations too? Could such deliberate lack of resolution, in certain circumstances, be more a matter of theological integrity than theological compromise? Might poetry, indeed, be supposed to provide a mode of engagement better suited to the exploration of some theological questions than approaches which tend too soon and inevitably finally towards the production of a neat systematic unity? Bearing this query in mind, we turn now briefly to consider the poem's treatment of the question which echoes through it from end to end: how, in the good purposes of God, was it ever possible for sin and its progeny to enter our world?

'Sufficient to have stood'?

According to God's own testimony in Book 3 of *Paradise Lost*, human beings were created 'sufficient to have stood, though free to fall' (3.99).[49] In many ways the poem constitutes a sustained reflection on the tensions inherent in this terse formulation and the ways in which it variously illuminates and complicates the dramatic action of Book 9 where the fruit of the forbidden tree is actually plucked and eaten. In what sense 'sufficient'? And in what sense 'free'? And if both sufficient and free, whither then the fall? In grappling with the issue, Milton keeps more than one vision of pre-lapsarian sufficiency identifiably in play; and the question is, why?

From one angle, then, Milton's poem follows closely the mainstream Augustinian tradition, offering us a paradisal couple in full enjoyment of 'unalloyed felicity', unperturbed 'by any agitation of the mind, nor pained by any disorder of the body', in full control, in other words, of their passions and their will.[50] These are not the childlike, naïve foundlings of Socinian theology, but regal beings, 'erect and tall,/Godlike erect, with native Honour clad/In naked Majesty' (4.288–90). The garden in which God has placed them provides everything they need and much more besides, so that the 'sole commandment' is one 'easily obey'd

[49] Citations from the poem are taken from Christopher Ricks, ed., *John Milton: Paradise Lost* (London: Penguin, 1968).

[50] *City of God* XIV.10. See Augustine, *City of God*, trans. Henry Bettenson, Penguin Classics (London: Penguin, 1984), 567.

amid the choice/Of all tastes else to please their appetite' (7.48–9).[51] It is Adam who asks the relevant question: 'can wee want obedience then/To him, or possibly his love desert/Who form'd us from the dust, and plac'd us here/Full to the utmost measure of what bliss/Human desires can seek or apprehend?' (5.514). It hardly seems possible, though we as readers, like God, have the relevant foreknowledge that grants the question powerful dramatic irony.

Milton also rules out any suggestion that the first sin might have been born of childlike ignorance rather than wilful disobedience. In Book 5 God sends the Archangel Raphael on a diplomatic mission to forewarn Adam in the most explicit terms that his faithfulness will be tried, thus rendering 'inexcusable' his actual capitulation when it comes. And finally, the poem disentangles the Fall quite explicitly from any predestinarian scheme in which, *sub specie aeternitatis*, the fall of human beings was as much a matter of God's willing as of Eve and Adam's own, a matter of 'divine overruling' or 'absolute Decree', which, even in their freedom, they were in no position to resist.[52] Cleverly, Milton makes God here a more than convenient mouthpiece for his own Arminian theological sympathies.[53] At the point of sin, Eve and Adam act undetermined by anything other than their own will.[54] They are, God insists, 'Authors to themselves in all/both what they judge and what they choose' (3.122–3); they decreed their own revolt (3.116), ordained their own fall (3.128). The weight placed on creaturely freedom with respect to God's purposes is quite breathtaking at points: As Eve leaves Adam for a bit of gardening on her own, the circumstance electrically charged by both their and our awareness of the impending danger, Adam contributes some dubious cheerleading: 'God towards thee hath done his part', he reminds her; 'do thine'! The emphasis, then, is on the capacity and the freedom to obey or to disobey (without which true obedience could not exist at all), and Milton's verdict is apparently God's own: whose fault is the Fall and all that follows from it? 'Whose but (man's) own' (3.96–7).

There is though, in the poem, another voice, another very different perspective on the whole matter, and it cannot, I think, be dismissed entirely as a seductive perspective which we are expected to entertain only to be duly rebuked and rescued from it as both Lewis and Fish suggest. To be sure, it is only from Satan's lips that God's human creatures are ever described in the poem as 'frail' (1.375) and 'puny' (1.367). They are not that. Yet Milton's God himself is finally ambivalent about the precise state in which his human creatures meet Satan's temptation. At one

[51] Cf. *City of God* XIV.12. ibid., 571.

[52] See especially 3.114–16: 'As if Predestination over-rul'd/Their will, dispos'd by absolute Decree/Or high foreknowledge …'.

[53] On Milton's Arminianism see, e.g., Campbell and Corns, *John Milton*, 106, 274f., 338, Neil Forsyth, *John Milton: A Biography* (Oxford: Lion, 2008), 137f., Hobson, *Milton's Vision*, 41–3, 54–5, Poole, *Milton and the Idea of the Fall*, 159.

[54] Cf. 5.525 : '… good he made thee, but to persevere/He left it in thy power, ordain'd thy will/By nature free, not overrul'd by Fate/Inextricable, or strict necessity.'

moment he insists that their sin is one committed with a high hand, like that of the rebellious angels before them; yet in the same speech God admits that there is a vital difference, since the angels 'by their own suggestion fell,/Self-tempted, self-deprav'd: Man falls deceiv'd/By the other first: Man therefore shall find grace,/ the other none ...' (3.129–32). Elsewhere, Satan is likened by the authoritative voice of the narrator to the thief who climbs into God's fold to harm the flock (4.192), and to a vulture just waiting to prey on helpless newborn lambs (3.434). In Book 5 Satan assaults Eve first not in waking reality but in a dream, seducing her through the organ of 'Fancy' or imagination, leading her all the way to the edge of the slippery slope of disobedience, holding the forbidden fruit to her mouth; but the dream (as so often) ends and evaporates before the fatal step is taken. Adam's response, on hearing of the dream, is to reassure: Don't worry, he tells her, there's nothing culpable in having had a dream like that in and of itself; 'Evil into the mind of God or Man/May come and go, so unapprov'd, and leave/no spot or blame behind.' (5.117–19). Perhaps. Or perhaps here Satan has driven the screw of temptation in just so far, engaging the imagination in order to prepare the path in mind and heart and will for the final, decisive drive in Book 9. Perhaps, in other words, there is here an initial 'virtual' temptation (if not quite a virtual fall) which renders the other when it comes more explicable. Eve has been softened up. The moral ground has been carefully prepared. Man's fall when it occurs will, God admits in his divine foreknowledge, be 'easy'; all too easy in fact; and when the actual Fall is narrated briefly in Book 9 what we are offered is a picture of credulous seduction, all trace of 'solid virtue' and sufficiency to stand now seemingly absent.

Again, Milton has Adam ask the relevant question (albeit this time from the perspective of fallen humanity): 'O why did God,/Creator wise ... create at last/This novelty on Earth, this fair defect/of Nature...?' (10.888–92). The 'fair defect' referred to is Eve, who falls 'deceived', taken in by Satan's seductive lies. But we can translate the question; because what Milton does, moving beyond the dynamics of Genesis 3:1–6 with the permission of 1 Timothy 2:14, is to symbolise in the characters of Adam and Eve respectively the twin terms of a Kierkegaardian paradox (viz., one which we should not expect or seek to resolve). Where human freedom is concerned (even unfallen freedom),[55] in a sense we are 'undeceived' and thus fully responsible moral agents (and fully 'guilty' when we sin); and yet we fall precisely because we are subject to forces preying upon us from without and from within, forces that prey upon us, furthermore, with divine foreknowledge and permission. Milton's God unashamedly leaves Satan 'at large to his own dark designs' and looks on as those designs bear their evil fruit; yet

[55] Milton's treatment effectively softens any rigid distinction between fallen and unfallen freedom. Again, one might write this off as a necessary cost of any attempt to imagine the paradisal circumstance concretely (since we *can* only imagine an alien experience by configuring it in terms of what we know); my suggestion here, though, is that Milton does this quite deliberately in order to keep a deeper theological question in play.

he does so precisely so that Satan 'enrag'd might see/How all his malice serv'd but to bring forth ultimate goodness, grace, and mercy ...' (1.213–18). Milton's account of divine Providence here in the poem and in his earlier systematic treatise echoes that of his Arminian mentor Grotius; God is involved in the production of evil in his world inasmuch as he permits its existence, 'throwing no impediment in the way of natural causes and free agents', and out of its effects God himself 'eventually converts every evil deed into an instrument of good ... and overcomes evil with good'.[56]

On Milton's Refusal to Conclude

Adam's question in Book 10 of *Paradise Lost* is really the one asked by Augustine in Book 11 of his *Literal Commentary on Genesis*: Why did God not make his human creatures *more* 'sufficient to stand' than he actually did? Milton's approach to this question through the dramatic devices of epic poetry permits him to leave the relevant tensions open and unresolved in a manner that more systematic theological treatments might not, keeping the ideas of human sufficiency and insufficiency paradoxically in play at the same time, rather than resolving them prematurely in the interests of any overarching logical unity. Lazy appeals to mystery can of course be an intellectual cop-out in theology as elsewhere; but as I have already suggested, not all appeals to mystery are lazy, and we must take care not to grant the spirit of Procrustes a dangerous foothold by tethering our notions of what counts as due intellectual rigour mistakenly to any particular mode of engagement. Arguably, Milton's open-ended poetic approach is at least faithful to the canonical pattern of biblical thought on this particular subject[57] and to the shape of our experience of evil in the world, neither of which encourages us to dignify sin and its outputs by 'explaining' them and thereby justifying them, ascribing some positive meaning to them within the scheme of things. And, whether we judge a higher systematic resolution to be warranted or not, the poetry of *Paradise Lost* undeniably affords a powerful theological engagement with the realities of human freedom, temptation and the commission of sin, one which admittedly raises rather than resolves the big questions, but which thereby, I would suggest, charts the relevant territory more rather than less adequately. In the end, Milton points us to Augustine's own answer in the *Literal Commentary*: 'Penes

[56] *On Christian Doctrine* I.8 in James Holly Hanford and Waldo Hilary Dunn, eds, *John Milton. De Doctrina Christiana*, ed. Alan Paterson et al., trans. Charles R. Sumner D.D., *The Works of John Milton*, vol. XV (New York: Columbia University Press, 1933), 67, 79/81. Cf. Grotius' defence of Remonstrant views, e.g. in his *Ordinum Pietas* of 1613. See Edwin Rabbie, ed., *Hugo Grotius: Ordinum Hollandiae ac Westfrisiae Pietas (1613)*, Studies in the History of Christian Thought, vol. 66 (Leiden: E.J. Brill, 1995).

[57] i.e. human freedom and God's sovereign responsibility for all that happens in his world.

ipsum est' (11.10.13).[58] Why did God set things up this way? 'God alone knows.' But then, while it may well seem to us to be a very odd way of proceeding, God, we may reasonably trust, knows best.

[58] See P. Agaësse and A. Solignac, eds, *La Genese Au Sens Littéral en Douze Livres (VIII–XII)*, Oeuvres de Saint Augustin, vol. 49 (Paris: Desclée de Brouwer, 1972), 250.

Chapter 7
Unseemly Representations

The Visual Mediation of Presence

The etymology of imagination suggests the correlate 'image' to refer to the outcomes and outputs of its productive activity, though the term is clearly desirous of some broadening and breaking if it is to serve the breadth of the circumstance. To begin with, while imagination always works in one way or another with the 'flesh' of human existence, summoning forth states of affairs already laden with sensory qualities, clothing abstract ideas and aspirations with concrete and particular dress for our grasp and consideration, the relevant sensation is certainly not always or primarily visual, as the otherwise perfectly serviceable metaphor of the 'mind's eye' tends naturally to suggest. On the contrary, where memory is concerned in particular, the more powerful and evocative 'images' called to mind (and drawing others readily in their wake by chains of association) may often be some distinctive soundscape, fragrance or flavour. We should not be misled by the dominant visual connotation. Furthermore, the products of imagination, whether they remain in the mind or are duly granted external form, are only occasionally fragmentary and static in nature, freeze-framing a particular moment from some remembered or projected stream of lived experience, to produce the mental or material equivalent of a photographic snapshot. Most imaginings, and most imaginative products, share instead the temporally extended and mutable quality of experience itself, differentiated from it, perhaps, most notably by their identifiable narrative and dramatic patternings of what is often in 'real life' a much more complex, open-ended and sometimes even chaotic manifold. Our attention to images as such in this book has thus far been directed chiefly to narrative imagining of one sort or another, and to verbal images (in poetry, in liturgy and theology, and elsewhere) rather than their visual and plastic correlates and equivalents. And yet the material image has enjoyed a long and fruitful (if at times admittedly tempestuous and problematic) coexistence with the religious institutions, needs and concerns of Christian faith, especially in the West, so much so that any adequate history of Christian tradition and theology ought arguably to afford such art its own place as a distinct strand of the reception, interpretation and performance of that tradition across the centuries.

In this chapter my concern will be with issues attaching to Christian belief and practice and the Church's appropriation, production and conscription into its religious life of the image in this more circumscribed sense. The relationship has certainly been very varied, and, as I have just indicated, sometimes uncomfortable.

At one end of an imaginary spectrum (quite possibly one unrecognizable in reality, and posited here, therefore, absent due qualification for the convenience of analysis alone) we might locate the figure of the artist as poet-priest, celebrated as someone participating directly in God's own creative energy, and fashioning works capable of transporting the viewer directly – if mysteriously – into the penumbra of the divine presence.[1] We may grant Welsh poet R.S. Thomas the privilege of depicting the spectrum's other imagined end, with his characteristically phlegmatic and caustic charge laid at the door of

> Protestantism – the adroit castrator
> Of art; the bitter negation
> Of song and dance and the heart's innocent joy –
> You have botched our flesh and left us only the soul's
> Terrible impotence in a warm world.[2]

The charge itself will no doubt stir up responses of one sort or another, both by its overstatement and the undercurrents of legitimacy which guide it home to its target. It also compels us, early on in our consideration of the subject, to draw some careful distinctions.

For our purposes I want here to disentangle four discrete strands of theological concern, all having to do with the nature and legitimacy of artistry, and which are sometimes fused together in an unhelpful manner.

- First, there is perhaps the most fundamental issue of all, namely, the question of the capacity or incapacity of creaturely (and specifically here *material*) reality to figure or mediate the presence of God as such. I do not want this to be confused with wider aesthetic considerations about the function of art in mediating that which 'transcends' the empirical given in some more general sense, or its capacity to put us in touch with 'spiritual' realities of one sort or another. These are interesting and important issues; but they are discrete from the specific problem posed by Christian accounts of God's radical otherness as Creator with respect to the creaturely (which includes, as the Fathers of Nicaea take care to remind us, both 'things visible and invisible').
- Second, the appropriateness, benefits and dangers of images of Christ (the form of God's own self-imaging in the flesh).
- Third, the benefits and dangers of locating *any* physical image (though they will generally be of some identifiable religiously significant narrative or

[1] A measured example of this emphasis can be found in Richard Viladesau, *Theology and the Arts: Encountering God through Music, Art and Rhetoric* (New York: Paulist Press, 2000). See, e.g., 151.

[2] From 'The Minister' in R.S. Thomas, *Collected Poems 1945–1990* (London: Phoenix, 1995), 54.

scene, depicting Christ, the Virgin, the apostles, patriarchs, prophets and saints) in liturgical space.

- Fourth, a wider concern about the propriety of human artistry as such, as an essentially creative and redescriptive engagement with the givenness of God's creation.

The first three of these issues belong closely together in any discussion of 'visual piety', a term I borrow gladly from David Morgan's book of that title, and which he defines conveniently for us as 'the visual formation and practice of religious belief'[3] – that is to say, the traditional uses of physical images to inform and nurture faith, the visual mediation not just of 'knowledge' in its more familiar precise sense, but *communion* with God in liturgical and devotional contexts. The fourth concern, while related to the others, is much broader in its scope, and it will concern us during most of the chapter only via occasional allusions. It may, nonetheless, be helpful here to make a couple of broader observations about art – and about the visual and material image in particular – which seem to me to bear directly on our more specific field of concern.

Art, Image and Reality

Nicholas Wolterstorff's book *Art in Action* reminds us of the dangerous anachronism involved in reading back into earlier periods the peculiarly modern (and Western) concept of 'the arts'.[4] When the language of art or 'the arts' is used in our society, Wolterstorff suggests, the notion lying closest to hand ('Art' with a capital A) is that of the production or presentation of works of art which have *disinterested intellectualized perceptual contemplation*[5] (that is, careful and lingering attention to the artefact itself and as such, probably in some space deliberately designed for this purpose) as one of their primary intended public uses. As the work of scholars such as Paul Oskar Kristeller shows, though, writers and thinkers of the many centuries preceding the eighteenth, 'though confronted with excellent works of art and quite susceptible to their charm, were neither able nor eager to detach the aesthetic quality of these works of art from their

[3] David Morgan, *Visual Piety: A History and Theory of Popular Religious Images* (Berkeley: University of California Press, 1998), 1.

[4] See Nicholas Wolterstorff, *Art in Action: Toward a Christian Aesthetic* (Carlisle: Solway, 1997), 7–18.

[5] I shall not attempt to deal here with the vexed post-Kantian notion of aesthetic disinterestedness. For our purposes Wolterstorff's definition of it as 'contemplation undertaken for the sake of the satisfaction to be found in the contemplating' (47) must suffice.

intellectual, moral, religious and practical function or content',[6] considerations which generally preclude the artefact as such functioning as our ultimate focus of concern. I mention this first because it provokes us to ask just what works of visual art in liturgical space are actually designed to *do* (and the answer, of course, may differ markedly from instance to particular instance, and sometimes no single answer will suffice) rather than tolerating sweeping statements about 'the use of images in worship'. Secondly, this distinction between different ways of thinking about art's purpose and its relationship to wider considerations raises again at an early juncture the vital issue of 'iconic transparency' – the capacity and function of the image to direct our attention beyond (if not away from) itself.[7] That is an issue to which we shall return in due course.

Another observation has to do with the enormous power and the residual ambiguity of the image. I'm not speaking now of artistic images nor even visual images alone, of course, but certainly of these too as part of a wider symbolizing and re-presentation of things. Images are a vital contributor to the so-called 'social construction of reality'.[8] They operate in the most subtle (and therefore the most ruthlessly efficient) ways to inform and to shape our sense of what is real, our awareness of self and others, our hopes, desires and aspirations. Physical images in particular are capable of evoking profound visceral responses, directing our willing, our particular actions and our accustomed habits of practice. They 'call out not only to the mind but also to the body (consider the immediate physical impact of erotic images), to thought, and also to emotion',[9] engaging us more completely as rounded beings, perhaps, than some other symbolic forms are capable of doing. They are no mere substitutes for words, then (as verbal images are no mere substitutes for or dispensable ornamentations of 'literal' speech), but an alternative, highly-charged medium of exchange between ourselves and the world. As we shall see, cultural theorists could have learned this much from reading Bonaventure or Aquinas, but their studies do serve to reinforce the point and to enhance our understanding of how it is that images do what they do. This essential and intrinsic power of the visual image to shape responses at the level of both body and soul, and thereby in part to make us the particular people we are, might be supposed either to endorse their entry into the sanctuary as useful tools in the shaping of religious identity, or to render us inherently suspicious of it.

[6] Paul Oskar Kristeller, *Renaissance Thought and the Arts* (Princeton, NJ: Princeton University Press, 1980), 174.

[7] See above, 33–7.

[8] For the thesis that what counts for us as 'reality' is in considerable measure 'constructed' by the social media of human cultures see, classically, Peter Berger and Thomas Luckmann, *The Social Construction of Reality: A Treatise in the Sociology of Knowledge* (London: Penguin, 1967).

[9] Richard Leppert, *Art and the Committed Eye: The Cultural Functions of Imagery* (Boulder, CO: Westview Press, 1996), 7.

Finally I want to allude to some familiar aspects of the image as treated and understood in postmodernity. One is the way in which the image has assumed or been granted a sort of priority over the 'reality' which, more traditionally, would have been supposed to be the vital correlate granting its warrant as 'an image of x'. In his now classic study, Daniel Boorstin cites the following exchange to illustrate the erosion of 'reality' by the generation of 'pseudo-events':

ADMIRING FRIEND:
'My, that's a beautiful baby you have there!'
MOTHER:
'Oh, that's nothing – you should see his photograph!'[10]

Here, Richard Kearney suggests, 'the image *precedes* the reality it is supposed to represent. Or to put it in another way, reality has become a pale reflection of the image'.[11] In more radical postmodern visions such as that of the French theorist Jean Baudrillard, of course, matters are more diffuse yet. Here the distinction between image and archetype, signifier and signified is erased entirely, casting us afloat on a sea of signifiers entirely lacking in anchorage, with such meaning as there is being had in relations of 'mimesis without origin or end',[12] and the opportunity to judge the artifice of the image in the light of our grasp on some supposed 'original' perpetually denied us, the altogether less secure surfaces of the 'hyper-real' or 'simulacrum' providing the only handholds available.[13] Again, parallels may be traced between recent theory and more ancient concerns. The tendency to afford practical (and devotional) priority to the religious image over its transcendent referent, and the subsequent collapse of any meaningful distinction between them in the practice of visual piety has been a recurrent problem for those seeking to endorse such practice, and a popular (because easy) target for its critics. Such collapse may, indeed, provide a convenient definition of the term 'idolatry' which I have so far held in reserve, but which I take to mean the inappropriate ascription of prerogatives proper to the transcendent to that which merely figures it. To refer in any sweeping manner to postmodernity as idolatrous in this regard would, of course, be as churlish as it would be inaccurate. When, for example, Mark Taylor refers to an artistic image as one which 'trembles with the approach of an Other it cannot figure',[14] instead of nihilistic abandonment of responsibility

[10] Daniel Boorstin, *The Image: A Guide to Pseudo-Events in America* (New York: Vintage, 1992), 7.

[11] Richard Kearney, *The Wake of Imagination: Toward a Postmodern Culture* (London: Routledge, 1988), 2.

[12] Ibid., 6.

[13] See, e.g., Jean Baudrillard, *Simulacra and Simulation*, trans. Sheila Faria Glaser (Michigan: The University of Michigan Press, 1994), 1–42.

[14] Mark Taylor, *Disfiguring: Art, Architecture, Religion* (Chicago: University of

we might discern rather an unqualified sense of mystery which copes better with a hidden *Logos asarkos* than with a Word which has truly become flesh. Both monophysite confusion and apophatic separation of the two terms in the artistic sign, though, lead ultimately towards the same practical outcome – the focusing of our attention unhelpfully upon the image itself and as such, and concomitant loss of that vital transparency to which we have already alluded in earlier chapters of this book. The Christological metaphor may prove to be more than a fleeting rhetorical device in this context. As the chapter proceeds, I will explore further the correctives which the resources of classical Christology in particular may furnish to address imbalances of one sort or another in theological estimations of the image. As a framework for consideration, though, I propose to pursue some of the issues already mentioned by engaging with aspects of that specific historical context in which, in Western Christianity, they acquired a particular religious urgency, namely, the European Reformation.

Image, Christology and circumspection

That the Reformation had immediate, substantial and negative implications for Christian attitudes to the arts is clear and is reflected, for example, in the barbed observation of the humanist Erasmus already in 1526 (explaining the departure of Hans Holbein the Younger from Basel for the Netherlands) that 'here the arts are freezing'.[15] Concern about the appropriate use of images in what Daniel Hardy refers to as 'the nonverbal mediation of religious belief'[16] did not, though, suddenly emerge fully-fledged in the early sixteenth century. Its history is as ancient as Christianity itself, and those Reformers who chose to do so were able to draw upon a long tradition of theological reflection on the subject. One substantive theological issue, as we have already noted, was that of the capacity of creaturely (and, more specifically, material) reality to represent, and thereby to mediate the presence and reality of God; or, perhaps, the capacity of God to make himself known through such things, the 'mediation of revelation through the eye' in David Brown's felicitous phrase.[17] For Christians this issue was and is heightened further by the claim that God, while wholly other than the created world, has

Chicago Press, 1992), 305. Cited in David Brown, *Tradition and Imagination: Revelation and Change* (Oxford: Oxford University Press, 1999), 368.

[15] See Hans J. Hillebrand, ed., *The Oxford Encyclopedia of the Reformation* (Oxford: Oxford University Press, 1996), art. 'Art', 74. See also Sergiusz Michalski, *The Reformation and the Visual Arts: The Protestant Image Question in Western and Eastern Europe* (London: Routledge, 1993), 192.

[16] Daniel W. Hardy, 'Calvinism and the Visual Arts: A Theological Introduction', in *Seeing Beyond the Word: Visual Arts and the Calvinist Tradition*, ed. Paul Corby Finney (Grand Rapids, MI: Eerdmans, 1999), 6.

[17] Brown, 322.

actually appropriated creaturely form, chiefly in the incarnation, but also through the physicality of baptism and the eucharist, and more broadly in sustaining and engaging directly with the life and history of his material creation. The modes of presence and activity posited are different in each of these cases, of course, and we must take care not to conflate them inappropriately; but each involves the relationship between God and the creature being mediated by creaturely realities which, if more than the sum and configuration of their physical parts alone, are nowhere and never less.

None of this was lost on exponents of icons in the Byzantine debate which rumbled on from the seventh to the ninth centuries.[18] So, for example, John of Damascus (c.665–749) argued directly from the incarnation that veneration of images of Jesus could not be judged idolatrous, since God himself had rendered himself in human form. It could not, he supposed, be breaking the second commandment to honour a picture of God's own self-imaging in the flesh. Opponents of icons, though, held that this defence was specious, and simply proved the idolatrous nature of such worship. What was pictured in these images was precisely the *humanitas*, the 'flesh' of Christ, and not his deity (which by definition could and should never be pictured). So, those who venerated them were not attending to God, but only a creaturely, physical reality behind which the invisible and mysterious reality of God remained hidden. Both parties, we should note, were agreed that what was imaged as such was not to be confused with the deity or divine nature of Christ. Where they differed was on its capacity, within the structure and by virtue of the hypostatic union, to refer beyond itself suggestively to God, and to direct human worship appropriately. Those who advocated the use of images thus developed a sophisticated theology of iconic transparency, insisting that in worship the mind's eye was naturally directed *through* the visual symbol to terminate on the mysterious reality beyond it. Either to collapse these two levels of reference, or to separate them from one another, so that attention was directed onto the image *as such* was to fall into a crass literalism, untrue to their proper understanding and legitimate use.

Similar arguments can be found among Western writers of the later medieval period concerning religious art more widely. Images, they insist, without being God are nonetheless capable of figuring or signifying God in such a way as to inform the mind and move the affections in worship. William Durandus (in his *Rationale Divinorum Officiorum* of 1286) cites approvingly some verses inscribed on an altar frontal in Bergen, reminding worshippers of the fundamental distinction between that which they see with their eyes *corporaliter*, and that which their

[18] For a thorough account of the history and issues see Averil Cameron, 'The Language of Images: The Rise of Icons and Christian Representation', in *The Church and the Arts*, ed. Diana Wood, Studies in Church History (Oxford: Blackwell, 1992). For a more concise account see Ken Parry, 'Iconoclast Controversy,' in *The Dictionary of Historical Theology*, ed. Trevor Hart (Carlisle: Paternoster Press, 2000).

hearts and minds are meant to discern *spiritualiter*.[19] It is the transcendent referent which is the proper object of worship, and not the physical image itself. The same careful insistence is found in Thomas Aquinas (c.1224/5–74) who, typically, cites Aristotle in support of his view: 'As the Philosopher says (*De Memor. et Remin.* i) there is a twofold movement of the mind towards an image: one indeed towards the image itself as a certain thing; another, towards the image in so far as it is the image of something else. ... Thus therefore we must say that no reverence is shown to Christ's image, as a thing – for instance, carved or painted wood ... It follows therefore that reverence should be shown to it, in so far only as it is an image.'[20] Given this circumspect understanding, Bonaventura (1217–74) confidently identifies three vital functions of the religious image: to educate the illiterate masses concerning core doctrinal and narrative tenets of the faith (he refers to images as 'more open Scriptures'), to arouse due devotion and inculcate a worshipful disposition since 'our emotion is aroused more by what is seen than by what is heard', and to imprint certain vital truths on our memory.[21] In each of these regards visible images were observed to be more efficient than the written or spoken word, and a higher value duly came to be placed upon them.[22]

Words, Images and Idolatry

This practical exaltation of the image over the word in medieval piety reminds us that even the most rigorous iconoclasm can never escape the image *per se*, since the word functions in significant measure precisely by its capacity to evoke or generate mental images of one sort or another, and nowhere is this more apparent than in the Christian Scriptures. To speak and think of God as Lord, or father, or shepherd, or a spring of refreshing water, or a consuming fire is just as surely to trade in images as to paint or sculpt him as such. To this extent, as noted above in Chapter 1,[23] Austin Farrer was correct to insist that for Christians knowledge of God is mediated 'in an act of inspired thinking which falls under the shape of certain images'.[24] And if, the German Reformer Martin Luther asks in a closely related observation, 'it is not a sin but good to have the image of Christ in my heart,

[19] See Michael Camille, *The Gothic Idol: Ideology and Image-Making in Medieval Art* (Cambridge: Cambridge University Press, 1989), 203.

[20] *Summa Theologica* 3, Q. 25, Art. 3, cited in ibid., 207.

[21] Liber III Sententiarum, IX, a. 1, q. 11, cited in William R. Jones, 'Art and Christian Piety: Iconoclasm in Medieval Europe', in *The Image and the Word: Confrontations in Judaism, Christianity and Islam*, ed. Joseph Gutman (Missoula: Scholars Press, 1977), 84.

[22] See ibid., drawing on the testimony of Durandus.

[23] See above, 27, 42.

[24] Austin Farrer, *The Glass of Vision* (Westminster: Dacre Press, 1948), 57.

why, should it be a sin to have it in my eyes?'[25] Luther's accompanying suggestion (which led him to adopt a far more sanguine disposition towards religious images than some others among the Reformers) is that a heart cured by the Holy Spirit of idolatrous inclinations is never likely to succumb to the error, even though church buildings be filled with all manner of visual and tangible occasions for temptation, while one left uncured will find occasion and excuse even in the most aesthetically austere of liturgical environments.[26] It is a reasonable contention, and one that cannot be skirted around by those more inclined towards image-free worship spaces. But Bonaventura's observation about the superior efficacy of the physical image for certain devotional purposes, Aquinas' careful analysis of the phenomenology of such images, and Luther's 'You can take the boy out of Wittenberg, but …' line of argument all draw attention helpfully to the distinction between the physical and the mental image, and suggest its importance for any evaluation of the uses of images in liturgical and devotional contexts.

The very solidity and sensuousness of the painting or sculpture, we might note, impresses itself upon us with a degree of concrete inflexibility and permanence, drawing our attention quickly and easily to the material qualities of the image itself and as such as an object situated identifiably in the same space as the beholder. Furthermore, while not all religious images conform to the canons and conventions of the beautiful, most have sought to do so, and others still, in light of their particular subject matter (perhaps most obviously certain *prima facie* 'ugly' treatments of the suffering of Christ),[27] challenge and compel reconsideration and adjustment of such conventions. It has sometimes been held that instances of material beauty refer us naturally and quickly to their eternal exemplar or 'horizon' in God, thus furnishing a fitting visual (or, in the case of music, aural) focus for worship quite apart from their particular subject matter.[28] Suggestive as this is, it fails to reckon adequately with another trait of beauty noted by Immanuel Kant. Judgements about beauty, Kant observes, are always finally judgements about particular manifestations or instantiations of it, which is why questions such as 'what is it meant to be?' fall quickly into abeyance as irrelevant to the circumstance.[29] While an object may also function for us as 'an image of x', therefore, in so far as we judge it to be beautiful, Kant

[25] See Jaroslav Pelikan and Helmut T. Lehmann, eds, *Luther's Works* (Philadelphia: Fortress Press, 1958–86), vol. 40, 100.

[26] See sermon preached on 11 March 1522, in ibid., vol 51, 83. Also 'Against the Heavenly Prophets' (1525) in Pelikan and Lehmann, 84–5.

[27] See Richard Viladesau, *The Beauty of the Cross: The Passion of Christ in Theology and the Arts – from the Catacombs to the Eve of the Renaissance* (Oxford: Oxford University Press, 2006), 9–12, et passim.

[28] So, for instance, Viladesau, *Theology and the Arts*, 34–46.

[29] See Immanuel Kant, *Critique of Judgment*, trans. Werner S. Pluhar (Indianapolis and Cambridge: Hackett, 1987), 64. '*Beautiful* is what, without a concept, is liked universally.' See further, §9, 61–4.

insists, we are effectively looking at it for the moment with all such external considerations bracketed out, allowing the material qualities of the object itself to impress themselves upon us in their sheer particularity. Beauty, we might say, often tends, in the first instance at least, to be opaque rather than transparent or translucent. Even in the relatively rare case of devotional images where judgements of beauty are either irrelevant, counter-intuitive or problematic, still the status of the material image as an object possessed of its own unique *hypostasis*, and capable of being attended to and treated as such, increases the propensity for the mind's eye (as well as the actual eye) to do precisely this – stopping short at the painted or sculpted surface and attending to its sensuous contours and features, rather than permitting these to become imaginatively permeable, and passing quickly beyond it to a transcendent referent (understood or anonymous), apprehended here only in the paradoxical form of its literal absence and imagined presence, but apprehended really nonetheless.

In the case of the mental image, though, the opposite appears to be true. It is fleeting, remaining in focus only so long as it takes for another of the same sort to enter consciousness in order to supplement, supplant, or morph out of it. It is inherently transparent, has its existence precisely and only as a vehicle for directing us to something else – is, in fact, precisely 'a way of thinking about' something else.[30] If we strip away the relation 'is an image of', then nothing whatever remains to be looked at by the (equally immaterial) 'mind's eye'. A physical image can be considered under more than one aspect: by the viewer as 'an image of' some person, event or place; by the art expert as a fine example of a certain sort of brushwork or other technique; by the restorer as aged canvas, cracked and dull oil paint all in need of careful professional attention; by the art dealer as a shrewd capital investment. But we cannot consider the mental image in these latter ways, for it has no existence apart from the mental activity of 'thinking about'. It is, to deploy a theological category, *anhypostatic*. It is not, that is to say, a 'thing' in its own right, but has its being and its proper meaning and force only in its vital relation to something else other than and transcending its own reality.

Given all this, it seems reasonable to enquire whether the mental image (evoked imaginatively through the word) might be more naturally suited to maintaining that careful distinction between image and prototype which the religious, and especially the liturgical or devotional context demands. Or, putting the matter negatively, is it more likely that the physical image with all its sensuous effect will always be more prone to collapsing these two levels with potentially idolatrous outcomes? If so, then of course this hardly constitutes in itself an adequate theological case against the use of physical images in worship. And, to balance the account, we would certainly have recognized that words too may, in their own

[30] So, for example Gilbert Ryle, *The Concept of Mind* (London: Penguin, 1963), Chapter VIII and Jean-Paul Sartre, *The Psychology of Imagination* (London: Methuen, 1972). For a full critical account see Mary Warnock, *Imagination* (London: Faber, 1977), Part IV.

distinct way, be susceptible to analogous modes of idolatry, for example through woodenly literal or theologically over-determined readings of the biblical text, fixing and exalting a single unchallengeable 'meaning' proffered, ironically, in the name of the putative 'authority' of the text, while failing utterly to reckon with it adequately as text, or to allow it to speak (possibly in ways that challenge and overturn our preconceptions and prejudices) on its own terms. Or, if we think of the force of the spoken rather than the written word, David Brown observes that such '(w)ords are potentially just as seductive as images, and so inherently in just as much danger of misleading the worshipper into idolatry as any visual image. The preacher has the ability to entice the listener into as corrupting and controlling an image of God as any construct offered by artist or sculptor'.[31]

It would certainly seem, then, that the pathology of images is not confined to those cast in material form, and that due care and discipline in their use is needed across the board. While gladly conceding this, though, and not wishing to underestimate the seductive capacities of words misused or deliberately abused, I remain to be convinced that the probabilities of misunderstanding or misuse are quite so evenly distributed as Brown tends to suggest. At the very least, verbal and mental images lend themselves more easily and naturally to the sort of continual kenotic breaking and remaking that I have suggested earlier in this book must be undertaken not just with the worst but even with the best of their uses in religious and theological contexts.[32] The material image does not lend itself naturally to such breaking open, except by that vandalism which would deny it any legitimate existence whatever, and to which the state of many pre-Reformation churches in northern Europe still bears painful witness. The logic of the iconoclast's hammer and pickaxe, in other words, is one which can only see the force of the metaphoric whisper 'it is not', and presses this to unfortunate lengths. If a more balanced and healthy attitude to art in liturgical space is to be inculcated, though, the distinctives of the material image (and in particular the propensity of its independent 'isness' to bolster the countervailing metaphoric suggestion that 'it is') behove us to develop, inculcate and nurture within our congregations a religiously and theologically-grounded visual hermeneutic of the sort to which Aquinas and Luther point us and upon which the Counter Reformation subsequently elaborated,[33] encouraging

[31] David Brown, *God and Mystery in Words: Experience through Metaphor and Drama* (Oxford: Oxford University Press, 2008), 110.

[32] See above, 33–8.

[33] So, for instance, Session 25 of the Council of Trent (3–4 December 1563) decreed that 'images of Christ, the virgin mother of God and the other saints should be set up and kept, particularly in churches, and … due reverence is owed to them, not because some divinity of power is believed to lie in them as a reason for the cult, or because anything is to be expected from them, or because confidence should be placed in images … but because the honour showed to them is referred to the original which they represent: thus, through the images which we kiss and before which we uncover our heads and go down on our knees, we give adoration to Christ and veneration to the saints, whose likeness they bear'. Norman

and enabling believers to be 'good readers' of images as well as good readers of biblical texts or responsible poets in the pulpit. It was the apparent lack or failure of any such strategy in late medieval churches, and not the presence of images as such, that provoked the vociferous response of some of the Reformers.

The Reformation, we should recall, was more a response to the grass roots popular religion of the late medieval period than to the highest thoughts of its theologians. The masses, unsurprisingly, had not read Aquinas, and, as Michael Camille notes, the need for constant reiteration of such a visual code during the period indicates at least the ever-present danger of popular misunderstanding and misuse.[34] In practice, as Camille's study shows, this danger was realized in all manner of ways. From the late thirteenth century onwards there can be traced an erosion of any popular awareness that images were, as it were, to be looked *through* rather than looked *at*. Instead, there was to be found an increasing attention and devotion to the image itself and as such, and the investment of it with powers and status unbefitting its reality as, in itself, a mere aesthetic object. A frankly superstitious preoccupation with the tangible paraphernalia of religion captured the public imagination and, in due course, spawned an entire economy as a veritable 'image explosion'[35] ensued. As William Jones notes, 'Popular piety filled the churches of Europe with a diversity of sacred art – rood screens, wall-paintings, stained-glass windows, crucifixes, statuaries, reliquaries and monstrances'.[36] To patronize the production of such devotional objects (whether for use in churches or domestically) came to be viewed as, in itself, an act of pious 'good works', and Europe's artistic community rapidly adapted itself to this growing market.[37] Spiritual, economic and wider political concerns became mixed up in this development, and thus iconoclasm, when it arrived, was laying an axe to the root of an entire social status quo in which the wider populace was heavily invested. Its chief focus remained, though, a theological and spiritual one. Statues and paintings (not just of Christ, but depicting God the Father and – most frequently – the Virgin and other saints) had become the focus of individual middle-class cultic guilds established to maintain them, and were regularly ascribed miraculous powers and associated with profound (and often bizarre) visionary experiences.[38] Such objects – increasingly realistic rather than abstract in their depiction[39] – were used in

P. Tanner S.J., ed., *Decrees of the Ecumenical Councils*, 2 vols., vol. 2 (London: Sheed and Ward, 1990), 775.

[34] Camille, 207.

[35] Ibid., 219.

[36] Jones, 83.

[37] See ibid., 86–7 and Camille, 214.

[38] See, e.g., Camille, 223–4.

[39] See ibid., 213–14. Cf. Hardy, 7.

liturgical drama and festival processions and, as one study observes, readily acquired 'an aura of peculiar sanctity as divine personalities or presences'.[40]

This popular fascination with cultic physicality was further stimulated and seemingly underwritten, as Camille notes, by the religious establishment when, in 1215, the Fourth Lateran Council promulgated the eucharistic doctrine of transubstantiation (in which the creaturely realities of bread and wine were held to 'become' – rather than simply 'figuring' or referring the worshipper through themselves to – the body and blood of Christ), a development further reinforced by the instigation of the Feast of Corpus Christi in 1264.[41] Nobody was formally suggesting that religious images were to be afforded analogous treatment; but popular imagination had been decisively encouraged to identify rather than to disentangle the sign and that to which it pointed. For some, if the result did not count as 'idolatry', then it was hard to see what ever would.

The Explosion of Iconophobia

This centrality of the cult of the image to the web of late medieval religion helps us to understand the otherwise seemingly odd attention granted to aesthetic concerns at the Reformation. John de Gruchy has suggested that 'The Reformation may even be regarded as a contest over the meaning and control of images, their power to save and to damn, and the legitimate authority or tyranny they represented'.[42] Like modern studies in the sociology of knowledge, the reformers in their own way recognized the powerful hold which image-based media may have upon the human spirit, and their capacity to shape and control religious, political and moral identity for good or ill.[43] While, though, the major reformers were agreed in their opposition to the idolatry which they perceived in the Roman Church, they differed as regards the practical implications of suppressing or correcting it.

Among the earliest and most radical responses was that of the Saxon Andreas Bodenstein von Karlstadt (1486–1541)[44] who, when, in the wake of his condemnation by the Diet of Worms in 1521, Martin Luther fled for the relative safety of the Wartburg, implemented a rigorous reform of worship at Wittenberg

[40] Ilene Forsyth, *The Throne of Wisdom: Wood Sculptures of the Madonna in Romanesque France* (Princeton, NJ: Princeton University Press, 1972), 49. Cited in Camille, 223.

[41] See Camille, 215.

[42] John de Gruchy, *Christianity, Art and Transformation: Theological Aesthetics in the Struggle for Justice* (Cambridge: Cambridge University Press, 2001), 38.

[43] See, e.g., David Freedberg, *The Power of Images: Studies in the History and Theory of Response* (Chicago, University of Chicago Press, 1989).

[44] See Alejandro Zorzin, 'Andreas Bodenstein von Karlstadt' in Carter Lindberg, ed., *The Reformation Theologians: An Introduction to Theology in the Early Modern Period* (Oxford, Blackwell, 2002), 327–37.

including the abandonment of clerical vestments and the removal from churches and destruction of all religious images. In writings such as his 1522 treatise 'On the Removal of Images' Karlstadt advocated the use of Mosaic law in the civic sphere, deprecated the role of scholarly learning in interpreting Scripture (and, indeed, the value of the arts and humanities for Christians), and urged all Christians to follow the immediate dictates of the Holy Spirit.[45] In response to such urgings by Karlstadt and others, many clearly judged themselves led by the Spirit to implement without further delay the apparently clear and relevant injunction of the second commandment,[46] regardless of official ecclesiastical or civil jurisdiction, and a spate of disorderly and illegal ransackings of churches ensued. Civic authorities were placed under huge pressure, and some were forced effectively to authorize in retrospect actions of violent iconoclasm for fear of the unrest and destruction getting completely out of hand. Others managed to effect a gradual and staged process while they weighed the possible political and economic consequences of their actions.[47] There can be little doubt that it was widespread public support that led to the spread, both unofficial and official, of rigorous iconoclasm where it occurred. As so often, though, democracy proved to be an unreliable index of truth, and the groundswell was theologically unsophisticated and often at the mercy of uneducated extremism.

More moderate than Karlstadt, but nonetheless unrelenting in his insistence that visual and plastic art be banished from liturgical and devotional contexts, was Ulrich Zwingli (1484–1531) whose influence among people and city magistrates alike in Zurich resulted in 1524 in 'an orderly but thorough destruction of virtually all material accessories to worship'.[48] Zwingli had no time for illegal acts of iconoclasm.[49] Nor (unlike some in the Radical Reformation) was he an opponent of the arts as such. Trained as a humanist, he retained respect for the cultural products of antiquity, and valued the highest achievements of the human spirit in any sphere[50] so long as they did not engender attitudes or practices incompatible with a Christian

[45] See J. Dillenberger, *Images and Relics: Theological Perceptions and Visual Images in Sixteenth-Century Europe* (Oxford: Oxford University Press, 1990), 90. See also Ronald J. Sider, ed., *Karlstadt's Battle with Luther: Documents in a Liberal-Radical Debate* (Philadelphia: Fortress Press, 1978).

[46] Exodus 20:4–5a : 'You shall not make for yourself an idol, whether in the form of anything that is in heaven above, or that is on the earth beneath, or that is in the water under the earth. You shall not bow down to them or worship them; for I the LORD your God am a jealous God' (NRSV).

[47] See on this, for example, Carl C. Christensen, 'Patterns of Iconoclasm in the Early Reformation: Strasbourg and Basel' in Gutmann, ed., *The Image and the Word*, 107–48.

[48] Christensen, 'Patterns of Iconoclasm in the Early Reformation', 107.

[49] See, e.g., G.R. Potter, *Zwingli* (Cambridge: Cambridge University Press, 1976), 130–31.

[50] See Martin Klauber, 'Zwingli' in Trevor A. Hart, ed., *The Dictionary of Historical Theology*, 576.

piety and hope properly focused on God alone through faith.[51] False bearings here were, he believed, by definition idolatrous and the essence of Godlessness.[52] Even artistry with a religious theme was tolerable for Zwingli, so long as it did not intrude on devotional contexts where it might give rise to inappropriate feelings of reverence.[53] Thus, what Bonaventure had celebrated as the image's positive gain (its capacity to arouse and direct the emotions in worship) Zwingli eschewed as its chief weakness since, he held, fallen human beings are naturally prone to false worship and, despite the careful distinctions of scholastic theologians, images in church or other devotional situations inevitably become the occasion of idolatry and rob God of the worship due to him alone. Images of Jesus are especially inappropriate and dangerous (though purely 'historical' representations of him in depictions of gospel scenes are acceptable outside churches and for non-devotional use), dealing only at the level of the sensuous and unable to communicate the true Christ to us[54] – a clear echo of the ancient iconoclasts' insistence that images could not show forth the deity but only the 'flesh' of the Saviour. For Zwingli, too, the religious image was spiritually opaque, rendered such by human sinfulness rather than its own incapacities or anything in the nature and capacities of God. His insistence that religious subjects in art must be purely 'historical', though, indicates resistance to any pictorial depiction of God even for non-devotional ends. The second commandment, therefore, Zwingli held to be binding on Christians as a prescription against the deployment of the visual arts inside places of worship, a divine strategy for the avoidance of an otherwise inevitable idolatry.

Martin Luther's (1483–1546) attitude to religious images was, as we have noted, more ambiguous.[55] For Luther the Reformation was always first and foremost about another theological issue altogether; namely, the doctrine of justification by grace through faith rather than works. Compared to this, he considered the matter of paintings and sculpture in church *adiaphora* – a matter of relative unimportance. Indeed, he insisted, no amount of smashing and burning could get rid of superstitious idolatry, since this was lodged deep in the sinful human heart and was likely to be established even more firmly there by any external attempt to dislodge it; whereas, once the heart was liberated by faith from the

[51] Potter, *Zwingli*, 114–15.

[52] See W.P. Stephens, *The Theology of Huldrych Zwingli* (Oxford: Oxford University Press, 1986), 154–5. Zwingli writes 'Whoever has sought help and confidence from a creature which the believer ought to seek only with God, has made a foreign god form himself'. 'A Short Christian Instruction' (November 1523) in H. Wayne Pipkin, ed., *Huldrych Zwingli Writings*, Vol. 2 (Allison Park, PA: Pickwick Publications, 1984), 69.

[53] 'Outside church as a representation of historical events without instruction for veneration, they may be tolerated.' Zwingli, 'A Short Christian Introduction', 71.

[54] See Stephens, *The Theology of Huldrych Zwingli*, 174.

[55] What follows in this paragraph is based largely on the helpful overview provided in Christensen, *Art and the Reformation in Germany* (Athens. Ohio: Ohio University Press, 1979), 43–65.

snares of works-righteousness, the ritual abuse of wood and stone in an attempt to court favour with God would be bound to cease, having no further motive force.[56] Luther's stated opposition to the religious image, therefore, centred primarily on its appropriation within and bolstering of a false understanding of how to stand justified before God. He also objected strongly to the huge amounts of money consequently invested in producing and venerating such images, money which could and should have been spent in alleviating poverty and human distress.[57] Luther certainly never resorted to the somewhat crude 'because the Bible says so' warrant for iconoclasm (the more violent manifestations of which he considered to be a triumph for the devil rather than Christ).[58] Indeed, he interpreted the second commandment explicitly as a gloss on the first, a proscription of the making and use of plastic 'gods' as such, and not a prohibition on representative artistry more widely, even for use in Church.[59] More broadly, Luther resisted the idea that Judaic ceremonial law is binding on Christians, it being part of what has been abrogated by the New Covenant. Possession of images, therefore, he considered to be a matter of Christian freedom, though the superstitious veneration of them was clearly sinful and to be abandoned. Luther's thought on the matter evolved over time, though, from critical and cautious tolerance to recognition of the value of the image as a device for shaping religious identity in positive, rather than negative ways. Human beings, he insisted, cannot help forming images of the objects of their attention and reflection. The religious image is merely an extension of the mental image. Thus Luther follows Bonaventura in advocating the benefits of religious art, though he identifies these benefits solely in pedagogy, 'for the sake of remembrance and better understanding' among the faithful.[60] Prioritizing of the Word was not, therefore, exclusive of the image since the 'Word' could, ironically, be faithfully painted and etched just as surely as it had been made flesh.

Calvin, Art and Idolatry

John Calvin (1504–64) is often listed together with Karlstadt, Zwingli and others as, at heart, an iconophobe,[61] and the theological tradition associated with him has frequently been identified as the chief perpetrator of art's adroit castration.[62]

[56] See sermon preached on 11 March 1522, in Helmut T. Lehmann, ed., *Luther's Works* (*LW*), vol. 51, 83. Also 'Against the Heavenly Prophets' (1525) in *LW* 40:84–5.

[57] See sermon preached on 12 March 1522, *LW* 40:86.

[58] See *LW* 40:105.

[59] See *LW* 40:86.

[60] *LW* 40:99. See also *LW* 43:43.

[61] So, e.g., Michalski, Chapter 2.

[62] Cf., for example, the observation of P.T. Forsyth that 'If our spirits habitually think of Nature as cursed and God-forsaken we can have no more Art than Calvinism has left to Scotland,' *Religion in Recent Art* (London: Hodder and Stoughton, 1905), 145.

The 1559 edition of the *Institutes* reveals, though, a more complex and subtle understanding than we might expect to find.

Calvin is certainly emphatic in his rejection of images in liturgical and devotional contexts. His criticism is directed chiefly towards visual representations of God as such, and reflects the tenor of his wider doctrine of God. Unlike Luther, Calvin appeals to the abiding force of the second commandment ('You shall not make for yourself a graven image, whether in the form of anything that is in the heaven above, or that is on the earth below, or that is in the water under the earth' [Exod. 20:4], a formulation which I take to correspond to the Nicene Creed's 'things visible and invisible', and thus sweeping in its exclusion of creaturely forms).[63] But the foundation for Calvin's rejection of visual piety in this mode is more securely rooted than any *ad hoc* appeal to biblical proof texts. Rather, he interprets this verse and the wider pattern of God's depiction in the canon as deliberately circumscribing human attempts to figure God's mysterious reality.[64] The God revealed in Scripture, Calvin insists, so transcends the creaturely order that any attempt at visual depiction amounts by definition to an assault upon his glory and majesty. Such 'unseemly representations' are, that is to say, not only *inadequate* to bear the weight of transcendence, but actively profane God's name and contradict his being. Since the chief end of human beings is to know God truly and to offer him due worship,[65] it follows that all visual figurations of deity must be prohibited absolutely, in church or anywhere else. Here, then, we have a concern the roots of which go much deeper than a pragmatic desire to avoid unhealthy superstition and practical idolatry. Calvin is convinced beyond doubt that the reality of God is inherently incapable of figuration in creaturely realities, and that any attempt do so in whatever context must amount to something little short of blasphemy.

As we have already observed,[66] the exegesis of the opening verses of the decalogue is far from straightforward, and the question of their interpretation in a specifically Christian context adds a further level of hermeneutic complexity. We have noted von Rad's contention that the original logic of the prohibition placed upon material images was directed toward the propensity for idolatrous conflation (as distinct from confusion) of the image with its divine archetype, and the supposition that Yahweh, like the gods of some of Israel's canaanite neighbours, might be rendered present, directly influenced or in any way given over into the hands of the worshipper through the cultic presentation and manipulation of the

[63] Aidan Nichols notes that the phraseology of the commandment deliberately and comprehensively covers 'the three basic habitats of creatures', viz., all that is distinct from God himself. See Aidan Nichols, *Redeeming Beauty: Soundings in Sacral Aesthetics*, Ashgate Studies in Theology, Imagination and the Arts (Aldershot: Ashgate, 2007), 22.

[64] See *Inst.* I.xi. in John T. McNeill, ed., *Calvin: Institutes of the Christian Religion*, ed. John Baillie, John T. McNeill, and Henry P. Van Dusen, *The Library of Christian Classics*, vol. XXI (Philadelphia: Westminster Press, 1960), 99–116.

[65] *Inst.* I.iii.3, ibid., 45–6.

[66] See above, 39–40.

sign. Understood thus, the exclusion of images from Israel's cult testified to the elusiveness and utter freedom of the God of Sinai with respect to the creaturely, and set her worship and theology starkly apart from the assumptions and expectations of the wider religious culture – assumptions and expectations which, hitherto, no doubt, most Israelites had shared. The prohibition is thus designed to drive home some of the radically new patterns of thought and speech which must be etched on Israel's imagination as she learns what it means to worship and to serve the elusive God of the covenant, the one whose holy name has only recently been disclosed in her midst. If this interpretation (effectively reading Exod. 20.4–5a as a single commandment, and as an extension of the range of the imperative contained in verse 3 ['you shall have no other gods before me']) is correct, then, of course, the issue is not one about the absolute impropriety of imaging God, nor the absolute impossibility of creaturely forms serving as mediators of God's presence and activity. As noted in our discussion in Chapter 1, the cornucopia of poetic images furnished by the very same texts that so rigorously exclude their material counterparts makes a nonsense of any such suggestion. Rather, it might be argued, it is about securing the theological presuppositions and understanding the religious conditions under which alone *any* such imaging (whether it arises in the mind's eye or in material form) may in due course properly be attempted, and dangerous misunderstandings of its significance and implications thereby duly avoided. Only by virtue of the appropriation of creaturely realities by God himself and their assimilation into the patterns of his gracious self-giving can they properly function as the forms of that divine self-disclosure and human response in which knowledge of this God consists.

Again, one might point to the particular qualities of the material as distinct from verbal and mental images as relevant to the context, though as we have seen, neither category is free from the problems of idolatrous misuse or abuse. In any case, as Aidan Nichols suggests, Christian readers of Exod. 20.4–5 need to reckon fully with the implications of the peculiarly Christian claim that this same God, in the fullness of time, himself took flesh and so 'figured' himself in the materiality of a life lived,[67] a claim which, as we have seen, informs to the full the Eastern theology of the icon, but has been granted less significance in much Western reflection on the legitimacy and nature of the religious image. The claim does not, of course, furnish warrant for a free-for-all in which any and every material form may be appealed to as a likely site of encounter with the God of Abraham, Isaac and Jacob, yet it certainly excludes the supposition that creaturely form as such is either wholly inappropriate or utterly incapable of being used by God in giving himself to be known and known intimately, a supposition further contradicted in Christian liturgical practice, as we have seen, by the dominically instituted extension of divine sign-giving to the material symbols of water, bread

[67] Nichols, *Redeeming Beauty*, 21. The case is argued more extensively in Aidan Nichols, *The Art of God Incarnate: Theology and Image in Christian Tradition* (London: Darton, Longman and Todd, 1980).

and wine. Let it be said at once, of course, that the incarnation, the dominical sacraments, the multifarious images for God used in Scripture, preaching and systematic theology, and material or artistic images of God of one sort or another must not be situated on the same level of consideration in theological terms, as though they were all and equally instances of the same kind and significance, as talk of an incarnational or sacramental 'principle' at the heart of Christianity might, without due qualification, be taken to suggest. The centrality and importance of flesh and blood realities to the account Christian faith and practice are obliged to give of God's own being and action, though (including the permanent assumption of our humanity in its fullness into the threefold existence of Father, Son and Holy Spirit), would seem to counsel a more judicious and Christologically informed reckoning with the propriety and possibilities attaching to the material image than has sometimes been attempted.

The Image and the Eye

Returning now to Calvin, who appears not to have reckoned adequately with such considerations, we should note that in addition to representations of God the Father he also banished from the sanctuary all images of other sorts too (of Christ, of other biblical characters and stories, of Christian saints), rejecting their frequently alleged pedagogical justification on the grounds that the human soul inclines naturally to idolatry wherever the opportunity for it arises,[68] that many of the likenesses (of virgins, martyrs etc.) to be found in medieval churches were actually morally dubious ('examples of the most abandoned lust and obscenity'),[69] and that there would be far fewer 'unlearned' Christians in the first place if the Church took seriously its responsibility to preach the Gospel and teach basic doctrine.[70] Interestingly, this unstinting iconoclasm with regard to the sacral sphere was not carried through to the domestic. Calvin was apparently quite content for believers to have narrative images drawn from Scripture adorning their homes and personal effects.[71] This, though, seems to be drawing an arbitrary distinction, and to overlook the likelihood that the 'liturgical space' within which worship occurs is in fact made up both of literal physical space and the objects which adorn it, and what we might call the 'space of our imagination' (and the objects which adorn that) which we undoubtedly bear with us into Church together with our hopes and fears and prayers. While we have already seen good reason to suppose that physical images have in significant respects a greater immediate impact upon us than their verbal and mental counterparts, we have seen too that it would be unwise to overlook or ignore the vital contribution which 'the imaginations of our

68 *Inst.* I.xi.9, McNeill, ed., 109–10.
69 *Inst.* I.xi.7, ibid., 106–7.
70 *Inst.* I.xi.7, ibid.
71 See Michalski, 70.

hearts' actually and inevitably make – for better or for worse – in disposing us with respect to God. And a picture impressed upon consciousness because hung on a familiar bedroom wall, or one fed subliminally into our subconscious via the ministrations of cable TV or the Internet, left unattended and allowed to sediment within consciousness, may in due course prove much harder to banish from our worship than plaster, wood and painted canvas.

The distinction between sacral and secular spheres of life, though, forms an important part of the Renaissance background to Calvin's thinking, and it emerges clearly in his attitude towards the arts more widely.[72] Despite the admittedly damning comments that he makes about the visual arts in church, it is quite misleading to suggest that Calvin had 'a negative attitude towards human creativity and imagination' as such.[73] While he inevitably insists that true creativity belongs to God alone, Calvin celebrates the second-order powers of imagination and invention ('the mother of so many marvellous devices') with which God has invested the human soul[74] and identifies artistic vision and skill as among those things which the Holy Spirit 'distributes to whomever he wills for the common good of mankind'.[75] These gifts, he notes, are distributed 'indiscriminately upon pious and impious',[76] being part of that common grace which is nonetheless to be acknowledged and admired by believers (together, for example, with the great learning of philosophers and scientists) lest, 'by holding the gifts of the Spirit in slight esteem, we contemn and reproach the Spirit himself'.[77] Indiscriminate rejection or belittling of the arts, therefore, is an affront to God just as surely as is their misuse in the sacral sphere. God, Calvin insists elsewhere – in a passage which shows him to be anything but aesthetically frigid – has provided for his creatures things which 'seem to serve delight rather than necessity',[78] and we should enjoy them as he intended us to.

Of course, Calvin steers carefully away from any apparent condoning of unbridled sensory excess. The key principle is that things should be enjoyed in accordance with their divinely-intended end. Hence, painting and sculpture are to be enjoyed as gifts of God, 'conferred upon us for his glory and our good'. In the hands of fallen creatures they can and have been abused (not least in the sacral context), but there is 'a pure and legitimate use' of them to be enjoyed.[79] The

[72] See M.P. Ramsay, *Calvin and Art Considered in Relation to Scotland* (Edinburgh: Moray Press, 1938), 12–17.

[73] de Gruchy, 41–2, drawing on a fleeting and unsubstantiated assertion in William J. Bouwsma, *John Calvin: A Sixteenth-Century Portrait* (Oxford: Oxford University Press, 1988), 80.

[74] See especially *Inst.* I.v.5, McNeill, ed., 56–8. and I.xv.6, ibid., 192–4.

[75] *Inst.* II.ii.16, ibid., 275.

[76] *Inst.* II.ii.14, ibid., 273.

[77] *Inst.* II.ii.15, ibid., 273–4.

[78] *Inst.* III.x.1, ibid., 719.

[79] *Inst.* I.xi.12, ibid., 112.

artist, though, Calvin suggests, should depict only that 'which the eyes are capable in principle of seeing', whether 'histories and events' or 'images and forms of bodies'.[80] We may take 'capable of' as meaning in principle rather than in fact, and thus read this as permissive of a degree of imaginative invention and licence. But it is clear that Calvin, following upon his absolute resistance to the visual symbolizing of God, is uncomfortable with the use of symbolism more broadly, tending towards a visual literalism in which art functions primarily as a secretary of nature's forms and history's salient happenings. It is in this particular sense that he emits negative signals about the imaginative (which functions precisely on the basis of tracing and constructing significant relations trespassing beyond the reach of the eye of the beholder) and fails to appreciate the more than mimetic capacities of art in engaging with the wonders of God's creation and the historic events of *Heilsgeschichte*.

The Image and the Hypostatic Union

In this regard, as has been observed, it is a pity that Calvin did not allow his avowed commitment to Chalcedonian Christology to inform his thinking more directly.[81] The relationship between the two 'natures' of the Son of God, while admitting of no confusion whatever, must be a relationship in which figuration of some sort occurs if the humanity is truly to inform our understanding of God, as Calvin insists it does.[82] What the fathers at Chalcedon attempted was to say the most that can be said positively, and to exclude whatever must not be said, about the relationship between God and any creaturely reality in the light of this, its most unique, pointed and defining instance. This is how close God and the creature are capable of being; and this is how far distinct, even in the midst of such a union, they nonetheless remain. Any theologically adequate account of the nature of the religious image must thus take adequate account of both poles of the relationship posited here, supposing that creaturely reality, at various levels of consideration, while remaining utterly distinct from God and all the while retaining its integrity as 'not-God', may yet mysteriously be broken open and granted a capacity to suggest, or to point, or to allude in some way to the mysterious presence and activity of God himself. Paul Endokimov's insistence that, where the icon is concerned, what is understood to be attested and mediated is precisely a *hypostatic* presence – i.e. the presence and action of God *in person* – and not a natural or substantial one, offers a valuable clarificatory framework here, though I would not wish to restrict it to the icon and the justification for its particular aesthetic.[83] Whenever and wherever the God made known in Jesus Christ is held to be present and active

[80] *Inst.* I.xi.12, ibid.

[81] So, de Gruchy, 41.

[82] See, e.g., *Inst.* II.xiv.3, McNeill, ed., 484–6.

[83] Endokimov, 196.

in and through creaturely realities, I would maintain, Chalcedon prescribes the category of *hypostasis* as the most appropriate one in terms of which to identify that presence in, with and through the relevant object or event.

This is not, of course, to suggest an open-ended series of *homoousioi*, but simply to infer that if God can enter so deeply into a union with the flesh as this (i.e. in the incarnation), then the same God may choose to enter into other less radical but nonetheless fruitful levels and sorts of 'union' with physical and other creaturely realities in order to draw us into relationship with himself (most centrally, perhaps, the preaching of the Word, the sacraments, the dynamics of communal liturgy and personal devotion, but including too all manner of visual and verbal poetry in which these are represented and made sense of in the life of the Body of Christ, and an endless range of natural and cultural phenomena). The emphasis here, though, lies decidedly upon what God is capable of doing and may choose to do, and not upon any intrinsic properties of the objects, actions and events themselves and as such (whatever effect these may otherwise have upon us). When it comes to visual piety, in other words, the aesthetic merits of artefacts may not be irrelevant (that, perhaps, would be an odd suggestion), but they are certainly not sufficient, and *may* not even be necessary. David Morgan's book provides adequate testimony to the fact that, for very many of those who habitually practice their religion in visual modes, it is works of religious kitsch rather than great art which serve as the media. This is hardly an argument against seeking the best in aesthetic terms to locate in our worship space. It is simply an extension of the logic of a theology of grace making good the shortfall in our offerings, no matter how great that shortfall may be, and reminding us not to have unrealistic expectations even of the greatest human creation taken in and of itself. For, concern with the object 'in and of itself', even its capacities to evoke response, we should recall, lies close by the way to idolatry.

There is not space to address it fully, but brief mention must at least be made in passing here of the Orthodox contention that, since the presence attested in the icon is not that of nature (either divine or human) but of the transcendent *hypostasis* of the Son, both skillful artistic evocations of empirical reality on the one hand and renderings possessed of great visual beauty on the other are wholly inappropriate to the circumstance, turning the representation into a mere piece of portraiture or a pleasing *objet d'art*. Instead, Endokimov argues, the sacred visual presentation is undertaken with 'a certain cultivated hieratic dryness along with an ascetic detachment in the technique', granting a theophany rather than ravishing the soul and the senses.[84] One might respond on aesthetic grounds that, whatever the intention of those who produce them, many icons are in fact possessed of a profound beauty which, if denied or overlooked, may prove all the more problematic by comparison with the unashamed sensuousness of some Western religious imagery. On theological grounds, the difficulty I have with the argument is that, in the interests of securing a due sense of transcendence (of the person

[84] Endokimov, 179.

or *hypostasis* attested as present), the fact that this same person is only known and knowable through an engagement with the flesh (the particular *humanitas* of Jesus) is relatively underplayed, and a transcendent abstraction from his creaturely form preferred. This is a visual counterpart to the problem I identified in Chapter 1, of allowing Christology to move too quickly to a level of conceptual or imaginative abstraction, and losing sight thereby of the particulars of Jesus' earthly and historical existence, action and passion as the New Testament bears careful witness to these. Furthermore, while Endokimov's insistence that the presence attested and mediated by the religious image is precisely a *personal* presence (rather than the divine 'nature' being supposed to be present 'within' or mixed together with the space-time realities of creation), the Eastern tendency towards radical apophaticism where the *ousia* or being of God is concerned, nonetheless needs to be balanced here by an appeal to an appropriate form of analogy between the creaturely 'flesh and blood' realities of Jesus' historical existence on the one hand and the character of God on the other. Otherwise, the revelatory force of that humanity is effectively undercut. By so transfiguring the human form of the Son as to render it virtually transparent, icons thus run the risk of robbing it of its vital abiding epistemic force. That there should be visual images which err in this direction and draw attention to a corresponding theological emphasis is not in itself problematic; but in the interests of a healthy Christology they need to be balanced by others which remind us that it was precisely in the midst and out of the depths of historical existence that God gave and still gives himself to be known personally, not by our withdrawing or ascending from the fleshy particulars of his human existence, but in a sense precisely by being drawn ever more fully and deeply into their meaning.

Indeed, as I suggested earlier in this book,[85] the logical structure of the incarnation as Chalcedon presents it comes tantalizingly close to that of metaphorical predication and thus of the religious image itself, in which both unity and distinction must be maintained without loss, which, as Sallie McFague puts it, always contain(s) the whisper, 'it is *and it is not*',[86] but in which one reality accommodates itself in giving another, strikingly different, reality to be known.[87] In her treatment of it, Janet Martin Soskice describes metaphor as possessed of unity of subject and plurality of associative networks, and as involving the positing of some striking or *prima facie* strained conjunction.[88] Might not something analogous be said (*is* it not *in fact* said) of that mystery whereby the Word becomes flesh, and God, for all his overwhelming otherness, is conjoined strikingly and surprisingly with our humanity? Some version of Karl Barth's

[85] See above, 86.

[86] Sallie McFague, *Metaphorical Theology: Models of God in Religious Language* (Philadelphia: Fortress Press, 1982), 13.

[87] See above, 87.

[88] See Janet M. Soskice, *Metaphor and Religious Language* (Oxford: Clarendon Press, 1985), 49–51, 64–6.

doctrine of an *analogia fidei* as distinct from an *analogia entis* will suffice here, for those uncomfortable with the suggestion of any natural likeness between the God who is Wholly Other and the realities of creaturely and fallen existence; but analogy of some sort and at some point there must be if God is to be apprehended through his appropriation of the forms of nature and culture.[89] God must take our imagination captive if we are to respond to him in ways that befit his divine reality. Capitulation to a radical agnosticism or non-cognitive anti-realist mysticism also generates theological activity of an imaginative sort, but one wholly unconstrained by the nature of faith's true object, and prone finally always to project its own desires and aspirations onto the clouds, rather than remaining genuinely mute.

I want in closing to return to a question I raised early in this chapter. Namely, just what is it that we expect a work of art to *do* in liturgical space? Without developing the point here, there is, it seems to me, a different set of things that might be said about artefacts which primarily 'construct' the space for us – informing us (consciously or subliminally) by their symbolic depiction of elements in the tradition, raising our hearts through their accompanying beauty to map that raising of our hearts in joy to God which worship involves, perhaps even guiding the worshipper's eye to some focal point in the physical space itself – and on the other hand artefacts which, by their nature or their location, assume the much more direct role of a physical symbol of God's or Christ's presence itself. This latter category of artefact, it seems, is likely to be afforded the sort of contemplative attention which raises all the vital questions about iconic transparency and opaqueness which we have already considered. But contemplation of a sort, we should recall, belongs in the gallery as well as in the Church, and we must finally be able to furnish some reason for distinguishing between them.[90] It was Karl Barth, again, who observed that, just as God could raise up sons for Abraham from stones, so this same God could make himself known (if he chose) equally well through a blossoming shrub, a flute concerto, or a dead dog.[91] But that doesn't suggest any levelling of differences between these various possible media, let alone commend a policy of locating canine corpses in the sanctuary (which might otherwise at least be more affordable than commissioning a new painting or sculpture). It is a point about God's capacities and God's abiding freedom where the matter of our personal encounters with him are concerned. What it reminds us is that

[89] On *analogia fidei* see above, 38.

[90] I do not, of course, wish to suggest that God might not be encountered by someone viewing a work of art (religious or otherwise) in an art gallery, but simply to distinguish between such an occurrence (wherever it arises) and the purely aesthetic gaze which lies at the centre of much current aesthetic theory and experience, and to facilitate which galleries are typically designed and constructed.

[91] Karl Barth, *Church Dogmatics* 1/1, ed. Geoffrey W. Bromiley and Thomas F. Torrance, trans. Geoffrey W. Bromiley (Edinburgh: T&T Clark, 1975), 55. Cf. Karl Barth, Church Dogmatics 1/2, ed. Geoffrey W. Bromiley and Thomas F. Torrance, trans. George Thomas Thomson and Harold Knight (Edinburgh: T&T Clark, 1956), 1–44, 203–79.

any adequate account of visual piety or 'the mediation of revelation through the eye', needs to locate itself finally not just within a doctrine of creation, nor even relative to the doctrine of the incarnation, but within a theology of worship as an imaginative participation in the threefold shape of divine action as, in Barth's formulation, Revealer, Revelation and Revealedness, or the one who is himself always both the objective and the subjective actuality and possibility of our knowing of him.[92] Apart from the continuing self-revelatory 'artistry' of this God, known to us in Jesus as Father, Son and Holy Spirit, no amount of exposure to the artistic work of human hands will ever differ much from what goes on daily and routinely as the crowds pour through the doors of Tate Modern and the Uffizi for yet another look.

[92] See Barth, 295–347.

Chapter 8
Unfinished Performances

I hold the world but as the world, Gratiano –
A stage where every man must play a part,
And mine a sad one.[1]

All-seeing heaven, what a world is this?[2]

In this chapter and the next, I return to some of those artistic genres in which imagination generates form extended through time, and presents it for our consideration variously via such devices as emplotment, narration and (in the case of drama) embodied performance in real time. My concern will be with the complex interplay between the texture of human experience itself (immediate and reflective) and its careful reworking and re-presentation by the artistic imagination. In particular, I shall consider the significance of the notion of aesthetic completeness and the nature of certain sorts of literary ending for a theological reflection on the shape of human personhood and its eschatological prospect, and for an adequate reckoning with the full cost of the divine kenosis in the incarnation.

The World Stage

Perhaps it is inevitable that playwrights and actors should come, sooner or later, to reflect on the curious relationship that holds between drama and life. If dramatic art is in some sense always a version of – or at least 'based on' – life as we know it, so, in its turn, life as we know it can and has often been figured according to models duly provided by the theatre. As an actor, Shakespeare could hardly help noticing the interstices. The 'microcosmic correspondence' between the two realities was driven home each time he stepped out to perform yet another role on the boards of the Globe theatre, a venue which in construction as well as in name held the two worlds closely together.[3] As playwright, too, the metaphor clearly intrigued him, and is already introduced into his work before the Globe's

[1] *The Merchant of Venice*, 1.1. See George Brandes, ed., *The Garrick Shakespeare*, Vol. 3 (London: William Heinemann, 1905), 6.

[2] *Richard III*, 2.1. See George Brandes, *The Garrick Shakespeare*, Vol. 6 (London: Heinemann, 1905), 408.

[3] The globe was constructed on the circular pattern of Roman amphitheatres, open to the view of the heavens, and with a stage that permitted actors to stand more or less centrally amidst their audience. See the article 'Globe Theatre' by Gabriel Egan in Michael

construction in 1599.[4] The world is a stage and life a drama in which each of us has a particular part to play, and perhaps many different parts. Once deployed, this image provokes questions thick and fast about the 'drama' of all that lies beyond the theatre's limits; questions about the script, about characterization, about how much freedom a player may have in determining his part and how it is played, about the quality of a performance, and so on. What are literary–critical and dramaturgical questions in the one world are, of course, religious and theological ones in the other. In order to ask and to answer them, we cannot help positing a reality which transcends the drama itself – a playwright, a director, an audience; something which was before and will be after the drama itself is played out, and which in some sense accounts for its existence at all. And if Shakespeare does not often explicitly push such theological questions into the foreground of his plays, one cannot live long with his imagery before some of the more uncomfortable ones begin to impinge. Sometimes, of course, he cannot resist giving us a helpful shove in the right direction:

> As flies to wanton boys are we to th' gods;
> They kill us for their sport.[5]

It's not precisely the same metaphor, obviously; but it's equally clearly in the same poetic (and theological) ball park. For here we have the gods as those in whose presence (and for whose amusement) our life is played out, with a degree of malicious inter-activity thrown in for good measure. The theatrical image lurking in the background (behind the more immediate and universal improvised entertainment of the 'wanton boys') is that of the ancient 'spectacle' rather than the theatre as Shakespeare himself knew it, but the theological issues lying close to hand are some of the same ones. While he arguably furnishes us with some of the most familiar and elegant examples, though, Shakespeare was certainly not the first to play with such images. They had already occurred to the ancients themselves.

Dobson and Stanley Wells, eds, *The Oxford Companion to Shakespeare* (Oxford: Oxford University Press, 2001), 165–6.

[4] *The Merchant of Venice* is dated 1596–97 by Margreta de Grazia and Stanley Wells, eds, *The Cambridge Companion to Shakespeare* (Cambridge: Cambridge University Press, 2001), xix. The Globe was constructed in 1599 for use by the Chamberlain's Men, a company founded in 1594 and to which Shakespeare seemingly belonged from its inception. See John H. Astington 'Playhouses, players and playgoers in Shakespeare's time', in De Grazia and Wells, *The Cambridge Companion to Shakespeare*, 99–113. Interestingly, Shakespeare's most developed use of the world-stage metaphor is the familiar passage in *As You Like It* (2.7: 'All the world's a stage, and all the men and women merely players …' etc.) a play that seems to date from the very period during which the Globe was being built, or immediately thereafter. Other uses of the image occur in *2 Henry IV* (1.1; 1597–98) and *Henry V* (Prologue, 3; 1598–99), immediately prior to the Globe's construction.

[5] *King Lear*, 4.1. See George Brandes, ed., *The Garrick Shakespeare*, Vol. 9 (London: Heinemann, 1905), 301.

The use of the world-stage image by the Roman philosopher Epictetus (c. 55–135 AD) is among the first significant instances.

> Remember that you are an actor in a play, and the Playwright chooses the manner of it: if he wants it short, it is short; if long, it is long. If he wants you to act a poor man you must act the part with all your powers; and so if your part be a cripple or a magistrate or a plain man. For your business is to act the character that is given you and act it well; the choice of the cast is Another's.[6]

It is Stoic philosophy which provides Epictetus with the specific theological context for his use of the dramatic metaphor; namely, a strong overarching doctrine of divine Providence fused with an equally strong account of the rational-soul's jurisdiction within a circumscribed but definite sphere of concern. Life, he insists, is lived on a stage, against a backdrop and props, and amidst a script and a cast not of our own choosing. And yet not *all* in a human life is determined. There is a sphere within which the exercise of human freedom makes all the difference to the quality of what occurs on stage.[7] Called to perform a certain 'part' or to play a character over which we have no control whatever, we are nonetheless in a position to perform that part well or badly, and here 'character' in the other sense is of the utmost importance. The highest calling is to face whatever life (the divine Playwright or his script) may send our way, and to respond to it well. Accordingly, we must learn not to desire (or to 'live for') the things which please us, nor, on the other hand, to complain when our part in life is to endure unpleasant and even painful events.[8] Nothing, Epictetus urges, is evil in itself; it only becomes such when we permit it to *affect* our soul in certain ways, and that is something entirely within our control.[9] 'Ask not that events should happen as you will, but let your will be that events should happen as they do, and you shall have peace.'[10] And no

[6] Epictetus, *The Discourses and Manual*, Translated with Introduction and Notes in Two Volumes by P.E. Matheson (Oxford: Clarendon Press, 1916), Vol. II, 219. Catharine Edwards refers us to a tradition according to which, already in the fifth century BC, Democritus observed the same trope: 'The world is a stage, life is a performance; you come, you see, you go away.' See Catharine Edwards, 'Acting and self-actualisation in imperial Rome: some death scenes' in Pat Easterling and Edith Hall, eds, *Greek and Roman Actors: Aspects of an Ancient Profession* (Cambridge: Cambridge University Press, 2002), 377. The work of Epictetus offers a sustained development of the image, and locates it within a clear religious and theological context.

[7] 'In our power are will and all operations of the will, and beyond our power are the body, the parts of the body, possessions, parents, brothers, children, country, in a word – those whose society we share' (*Discourses* I.22). See Epictetus, *The Discourses and Manual*, Vol. 1, 110.

[8] 'The will to get and the will to avoid.' See, e.g, *Discourses* I.4; III.2 in Epictetus, *The Discourses and Manual*, Vol. 1, 55; Vol. II, 10–11.

[9] See, e.g., Discourses I.29 in Epictetus, *The Discourses and Manual*, Vol. 1, 131.

[10] *Manual*, 8 in Epictetus, *The Discourses and Manual*, Vol. 2, 216.

human circumstances are truly 'tragic'. Tragedy is a theatrical genre, and ought properly to be confined to the world of the stage alone. Tragedies are 'a portrayal in … metrical form of the sufferings of men who have set their admiration on outward things',[11] rather than mastering the appropriate detachment from them. Accordingly, in real life tragedy is what occurs only when fools are compelled to face everyday events, and cannot respond as they ought.[12] It is a state of turmoil in the heart, mind and will, and at odds with that 'true nature of things' to which each soul ought voluntarily to adapt itself.[13] 'Blows are not by nature intolerable', Epictetus writes.[14] And if they are, it is *we* who make them so. So yes, life is indeed lived under the gaze of One who is Playwright, Director and Audience. The gods are watching.[15] But they are not toying with us for the sake of their own gratification, wantonly removing legs or wings, or capriciously dispatching us with a down-turned thumb. That's not an appropriate characterization of the human situation at all. Rather, we are offered a part in life's great play, a private performance for the gods no less, and with it the opportunity to become a great actor capable of taking whatever part may be offered to us and rendering it with a noble artistry worthy of that which first created it. So, if we find ourselves given a short rather than a long part, or if we must bear much suffering and disadvantage rather than honour and privilege, there is no room for complaint; rather, we must strive to play even the most ignominious part well, and thereby make our personal contribution to the success of the drama as a whole. Even death itself, Epictetus reassures us, is no evil to be feared; it is simply the divinely ordained end of our allotted time on stage, and, being able to do nothing about it, we should not fear it, but should simply accept it and 'die well', as it were, rather than badly.[16]

[11] *Discourses* I.4 in Epictetus, *The Discourses and Manual*, Vol. 1, 56.

[12] *Discourses* II.16 in Epictetus, *The Discourses and Manual*, Vol. 1, 198.

[13] 'Have courage to look up to God and say, "Deal with me hereafter as Thou wilt, I am as one with Thee, I am Thine. I flinch from nothing so long as Thou thinkest it good. Lead me where Thou wilt, put on me what raiment Thou wilt. Wouldst Thou have me hold office, or eschew it, stay or fly, be poor or rich? For all this I will defend Thee before men. I will shew each thing in its true nature, as it is"' (*Discourses* II.16, Epictetus, *The Discourses and Manual*, Vol. 1, 199–200).

[14] *Discourses* I.1 in Epictetus, *The Discourses and Manual*, Vol. 1, 47.

[15] Edwards reminds us that for the Stoics human actions are meaningful 'insofar as they are witnessed', and alludes to the essentially social and public situation of such performance before a human audience. 'Acting is a success or a failure insofar as it communicates the part to those watching. The audience has expectations.' As such, Stoicism, she suggests, has an inherently 'theatrical' aspect because it is 'intrinsically social'. (Edwards, 'Acting and self-actualisation in imperial Rome: some death scenes', 382–3.) While Epictetus certainly affords due weight to the social location of human action and its implications, the 'audience' he has in mind in his appeal to the metaphor of the world-stage is generally divine rather than human.

[16] See, e.g., *Discourses* II.1; III.24. Epictetus, *The Discourses and Manual*, Vol. 1, 144–5; Vol. 2, 98–9. It goes without saying that the deaths of others 'close' to us (parents,

Karl Barth was certainly no Stoic, but his theology does manifest an analogous concern to affirm both a high view of Providence and the freedom and ethical responsibility of the creature. And it is interesting, therefore, to note that the metaphor of the world-stage commends itself to him

> In so far as I am caught up in this movement from my beginning to my end, my life becomes my history – we might almost say my drama – in which I am neither the author nor the producer, but the principal actor. I did not place myself in this movement, nor do I maintain myself in it. But I myself am this movement. Between my birth and my death the freedom is given to me to be myself in this movement, in this ascent and descent. To be in this freedom is to live.[17]

In this chapter I propose to explore further the fruitfulness of this image of drama, performance and some of its natural correlates for understanding two particular aspects of human existence: (1) The possession of what psychiatrist Victor Frankl calls the 'will to meaning'[18] due to which narrative patterns of one sort or another suggest themselves naturally as the form of the human hypostatic trace in time ('I myself *am* this movement' in the drama). (2) The way in which our living of life, and more precisely our embracing of discipleship, is *related to* the patterns of meaningfulness which we trace and project; as we perform the part we have been given in the drama. So, this is an exercise in what Frank Kermode calls 'making sense of the ways we make sense of the world'.[19] And, since death is the one thing we can be sure of in life, I shall do so with a particular view to our finitude as human creatures, and the significance of our death for the patterning of life. Is it part of the performance, or the final curtain which indicates that the horizontally challenged lady has now sung, and everyone else can safely leave the theatre? And, as we act out our part, what impact does its inexorable approach have upon our performance?

wives, sons, daughters etc.) are to be treated with the same dispassionate acceptance rather than becoming the occasion for (essentially indulgent) grief. Their parts in the play are over, and Epictetus indicates that we should be moved by them as little as any actor is by the stage 'death' of one of his fellow players. See, e.g, *Manual*, 11 in Epictetus, *The Discourses and Manual*, Vol. 2, 217.

[17] Karl Barth, *Church Dogmatics*, III/3 (Edinburgh: T&T Clark Ltd., 1960), 231.

[18] Victor Frankl, *Man's Search for Meaning* (New York : Washington Square Press, 1985), 121.

[19] Frank Kermode, *The Sense of an Ending* (London: Oxford University Press, 1967), 31.

Finitude and Fulfilment

Let us suppose that my life is indeed a drama in which I am the principal actor; a drama, then, played out on the stage of the world, and bounded at each end by my birth and my death. *This* is who I am. This is who *I* am. The answer to the question of my 'hypostasis' is answered in this performance, and not in abstraction from it (as though in some eternal programme note).

Some literary allusions (borrowed from novels rather than the theatre) may help further to draw out and sharpen the force of the metaphor and the problems involved in fitting it to the shape of life. First, from the final chapter of George Eliot's novel *Middlemarch*, where we find the following reflection: 'Every limit is a beginning as well as an ending. Who can quit young lives after being so long with them, and not desire to know what befell them in their after-years?'[20] In the book, this paragraph prefaces, and serves to justify, several pages of narrative closure in which first one minor character and then another is tied neatly, like so many loose ends, into the tapestry of the novel's world. The same narrative contrivance, disparagingly referred to by Henry James as 'a distribution at the last of prizes, pensions, husbands, wives, babies, millions, appended paragraphs and cheerful remarks',[21] is to be found in many classics of the genre (Dostoyevsky's *The Idiot* is another example), and prompts us to ask why. No doubt it would have been *possible* to leave these stories within a story incomplete, fragmentary, unresolved. That the novelist felt the device *needful*, though, tells us something about life as well as fiction; namely, that when it comes to story, we crave some sense of an ending, a resolution, a pattern completed rather than left open and unresolved. We wonder how things turned out, what happened to whom, where they ended up. In life, where we resort habitually to narrative in order to give some account of ourselves, who we are, how we came to be where we now are, it is as if the very meaningfulness of individual lives (our own, or those of others) is at stake in this quest for unified form. Literature, at least, might be judged aesthetically deficient to the extent that it fails to bring its *principal* characters to some satisfying narrative closure. Can we say the same of human lives, of personhood?

Frank Kermode has famously suggested that narrative *imposes* form on what is in reality a chaotic world, and thereby deceives in order to console us. We are beings who crave form and meaning. This is why we find stories so compelling: they provide form where, in reality, there is none to be had. 'It seems', he writes, 'that in 'making sense' of the world we … feel a need … to experience that concordance of beginning, middle and end',[22] the overall unity of form which characterizes literary fictions. And in particular, he suggests, it is in the sense of an *ending* which narrative provides that we find the most satisfaction; for it is in the narrative resolution of character that the meaningfulness of the plot as a whole

[20] George Eliot, *Middlemarch* (London: Penguin, 1965), 890.

[21] Cited in Kermode, *The Sense of an Ending*, 22.

[22] Kermode, *The Sense of an Ending*, 35.

really becomes apparent. Of course we know that life and literature are not the same thing, but the powerful aesthetic satisfaction provided by the contrivances of fictional emplotment may at least reveal a deep down sense that life, too, *ought to be* possessed of shape or pattern, brought to some satisfying closure, its form shown to be meaningful rather than meaningless.

The same sense that *ending* is definitive with respect to the meaningfulness of a life lived is echoed in Heidegger's claim that an authentic personal existence is to be had precisely by facing the inevitability of our own death (the 'end' towards which our existence inexorably moves), accepting it, and 'living toward' it rather than repressing all thought of it. Thereby, he suggests, death becomes the unifying factor in our existence, that to which everything is related, and we are enabled to seize the concrete opportunities and possibilities proper to our particular existences, being responsible in the face of them, rather than missing or ignoring them.[23] Because he knows that every moment is unrepeatable, and his life itself, which must some day end, is the boundary beyond which there are no motion replays or second chances, 'At any moment, man must decide, for better or for worse, what will be the monument of his existence'.[24]

Jean-Paul Sartre, though, demurred from this view, insisting that the meaningfulness of a particular life could only be discerned from the *specific* ending which it had (rather than 'ending' or 'death' as an abstraction, however inevitable it may be), and – since the particularity of death is almost always unexpected – it cannot be lived towards as something clearly anticipated. Hence, he argues, mortality does not bestow meaning upon our living or reveal its meaning, but in fact robs it of the only sort of meaning we might have found in it. We are *never* the ones to see the whole of our life from the perspective of this ending, and during our living, therefore, we are by definition in no position to discern the meaning of our actions or experiences. 'If we must die', he concludes, 'then our life has no meaning because its problems receive no solution, and because the very meaning of the problems remains undetermined'.[25] Again, we *crave meaning* for our lives, our 'selves', but our finitude, rather than bestowing such meaning finally denies us the opportunity of tracing any.

But this is not all. More must be said. And my other literary allusion is to Ian McEwan's novel *Atonement*. Here, in a coda to the main story, the narrator (whose account is based on events in her own early life) confesses to having falsified her ending in order to render it more bearable and satisfying. The two lovers whose frustrated passion and separation is finally resolved and consummated in the novel, in fact never saw one another again, one having died on the battlefield and the other in a bombing raid in the London blitz. But, the narrator asks, 'How could that constitute an ending? What sense of hope or satisfaction could a

[23] See John Macquarrie, *An Existentialist Theology* (London: SCM Press Ltd., 1955), 116–31.

[24] Frankl, *Man's Search for Meaning*, 143.

[25] Jean Paul Sartre, *Being and Nothingness* (London: Methuen, 1957), 539–40.

reader draw from such an account? ... Who would want to believe that, except in the service of the bleakest realism? I couldn't do it to them. I'm too old, too frightened, too much in love with the shred of life I have remaining.'[26] It is not simply a sense of *an ending as such* that we seem to crave, but a certain sort or quality of ending. A novel which brings all its characters to clear narrative closure may still not provide the sort of aesthetic satisfaction we are hoping for, because it leaves so many half-completed projects, relationships, hopes and aspirations. Some postmodern art deliberately plays on such interruptive endings (Quentin Tarantino's film *Pulp Fiction* for example), and in some respects it is the stock in trade of those dark literary tragedies where all finally comes to nothing. But the sort of aesthetic satisfaction we derive from such depictions is of a very peculiar sort, and might even be thought to lie in the sense of protest which it stirs in us against the fragmentary, broken and unfulfilled potential which they lay before us. What we desire, for the characters on screen or page, and for ourselves and the others with whom we live, is a different sort of ending, an ending in which the opportunity for fulfilment and realization of self is offered and seized, rather than wrenched from human grasp. We crave not just an ending, but a *good* ending in which all shall be well, and all manner of things shall be well.

Here though, it is even more apparent that life cheats us. Even in our own affluent, healthy and ageing modern societies, relatively few people approach the prospect of their death with a sense of being 'sated with years', or of having fulfilled their lives' human potential. We only have to cast our gaze more widely to see a circumstance far more troubling. In the words of one report, due to endemic poverty 'the actual life of most (humans) has been cramped with back-breaking labour, exposed to deadly or debilitating disease, prey to wars and famines, haunted by the loss of children, filled with fear and the ignorance that breeds more fear'.[27] Jürgen Moltmann drives the nail home with characteristic force: 'Think of the life of those who were not permitted to live, and were unable to live: the beloved child, dying at birth; the little boy run over by a car when he was four; the disabled brother who never lived consciously, and never knew his parents; the friend torn to pieces by a bomb at your side when he was sixteen; the throngs of children who die prematurely of hunger in Africa; the countless numbers of the raped and murdered and killed.'[28] What are we to make of the alleged meaningfulness of these lives? Their particular 'endings' are clear enough, but they are not the endings to, do not bestow the meaningfulness upon the lives which we might naturally crave for them. Despite the temporal ending which death inevitably constitutes to our living, few if any human lives appear to constitute anything other than incomplete and unsatisfactory stories, and many present themselves as tragic. Because they are life rather than literature, this sickens rather than satisfies us, and leaves us with

[26] Ian McEwan, *Atonement* (London: Jonathan Cape, 2001), 371.

[27] Barbara Ward and René Dubos, *Only One Earth* (New York: Penguin, 1972), 35. Cited in John Hick, *Death and Eternal Life* (London: Collins, 1976), 153.

[28] Jürgen Moltmann, *The Coming of God* (London: SCM Press Ltd, 1996), 117.

the sense that it should all be otherwise. If we could rewrite the endings to their stories, we should do so. But in real life, unlike fiction, we are unable to do so.

In his essay 'Art, religion, and the hermeneutics of authenticity', philosopher Nicholas Davey focuses on the notion of 'the withheld' in art, and relates it to the nature and pattern of certain sorts of religious experience.[29] Aesthetic experience, he notes, especially in the case of art performed, is intensely temporal, and sees meaning brought into form through time. He cites Gadamer: 'Every performance is an event, but not one in any way separate from the work – the work itself is what "takes place"'.[30] As meaning unfolds, so what was withheld is disclosed to performer and audience alike. In a statement sounding remarkably consonant with Heidegger's perspective Davey writes: 'As a dwelling between past and future possibilities, authenticity involves a being open to the call of the withheld, not a prising open of the withheld, but a remaining open to and a holding with that which is still withheld from us.'[31] In the case of religious experience, he suggests, we have to do with the anticipation of a meaning as yet to be revealed in the living of a particular life. Such anticipation 'projects a horizon of meaning whereby the incoherent and presently fragmented aspects of a work [or life?] might achieve an envisaged but as-yet-to-be-attained coherence'.[32] Aesthetic experience, in which precisely this comes to pass, Davey notes, lends substance to religious hope and its manifestations in existence. Religious performance, we might say, involves a responsiveness to a call to venture out in faith in a meaning for our lives as yet to be disclosed.

There is, of course, at least one vital difference between performance in art and in life, one shuddering 'it is not' which qualifies the poetic 'it is'. In drama, the performer is confronted with openness and the freedom for realization of a meaning as yet still withheld; yet he also generally has a script, indicating in broad outline at least the shape which his movement towards dramatic closure will take. So too in musical performance. If a rendering of a sonata is of aesthetic value it will disclose new depths of meaning in the work; yet for it to be a performance of *this* sonata, and not some other, it must have an identifiable relationship to a score indicating the limits within which freedom may be exercised. (I'm not suggesting that there aren't exceptions to this – of course there are. But *most* artistic performance is like this.) But in life it is hardly ever like this. Mostly, as 'actors', we face a future which is open, unknown in its openness, and often threatening in its unknowability. Even our best projections and most reasonable expectations can be and frequently are defied or rudely interrupted by the unexpected development, by 'events' which are no respecter of the neat patterns of our planning. Apart from

[29] In Salim Kemal and Ivan Gaskell, eds, *Performance and Authenticity in the Arts* (Cambridge: Cambridge University Press, 1999), 66–93.

[30] *Truth and Method*, 147, cited in Kemal and Gaskell, *Performance and Authenticity in the Arts,* 77.

[31] Davey in Kemal and Gaskell, *Performance and Authenticity in the Arts*, 89.

[32] Davey in Kemal and Gaskell, *Performance and Authenticity in the Arts*, 69.

the singular certainty that we shall one day die, all else is, in the strictest sense, contingent and vulnerable in this way. As we have already seen, the Stoic ideal was one of acceptance and readiness to face whatever might come next, determined not to allow events and emotions to get us down, thereby turning life's drama into a tragedy. But is stoicism (in the technical or the more extended sense) really enough if we are to live well? Do we not need, we might well ask, something *more* to be disclosed, something akin to the actor's script or the musician's score, some indication of the relevant limits within which our own freedom may and must be exercised, so that we know just what it is that we are supposed to be performing?

Perhaps in this respect the performance of life is indeed rather more like a certain sort of improvised drama than the playing of a carefully scripted role. There is something about it, too, which resembles the literary device of *peripeteia*, in which readerly expectations are deliberately thwarted by the omnipotent author generating 'events' to throw in the protagonist's path. If the device is successful, then the expected end is eventually reached, but via anything but the expected routes. And it is this, of course, that keeps us reading, always eager to know what will happen next. Shifting perspective again from the standpoint of 'reader' to that of 'actor', we might say that it is this same structural pattern in which starting points and promised ends are given, but the route between them as yet unclear or 'withheld', that keeps us living, striving, moving forward in our own personal or communal dramas. In other words, while we may not have access to a script, we need, and are offered, some imaginative vision of an end, a closure, a *telos* to our living which bestows meaning and worth upon it, and which grants a sense of direction. To borrow categories used by Sam Wells in his discussion of drama and Christian ethics, we need to be able to relate our here and now to some larger pattern which enables us to 'overaccept' the contingencies and accept them as gift.[33] And while we may hope that hitherto undisclosed meanings will be revealed along the way, we know that the meaningfulness cannot finally be had in the here and now at all. This consideration is one to which we shall return in our final section.

The novelist Gustave Flaubert observed that 'Real life is always misrepresented by those who wish to make it lead up to a conclusion. God alone may do that'.[34] Perhaps our human bid for form, our 'will to meaning', is rooted here in an implicit eschatological sense that, despite the experienced gap between literature/drama and life, our existence and that of others may *yet* be revealed as meaningful through the closure provided by the one in whose hands the drama, the plot, the performance finally lies. Sartre's point remains to be addressed. Can an authentic performance of life, let alone discipleship, be approximated to without some sense, however

[33] Samuel Wells, 'Improvisation in the Theatre as a Model for Christian Ethics' in Trevor A. Hart and Steven R. Guthrie, *Faithful Performances: Enacting Christian Tradition* (Aldershot: Ashgate, 2007), 147–66. For a more developed version of the argument see Samuel Wells, *Improvisation: the Drama of Christian Ethics* (London: SPCK, 2004).

[34] Cited in P.T. Forsyth, *The Justification of God* (London: Duckworth, 1916), 223.

provisional and partial, of the broad pattern of that meaning which remains to be disclosed? In theological terms, do we not need some sort of eschatological vision to fuel our existence? And if so, what sort?

Two Theological Approaches

I want in this section briefly to consider the ways in which two theologians have handled questions pertaining to the pattern of human existence, especially in relation to the issue of death and what it says about the meaning of human lives considered in eschatological perspective. The two theologians concerned are John Hick and Karl Barth.

In his book *Death and Eternal Life* Hick picks up on some of the problems we have already mentioned. Thus he notes that most of the world's population has lived in 'a condition of life so degrading as to insult human dignity'.[35] We see daily the sort of potential that human lives contain, and yet everywhere we see such potential unfulfilled, cut short, and in many cases blighted by terrible suffering while it lasts. The advanced state of science and technology in the modern world makes little dent in all this. The final stages of editing undertaken before submitting the manuscript of this book to the publisher were completed on a train journey from Kolkata to Darjeeling, and in the immediate wake of several days spent visiting HIV/AIDS hospices, slum relief projects and the abandoned infants taken in by Mother Teresa's Missionaries of Charity; all ample evidence, were any needed, of the verity of Hick's observation. If, then, we are to suppose that human life has meaning, that there is fulfilment to be looked for, a pattern to be traced, it is apparent that the span of this life as such is not where we shall find it. The time between birth and death, even in the case of those longest lived, is insufficient for its realization. Furthermore, the traditional Christian focus on the span of this earthly life as the environment within which human salvation is realized (or not) is, Hick insists, 'unrealistic both as regards what is to happen before death and as regards what is to happen after death. If salvation in its fullness involves the actual transformation of human character, it is an observable fact that this does not usually take place in the course of our present earthly life'.[36] Therefore, he concludes, we must suppose that the pattern of a human life continues beyond what we see of it, that its development towards fulfilment is extended temporally, that it is 'given more time' to grow and advance towards that spiritual perfection which alone (however we think of its nature) secures the person's story as a comic, rather than a tragic one.

This, then, is the fundamental claim that Hick makes. Death must not be the point at which the pattern of any particular human life is finally concluded and determined. It can at most be the conclusion of a key stage along the way toward

[35] Hick, *Death and Eternal Life*, 154.
[36] Hick, *Death and Eternal Life*, 455.

the completion of this pattern. In some sense, when we die, 'the persisting self-conscious ego will continue to exist'. But the model of personal identity which Hick entertains is not at all abstract, but is rooted in particularities of space and time, the contingencies of culture and circumstance. All this, he holds, is necessary to the idea of the self as an entity capable of moral and spiritual development, and hence salvation (rather than mere escape from the exigencies of historical existence). 'For', he writes, 'we have been formed as empirical egos within a particular culture and a particular epoch of history. The language in which we think and speak, the structure of society through which we are related to our neighbours, the traditions and mores which we inherit, the state of public knowledge, the unconscious framework of presuppositions through which we perceive the world, the contingencies of political history ... have all helped to make us what we are'.[37] 'Strip all these culturally conditioned characteristics away', he continues, 'and I should be someone else – or perhaps no-one'.[38] We have our identity, in other words, are who we are as embodied selves in more than a merely physical sense. Our being is enfleshed in the realities of a socio-political, cultural and historical context, and the very particular opportunities, challenges and possibilities with which it presents us.

Thus Hick arrives at his preferred account of the patterning of human existence, an account which draws consciously upon, but is quite distinct from, certain Eastern models of reincarnation. The self, he suggests, is extended in time after death through 'a series of lives, each bounded by something analogous to birth and death, lived in other worlds in spaces other than that in which we now are'. This enables him to take seriously both the idea of more time being granted *and* the finite particularity which seems to provide the backdrop, props and cast list needful for the performance which I am called to give (since all these together are constitutive of the I who is called to give it). Each life in the series is finite in itself, each represents, as it were, another act in my personal drama, and each provides opportunity for an advance of the self from the stage of development it had reached at the end of the previous Act. Furthermore, the action of each is directly related to that which is needful for particular stages of the self's development, and has its meaning therein. Here Hick's concern with theodicy dominates the shape of his eschatology. For now we can, indeed must, say that the suffering of this life is revealed at the last to be meaningful, since through participation in our particular portion of it we become the persons we are, and are fitted to progress to the next Act. Hick does not indicate just how many such lives each of us may have to enjoy or endure, though he seems to suppose it may indeed *be* many, depending upon the rate of our progress.

What is notable in Hick's account of salvation and survival of the self through death is the relative absence of reference to God as the one through whose agency and direction all this occurs. The drama – to return to our core metaphor – is played

[37] Hick, *Death and Eternal Life*, 411.
[38] Hick, *Death and Eternal Life*, 412.

out as a lengthy series of related Acts, but it appears to be largely an improvised performance, with nothing resembling a script, a playwright, or a Director in whose hands the movement to the final scene rests securely. Nothing, of course, could be further from the truth in Barth's theology to which we now turn.

To be human, Barth notes, is to be temporal, to have our existence in time.[39] This is part of our proper creaturely contingency and, as such, distinguishes us from our Creator. Specifically, it is not that we are temporal which differentiates us from God, but the form of temporality in which our existence is played out. God's eternity is not timeless, but rather 'authentic temporality' from which our creaturely temporality derives. In God (for eternity is a perfection of God himself, proper to the form which God's existence takes, and not a field within which God exists and to which he is in any sense subject) 'present, past and future, yesterday, to-day and tomorrow, are not successive, but simultaneous'.[40] As creatures, on the other hand, we live transient lives, existing on the uncomfortable present cusp of a pastness in which all that we value decays and disappears ('is' no more) and a future which threatens possible horrors and terrors, and holds out at best uncertain hopes. Furthermore, our temporality, our 'own time', the span which God has granted us, is precisely that – a limited span, bounded at each end by the events of birth before which we did not exist, and death after which we shall not exist.

Barth recognizes that, in our fallenness and guilt, this finitude is experienced by us as a problem, even a threat. But he is not sympathetic to Hick's bid for the extension of our personal drama beyond death. The idea that the granting of further time – even infinite time – would somehow redress the problem of personal fulfilment or salvation, is one that he rejects as a dangerous illusion. 'This could only mean in fact that we should be able to sin infinitely and even quantitatively multiply our guilt on an infinite scale.'[41] Far from treating it as a curse, therefore, Barth suggests, we should view our finitude as a good thing. Death comes as a blessed release from a life in which the forces of chaos and sin reign supreme and torture us. Far from the curve of our pattern of personhood being a gradual climb towards perfection, viewed in itself it is plunging ever further down beneath the point where the graph stops. 'Could there', Barth asks, 'be any better picture of life in hell than enduring life in enduring time?'[42] Finitude, on the other hand, puts us out of our misery, sets us free from a life of addiction to sin, grants us peace. It is a form of euthanasia.

In positive terms, finitude is a blessing because it bestows particularity, form and thereby meaningfulness upon our personal existence before God. Like Hick, Barth recognizes that human life and identity is rooted and played out in relation to the contingencies of time, place and culture. It is this that gives the creature its

[39] Karl Barth, *Church Dogmatics*, III/2 (Edinburgh: T&T Clark Ltd, 1960), 437. See also 526.

[40] Barth, *Church Dogmatics*, III/2, 437.

[41] Barth, *Church Dogmatics*, III/2, 631.

[42] Barth, *Church Dogmatics*, III/2, 562.

specific and genuine reality. 'Only the void is undefined and therefore unlimited.'[43] 'The creature must not exist like the unhappy centre of a circle which has no periphery. It must exist in a genuine circle, its individual environment. It must not exist everywhere, but in a specific place. It must not exist endlessly, but in its own time. It must not comprehend or understand or be capable of or accomplish everything. It has freedom to experience and accomplish that which is proper to it, to do that which it can do, and to be satisfied.'[44] In other words, the limitations of our finitude, culminating finally in the horizon that is our death, provide a shape, a set of horizons, within which our life may and must be lived. It limits the opportunities presented to us, and thereby the demands placed upon us. It furnishes a matrix of relationships, capacities and possibilities that are ours alone, the hypostatic fingerprint which differentiates us from all others and seals our personal uniqueness before God. We may be playing on the same stage, but the character *we* are called to perform and to *be* is unlike any other in the drama. God's specific limitation of an individual life is thus his granting of overall form *to* that life, a pattern which we are called to develop and to improvise upon in our free performance of life, but which defines the thresholds, the limits within which such freedom may actually be exercised. This pattern, this role, this character within the drama is our particular place within, our personal portion of the whole creation, and we should value it as such.[45] That it comes to an end is indicative of God's affirmation of a particular life, since 'I am and can be only what I am in this one time, in the few years of this single lifetime', and those who resist such limitation 'necessarily resist themselves, for they themselves are none other than those who are limited in this way'.[46] The span of time which God grants us, our allotted portion of time *is* the duration of our 'part' within the wider drama of human history. The form is completed. The pattern is what it is, and we are who we are within its limits.

The further and final reason why God's limitation of our time, his granting of particularity to our personhood through finitude, is something to be welcomed rather than eschewed is simply that it is in *this* time, *our* time, *our* particularity, that God makes us the subject of his promise, and calls us to a response of faith and obedience. Our time is our unique opportunity for response, and it is to me (who I am in all my finite limitedness) that God calls, and from whom he looks for a particular personal response. 'The promises must be claimed' by each, Barth writes, 'Otherwise what is objectively true in [Christ] is not true for him. Otherwise he himself is not within the truth of his creatureliness but somewhere outside'.[47] And here it is precisely the form provided by our finitude, the inevitability and unexpectedness of our own death, which grants significance to our living, since it

43 Barth, *Church Dogmatics*, III/4 (Edinburgh: T&T Clark Ltd., 1961), 567.
44 Barth, *Church Dogmatics*, III/3, 85.
45 Barth, *Church Dogmatics*, III/4, 569, 573.
46 Barth, *Church Dogmatics*, III/4, 571, 570.
47 Barth, *Church Dogmatics*, III/4, 580.

charges the divine summons with an urgency it would not otherwise possess. Now is the day of grace. The opportunity to fulfil our particular creatureliness, to seek the correspondence of the pattern of our personhood with that of Christ's (in all *its* particularity) is one which presents itself to us as who we are and through what we do and become in this limited life, and not otherwise. This, though, if it is indeed a blessing, may seem to us to be a mixed one, a daunting prospect. Our character is cast for us, the stage is set, and all the props in place. But there is no rehearsal, and only a single performance before the reviews are written. Thus a burning question presents itself to us. Is this all there is? And, if not, if the absence of any further time is not the end for us personally, how are we to think of what lies beyond and its relationship to the person we have been granted the freedom to be and become between the limits of our birth and our death?

Here, Barth insists, we must remain largely agnostic. Hence, 'We do not know what and how we shall be when we are no more and have no more time for being in virtue of our death. ... We can only cling to the fact ... that even in our death and as its Lord (God) will be our gracious God, the God who is for us, and that this is the ineffable sum of all goodness, so that everything that happens to us in death will in some way necessarily work together for good'.[48] So, in the strictest sense, 'our consolation, assurance and hope in death are restricted to the existence of God'.[49] The question we must ask is whether such apophatic 'clinging' is really sufficient as an imaginative basis for living hopefully towards death. In fact, of course, Barth does give us something to work with. He cannot help invoking some positive imagined content with respect to this hereafter, even as he adopts a deliberately agnostic approach. Hence death will *not* mean our return to the sort of non-being out of which we were originally called in creation.[50] God will 'be there for us', and will hold us in some form of continued existence with himself.[51] But 'whatever existence in death may mean, it cannot consist in a continuation of life in time'.[52] We shall have had our allotted time, and more of it would only be bad rather than good news. Instead, we must imagine some distinct mode of creaturely correspondence to God's own 'authentic temporality' in which past, present and future are no longer strung out in a series of consecutive moments, but coexist in perichoretic simultaneity.[53] Even as one 'who has been', I shall somehow share in God's own eternal life.[54] But here a further problem arises. Who, we must ask, is this 'I' who thus enjoys eternal fellowship with God? What is the relevant content indicated by the pronoun? Again, perhaps a certain level of agnosticism is in order; but in as much as Barth addresses the question directly, he points to an

[48] Barth, *Church Dogmatics*, III/2, 610.

[49] Barth, *Church Dogmatics*, III/2, 616.

[50] Barth, *Church Dogmatics*, III/2, 611.

[51] Barth, *Church Dogmatics*, III/2, 611.

[52] Barth, *Church Dogmatics*, III/2, 589.

[53] Barth, *Church Dogmatics*, III/2, 526.

[54] Barth, *Church Dogmatics*, III/2, 632–3.

identification of the particular person with whom he or she 'has been' in the time allotted to them by God. Thus, 'man is, only as he is in his time. Even in eternal life he will still be in his time'.[55] The 'whole time' given us by God is his gift to us of our distinctive existence, and is thus the subject of our redemptive participation in God's own life. Man 'looks and moves', Barth writes, 'towards the fact that this being of his in time, and therewith its beginning and end ... will be revealed in all its unmerited shame but also its unmerited glory, and may thus *be* eternal life from and in God'.[56] In itself, this seems to exacerbate the problem rather than to resolve it. The pattern of who I shall have been in my life (as brought to closure by death) is, as Barth rightly sees, precisely what needs to be redeemed. Yet the things he is willing to venture (positively or negatively) about the possible shape of this 'eternal future' end up sounding more like a *rescue from* the particulars of our embodied and historical existence than the *redemption of* them.

The issue which divides Hick's view from Barth's from the outset and fundamentally is the claim that the granting of 'more time' to a person's existence might somehow address the theodicy issue. Both begin with a frank recognition of the problem – human lives as actually lived are, by the time death brings them to an end, identifiably incomplete and imperfect, and sometimes woefully so. Hick appeals precisely to this solution (a whole series of temporal extensions to our allotted time), and Barth rejects it outright. This rejection is needful in order to underwrite his conviction that – human beings being what they are – no amount of extra time (time, that is, of the sort and under the conditions we currently know and experience) could ever suffice to address the problem of sin and suffering, but only the radical intervention of God's grace. 'Only God can do that.' In fact, though, Barth takes a further significant step, drawing a sharp contrast between the nature of historical time (essentially linear, sequential and consecutive) and the simultaneous shape of 'eternity'. He also suggests that the pattern of personal identity (who 'I' am in the final analysis) will be closed by death, and thus within our allotted span of historical time. Such suggestions do not arise in the form of imaginative 'takes' on how things *might* be in the Eschaton, but are effectively limit statements. They are meant to exclude the feasibility of supposing that anything analogous to the sequential nature of historical time could pertain beyond the bounds of history (or those of a particular life). This, it has to be said, is hardly a necessary insistence on biblical grounds or any other, and sits ill with Barth's professed minimalist agnosticism with regard to the shape of post-mortem existence. Were we to treat it just as one imaginative scenario to set alongside others, though, it remains one with some highly problematic entailments for the way in which we might suppose this life (and our identity as particular persons in it) to be related to the next.

[55] Barth, *Church Dogmatics*, III/2, 521. Cf. 523: 'whatever I am, I am in my temporal reality, in the totality of what I was and am and will be.' Also 554: 'Man is ... in this span, and not before or after it.'

[56] Barth, *Church Dogmatics*, III/2, 633. My italics.

In short, Barth's account leaves no 'time' available for us to imagine anything further taking place in. Put differently, it leaves no 'time' for God to do anything further with us. (And we are capable, surely, of imagining some alternative mode of temporality unlike that we know in all sorts of ways, but in which things might nonetheless still be imagined meaningfully as 'happening'?) In Barth's account, eternity consists, in effect, of the simultaneity of our past, present and future, a pattern played out, as it were, in the presence of God, and now bathed somehow in the glory characterizing the penumbra of that presence. But there is no more time for any further modification of the pattern of a life itself. What will be simultaneously present to us and to God, therefore, we must suppose, is the 'whole time' of a particular life bounded by birth and death, and lived in the world. Yet this seems to leave us trapped eternally with what, by the time of our death, we 'shall have been', an inference that hardly addresses the theodicy issue satisfactorily. Arguably, it exacerbates it. Of course, in meeting this concern, Barth insists that we shall nonetheless by then be in the presence of God, and none of this will blight our eternal joy. But this seems to meet the problem only by effectively disentangling the substance of a particular personal identity (the 'me' who will be there with God to witness and enjoy all this) from the content of a particular life as lived and suffered. Eschewing the imagination of post-mortem temporality altogether, Barth is driven to a very high level of imaginative abstraction (the concrete is inexorably embedded in time); and this leads in turn to a vision in which, rather than the content of our life being *redeemed* in any identifiable sense, we are effectively rescued *from* it (even though 'it' is in some sense still 'ours'). Barth may be at one with one important element in the theological tradition here, placing emphasis upon death as a decisive cut-off point where much about the creature's form and eternal destiny is already decided; but he is equally clearly at odds with the wider rich and fertile imagining of the redeemed state in Scripture (e.g. in the prophets) as a transformation and renewal of what this life amounts to, a raising of it to new life in which it both remains the creature that it has been, and yet is transfigured into a joyful and glorious version of itself which we can, as yet, *only* imagine. The pattern of history, and of individual lives lived within it, need to be reconfigured, healed, cleansed, completed and brought to fulfillment. But this, we must suppose, 'takes time', time beyond the limits of historical existence itself. To the extent that we refuse at least to *imagine* any such time, we risk positing an arbitrary disjunction between this life and the next, tracing no meaningful connection between the two stages. Far from justifying God's decision to create (which is what Barth intends), this in turn calls into question the status of our embodied, historical existence as the unequivocal object of God's redemptive purpose and activity, and thereby devalues it.

Hope, Improvisation and Eschatological Imagination

What, Jürgen Moltmann asks, should we make of the Pauline claim that '"this mortal life will put on immortality" (1 Cor. 15:54)? ... Will this life be "immortalized", as obituary notices sometimes say? If that meant that this life from birth to death is recorded as if on a video, and stored up in the heaven of eternity, that would be anything but a joyful prospect: immortalized with all the terrible experiences, faults, failings and sicknesses? How would we imagine the immortalizing of a severely disabled human life, or the immortalizing of a child who died young?'[57] It is this question, answered in the light of convictions about God's justice, that leads Moltmann finally to demur from Barth and to affirm a version of the doctrine of the intermediate state in which further 'time' is granted by God for the task of completing his creation and fitting us individually for eternity. 'I shall again come back to my life', Moltmann writes, 'and in the light of God's grace and in the power of his mercy put right what has gone awry, finish what was begun, pick up what was neglected, forgive the trespasses, heal the hurts, and be permitted to gather up the moments of happiness and to transform mourning into joy'.[58] This is certainly no mere extension of our creaturely time, or 'another chance' to get it right this time. It is a qualitatively distinct form of temporality in the presence of Christ, spanning the time between our death and the general resurrection of the dead, and furnishing space for us to become the persons God intended and intends us to be. Like Barth, Moltmann sees the content of eternity as a transformed version of temporality. Indeed, his own account of the 'aeonic' time of God's new creation is similar in many respects to Barth's proposed eternity of 'simultaneity'.[59] Like Barth, too, he insists that the content of this aeonic reality will be directly related to the particular lives we live in the here and now. Unlike Barth, though, he understands death not as that which closes and completes the pattern of a life, but as a penultimate scene leaving 'time' yet for the necessary healing, sanctification and fulfilment of a life in God's hands. The Gestalt of an individual life, therefore, is not apparent from the perspective afforded by its point of death, but only eschatologically, in the transformation of its form by the Spirit.

Let's attempt, then, to cash out these eschatologies in relation to our dramatic metaphor. Hick presents our personal existence as a series of largely unrelated performances, hardly even 'acts' in a unified story, except insofar as they are all linked by their relationship to a common human 'actor' or subject. From another angle we might think of them as 'rehearsals', designed specifically to fit this actor for an existence in eternity (the 'command performance' for which such thorough

57 Moltmann, *The Coming of God*, 70.

58 Moltmann, *The Coming of God*, 117.

59 See, e.g., Moltmann, *The Way of Jesus Christ* (London: SCM Press Ltd., 1990), 330. For a critical account of Moltmann see Richard Bauckham, 'Time and Eternity' in Bauckham, ed., *God Will Be All in All: The Eschatology of Jürgen Moltmann* (Edinburgh: T&T Clark, 1999), 155–226.

preparation is necessary). And this, we should note, places a particular value on the pattern of personal development: Salvation pertains to, is constituted by, the *final stage* in the drama. All else is preparatory, and thus of merely transient significance. In truth, though, the performative metaphor breaks down badly at this point, and is really much better replaced by a more timeless, contemplative model of aesthetic experience. Like Barth, although Hick tries hard to hold on to personal particularity, he finally loses touch with it in his own way, spreading identity much too thinly over a whole series of particular lives lived consecutively, and affirming its eventual absorption into atemporal pattern of 'atman' or the 'universal self'.[60] Barth, meanwhile, places his initial emphasis entirely differently. Life itself – and we only get one allocated span of time between our birth and our death – *is* the drama. There is no further 'final act' to be played out. What remains beyond death is a 'redemptive' eternalizing of the various acts in the drama of our lives. It is those same acts revisited, viewed now in the light of the denouement and bathed in the light of another story, Christ's, which has been played out in juxtaposition to it. And the relevant action in question is God's, not ours. Our life, in its entirety, is in this sense both the singular time and the sole object of redemption. There is no rehearsal, and no post-production party. But, for reasons which we have addressed above, Barth's emphatic eschewal of post-mortem time undercuts some of what he intends. Specifically, it leads him, too, in the direction of an abstraction of personhood from the particulars of a life as lived, makes it difficult to imagine in concrete terms how this life may actually *be* the object of God's redemptive activity, and thus raises questions about the meaningfulness and value of the lives we live. Moltmann, too, wants to insist that the whole pattern of our living, and not just its most developed stage, is the object of God's redemptive action. But the 'whole pattern' of our living, he insists, is more than it amounts to at the point of our dying. In order to address the problems raised by Barth's account, Moltmann, as it were, introduces another intermediate series of dramatic 'scenes', a performative transform which shifts us decisively from the pattern of what we 'shall have been' by the time of our death, and prepares that pattern for its eternalization in the presence of God. What perdures in the new creation (Moltmann's favourite biblical image for the final act), therefore, is not the drama of a particular life *as lived*, but that same life redeemed, transfigured, its evil purged and its lacks made good.

I noted earlier that life is *unlike* drama in as much as no precise script for the remaining sections of the Act exists (or, if it does exist, its larger shape is known only to the Playwright and Director, and not yet to the actors). Perhaps, I suggested, life is indeed in this respect (viz., from the standpoint of the actor) rather more like improvisation than the performance of a script. I want now in closing to suggest that it may be well-likened to a particular form of improvisation; namely, the musical cadenza. Here, within a space left precisely for the purpose, the musician improvises in a manner which fits both what has gone before and (crucially) what

[60] See Hick, *Death and Eternal Life*, 450f.

lies still in the future. It is this view to what is yet to come which differentiates the patterning of Christian performance in certain respects from some forms of improvisation. Our performance is rooted and nurtured necessarily in a tradition, a pattern assimilated, a set of habits acquired and skills gained. And it demands the skilful (though I don't want to allow the virtuosity of the cadenza much space in the appropriation of the metaphor) and imaginative application of these to new and unexpected circumstances. There is a vital Christological component to this performance which time does not permit us to deal with here. Let me simply refer the reader to the sensitive and helpful treatment provided by David Brown in *Discipleship and Imagination*. 'Discipleship', Brown writes, 'is ... both a matter of locating ourselves within Jesus' story *and* acknowledging the way in which our own situation differs significantly from his'.[61] Nonetheless the pattern of his performance is a vital nourishing source for ours, not just as we reflect on it in the narrative, but as the Spirit unites us to him, takes our imagination captive and makes our performance part of the same drama, the same piece. In this sense the action of our lives is an improvised development of themes drawn from an earlier Act.

At the same time, though, the performance has a vital eschatological dimension and energy. In our Christian 'will to meaning', we do not just look backwards, but perform hopefully towards a promised and imagined end. It is this same promise and its imaginative apprehension which releases energy for our living the life of discipleship.[62] To return for a moment to Davey, we recall his insistence that 'As a dwelling between past and future possibilities, authenticity involves a being open to the call of the withheld, remaining open to and a holding with that which is still withheld from us'.[63] In the case of Christian performance, there is precisely this sense of an existence 'between the times'. That which is withheld from us, though, is also granted us to grasp, at least in the form of hints and clues. There is imaginative apprehension of our end together with God, even though comprehension is (perhaps will forever be) beyond our intellectual reach. The biblical symbols of 'bodily resurrection' and 'new creation' seem to me both to fit into this category, and both point clearly in the direction of a redemptive renewal of current states of affairs, and one which clearly does not occur prior to our death. While Moltmann's imaginative proposal of an 'intermediate state' may well raise its own theological questions and concerns, so far as the inculcation of an ecology of 'hopeful performance' is concerned, it stands identifiably in this same tradition, affording a way of imagining in concrete and sufficiently coherent terms (ones we can 'make sense of') how it might be that, in our post-mortem existence with God,

[61] David Brown, *Discipleship and Imagination: Christian Tradition and Truth* (Oxford: Oxford University Press, 2000), 8.

[62] See further on this Richard Bauckham and Trevor Hart, *Hope Against Hope: Christian Eschatology at the Turn of the Millennium* (Grand Rapids: Eerdmans, 1999), esp. 44–71.

[63] Davey in Kemal and Gaskell, *Performance and Authenticity in the Arts*, 89.

the broken, distorted and incomplete patterns of particular lives may yet, in God's hands, come to satisfying closure and be rendered fit for our eternal enjoyment, and God's.

Chapter 9
Unexpected Endings

Death has been swallowed up in victory …
Where, O death, is your sting?[1]

'Spem in Alium' – A Theological Overture

As we saw in the last chapter, Christian faith typically begins at the end. It has its provenance in, draws its vital energy from and patterns its living towards an ultimate future divinely promised and imaginatively apprehended. Christian faith, we might say, is irreducibly hopeful, and Christian theology irreducibly eschatological. These are terms carefully chosen, and they need to be equally carefully defined: faith is hopeful, not optimistic; and eschatology is not teleology except in a very peculiar sense. For there is, in the distinctively Christian patterning of our end, a 'catastrophe' to be reckoned with – an overturning of the cosmic furniture, a subversion of all reasonable expectations, a sudden interruption of the wider order or system of things to which we have become used, and a contradiction of many of its capacities and incapacities. The hope in which faith is invested is, we might say, finally and decisively a *transcendent* rather than an immanent hope. Its constraints lie not with the 'real possibles' nor even the 'not-yet-possibles' of history,[2] but only with what is possible for the God in whose hands alone our end, as our beginning, rests, and whose hallmark is the gift of life – life called forth not just out of some imagined murky primeval 'nothing', but out of the altogether more concrete and familiar darkness and dankness of the tomb which, otherwise, 'gets us all in the end'. 'Thanks be to God', writes Paul, 'who *gives us* the victory through our Lord Jesus Christ'.[3] So, to reiterate, the reach of Christian hope is always beyond the thresholds of the most and the best of what, otherwise, the world amounts to and is capable of. Christian hope is always hope invested in a divine 'other', and it cannot *be* other, therefore, than faith – trust in a promise given and received, and obedient willingness to live and to die by it.

[1] 1 Cor. 15:54–55 (NRSV).

[2] The distinction is based loosely on that drawn by Ernst Bloch *The Principle of Hope* (3 vols, Oxford: Blackwell, 1986), 144. Bloch differentiates hope from mere fantasizing in terms of the former's imaginative apprehension of a 'Real-Possible' or a 'Not-Yet-Being of an expectable kind'. Both categories include states of affairs the conditions for the possibility of which may themselves as yet not exist. See further below, 236–8.

[3] 1 Cor. 15:57. My italics.

Correspondingly, therefore, the question contained in the epigram from 1 Corinthians with which I opened this chapter ('Where, O death, is your sting?') remains, I suggest, at one level a genuine rather than a merely rhetorical question for Christian faith and for its theologians. It is not the religious equivalent of the taunt chanted by fans of the winning team on the football terraces to their counterparts in the opposite stand (sung to the tune, 'She'll be coming round the mountain when she comes') 'Oh, it's all gone quiet over there …'. Perhaps some of Paul's original readers took it that way, which would explain why he had subsequently to address a second epistle to them seeking to correct the errors of inappropriate triumphalism and an overly-realized eschatology. But hope in the resurrection and faith in the God who promises it, for all the appropriateness of the rhetoric of 'victory', cannot and must not behave as if it could erase, obscure or trivialize the pain, alienation and death which continues to characterize so much of life in this world, and which is so central to the peculiar way in which, according to Christian faith, that same victory was won. I shall have more to say about these things later in relation to the literary category of tragedy and its uses in theology; but for now I want to go back temporarily to the future, or the end, or at least to the matter of 'endings'. In particular, literary endings, and what they may have to tell or to show us about endings of other sorts.

Odd Consolations

In his Andrew Lang lecture on 'Fairy-Stories' (delivered in the University of St Andrews in March 1939) J.R.R. Tolkien observed that one of the most characteristic features of that genre was the happy ending, a fact made the more remarkable by the accompanying fact that the beginnings and middles of the stories concerned are often anything but happy or even pleasant. Some are positively grim, and apart from the demands of literary convention seem bound, indeed, to end badly and perhaps even rather messily. The relevant consolation is, though, Tolkien indicates, essential to the genre, and 'its highest function',[4] not just a convenient way of bringing terrified and traumatized bedtime consumers of the genre back to a point where sleep (and sleep without nightmares) is a genuine possibility. Whereas, he suggests, tragedy is the highest form of drama, fairy-tale *cannot* have a 'tragic' resolution. No matter how dark its initial vision, it must end well and console. Notice, though, that on this account the opposition between the tragic and 'faerie' is defined in terms of its ultimate outcome, and not necessarily its prevalent mood or much of its content. Indeed, something capturing the dark mood and vision of tragedy might well be supposed to provide the perfect prelude

[4]　See J.R.R. Tolkien, *Tree and Leaf* (London: HarperCollins, 2001), 68. The text of Tolkien's original lecture is lost, and all references are to the revised and expanded version eventually produced for a 1947 Festschrift for Charles Williams and subsequently republished several times.

to a drastic *peripeteia* of the sort which Tolkien has in mind. There are, after all, other genres which typically arrive at a happy ending through contrivance of one sort or another. But Tolkien coins the term 'eucatastrophe' to refer to the particular sort of ending he has in mind: a 'good catastrophe'; an outcome, then, which itself stands in stark opposition to much that precedes it, and pulls the rug cleverly out from beneath the feet of our expectations and predictions.

In Tolkien's terms a eucatastrophe is something highly improbable and perhaps even impossible within the secondary world of the text itself. Within this world, Tolkien insists, the ending arises precisely as a 'sudden and miraculous grace: never to be counted on to recur'.[5] Its characteristic product in the heart of the reader, he suggests, is a form of joy, which is all the more joyful to the extent that it breaks the apparent stranglehold otherwise of sorrow and failure on the outcome. The source of the joy, therefore, comes from 'beyond the walls of the world'[6] in which the tale itself is set. There may seem to be a price to be paid for this in aesthetic terms, as what – in the tale's own terms – can only be construed as a *Deus ex machina* is summoned to secure the conclusion. The move made, though, is no arbitrary grafting of a happy ending where it does not belong. Rather, the reader is invited to situate the world of the tale now within a wider and higher pattern (still fictional, but nonetheless distinct) and the possibilities pertaining to *it*, thereby shifting the grounds of what might eventually count as convincing in literary terms or compelling in aesthetic ones. Catastrophe, of course, by definition never leaves unified wholes uninterrupted or intact; and Tolkien's *eucatastrophic* ending is compelled to break the pattern of the tale open precisely in order to redeem it. The relevant aesthetic satisfaction is linked directly to the joy of recognizing (and endorsing) the beauty of the bigger picture which is invoked or revealed in the process.

Golgotha and Parnassus

Tolkien was never interested in literary form or literary affect for its own sake. Art, he believed, was of a piece with reality in one way or another, even when it seemed farthest flung from it. So, here, his reflections on the unashamed and explicit literary consolations of fairy-story move quickly on to questions about what such endings may have to tell us about our own humanity, about life, and about the shape of the wider reality within which we find ourselves. Here it is to the essential *brokenness* of so much of what we experience in life, and our corresponding desire that things should be otherwise, that Tolkien directs us in the first instance. Fantasy more widely and faerie in particular, he notes, plays directly and deliberately upon ancient and deeply rooted human desires, affording a form of imaginative 'escape' from sufferings, lacks and limitations which frustrate and

[5] Ibid., 69.
[6] Ibid., 69.

blight our existence daily, things which make the world a 'grim and terrible' place for many people much of the time. Hunger, thirst, poverty, pain, loss, sorrow, injustice, alienation; and under-girding and sealing the grip on human lives of all these there is death; death towards which life moves inexorably, and by which life (together with all those pleasures and joys and achievements which go some way, at least, to balancing the account) is finally swallowed up. No surprise, then, perhaps, that escape from death's clutches should be among the most basic and central of human desires, and the consolation of the eucatastrophic ending, Tolkien avers, is to be understood in part as a literary scratching of this deeply felt itch.

In a discussion of art in the first chapter of her Gifford Lectures, Iris Murdoch also notes its role as a consoling force in human life.[7] In particular, she suggests, through literary and dramatic art we situate ourselves within imaginatively framed unities of one sort or another, granting form and meaning to what frequently appears otherwise to be a formless, meaningless and unpalatable manifold of experiential flotsam and jetsam. As human beings, Murdoch says, we instinctively crave meaning, the security of the familiar pattern. We are, she suggests, naturally 'one-making' creatures. And, drawing on the accounts of Hume, Kant and others, she notes the wider contributions of human imagination in this regard, furnishing various 'limited wholes' for our consumption – 'We see parts of things, we intuit whole things'[8] – despite the philosophical problems involved and the paucity of evidence. Day to day material objects, the coherent world in which we confront and grasp them, ourselves and others as continuous bodies and continuous minds, the wider movement of events, actions and outcomes in history – all this experienced reality has already been extensively 'worked' by the imagination. In art, therefore, we are dealing with something on the same basic spectrum, though clearly at a different point on it.

At one level, of course, literary and dramatic art in particular are always a version of (based on certain elements or patterns in) life as we know it. Art, that is to say, imitates life, at least to a certain extent. But it rarely *only* does this. There is always some element of modification, some transformation of the commonplace involved, even when it is hardly apparent. Indeed, the most compelling realism and naturalism in art is generally only possible through a complex and skilled encoding, persuading us that what we see is 'like' real life, when actually it isn't at all. And a simple 'mirroring' of daily experience, were it served up to us, would be much less compelling, perhaps even hardly recognizable.[9] But art also modifies

[7] See Iris Murdoch, *Metaphysics as a Guide to Morals* (London: Vintage, 2003), esp. 1–24.

[8] Ibid., 1.

[9] That representational art encodes reality in the terms proper to its distinctive media in order to solicit from us the 'beholder's share', stimulating sensory, neural and imaginative responses from us of the same sort as 'reality' itself, is one of the key insights developed by Sir Ernst Gombrich in his writings. See, e.g., *Art and Illusion: Further Studies in the Psychology of Pictorial Representation* (London: Phaidon, 1982). The point Gombrich

the stuff of life not in order to generate likenesses to the texture of our experience of it, but in order to make good some its felt deficits and contradictions too. When the volume of darkness and chaos is cranked up to a point where it threatens to break through and deconstruct our most cherished unities, art is one of the ways in which, sometimes, we console ourselves. It does so, Murdoch suggests, by representing 'something which we deeply (unconsciously) want to be the case. We intuit in art a unity, a perfection, which is not really there'.[10] We 'take refuge' in art, and we do so in various ways. Not only by using it as a means of temporary escape from the relative lacks of the world, but, when the world becomes too threatening, too dark, we borrow from art some of its carefully constructed 're-workings' of reality and deploy them in order to pattern life itself. Thus, Murdoch notes, art often provides us a 'language' in terms of which to confront, and make sense of, and speak about the 'contingent dreadfulness of the world'.[11] When, for example, we instinctively or habitually say of some horror in life that it is 'tragic', the circle is complete, and life begins to borrow its forms from art rather than vice-versa.[12] Directly and indirectly, consciously and unconsciously, then, life is 'aesthetically worked' as part of the 'calming, whole-making' tendency of human thought. Art consoles us, and we are glad for it to do so.

Now, it is true enough that at first blush Tolkien and Murdoch are saying something remarkably similar. Art, among other things, consoles us, and it does so in certain instances by contradicting the shape (or perhaps the threatening shapelessness) of life. Whether by supplying the 'happily ever after' endings which transience and death deny to our actual lives, or furnishing imaginative templates to obscure the chaos and 'dreadful contingency' of living, art transforms the stuff of human existence into something more bearable, something, maybe even, for which to be glad. Of course, though, art is artifice, and questions of a metaphysical sort will not long be kept at bay (as they never can be). And it is here that we find a radical division between the two accounts. The shared claim about art's consoling role, in other words, is situated against two wholly different, opposing accounts of what is 'really' the case and how things fare ultimately with human beings and their place in the world.

For Tolkien, eucatastrophe in literature is no mere projection or wish-fulfilment, bravely erecting imaginary bulwarks against a raging tide which will ultimately wash them and us away, permitting us for the time being at least to build our sandcastles as though doing so really mattered. Rather, he suggests, the peculiar quality of joy associated with it is an index of its imaginative intuition of

makes about the visual arts is transferable, *mutatis mutandis*, to other art forms, and lies at the heart of Paul Ricoeur's account of threefold *mimesis* in *Time and Narrative*, Vol. 1 (London and Chicago: University of Chicago Press, 1984), 52–87.

[10] Murdoch, *Metaphysics*, 19.

[11] Ibid., 100.

[12] 'It is difficult to talk about terrible things and we tend to turn 'the facts' into quasi-tragic art in our minds.' Ibid., 96.

a deep underlying reality or truth about the world, a truth of which it furnishes a sudden, unexpected and fleeting 'glimpse'. It suggests that our deeply cherished conviction, held perversely in the teeth of uniform global experience, that things 'ought not to be this way' may actually be something other than a cruel and mocking discrepancy between aspiration and the facts of the matter. Of course, the eucatastrophic imagination is compelled to appeal 'beyond the walls' of this world; but precisely what it refuses to accept, therefore, is that 'this world' is finally identifiable with the sum of what is and will be real. Christians, Tolkien notes, have a particular reason for insisting that this is so; but the intuition that here 'ought' and 'is' may actually coincide eschatologically is a broader one, and we find it more widely distributed in forms of literary eucatastrophe which afford a 'far off gleam or echo of *evangelium* in the real world'.[13]

Murdoch's take is quite different. Her premise is essentially Nietzschean, drawing on the sharp distinction posited in *The Birth of Tragedy* between the Dionysiac chaos of 'reality' and the Apolline impulse of imagination to impose illusory (and consoling) order on the absurd, swirling play of forces. Apollo is the god of 'beautiful illusion', and for Nietzsche the illusions are not simply pleasurable but *necessary* ones, a view which Murdoch, in her turn, re-echoes. The consolations of great art, then, are indeed artifice, illusions obscuring the awful truth and, in doing so, permitting us to organize and to live our lives on the very brink of truth without toppling over into the despair and turmoil which, otherwise, it must inevitably provoke in us. Murdoch, therefore, has little time for art which 'consoles too much', effectively pushing us away from the edge into illusions designed to shield us altogether from the truth of our circumstance, something which, she insists, even some forms of tragedy themselves end up doing. Happy endings and eschatological consolations, therefore, she resists as manifest departures from reality and, in that sense, failures artistically. Art's highest calling is to lift the lid on reality, to evoke its Dionysiac absurdity, stripping away the layers of consoling form and meaning until there remains only the bare minimum needful to permit us to gaze upon its face without being consumed. The view from Parnassus, then, is of a rather different sort than that which gazes out from Golgotha, and sees the Mount of Transfiguration and Ascension on the far horizon. For Murdoch, we shall see (and she is not alone), it is *tragic* art which draws closest to the truth, and it can have nothing whatever to do either with *eucatastrophe* or *evangelium*. Its darkness is of a much more ultimate and enveloping sort.

The Value of Agony

Tragedy has frequently been awarded the accolade of being the most serious, the greatest, the truest among literary and dramatic forms. It is worth asking ourselves why, because on the face of it this is an odd fact. After all, 'tragic' art as more

13 Tolkien, *Tree and Leaf*, 71.

precisely defined (i.e. by tragic theorists from Aristotle onwards) is far from being a universal phenomenon; in fact, according to most standard accounts, it really only crops up properly twice: in the classical world (Aeschylus, Euripides, Sophocles, Seneca) and then again in the wake of the Renaissance (Marlowe, Jonson, Shakespeare, Racine). Of course one may choose to expand or contract the canon by shifting the terms of the relevant definition, and Terry Eagleton's refreshing study of the subject lambasts 'normative' uses of the term tragedy which, in the pursuit of some tragic essence, end up reducing the list of relevant texts down a few splendid instances here and there, and affording others the status of 'failed attempts'. This, he suggests, 'is rather like defining a vacuum cleaner in a way which unaccountably omits the Hoover'.[14] Tragic theory, Eagleton argues, is a theory in ruins, and one which cannot possibly do justice to the wider pattern of works deserving the description, as attempts to grapple seriously with the 'tragic' dimensions in life. His point is well-made, and Murdoch, for one, falls well foul of it. If, though, there are some good reasons for democratizing the concept of tragedy, there may still be other reasons for attending to particular forms of it, and to the theory which has exalted these above the rest. And for our purposes this more rarefied, 'purist' canon provides at least a useful source of comparison, even if it is a bit of an abstraction or an ideal to which few works aspire let alone attain.

Another reason why the celebration of tragic drama might be thought odd is simply its *prima facie* sado-masochism. There is something odd and complex, surely, George Steiner notes, about the re-enactment of terrible private anguish on a public stage, and the derivation from this by the audience of some form of satisfaction or pleasure?[15] Even if we adopt Eagleton's Hoover-inclusive definition of tragedy as any drama which is 'very sad', the problem persists. Why should we want to attend to such things, to contemplate them? Do we not get enough of them in life itself? What, in short, does the enjoyment of tragedy tell us about ourselves, about the so-called 'human condition'?

Provision of answers to this question, of course, is precisely the domain of tragic theorists such as Murdoch, and we have already begun to see something of the direction her answer takes. Eagleton, still driven by a democratic urge, broadens things out much further, but leaves them in the same basic ballpark. It is precisely the fact that tragedy *does* tell us or show us something basic about the human condition, he suggests, that is the point, and which makes depictions of horror and pain so compelling for audiences across cultural boundaries, rendering them much more than 'a kind of high-brow version of ripping yarns for boys'.[16] Of course, the very idea of a shared human condition is highly suspect in some dominant intellectual circles, but, Eagleton insists, tragedy has its sights set firmly on something securely 'trans-historical' even if the manifestations and representations of it are different. The fact is, he writes, 'that we die ... It is, to

[14] Terry Eagleton, *Sweet Violence: the Idea of the Tragic* (Oxford: Blackwell, 2003), 7.

[15] See George Steiner, *The Death of Tragedy* (London: Faber, 1961), 3.

[16] Eagleton, *Sweet Violence*, ix.

be sure, a consoling thought for pluralists that we meet our end in such a richly diverse series of ways, that our modes of exiting from existence are so splendidly heterogeneous, that there is no drearily essentialist "death" but a diffuse range of cultural styles of expiring … But we die anyway'.[17] Death, then, is the unavoidable truth which unites us as human beings. And not just death as such, but the pain and suffering and sorrow which lead up to and are duly caused by it, the whole world of darkness for which it serves as an appropriate and chilling symbol. 'Wretched man that I am, who will rescue me from this body of death?'[18] The fact of suffering, Eagleton notes, 'is a mightily powerful language to share in common'.[19] In the final analysis, 'there is nothing hermeneutically opaque' about it.[20] It speaks loudly and clearly across miles and years, and we hear what it has to say, not just about those depicted on the stage, but about ourselves. Perhaps tragedy's greatness lies in part, then, in the fact that, to cite Donald MacKinnon, it is 'powerful in the disclosure of what is'.[21] Or, in Murdoch's phrase, it looks 'the contingent dreadfulness of the world' squarely in the eye, without flinching, and in doing so enables us to reckon with the final truth of our human circumstance.

And yet, of course, tragic drama is no mere replication in the theatre of life's horrors and terrors, or of its inevitable end in death. And the greatness of tragedy cannot lie in such depiction alone, otherwise we should accord similar greatness to the prurient 'gore-fest' of many contemporary films, and even to the 'on the spot' TV journalism which, while it is certainly not unedited, nonetheless comes closer in its coverage of horror and suffering to the sheer messiness, fragmentation and bewildering chaos of life itself. Well then, 'can art', Murdoch enquires, 'actually convey the horrors of life better than the television news?'[22] The supposition that in some sense it can has to do with the recognition that, in representing our shared pain and transience, tragic drama grants it a form which, in real life, is lacking or at least not readily available to us for contemplation.[23] It is this, of course, that lies behind the insistence by theorists such as Murdoch and Steiner that, despite the universality of things to which we habitually refer as 'tragic' in human life, in the strict sense 'Real life is not tragic', and cannot be, because 'tragedy' refers

[17] Ibid., xiii.

[18] Rom 7:24.

[19] Ibid., xvi.

[20] Ibid., xiv.

[21] Donald MacKinnon, *Borderlands of Theology and Other Essays* (London: Lutterworth Press, 1968), 101.

[22] Ibid., 117.

[23] Perhaps the latter rather than the former. Appeal to the epiphanic force of tragic genres, after all, seems necessarily to presuppose that, as Ricoeur suggests, its artistic representations are indeed first *drawn from* the substance of life itself as well as *reconfiguring* it for our contemplation, and challenges the Nietzschean assumption that 'real life is shapeless, and art alone is orderly' (Eagleton, *Sweet Violence*, 15). Cf. Ricoeur, *Time and Narrative* 1, 72.

to a particular way of working life aesthetically, patterning the raw materials life provides (raw in more than one sense of the word) in drama. Here, what otherwise sounds like academic prissiness of the first order (so, Eagleton enquires pointedly, 'All-out nuclear warfare would not be tragic, but a certain way of representing it might be'?) does have an important point to make. It draws our attention again to the fact that life is always aesthetically worked, and that the peculiar appeal of tragic art probably has to do not just with its subject matter, but with the particular ways in which that subject matter is deliberately configured for us on the stage, which are quite different to most of our experiences of it in reality.

In what sense, then, might it be supposed that these representations of suffering are 'better', rather than merely 'different' to those in our TV news bulletins, or even the ways in which we experience 'tragic' things as they occur to us and to others around us? For Murdoch the answer has to do, paradoxically, with the capacity of great tragic drama to prise open our sweaty grip on art's consoling forms, and thereby bring us face to face with the brokenness and chaos of a Dionysiac cosmos. Tragedy gives us just enough to hold on to, while compelling us to confront the reality lurking behind our dreams and illusions. Tragic genius, she argues (and she acknowledges that instances of this are rare), manages to steer a course between consoling us on the one hand, and allowing us to be swept away by despair on the other. As art, great tragedy must have borders, it must have shape; and yet it must not have shape or form which finally redeems or dignifies its subject matter, granting it some form of silver lining, and thereby robbing it of its authentic and unalloyed darkness.

Yet, of course, this is exactly what some other tragic theorists have looked for and found in it. Here, the dark focus of tragedy is effectively undercut by an ascription to its representations (and to what they represent) of certain sorts of value: tragedy itself, that is to say, consoles, justifying the pain and suffering and loss of the world it depicts, but doing so, paradoxically, in a manner which affirms their ultimacy rather than ever calling it into question. So, for example, Dorothea Krook maintains that mere pessimism is just as inimical to the tragic as optimism, being blind to 'the redeeming power of the knowledge born of suffering'; and 'the final paradoxical effect of great tragedy', she indicates, 'is to leave us not wretched and oppressed, but liberated, restored and exhilarated'.[24] It all begins to sound, Eagleton notes in typically ironic vein, like 'a superior way of cheering yourself up',[25] 'just the thing to lift one's spirits after a bankruptcy or bereavement, a tonic solution to one's ills'.[26] The seeds of this 'affirmative' account of tragedy are sown early, in Aristotle's account of it as possessed of 'cathartic' benefits – 'effecting

[24] Dorothea Krook, *Elements of Tragedy* (New Haven, CT and London: Yale University Press, 1969), 116, 239.

[25] Eagleton, *Sweet Violence*, 26.

[26] Ibid., 25.

through pity and fear the purification (*catharsis*) of such emotions'.[27] We need not concern ourselves with the contested question of what precisely Aristotle means here – it suffices to note his conviction that there is good of some sort to be had even out of terrible ills, at least for those who watch them played out.[28] Some have noted the way in which tragedy underscores and draws our attention to the value of things precisely as it wrenches them cruelly from our grasp. Despite the persistent longing for a world healed of its suffering, W. Macneile Dixon suggests, to wish that the world were otherwise than it is, is in practice to wish away our humanity itself. 'Everything ... is what it is', he writes, 'and in the moral world leans for its existence on its contrary, as courage upon the possibility of cowardice, magnanimity on that of meanness. ... What makes us haters of evil makes us lovers of good; and if evil vanished from the world much good, the most precious, would assuredly go with it, and the best in us rust unused'.[29] Far from undermining our sense of value or the worth of things, therefore, tragedy serves to do the opposite, and shows us that, in fact, value itself (and not just our sense of it) is finally tied inexorably to contingency, suffering and transience. For others, it is not in the stalls or the balcony that tragic goods are to be traced first and foremost, but on the stage, where not just suffering is enacted, but suffering of certain sorts, and suffering as an action rather than a mere passion. In other words, it is to the quality of response to horrific and terrible events, rather than the events themselves, that our attention is drawn by the drama. This notion, too, goes back to Aristotle and his suggestion in the *Poetics* that the suffering of the tragic hero must be 'admirable'.[30] The events themselves may be dark and meaningless; but when they are borne or faced in certain ways, they may produce dignity, nobility, wisdom, whether through a stoic resignation and acceptance, or a protest against the absurdity and futility of it all.[31] In the world of tragedy, George Steiner writes, '(t)here is no use asking for rational explanation or mercy. Things are as they are,

[27] Aristotle, *Poetics*, translated with an introduction and notes by Malcolm Heath (London: Penguin, 1996), 10.

[28] On Aristotle's notion of catharsis see, helpfully, David Ross, *Aristotle*, 5th ed. (London: Methuen, 1949), 283–5.

[29] W. Macneile Dixon, *Tragedy* (London: Edward Arnold, 1924), 110–11.

[30] Aristotle, *Poetics*, translated with an introduction and notes by Malcolm Heath (London: Penguin, 1996), 10. For this reason, Aristotle argues, the character of the person whose suffering is represented is of the utmost importance. He must be neither exceptionally wicked (in which case we should judge his suffering to be deserved) nor exceptionally good (in which case we should not be able to identify with him in his response), but 'someone intermediate between these' – in other words, someone like us. Aristotle, *Poetics*, 21.

[31] Krook suggests that it is neither in the 'fighting spirit' of the tragic hero nor in 'acceptance and resignation', but 'in his great moments of knowledge, insight, illumination, when he discloses to us some aspect of the ultimate condition of man, and shows us how a man may face it and be reconciled to it' that the truly tragic disposition and the 'restorative, re-affirmative effect of tragedy' is found. Krook, *Elements of Tragedy*, 243.

unrelenting and absurd. We are punished far in excess of our guilt. ... Yet in the very excess of his suffering lies man's claim to dignity. Powerless and broken ... he assumes a new grandeur. Man is ennobled by the vengeful spite or injustice of the gods. It does not make him innocent, but it hallows him as if he had passed through flame'.[32]

Such accounts, for all their insistence that tragedy depicts an irrational and unjust cosmos, finally offer us a sanguine view of suffering which 'makes sense' of it, reassuring us by an appeal to some obscure higher order of things, to values and meanings to be derived from the very heart of the pain which it represents. In effect, as Eagleton notes, in taking this turn 'Tragic theory becomes a kind of secular theodicy',[33] and we might add that it suffers from some of the problems pertaining to its religious counterparts. We need not deny that sometimes some good can be born out of awful human suffering in order to insist that the connection is far from necessary or pervasive, let alone that they are related as end and justifiable means. Much human pain is squalid, cruel, unbearable, and to all appearances futile, and has little more to be said about it than that. There have been many victims who have passed through the flame quite literally, and it is far from clear that their ashes contain the seeds of a Phoenix of any sort. And in any case, even where we can trace a link between suffering and some emergent good, the connection is not thereby established as one which grants any positive value to the suffering itself and as such, as though certain ways of enduring or presenting it were intrinsically uplifting to the spirit. Far from penetrating the depths of life's darkness, and its tragic contingencies, in the final analysis such accounts have a tendency to sanitize it unduly, to view even the darkest suffering as containing the seeds at least of its own redemption, as something which, endured in certain ways, 'hallows' rather than crushes us.

It is for this reason, perhaps, that Iris Murdoch repeatedly emphasizes the centrality of *death*, and not just suffering as such, to all great tragic art. 'Our concept of tragedy', she writes, 'must contain some dreadful vision of the reality and significance of death'.[34] Death, after all, snuffs out nobility, dignity, wisdom and everything else sooner or later, bringing it all back to the nothingness from which life was originally called. And it is death, therefore, Murdoch insists, that tragedy must stare in the eye, and suffering only as it leads to death. Thus she sets her face resolutely against all accounts of tragedy as affirming or uplifting, and insists that genuine tragedy attempts no such thing. Having been taken to the edge of the pit of reality and truth, she urges, we should go away not uplifted or exhilarated, but chilled by an 'unconsoling coldness'. Hence even some of Shakespeare's tragedies must be judged deficient: 'After witnessing the superb deaths of Othello, Macbeth and Hamlet', she writes, 'we leave the theatre excited, exalted, invigorated,

[32] Steiner, *Death of Tragedy*, 10.
[33] Eagleton, *Sweet Violence*, 36.
[34] Murdoch, *Metaphysics*, 104.

perhaps even persuading ourselves that our pity and fear have been purged'.[35] To this extent, though, we have been reined in, pulled back from a real encounter with the way things are in the world, and given a sop to console us. But, 'we must not be too much consoled'.[36] And Shakespeare's tragic genius is realized more fully in Lear, where, with the final turn of the plot's screw, the vice-like grip of death and loss and its capacity to dash hope to pieces is affirmed, and all suggestion of a redemptive aspect to suffering finally and completely extinguished.[37] Here, then, is the true tragic vision: pain unredeemed and unredeeming, because it is the henchman of Death and dissolution. To present this 'awe-full' vision, to expose us sufficiently to its sublime magnitude, Murdoch suggests, this is the greatness of genuine tragedy, and in order to achieve it art itself must almost break down, sailing as close to the wind of truth as it is possible to do without being capsized by it and enveloped by the waters of despair.

Between Tragedy and Eucatastrophe

We have strayed quite a long way from the theme of eucatastrophe, and I want now to return to it in this final section. I want to do so, though, by way of a further claim often made about tragedy. Tragic art, it is often held, requires a tragic world-view to produce and to sustain it. Tragedy's foremost obituarists such as George Steiner have traced the decline of the form to the concomitant rise and prevalence of more hopeful and optimistic visions, inhospitable to tragedy's resolute refusal to shift its gaze from life's tragic aspects. In the modern era there are various suspects – humanism, Romanticism and Marxism generally find a mention, each accommodating some essentially optimistic account of history and its prospects. But the rot sets in much earlier than the modern age, and we may trace it, Steiner suggests, to the Garden of Gethsemane, where 'the arrow changes its course, and the morality play of history alters from tragedy to *commedia*'.[38] More precisely and pointedly still, 'Christianity is an anti-tragic vision of the world'.[39] It 'offers to man an assurance of final certitude and respose in God. It leads the soul toward justice and resurrection'.[40] Romantic melodrama with its happy endings, Steiner suggests, is sound theology, whereas tragedy can never be. Murdoch more or less concurs with this assessment. God, she insists, cannot be a character in a tragedy; his presence is unavoidably reassuring. And while there is much in the gospel story that is dark, the darkness is not properly tragic because Jesus' death is not 'real death' (i.e. death as we know it to be), being finally swallowed up in the victory

[35] Murdoch, *Metaphysics*, 121.

[36] Ibid., 99.

[37] Ibid., 119.

[38] Steiner, *Death of Tragedy*, 13.

[39] Ibid., 331.

[40] Ibid., 332.

of resurrection, and suffering is affirmed as a redemptive rather than a destructive force. Ironically, therefore, for all its explicit and sometimes prurient focus on the suffering and death of Jesus, the Christian story undermines rather than sustains the tragic vision. 'The risen Christ', Murdoch writes, 'can be seen beyond the appalling anguished sufferer. Together with the crucified one we see the terrifying authoritative figure of Piero della Francesca's picture (of Christ stepping out of the tomb), or the strange magical being, portrayed by so many painters, who told Mary Magdalene not to touch him'.[41] It is precisely the gospel's nature as 'good news', therefore, Christian faith's resolute hopefulness based on the pledge of Christ's resurrection from death, which is anti-tragic, and which means that there can never be any convergence of insights between the two. For this difference, Murdoch insists, makes true tragedy anti-Christian as well. We are dealing with mutually corrosive visions of the place of humanity in the world.

Let's pause for a moment to consider exactly what is, and is not, at stake here. The question is not, of course, primarily a literary one, but precisely a theological one. We are not concerned, that is to say, with the issue of whether the overall shape of the Christian story (the story of Jesus as narrated in the gospels, and the wider story of humankind narrated in the biblical canon and the wider Christian tradition) fits a tragic template, and can simply be added to the list of tragic works. The answer to that must be a resounding negative. Nor does that story have an easily detachable ending, a literary coda apart from which the story could then be so adopted. The gospels are written from the standpoint of faith in the resurrection, and faith (as I suggested at the outset of this chapter) has its own beginning in its end. The question is, rather, whether despite the presence of this happy ending and the imaginative backwash from it, there might nonetheless be some significant (i.e. theologically significant) concurrences and resonances between elements in or dimensions of the Christian story, and the ways in which tragic poets have seen and 'felt' the world. Might theology, in other words, have something to learn from tragedy about its own story, something apart from which it risks misunderstanding itself? I want to argue that in fact, the 'happy ending' of the resurrection leaves this possibility wide open, and does not compromise it. And this is precisely because of the sort of happy ending it is, and its peculiar relationship to the shape of all that precedes it. It is, in Tolkien's terms, precisely a eucatastrophic ending, rather than a comic or melodramatic one.

First we may note briefly the views of two theologians who have responded, in quite different ways, to the claim that Christianity is indeed inherently and irredeemably anti-tragic. Perhaps the most familiar voice is that of Donald MacKinnon who, in various essays and in his own Gifford lectures argues directly in the face of Steiner and Murdoch,[42] insisting that 'there are lessons of

[41] Murdoch, *Metaphysics*, 131.

[42] See, for example, 'Theology and Tragedy', *Religious Studies* 2 (1967), 163–9; 'Atonement and Tragedy' in Donald MacKinnon, *Borderlands of Theology* (London: Lutterworth Press, 1968), 97–104; Donald MacKinnon, *The Problem of Metaphysics*

the greatest importance to be learnt here by Christian theology, and not least in the field of Christology, which is arguably its heart and centre'.[43] MacKinnon's own Christology was profoundly kenotic, and it is to the depths to which the Son of God descended in taking flesh that his vision returns us again and again, and to the pain and waste and loss endured not just by Christ himself but by others too as a direct outcome of this flesh-taking. Thus '(w)hat it was for him to be human', MacKinnon reminds us, 'was to be subject to the sort of fragmentation of effort, curtailment of design, interruption of purpose, distraction of resolve that belongs to temporal experience. To leave one place for another is to leave work undone; to give attention to one suppliant is to ignore another, to expend energy today is to leave less for tomorrow'.[44] And these entailments of the structure of creaturely temporality itself, and their power to frustrate and truncate human efforts and designs, bear tragic consequences in their wake no less in the case of the enfleshed Logos than in any other life. 'To Christian faith', MacKinnon writes elsewhere, 'Jesus is without sin; yet from his life, as a matter of historical fact, there flows a dark inheritance of evil as well as good'.[45] 'Indeed, increasingly one sees that the reality of Christ's humanity resides partly in the fact that as he lived he was confronted with real choices, fraught, in consequence of the way in which he chose, with disaster as well as achievement in their train.'[46] There is the story of Judas, whose actions and fate serve as a fulcrum for what, viewed without anachronistic reference to the events of Easter Day, can only be viewed as the abject failure of Jesus' ministry. 'Good were it for this man if he had not been born' says Jesus. It doesn't get much more darkly 'tragic' than that, and Judas goes out and hangs himself.[47] There is the fact, too, of Jesus' effective abdication of responsibility for the welfare and fate of his own people in the way that he eventually took, whether we think of 'the catastrophe that was to overtake the

(Cambridge: Cambridge University Press, 1974),114–45; 'Ethics and Tragedy' in Donald MacKinnon, *Explorations in Theology* 5 (London: SCM Press Ltd, 1979), 182–95. For an illuminating account of MacKinnon's engagement with Steiner see Graham Ward, 'Tragedy as Subclause: George Steiner's Dialogue with Donald MacKinnon' in *The Heythrop Journal* 34.3 (1993), 274–87. For a wider discussion of MacKinnon's treatment of tragedy see Giles Waller, 'Freedom, Fate and Sin in Donald MacKinnon's Use of Tragedy' in Kevin Taylor and Giles Waller, eds, *Christian Theology and Tragedy: Theologians, Tragic Literature and Tragic Theory* (Farnham: Ashgate, 2011), 101–18. Unfortunately this book was published too late in the process of editing the current volume for proper account to be taken of it in this chapter.

[43] MacKinnon, *Explorations in Theology*, 195.

[44] MacKinnon, *Themes in Theology: The Threefold Cord* (Edinburgh: T&T Clark, 1987), 162.

[45] MacKinnon, *Explorations in Theology*, 65.

[46] Ibid., 194.

[47] See MacKinnon, 'Theology and Tragedy', 168–9.

Jewish people less than forty years from the crucifixion'[48] or, taking a broader view, 'the infection of anti-Semitism present in the Christian church from the earliest years', and culminating in the horrors of the Shoah and its 'final solution'.[49] So far as I am aware MacKinnon himself does not, but we might, mention too the so-called massacre of the innocents in Matthew 2, a story which, in our rush to celebrate the good news of 'God with us' each year, we conveniently overlook.[50] The way in which God enters our world is itself messy, and fraught with some of the attendant pain and death to the futility of which tragic poets regularly draw our attention. It is unalloyed disaster, and the narrative makes no attempt to justify or account for it. Matthew cites Jeremiah: 'Rachel weeping for her children; she refused to be consoled, because they are no more' – again, tragedy *par excellence*. And of course, there is Jesus' own suffering, not just of the pain of betrayal and crucifixion, but of the personal failure and defeat with which in actual fact these were inexorably bound up – another raw historical reality which, in our rush to insist that of course all this was embraced willingly and 'for our sakes', we all too easily sanitize, diminish or overlook altogether.[51]

For MacKinnon, then, the story of the incarnation is from the very first one with deep tragic resonances. Indeed, without blindly overlooking the multiple complexity of those works typically classified as tragedies, and without being careless in identifying the sense in which the term may significantly be applied, there is nonetheless a sense, he argues, in which, *mutatis omnibus mutandis*, the term may apply 'in full measure' to the way in which the canonical gospels recount Jesus' life and ministry, and to elements of the wider Christian story too.[52] The 'flesh' which the Son of God assumed and made his own in the incarnation was precisely *tragic* flesh – flesh marked, that is to say, by weakness, triviality, contingency, failure, perplexity, bewilderment, hopelessness and at the last even god-forsakenness. In Christ, God himself sounded the 'abysses of existence' and plumbed and explored the 'ultimate contradictions of life', and the tragic imagination knows of no depths or dark, nesses of human suffering, therefore, of which Christian faith may not legitimately claim together with the psalmist's wondering recognition 'Thou art there also'[53] – there, that is to say, as a fellow sufferer together with us, and not simply as the one in whose presence suffering cannot and will not finally endure. 'It is a lesson to be learnt from tragedy', MacKinnon writes, 'that there is no solution of the problem of evil; it is a lesson which Christian faith abundantly confirms, even while it transforms the teaching

[48] MacKinnon, *Borderlands of Theology*, 103.

[49] MacKinnon, *Explorations in Theology*, 65; MacKinnon, *Borderlands of Theology*, 103.

[50] I am confident that I owe this thought to an essay by Rowan Williams, but have been unable to trace the precise reference.

[51] MacKinnon, *Borderlands of Theology*, 103.

[52] MacKinnon, 'Theology and Tragedy', 163, 168–9.

[53] Ps. 139:8 (KJV).

by the indication of its central mystery'.[54] Conventions of Christian interpretation
of the gospels, he observes, slip too easily into reading them as if they were
orientated from the start towards a happy ending. Yet, despite the fiduciary
standpoint from which they were undoubtedly compiled and written, we misread
and misunderstand them if we represent the resurrection 'as in effect a descent
from the Cross, given greater dramatic effect by a thirty-six hour postponement'.[55]
It was not that, and we must not allow the light of the empty tomb to seep back too
far too soon in our understanding, inducing forgetfulness or any amelioration of
the route which led him there. The gap – chronological and theological – between
Golgotha and the resurrection appearances is vitally important, and for more than
one reason alone. If we do not preserve it intact, MacKinnon suggests, then we
'blunt the edge' of Christological and soteriological doctrine and lose sight of
its significance for theological (and pastoral) responses to the problem of evil.
Resurrection is certainly a 'victory' at which the story finally arrives, but it is a
victory which does not obliterate the tragic quality of the life and action by which
alone it is won,[56] and on the heels of which it follows not as a natural outcome,
but after the interruption of death and decay, and therefore as the most remarkable
peripeteia imaginable. In the account of Christ's passion, there is no attempt to
sanitize or dignify human suffering or to lighten its darkness (a fact which, we
have seen, actually sets it apart from some strands of tragic theory), and death is
owned as a genuine threat, a dangerous enemy threatening to devour us. On the
eve of Good Friday, therefore, the sun goes down on a scene which looks as tragic
as anything could possibly look.

The other theological voice I want at least to reckon with in passing is that of
David Bentley Hart, who argues forcefully in the other direction. The Christian
narrative *is*, he insists, resistant to a tragic reading, and 'tragic theology lacks
theological depth'.[57] Specifically, what it risks doing, he suggests, is to allow evil to
obscure the aboriginal goodness of creation, and so cause us to overlook or forget
it. Hence 'for Christian faith the only true tragic wisdom is that there is no final
wisdom in the tragic'.[58] There is much in Hart's analysis that I find compelling, but
at this point it underestimates the seriousness and the full extent of what theology
describes in terms not of tragedy but 'fallen-ness' and its consequences. Whatever
status we afford the aboriginal goodness of creation in our narration of the world's
history in God's hands,[59] the gravity of sin and its corruption of such goodness

[54] MacKinnon, *Borderlands of Theology*, 104.
[55] Ibid., 100.
[56] MacKinnon, *Explorations in Theology*, 194.
[57] David Bentley Hart, *The Beauty of the Infinite: The Aesthetics of Christian Truth* (Grand Rapids: Eerdmans, 2003), 374.
[58] Ibid., 387.
[59] I have in mind here, for instance, Karl Barth's suggestion that, as the external basis for the covenant, God's judgement in Gen.1:31 that all that he had made was 'very good' pertains to its being adapted to the purpose which God had in view' rather than a primeval

in the texture of human experience can hardly be overestimated. Aboriginal goodness is not and cannot be the focus of Christian hope in history's midst, but the *eschatological* goodness of God's promise, a promise adhered to for the time being in the teeth of an experience which repeatedly contradicts it and threatens to eclipse it. And it is precisely here, in dealing with what the world presently amounts to in its sin and apart from God's redemptive activity and promise, that tragic vision arguably has much to offer. 'So much of our religious teaching' writes P.T. Forsyth, 'betrays no sign that the speaker has descended into hell, been near the everlasting burnings, or been plucked from the awful pit. He has risen with Christ … but it is out of a shallow grave, with no deepness of earth, and no huge millstone to roll away'. And then, 'it was not Galahad or Arthur that drew Christ from heaven. It was a Lancelot race. It was a tragic issue of man's passion that called out the glory of Christ. It is a most tragic world, this, for those who see to the bottom of it, and leave us their witness to its confusion, as Shakespeare did in *Hamlet*, *Lear* and even *The Tempest*'.[60] Of course the key word in the citation from Hart is 'final': tragedy has no *final* wisdom; the darkness which it depicts can never, according to Christian faith, be ultimate, but only ever penultimate. Here one may indeed properly worry that some advocates of tragic readings of the gospel do insufficient to keep the joy and finality of the resurrection hope clearly in their sights. But need it be the case that an emphasis on the 'tragic' qualities of an unredeemed cosmos robs the final denouement of an equivalent amount of its joy and glory? Or vice-versa? Must we rob Peter to pay Paul?

It seems to me that it is not so, and that in fact the very opposite is true. Indeed, Hart himself gives us the clue here: Christian faith, he writes, clings finally to an 'impossible' hope, rather than the dark but clarifying vision of necessity which tragedy affords.[61] This note of *impossibility*, a discrepancy or mismatch at the very deepest level between what is possible now and what God has promised, is of the utmost importance. It is the vital gap between cross and resurrection, between the conditions of any teleology immanent to nature and history and those generated alone 'from above' by God's activity as Creator in raising Jesus again to be the first-fruits of a cosmos redeemed from death's hold over it. And it means, I suggest, that the genuine insights which tragedy affords into human existence, its unrivalled imaginative power 'in the disclosure of what is'[62] in an as yet still unredeemed world (a world which awaits the fulfilment of the promise), can and must be acknowledged and faced fully by theologians without squeamishness, yet

perfection subsequently lost. See Karl Barth, *Church Dogmatics* III/1 (Edinburgh: T&T Clark, 1958), 213. For a consonant restructuring of the Christian story see Paul Fiddes, *Freedom and Limit: A Dialogue Between Literature and Christian Doctrine* (London: Macmillan, 1991), 47–64.

[60] P.T. Forsyth, *The Church, the Gospel, and Society* (London: Independent Press, 1962), 100; 102.

[61] Hart, *Beauty of the Infinite*, 392.

[62] MacKinnon, *Borderlands of Theology*, 101.

without any compromising or denial or attenuation of the final glorious vision, or any suggestion that darkness has some ultimate status alongside it.

The Christian hope, we might say now, is properly invested not just in a 'happy' ending, but in a *eucatastophic* ending. And in eucatastrophe, the relationship between the ending and the story which leads up to it is precisely one in which the story doesn't actually 'lead up to it' at all. The ending indulges in a radical *peripeteia* the hallmark of which is precisely impossibility. The sudden joyous turn which lifts our hearts can do so precisely and only to the extent that it does not seem to rely upon or emerge out of any patterns or possibilities latent within what has gone before, but only to contradict and subvert them in the most outrageous and undeserved and unbelievable fashion. This disjunction between the mood and the pattern of the two elements is precisely the point; and while, therefore, the eucatastrophic ending certainly consoles, it does so in a manner which does nothing whatever to deny or to rob of its terrible reality the dark and awful nature of what has gone before it. On the contrary, Tolkien insists, the reality of *dyscatastrophe*, sorrow, failure and doom, our futile struggle with a hostile world, all this is not at odds with but *furnishes the necessary conditions* for the truly eucatastrophic climax. What eucatastrophic consolation *denies*, therefore, is not the reality, the scale or the awfulness of the struggle, but 'universal final defeat',[63] and it does so, he notes, in the face of much evidence.

'Resurrection for Christianity', notes Terry Eagleton, 'involves a crucifixion and descent into hell. Otherwise what is reclaimed … would not be *this* condition in all its deadlock and despair'.[64] Christian faith, he notes, confronts the worst, yet hopes for the best. That it *can* hope for the best, and that it can look the worst in the face and take it fully seriously, is due, I am suggesting, to the fact that it sees no necessary or organic relation between them, but an entirely contingent one. The worst is captured just as surely in the terrible and despairing symbol of crucifixion as it is in the banishment of the self-mutilated Oedipus or the death of Shakespeare's Cordelia. For Christianity, the best issues eucatastrophically from the divinely plundered tomb on Easter day. But, as Alan Lewis has reminded us (following von Balthasar's lead), the story of Jesus culminates in a *triduum* – a three-day sequence: the day of crucifixion, the day of burial and the day of resurrection.[65] And the story, Lewis insists, may and should be 'told and heard, believed and interpreted, *two different ways at once* – as a story whose ending is *known*, and as one whose ending is discovered only *as it happens*. 'The truth is victim', he writes, 'when either reading is allowed to drown out the other; the truth emerges only when both readings are audible, the separate sound in

[63] Tolkien, *Tree and Leaf*, 69.

[64] Eagleton, *Sweet Violence*, 40.

[65] Alan E. Lewis, *Between Cross & Resurrection: A Theology of Holy Saturday* (Grand Rapids, Eerdmans, 2001). Cf. Hans Urs von Balthasar, *Mysterium Paschale*, trans. A. Nichols (Edinburgh: T&T Clark, 1990).

each ear creating, as it were, a stereophonic unity'.[66] The retrieval of this same stereophonic effect is an important part of 'hearing the story again' and re-enacting it through participation in the liturgy of Holy Week, during which the faithful are taken back to a point where, by an imaginative erasure or suspension of that which faith holds most dear, within the unfolding logic of the story itself the approaching Friday presents itself as it did to the disciples, not as the first of a sequence of three (destined to end well, in victory and life) at all, but as 'the last day, the end of the story of Jesus. And the day that follows it is not an in-between day which simply waits for the morrow, but it is an empty void, a nothing, shapeless, meaningless, and anticlimactic: simply the day after the end'.[67] The death of Jesus on Good Friday must thus be experienced and understood as '*both* the disastrous finale to Christ's life as it sounds on the story's first hearing, *and* as the first episode in a three-day event of triumph, and thus retrospectively not a disastrous but a saving, resurrecting death'.[68] The complex meaning and theological significance of the story will only be appreciated, Lewis insists, if we indulge in this careful act of shifting from one imaginative vantage point to another. We must hear 'what the cross says on its own, what the resurrection says on its own, and what each of them says when interpreted in the light of the other'.[69] Again, following the logic of the narrative itself, the resurrection is a powerful act of glorification 'for which we have not been prepared by the defeat and ignominy which went before', and it compels us to recognize and reminds ourselves in retrospect, therefore, that it is the resurrection 'specifically and exclusively of one crucified, buried, terminated'.[70]

It is the enigmatic second day in this same carefully emplotted sequence, with its seemingly empty but in reality pregnant silence, which captures the tension and relation between the other two days. As a buffer it both keeps them apart, preventing either from encroaching on the other, and yet – paradoxically – holds them together. This day is, we might say, the eucatastrophic space which determines the meaning of what precedes and what follows it, and their relation to one another, resisting maudlin and despairing readings of the cross in equal measure. By taking 'time to regard the death of Jesus in all its unabbreviated malignancy and infernal horror', Lewis writes, 'we both protect the cross itself and throw into the sharpest relief the resurrection gospel: that out of just such a cross as *this*' (and not some circumstance less dark or threatening, 'a shallow grave, with no deepness of earth') '… come life and joy and hope'.[71] If, in literary terms, this interruptive relationship is 'eucastrophic', the relevant theological category in terms of which to make sense of it, surely, is 'grace': a grace which calls the world into being out of nothing, which calls sinners into an adopted 'sonship' which we not only do not

[66] Lewis, *Between Cross and Resurrection*, 33.

[67] Ibid., 31.

[68] Ibid., 33.

[69] Ibid.

[70] Ibid.

[71] Lewis, *Between Cross & Resurrection*, 40.

deserve but actively resist, which takes our sinful flesh upon itself and bears it all the way to the cross not in order simply to 'unmake' it, but so that it may duly be heir to a new life and a new creation which its empirical form cannot yet bear. And, of course, it is in the eschatological reality of Jesus raised from death, the first-fruits of God's promised ending, that all this finds its most concrete focus. Here, as Tolkien himself suggests, imagination and faith, literature and theology, 'Legend and History have met and fused'. Here 'Art has been verified'.[72]

[72] Tolkien, *Tree and Leaf*, 73.

Chapter 10
The Substance of Things Hoped For

Theology ... is imagination for the kingdom of God in the world,
and for the world in God's kingdom.[1]

What I propose to do in this final chapter is to explore some themes relating to
the transformative impact of eschatological hope upon the shape of the Christian
present. I begin with some select examples of this which themselves serve to raise
a question about an apparent incommensurability between the experienced present
and the hoped for future of God. This theme will concern us again later in the
chapter. Next I turn to two secular analyses of the transformative impact of the
human capacity to imagine the future; those of George Steiner and Ernst Bloch.
Finally, turning at last to Jürgen Moltmann's work, I shall explore some of the
ways in which it forces us to differentiate a distinctively Christian imagining of
the future from these extra-Christian versions.

Seeing Beyond the Silence

Shusako Endo's novel *Silence*[2] tells the story of a seventeenth-century Jesuit
missionary. Sebastian Rodrigues is sent to Japan in 1643 at the tail end of the
so-called 'Christian century' in that country's history. It is a time of enormous
hostility to the Christian faith and all that is associated with it, a backlash of
indigenous culture against the rapid growth and flourishing of the Church there.
Upon his arrival (secretly) Rodrigues is met by some of the many thousands of
native believers clinging tenaciously to a way of life outlawed by the authorities
and punishable by savage torture and execution. The novel recounts his brief
existence as a guerilla priest, emerging from the forest to baptize, hear confessions
and celebrate the eucharist for communities of the faithful who have for several
decades been forced to keep their faith well hidden from public gaze, and deprived
of priestly ministry. It tells of his capture and torture, and of the awful struggle he
has in coming to terms with his own eventual forced apostasy, trampling on an
image of the face of Christ in order to save, not himself, but Japanese Christians
held in adjacent prison cells, from the cruelty of judicial execution.

At one key juncture in the story the Samurai come and arrest two elders of
a village where Rodrigues is being hidden. Accused of practising an outlawed

[1] Jürgen Moltmann, *The Coming of God: Christian Eschatology,* trans. Margaret
Kohl (London: SCM Press Ltd, 1996), xiv.

[2] S. Endo, *Silence* (London: 1988).

religion, and refusing to spit on a crucifix, the two men are duly sentenced to death. Yet neither they nor anyone else in the community will do that which will secure their immediate release: betray the priest. The men are executed, bound to two stakes on the seashore, stakes positioned carefully and cleverly so that the incoming tide will not quite cover their heads, but will come and go, gradually sapping their strength and bearing their life away with it. Endo narrates this part of his tale from Rodrigues' own perspective:

> Night came. The red light of the guards' blazing fire could be seen faintly even from our mountain hut, while the people of Tomogi gathered on the shore and gazed at the dark sea. So black were the sea and the sky that no one knew where Mokichi and Ichizo were. Whether they were alive or dead no one knew. All with tears were praying in their hearts. And then, mingled with the sound of the waves, they heard what seemed to be the voice of Mokichi. Whether to tell the people that his life had not yet ebbed away or to strengthen his own resolution, the young man gaspingly sang a Christian hymn:
>
> We're on our way, we're on our way
>
> We're on our way to the temple of Paradise,
>
> To the temple of Paradise …
>
> To the great temple …
>
> All listened in silence to the voice of Mokichi; the guards also listened; and again and again, amid the sound of the rain and the waves, it broke upon their ears.[3]

The silence of which the novel's title speaks is God's seeming silence in the face of his people's enormous suffering. This, above all, is the issue with which Rodrigues is driven to wrestle as he comes to terms with the vulnerability of his own faith. Yet what stands out in passages such as this one, and what Rodrigues himself eventually discovers through his journey to self-knowledge through suffering, is the striking and ironic juxtaposition of darkness and light, terror and fearlessness, humiliation and great dignity, the inevitability of death and the expectancy of new life. The Japanese Christians go to their deaths singing this hymn not (as Rodrigues himself at first avers) as a form of 'whistling in the dark to keep their spirits up', but because they are possessed by a vision of God's faithfulness and his promised future which subverts the darkness of their experienced present. They are afraid, yet not bowed. In death, as in life, they bear the apparent silence and absence of

[3] Endo, *Silence*, 102.

God because they share a hope which transcends this present, and which bathes it in a quite different light.

It would seem that it is often thus in the experience of God's people. The times of great struggle or suffering, when to all appearances God's face is hidden, have often been precisely those times which have given birth to the most colourful and convicted visions of God's promised salvation, when the sense of promise has, as it were, been renewed and developed. Refusing to buckle under the painful weight of actuality (whether that be persecution, exile or whatever) the faith which holds fast to such hope resists and contradicts it, insisting upon living as if it were not thus, living in the light not of the way things are, but of the way things will be in God's future. Two brief examples from Scripture will suffice to illustrate this further.

First, chapters 40 to 55 of *Isaiah*, written from the estrangement of exile in Babylon at a time when the nation of Judah was effectively a nation no more; removed from the now ruined sanctuary of Zion around which her faith was focused, frog-marched in fetters some 700 miles east across the desert plains, broken on the wheel of events which were also the instrument of God's judgement. The land of promise, the land flowing with milk and honey, was now preserved and cherished only in her corporate memory, the theme of so many folk songs and tales designed to preserve a sense of national identity. The familiar words of the psalmist from this same era capture in a sentence or two what the hearts of the people must have felt: 'By the rivers of Babylon we sat and we wept when we remembered Zion. ... How can we sing the songs of Yahweh in a strange land?' (Ps. 137:1–4)

Yet, curiously juxtaposed with such understandable lament, we find the green and vigorous shoots of new hope bursting through the arid and seemingly inhospitable soil of exile. 'Comfort my people, says your God. ... In the wilderness prepare the way of Yahweh, make straight in the desert a highway for our God. ... For a long time I have held my peace, I have kept still and restrained myself; now I will cry out like a woman in labour, I will gasp and pant. ... Now thus says Yahweh, he who created you, O Jacob, he who formed you, O Israel: Do not fear, for I have redeemed you; I have called you by name, you are mine. ... Do not remember the former things, or consider the things of old. I am about to do a new thing'. And so it continues. As shrewd estimates of political reality go this can hardly number high on anyone's list. Yet *Isaiah* weaves a hopeful vision which contradicts the apparent realities of his people's circumstance, promising what seems beyond the bounds of current possibility, convinced that the redemptive capacities of the God who created all things cannot be circumscribed or measured by expectations rooted in the actual. In his imagination the prophet sees beyond the given to an unexpected and surprising future, a future in which his fellow Jews are able to find hope even in the midst of despair, renewed purpose in the face of servitude and an identity as the people of God which exile had threatened to obliterate. Holding firm to such a vision, the present suffering loses its ultimacy and hence its capacity to crush the spirit.

Something similar may be observed in the New Testament book of *Revelation*. Now it is the Christian Church rather than the Jewish nation which finds itself in a form of exile in a world dominated by the forces of Roman empire. Writing to those for whom resistance to this regime and faithfulness to Christ may mean persecution, arrest and even death, John unfolds what Richard Bauckham has classified as a 'prophetic apocalypse' which discloses through its imaginative form a transcendent perspective on this world and the events of contemporary history, setting them in the wider and fuller context of God's ultimate purposes for the coming of his kingdom. Bauckham writes as follows:

> John (and thereby his readers with him) is taken up into heaven in order to see the world from the heavenly perspective. He is given a glimpse behind the scenes of history so that he can see what is really going on in the events of his time and place. He is also transported in vision into the final future of the world, so that he can see the present from the perspective of what its final outcome must be, in God's ultimate purpose for human history. The effect of John's visions, one might say, is to expand his readers' world, both spatially (into heaven) and temporally (into the eschatological future), or, to put it another way, to open their world to divine transcendence. The bounds to which Roman power and ideology set to the readers' world are broken open and that world is seen as open to the greater purpose of its transcendent Creator and Lord. It is not that the here-and-now are left behind in an escape into heaven or the eschatological future, but that the here-and-now look quite different when they are opened to transcendence.

> The world seen from this transcendent perspective ... is a kind of new symbolic world into which John's readers are taken as his artistry creates it for them. But really it is not another world. It is John's readers' concrete, day-to-day world seen in heavenly and eschatological perspective. As such its function ... is to counter the Roman imperial view of the world, which was the dominant ideological perception of their situation which John's readers naturally tended to share.[4]

What we have here, then, is an imaginative vision in which the dominant way of seeing things (both present and future) is fundamentally challenged and an alternative picture painted of the potentialities and possibilities inherent in God's future. Rome is not the ultimate authority, and will not have the final victory. God is not absent, and his kingdom is coming. Whatever experience may suggest, and whatever the voices of power may insist, these are the realities of the readers' situation. The challenge to the Christian Church in the midst of the all too real discomfort and danger of actuality is, as always, to live in the light of this alternative vision rather than submitting to the dominant ideology, even when the latter is

[4] R. Bauckham, *The Theology of the Book of Revelation* (Cambridge: Cambridge University Press, 1993) 7–8.

backed up with military and political force. *Revelation*, like deutero-Isaiah, offers God's people a subversive vision, furnishing the resources to wage what Amos Wilder calls a campaign of 'guerilla theatre', a battle for people's hearts and wills, and rooted firmly in a bid to capture their imaginations.[5]

Imagination is a key category for making sense of this hopeful living towards God's future. One of the key functions of imagination is the presentation of the otherwise absent. In other words, we have the capacity through imagination to call to mind objects, persons or states of affairs which are other than those which appear to confront us in what, for want of a better designation, we might call our 'present actuality' (i.e. that which we are currently experiencing). I do not say 'reality' precisely because the real itself may well prove to be other than what appears to be actual. Another key role of imagination in human life is as the source of the capacity to interpret, to locate things within wider patterns or networks of relationships which are not given, but which we appeal to tacitly in making sense of things.[6] We see things as particular sorts of things, and this is, in substantial part, an imaginative activity. And, since more than one way of seeing or taking things is often possible, what appears to be the case may actually change with an imaginative shift of perspective, rendering a quite distinct picture of the real. As numerous accounts of *Gestalt* and paradigm shifts have observed, a useful model for this is the religious 'conversion' in which the selfsame set of particulars is observed or experienced by the subject now quite differently because viewed in a wholly new light, located within a different pattern. In the examples we have just considered, the difference between what the eye of faith 'sees' and what is seen by the faithless eye is precisely a difference of interpretation or, we might say, a different imagining of reality. The prophet in each case feeds the imagination of God's people to enable them to see the world in ways other than those engendered by the dominant ideology.

Imagination, then, enables us to call to mind sets of circumstances other than the actual. These may be things which we (or others) have known in the past but which we are not perceiving or otherwise experiencing in the present (in which case we are dealing either with some form of memory or historical reconstruction). Or, drawing again inevitably on our knowledge and experience of what has been and what is, we may think about the future, about what is yet to be. In this case our expectations will be shaped more precisely by the 'laws' of association/ nature which seem to govern the world of our experience. Thus, while we may well imagine any number of futures which could but will not in fact arise (some perhaps highly *unlikely* to do so) we will, in this mode, not be prone to imagine things which are, so far as we are able to judge from a shared human experience of the world, not *possible* futures. States of affairs which trespass beyond the bounds of the unlikely or improbable into the realm of that which is in some obvious way

5 A. Wilder, *Theopoetic: Theology and the Religious Imagination* (Philadelphia: Fortress Press, 1976).

6 On this see, e.g., M. Warnock, *Imagination* (London: Faber, 1976).

incommensurable with the world as we know it we might ordinarily choose to classify as fantasy rather than expectation, and as such a distinct sort of imaginative activity. In fantasy, for example, while we must always root our imagining in some identifiable way in the regularities and continuities of what we have known (we cannot imagine *ab initio*), we nonetheless modify the known to such an extent that what results is well removed from either memory or expectation. I labour this point slightly because it is relevant to issues raised later in the chapter.

Imagination and the Grammar of Hope

I want now to focus on the human capacity for hope: the capacity, that is to say, to imagine a future which, in broad terms, furnishes an object of hope for us in the present, a vision of how things may be to which, as we say, we look forward. What I am specifically interested in, again, is the way in which certain aspects of that capacity exercise a necessary and transformative reflexive impact upon our ways of being in the present. As already indicated we shall proceed by drawing on the thought of two Jewish thinkers who have engaged carefully with these issues.

George Steiner in his classic work on the nature of language and translation, *After Babel*,[7] notes that our ability as human beings to think about (we might reasonably substitute the word 'imagine') temporality, to construe past and future as distinct from the present, is in large measure bound up with our use of language. Our possession of a grammar complete with tenses is what makes such imaginative projection possible. 'Language', Steiner writes, 'happens in time but also, very largely, creates the time in which it happens'.[8] Language, that is to say, shapes our perception of the moment of speech or thought as present, and of other times as either past or future. Especially in the case of the future this capacity to transcend the present, to speak of or imagine a state of affairs other than the present, is vital to the direction of our ways of being in the world. 'The status of the future of the verb,' he observes, 'is at the core of existence. It shapes the image we carry of the meaning of life, and of our personal place in that meaning'.[9]

The potential shaping impact of such linguistic or imaginative projection was already clearly grasped by Karl Marx who, in reference to what he deemed illusory hopes of a religious nature, construed that impact in negative terms, as debilitating the urge for political reform in the real world. The substance of religious belief (the opiate of the people) is a deliberately engineered illusion designed to generate and sustain fantasies and dreams which will divert the attention of the oppressed masses from the actual awfulness of their circumstance long enough for their labour to be thoroughly exploited. What is required, on Marx's analysis,

[7] G. Steiner, *After Babel*, 2nd ed. (Oxford: Oxford University Press, 1992). See especially Chapter 3, 'Word Against Object'.

[8] Steiner, *After Babel*, 144.

[9] Steiner, *After Babel*, 145.

is a regime of cold turkey sufficient to kick the habit, allowing reality to break through the illusion, and provoking in due course a thoroughly justifiable reaction against those pushing the drug. But Steiner turns this around, and reminds us of the deliberate suppression in former communist regimes, not this time of hope, but of memory. The outlawing of the past, the careful editing of national memory was designed precisely to mould and shape present consciousness, and thereby to control it and direct it in particular ways. 'One can imagine a comparable prohibition of the future', he ruminates. 'What would existence be like in a total (totalitarian) present, in an idiom which limited projective utterances to the horizon of Monday next?'[10] His point is clear. The suppression of imaginative projection into the future, the enforced removal of the future tense from the language, would just as surely be debilitating with respect to present activism and energy, because future tenses necessarily entail the possibility of change of one sort or another. Without them, hope for a better future is simply not possible. Such hope, far from dulling the senses to the pain of the present, is precisely the thing which makes a deprived present unbearable.

Steiner proceeds to suggest that human life as such is characterized (and distinguished from other forms of life) by its essential directedness towards the future, and its fundamental capacity for hope. And the capacity to imagine and to speak of what lies beyond the given here and now is vital to this direction. 'We move forward', he writes in characteristically graphic vein, 'in the slipstream of the statements we make about tomorrow morning, about the millenium'.[11] Through imaginative construction we posit what he calls, paradoxically, 'axiomatic fictions' which, as it were, drag us forward in their wake and energize our living towards tomorrow rather than merely in today. We live in hope. Apart from it we are inert and, like sharks in water, would quickly drown in our own despair, trapped in an eternal and 'total' present. Change, progress, intention, excitement, anticipation, all the things which enable us to cope with and to overcome the undoubted pains, trials and disasters which we experience, these are bound up with our movement towards the future. 'The conventions of forwardness so deeply entrenched in our syntax make for a constant, sometimes involuntary, resilience. Drown as we may, the idiom of hope, so immediate to the mind, thrusts us to the surface.'[12] This ability to imagine ahead, to see beyond the given to a better and brighter future, Steiner avers, furnish distinct advantages in the evolutionary process, and have doubtless contributed to the survival and superiority of humankind. 'Natural selection', he suggests, 'has favoured the subjunctive'.[13]

We might, I suppose, prefer a more specifically theological construal of that claim, but its essential point is well made. The capacity to construct futurity, we

10 Steiner, *After Babel*, 146.
11 Steiner, *After Babel*, 168.
12 Steiner, *After Babel*, 167.
13 Steiner, *After Babel*, 228.

might rather say, which is a central function of the imagination, is essential to our humanity and to its movement forward in the creative purposes of God.

Steiner identifies another closely related imaginative function as equally important in this regard which we must mention briefly; namely, our capacity for counter-factuality, for the deliberate construction of falsehoods or alterities. The generation of 'counter-worlds' is, of course, the source of fantasy, illusion and lies. But it is also the source of our ability to see how things might be different (i.e. how they might change in the future, or how the present can already be seen or taken differently), to refuse to accept the world as it is given to us. Insofar as the language which we habitually use to describe the world, the ways in which we image and construe it, are a vital component in the shaping of our experience of it, to the extent, that is to say, that reality is a social and linguistic construct (and there is no need to capitulate altogether to radical accounts of this in order to recognise some truth in the claim), the capacity to picture and to speak of the world otherwise than in accordance with the currently favoured social construct, is itself a capacity to change reality, to deconstruct and then reconstruct it for ourselves. As Christians, for example, we shall probably want to construe the world in which we live as one in which Christ is Lord, rather than as a meaningless complex bio-chemical accident on a cooling cinder; and this insistence on describing the world differently will generate quite distinct ways of being in the world.

Turning now from Steiner to Ernst Bloch, we find a strikingly similar recognition of the essential directedness of human life towards the future, and of the vital contribution of imaginative hope in the realization of this futured existence. In his massive magnum opus *The Principle of Hope*[14] Bloch traces the patterns and manifestations of this constant 'venturing beyond', as he calls it, in the forms of human life.

Human existence, Bloch observes, is driven by cravings, urgings, desires and strivings, all of which are essentially forms of discontent with the way things are. Some of our cravings are duly clothed by imagination with particular form, and transformed into wishes. But the nature of wishes is to be somewhat detached from moral commitment. We may entertain two or more mutually exclusive wishes at once. 'I wish I were playing golf rather than sitting at my word processor' and 'I wish I were sitting in the garden at home with a good book instead of …', are wishes which, as such, may both be entertained at once. Only when we choose between them and begin to invest them with moral intent, acting towards their eventual fulfilment, do they become what Bloch calls 'wants'. The central category with which Bloch deals in expounding all this is that of dreams, and especially daydreams. In daydreams, he notes, we are more in conscious control of our imaginings than in dreams, and we are able to bring our wishes and wants to ficititious fulfilment. But daydreams are certainly not just the stuff of self-gratifying entertainment, nor armchair aspiration. They are not contemplative or analgesic, but invigorating and empowering. All freedom movements, Bloch

[14] E. Bloch, *The Principle of Hope* (3 vols, Oxford: Blackwell, 1986).

insists, are inspired and guided by daydreams, by utopian aspirations which posit a disjunction between knowledge of how bad the world is and 'recognition of how good it could be if it were otherwise'.[15] 'The pull towards what is lacking', he writes, 'never ends ... The lack of what we dream about hurts not less, but more. It thus prevents us from getting used to deprivation'.[16] Daydreams, then, are the imaginative form in which hope is cast.

Bloch does, however, draw a careful distinction between imagination's construction of daydreams on the one hand and what he calls 'mere fantasizing' on the other. Genuine hope is possessed of both subjective and objective aspects. As a component of human consciousness it is, nevertheless, soundly rooted in real ontological possibilities in the world. Hope, that is to say, as manifest in daydreams, intuits what Bloch calls 'a Not-Yet-Being of an expectable kind'. It 'does not play around and get lost in an Empty-Possible, but psychologically anticipates a Real-Possible'.[17]

Here we must identify Bloch's framework as a metaphysic of the world and its history as an incomplete process which moves forward, above all, through the capacity of human hope to lay hold of the 'Not-Yet-Existent' and the 'Not-Yet-Conscious' and, precisely in anticipating them, to transform the present, energizing us in the here and now to transcend the here and now with its apparent limitations and actual deprivations. Hope empowers our striving towards its own realization. But it must be genuine hope, and not mere fantasy. Only a Real-Possible has the resources to draw us forward into the future in this way. The *Novum* (genuinely new thing) to which hope attaches itself and looks forward is, paradoxically, in one sense not new at all. It is wholly new in as much as it has never previously existed, and in as much as the conditions for the possibility of its existence may not yet themselves even exist. But it is, nonetheless (and in retrospect will be able to be seen to have been) a real possibility, because the conditions for that possibility are already latent within the conditions and possibilities of the present.

An illustration may serve to make the point here. In climbing a mountain, while one may glimpse the summit through the clouds from the car park at the bottom, experience on the climb is often characterized by being able to see only the next ridge, not knowing precisely what lies beyond it, or whether and how the route transcends it and subsequent visual blockages to reach the top. Having glimpsed the top, however, knowing it to be there to be reached, one carries on and overcomes these numerous limited horizons, committed to the task and determined to attain the peak. The apparent disjunctions and discontinuities presented to sight do not make life easy, but they are not insurmountable. We press on, even though we cannot see exactly where we are going or how the top is to be reached. On having reached the top, however, and turning to consider the distance we have climbed, it is sometimes possible for the whole route from the car park to be more

15 Bloch, *The Principle of Hope*, 95.

16 Bloch, *The Principle of Hope*, 451.

17 Bloch, *The Principle of Hope*, 144.

or less visible at least in its broad outlines, so that the possibilities and continuities of each stage along the way are manifest in a manner that they could not previously have been.

What the imagination does in hope, its 'utopian function' as Bloch calls it, is thus twofold. First it leaps over the limits and perceived discontinuities which lie between present reality and the utopian future, even though it cannot yet see clearly the route from here to there – it intuits it as a real-possible. Second, through setting this vision before us and enabling us to 'look forward' to it, hope drives us forward, empowering and guiding ways of being in the world in the present which themselves serve to create the conditions in which the object of hope becomes possible. There is no hint of a rationalistic prediction or plotting of the future here, therefore. We cannot, for Bloch, *know* the future, or precisely how it will arise. (In passing it is perhaps worth asking whether, if we could, there would always be aspects of what lies in front of us which would so cripple us with fear as to render us incapable of action?) Hope, as Bloch sees it, is that activity of the imagination which lays hold intuitively of something which may or may not actually come to pass, but the potential for which lies genuinely within the latent capacities of the system or process of human history. 'The historical content of hope', he writes, 'is human culture referred to its concrete-utopian horizon'.[18]

The Imagination of Glory

In the remainder of this chapter I shall consider some of the key elements in Moltmann's eschatology which, I shall suggest, compels us at certain points to differentiate a distinctively Christian understanding of hope from general analyses such as those offered by Steiner and Bloch, valuable and compatible though these remain in many respects. My overview of Moltmann will draw particular attention to questions pertaining to the nature of the relationship between present and future, old and new creations, and the transition between them, and to the roles of imagination as a locus of God's transforming activity in human life.

The Goad of the Promised Future

Like Steiner and Bloch, Moltmann insists that the capacity to envisage a hoped-for future, far from dulling our sensibilities to the pain of the present, actually serves to heighten those sensibilities and is a powerful stimulus to resistance and reaction which itself drives us to break away from the present towards the future.[19] Hence:

[18] Bloch, *The Principle of Hope*, 146.

[19] Jürgen Moltmann, *Theology of Hope*, trans. James W. Leitch (London: SCM Press Ltd, 1965), 100.

Faith, wherever it develops into hope, causes not rest but unrest, not patience but impatience. It does not calm the unquiet heart, but is itself this unquiet heart in man. Those who hope in Christ can no longer put up with reality as it is, but begin to suffer under it, to contradict it. Peace with God means conflict with the world, for the goad of the promised future stabs inexorably into the flesh of every unfulfilled present.[20]

While on the one hand, therefore, this hope certainly strengthens our resolve in bearing 'the cross of the present', granting us a perspective which robs that cross of its finality,[21] on the other hand it 'sets loose powers that are critical of being' and seek to subvert what is in the name of the One who is to come.[22] It is anything but an encouragement towards a resigned or passive submission in the face of injustice, suffering and other characteristic features of the present regime therefore. On the contrary, its transformative impact upon the present lies precisely in its furnishing of 'inexhaustible resources for the creative, inventive imagination of love'.

It constantly provokes and produces thinking of an anticipatory kind in love to man and the world, in order to give shape to the newly dawning possibilities in the light of the promised future, in order as far as possible to create here the best that is possible, because what is promised is within the bounds of possibility.[23]

The possibilities of God's open future are, then, genuinely anticipated in the midst of this present age, with a resultant transformation of present ways of being and doing and thinking in the world on the part of God's people. This takes place, we might aver, primarily through the stretching of their imaginations, and thereby the reshaping of their expectations, desires and values, fashioning an alternative vision of 'the bounds of possibility' and liberating people from the despairing horizons of a history rooted in the past rather than open to the future.

Imagining Future and Reimaging Present

Picking up on the previous point, Moltmann indicates that the nature of hope is to force a radical reinterpretation (reimagining or reimaging) of the real, seeking a meaning for the present which is historical in the sense that it is teleologically determined. The present, in other words, does not contain its full meaning within itself, but only in its relatedness to what is yet to come. To reimagine the future differently in the light of God's promise is thereby also at once to force a reevaluation of the present and its significance. The *Gestalt* shift has to do not with the future alone, but with the present which that future informs and shapes.

[20] Moltmann, Theology of Hope, 21.

[21] Ibid., 31.

[22] Ibid., 119.

[23] Ibid., 34–5.

Our view of what *is* the case as well as what *will be* is transfigured. Here again there would seem to be a positive relationship between the future and the present whereby God's future reaches back into the present and effectively refashions it by altering its meaning, an altered meaning which faith subsequently discerns and seeks to acknowledge in appropriate forms of life and thought.

Since, however, it is in the nature of our 'knowledge' of the future to be at best partial and provisional, a further implication of this would seem to be that questions of meaning and truth may in the interim only be answered in partial and provisional ways. The final answer to the question of the real and the true must wait for that eschatological moment when, as the apostle suggests, we shall know fully as we in turn are fully known. For now we must make do with seeing through a glass darkly, and must not allow our Western eschatological impatience to get the better of us. This ought to drive us to reassess the status not only of eschatological and theological statements, but all the statements we make about the real, and perhaps to moderate the claims which we make for those statements.

The Power of the Future Made Present

For Moltmann, the relationship between the here-and-now and the hoped for future which transforms that here-and-now is, we have seen, in certain respects understood to be a positive one, at least in the sense that the power of the future is capable of *being present within and exercising a transforming influence over* the present. At this level, therefore, we must suppose that there is some degree of commensurability and continuity between the two realms.

This is especially clear (as one might reasonably expect) in Moltmann's pneumatology. Here, in discussing the Christian doctrine of regeneration, he insists that while the *palingennesia* of our humanity is decisively rooted in that objective rebirth which occurred on Golgotha and will be fulfilled only in 'that life which is eternal', regeneration is nonetheless something which spans the period between these two points in the lives of particular Christian people. 'We are still involved in the experience of renewal, and the becoming-new travels with us.'[24] The God who is yet to come in glory has already come both in the economy of the incarnate Son and as the Spirit poured out upon the Church at Pentecost. In our experiences of this same Spirit 'God himself is present in us', and 'we are possessed by a hope which sees unlimited potentialities ahead'. 'The goals of hope in our own lives, and what we ourselves expect of life, fuse with God's promises for a new creation of all things'.[25]

Human experiences of joy, of peace, of sanctification and the affirmation of life, all these things are anticipations of this same promise within that sphere where we would most naturally be '"Trauergeister" – sad or grieving spirits'.

[24] Jürgen Moltmann, *The Spirit of Life: A Universal Affirmation*, trans. Margaret Kohl (London: SCM Press Ltd, 1992), 155.

[25] Ibid., 153.

They issue from an experience of the Spirit of the resurrection, the one in whose power Jesus himself was raised from death in that most decisive and paradigmatic anticipation of the new creation within the old. They are 'the presence of eternity' in the midst of history.[26] Eternity, indeed, is not some abstract and timeless simultaneity but 'the power of the future over every historical time'.[27] The Christian disciple, therefore, is not limited to hoping for the power of the future, but also experiences that same power in his or her present life; not in its fullness, to be sure, but genuinely nonetheless. 'Expectations hurry ahead. Experiences follow. They follow like *a divine trail* laid in the life of the individual. Every exodus is accompanied by trials and perils, but also by "signs and wonders" which are perceived by the men and women who are travelling the same road.'[28]

The same insistence upon a certain continuous relationship between God's promised future and our experienced present is identifiable in Moltmann's metaphorical extension of the model of conversion to describe what happens to the old in its transition to the new.

> Conversion and the rebirth to a new life change time and the experience of time, for they make-present the ultimate in the penultimate, and the future of time in the midst of time. ... The future-made-present creates new conditions for possibilities in history. Mere interruption just disturbs; conversion creates new life.[29]

That which God fashions in the 'new creation', Moltmann insists, is not something novel. God does not set aside his original creation and replace it with one which is 'new' in that sense. Rather, God is faithful to his original creation and *renews* it through the exercise of that same power which raised up Christ to life from the emptiness of death, and which, in the beginning, called the universe itself into being out of nothing. God's promised future, then, is anticipated in the midst of the old order of things not only through an imaginative looking forward to it, but through actual irruptions of the power of the Spirit who raised Jesus from death.

The Contradiction of Corruption

Here, though, we reach a point where a rather different emphasis must be taken equally into account. If there is indeed a positive relationship, a measure of commensurability and continuity between the old and the new creations, for Moltmann it is vital that we do not mistake the nature of this positive relation.

The point may be made quite clearly by contrasting Moltmann's account with that offered by Bloch. For the latter, as we have seen, hope is essentially that

[26] Ibid., 153.

[27] Moltmann, *The Coming of God*, 23.

[28] Moltmann, *The Spirit of Life*, 152.

[29] Moltmann, *The Coming of God*, 22.

which intuits a 'Real Possible' the conditions for which are already latent within the process or system of human history. In Leibniz's phrase (cited by Moltmann)[30] the present is 'pregnant with future'. What remains is for us to grasp the potential inherent in the present, and then work towards its realization, spurred on by the energy of our hopeful imaginative vision. But this will not do as an account of the Christian hope. Here what is presented to us is precisely 'the thing we cannot already think out and picture for ourselves on the basis of the given world and of the experiences we already have of that world'.[31] Again, 'Christian eschatology does not examine the general future possibilities of history. Nor does it unfold the general possibilities of human nature in its dependence on the future'.[32] This is where Moltmann finds it necessary to part company with Bloch.

For Moltmann the Christian gospel is precisely about something *surprisingly* new, something which is not rooted in and does not rest upon the inherent potentialities and possibilities of the actual present, but upon the capacities of the God of creation and resurrection who has promised to make all things new. Indeed, that upon which Christian hope rests is precisely the action of this same God in summoning life forth out of death in the resurrection of Jesus, an action in which faith discerns both an anticipation and a pledge of the ultimate resurrection and renewal of all things. Just because it is this promise made by this same God which establishes and undergirds Christian hope, 'the expected future does not have to develop within the framework of the possibilities inherent in the present, but arises from that which is possible to the God of the promise. This can also be something which by the standard of present experience appears impossible'.[33] The hope which is rooted in an event discontinuous with the general capacities of the old creation is also a hope which looks beyond those capacities for its eventual fulfilment.

What all this amounts to is an insistence that whatever level of continuity and commensurability between the old and the new may have to be discerned and acknowledged, it is radically offset by a level of stark discontinuity and incommensurability. At its starkest Moltmann puts the matter thus: 'this world "cannot bear" the resurrection and the new world created by resurrection.'[34] It can begin to sound as if the here and now is not at all the sphere of God's presence and activity, although Moltmann clearly cannot mean this. Yet: 'the kingdom of God is present here as promise and hope for the future horizon of all things, which are then seen in their historic character because they do not yet contain their truth in themselves. If it is present as promise and hope, then this its presence is determined by the contradiction in which the future, the possible and the promised stands to a corrupt reality.'[35] Moltmann indicates that the promise of God generates an interim

[30] Moltmann, *The Coming of God*, 25.
[31] Moltmann, *Theology of Hope*, 16.
[32] Ibid., 192.
[33] Ibid., 103.
[34] Ibid., 226.
[35] Ibid., 223.

period prior to the fulfilment of promise in which (as hinted above) the kingdom is present in the here-and-now *tectum sub cruce et sub contrario*, rather than in any explicit or apparent manner. 'Yet this its hiddenness is not an eternal paradox, but a latency within the tendency that presses forwards and outwards into that open realm of possibilities that lies ahead and is so full of promise.'[36]

Such statements stand in a clear tension (although not contradiction) with those which appeal to a genuine suffusing of the present with the transformative power of the future in such a way that that power is manifest in people's lives and actually changes things. That Moltmann wishes to affirm both things is clear; but it provokes questions about the precise extent and nature of the presence of this contradictory and incommensurable future in our midst, questions to which we must return duly.

There is, then, a contradiction between that which characterizes the new creation and that which marks the old, between the promise and our experience of the present. This, we might note, is essentially the point which Barth was making in his notorious dispute with Emil Brunner over natural theology, albeit cast now in terms of an eschatological framework. The old creation is not capable of ('cannot bear' i.e. give birth to) the new creation. The present is not 'pregnant with future', we might say, except insofar as the God of the virgin conception is present and active in its midst, working ever afresh the miracle of life where there is only the potential for not-life. The new creation does not come simply to perfect the old creation, but to do something radically new which transcends any capacities latent within it. There is no natural capacity for the new within the old.

What is especially interesting is the fact that Moltmann and Barth deploy the very same theological examples to drive home their point: in nature *ex nihilo nihil fit*, yet the God who is the author of life is able to call life even *ex nihilo*. The crushed and lifeless form of the crucified has no latent capacity for new life, yet the God who is the author of life is able to raise him out of death as the first fruits of a new humanity. The point which both theologians wish to make is that the proper question is not, and must never be, about the latent capacities of the created, but rather about the capacities of the God of the future to do with his creation that which he has promised.

For Moltmann this relationship of incommensurability or contradiction between the present and the promised future makes the crucifixion-resurrection of Jesus, the 'enigmatic, dialectical identity of the risen Lord with the crucified Christ'[37] much more than the occasion upon which Christian hope is founded; it is itself *a paradigm for thinking about* the relationship of old to new creation. Again, this is a point to which we must return.

[36] Ibid.

[37] Ibid., 220.

Hope, Promise and the Logic of Grace

One key difference between Moltmann's theology of hope, rooted as it is in the category of the promise of God, and Bloch's principle of hope is that it is an *assured* hope. This certainly does not mean that we know precisely what will happen in the future. On the contrary 'the knowledge of the future which is kindled by promise is … prospective and anticipatory, … provisional, fragmentary, open, straining beyond itself. It knows the future in striving to bring out the tendencies and latencies of the Christ event of the crucifixion and resurrection, and in seeking to estimate the possibilities opened up by this event'.[38] Yet the Christian hope is assured in the sense that it is invested in the capacities of the one who has raised Christ from the dead.[39] Bloch, on the other hand, while he does not seem seriously to entertain the option of failure, nonetheless unfolds a model in which hope intuits a future which in principle may or may not ultimately come to pass.

It might be asked whether such a level of assurance ('because he has raised Christ from the dead, therefore the fulfilment of his promise is certain'),[40] rooted as it is in an insistence that the hoped for future is not contingent upon preconditions in the here-and-now, is not likely to reduce (if not remove altogether) the transformative impact of such hope? One might suppose so. After all, if the eventual outcome is secure regardless of our striving or lack of it towards the goal of our hope, if redemption does not rest on our fashioning of the conditions for the coming of the kingdom, then surely the more economic and comfortable option is to sit back and wait for it all to happen. Is Bloch's model with its element of risk and genuine responsibility on the part of those who strive for the utopian future not more likely to generate the sort of enthusiasm and effort necessary to see the kingdom at least approximated to in this world?

It would not be surprising if such a question were asked or answered in the affirmative. But the Christian answer to it must be an emphatic negative, for it misunderstands the logic both of the gospel and of Bloch's alternative to it. To begin with, we should observe that if this were so then it would not be the principle of hope about which Bloch was writing at such length, but rather a principle of fear or anxiety (generated by the risk of failure) which drives humans forwards in a frenzied bid to do their best, for fear of the consequences of inaction. To suppose this would in fact be to have missed the entire thrust of Bloch's case. For him it is actually hope, and not fear, which energizes and transforms our present activity. Fear inhibits and cripples. Yet the question is worth asking precisely because it provokes a reasonable counter-question: namely, whether, without the introduction of some transcendent guarantor of the outcomes of hope, without the receipt of something akin to the promise of the God of the resurrection, hope can really be the genuine source of a transformed present at all. If, in the final analysis our hope

[38] Ibid., 203.

[39] See ibid., 145.

[40] Moltmann, *The Coming of God*, 145.

is rooted in the latent potential of the present, including our own potential to act and thereby generate the conditions for its eventual realization, then it is difficult to see just how we can escape the despair which accompanies the juxtaposition of our self-knowledge and the demands which the road to self-redemption makes. Thus Moltmann writes of Bloch:

> His ontology of "not-yet-Being" fails to provide a foundation for hope because it inescapably has to become the ontology of "Being-that-is-no-longer". If future arises from the tendencies and latencies of the historical process, the future cannot bring anything surprisingly new, and never a *novum ultimum*. Eschatology is then only possible as teleology. But, as Bloch knew, teleology runs aground on death.[41]

Within the logic of the Christian gospel of grace, with its explicit rejection of every attempt at self-justification, the priority of indicatives over imperatives is everywhere apparent. Redemption comes to us as a free gift of God created *ex nihilo*, rather than a staged initiative which demands the prior fulfilment of conditions on our part before final bestowal of the 'promised' blessing. Yet this utter freeness does not create a context for antinomian lethargy. Nor, indeed, is it lacking in its demands. But the evangelical ordering of promise and demand is all important. Because the gift is offered freely and does not rest on the adequacy of our response, it actually liberates us from the culture of fear and anxiety, and thereby sets us free to act with radical confidence, confidence which is free to make mistakes because it knows they will not result in rejection. Failure itself is forgivable and redeemable. When, therefore, God's promise comes to us and fashions our hope, in the very same moment it demands what it offers and offers what it demands. What it demands is that we should become the children of God, citizens of his kingdom. What it offers is the opportunity to become children of God, citizens of his kingdom. The demand is to embrace the freely given gift, that which is promised to us, and to live it out in the here and now. Hence the promise certainly calls for obedience: 'It is necessary to arise and go to the place to which the promise points, if one would have part in its fulfilment. Promise and command, the pointing of the goal and the pointing of the way, therefore belong immediately together.'[42] But here the logic of gospel sets us utterly free from the burden of having to become the condition for the realization of the kingdom. And it is this liberation, rooted in the imaginative vision which lays hold of God's promised future, which transforms our way of being in the present and generates patterns of obedience and response. Here again the acknowledgement that this world 'cannot bear' the new creation lifts from our shoulders the responsibility of having to establish it by our own labours. Yet it must be held in tension with the

[41] Ibid., 344, n.58.

[42] Moltmann, *Theology of Hope*, 120.

constant call of God to live in the here-and-now as those whose lives are shaped by the power of his future at work as the contradiction of corruption.

Modulation, Messiah, and the Moment

We have seen that this essential tension between recognizing the radical newness of the new creation and its incommensurability with the present order of things on the one hand, and on the other hand the genuine presence of the *Novum* in the midst of the present order, drawing us forward transformatively into God's future, is maintained in Moltmann's theology. Thus of the resurrection he writes:

> The new thing, the kainos, the novum ultimum, is the quintessence of the wholly other, marvellous thing that the eschatological future brings. With the raising of Christ from the dead, the future of the new creation sheds its lustre into the present of the old world, and in "the sufferings of this present time" kindles hope for the new life.[43]

Yet this event 'has no analogies in experienced history'.[44] This, on Moltmann's own account of the matter, is both true and untrue. There are no historical preconditions for the resurrection of Jesus to be sure; yet Christian experience is now filled with happenings which are analogous to it in the sense that they too introduce the lustre of the new into the old order, that they too derive not from potentialities latent within nature, but from the creative power of God calling forth life out of death. There is, in this present order, a repeated and identifiable 'eschatologically new intervention of God's creative activity'.[45] Like Barth's *analogia fidei*, however, the analogy to be discerned here is always in one direction, *from* the paradigm event of the resurrection *to* those subsequent partial and dependent anticipations of the new creation which arise out of its power at work in the world. The relationship is not reversible. The resurrection has no *natural* analogies in this world.

Yet the insistence that there are *unnatural* analogies, arising directly and only out of the power of the future-made-present, forces us to qualify the sense in which we construe the incommensurability between the two orders. It cannot be such that the old 'cannot bear' the new in the sense of 'cannot endure' it or accommodate it in its midst at all, but only in the sense that it cannot give birth to it in and of itself.

Through what figure, then, should we picture the transition from the old to the new creation? Moltmann, we have seen, typically takes the crucifixion and resurrection of Jesus as paradigmatic. This accommodates both a vital degree of continuity (the identity of the historical Jesus with the risen Lord) and the all important discontinuity since, as has often been observed, 'dead men don't rise'! The problem with this figure, though, important and necessary though it may be, is

[43] Moltmann, *The Coming of God*, 28.

[44] Ibid.

[45] Ibid.

the fact that it emphasizes the discontinuity and incommensurability to such an extent that it becomes hard to make much sense of the genuine presence of the new order in the old, the suffusing and transforming of the old with the power of the new. It tends rather to indicate a model in which the old will be transformed 'in the blink of an eye' into something only faintly (yet nonetheless genuinely) recognizable as continuous with the old, just as the transfigured and the risen Jesus were. Again, while this may in itself be appropriate and necessary enough as a pointer to what may ultimately occur in God's eschatological future, we also need a model to set alongside it which allows us to say in unequivocal terms that the shift from the old to the new has already begun, that there is an overlap between the two orders *not* in the sense that there is some prior basis or precondition for the new already latent in the old, but in the sense that the new has already begun to create its own presence in the midst of the old by assuming it and drawing it into new self-transcendent anticipations of what it will ultimately be.

> The messianic interpretation sees "the moment" that interrupts time, and lets us pause in the midst of progress, as the power for conversion. At that moment another future becomes perceptible. The laws and forces of the past are no longer compulsive. ... New perspectives open up. ... The way becomes free for alternative developments.[46]

The paradigm offered by the compound event of crucifixion-resurrection, then, needs to be supplemented as a basis for imagining the shift between the old and the new creations of God.

In the composition of a piece of music, if one wishes to change key (especially if one wishes to change into a relatively unrelated key) there are ways and means of doing so. One may, of course, simply change in a largely unannounced and unanticipated manner, causing a jarring to the sensibilities of the listeners who will very likely find it hard to link the two passages together at first. This is sometimes done for effect. But the more accepted and likely means of achieving the change is via a modulation or series of modulations in which one takes a chord belonging properly in the old key, but uses it in ways which are proper to a new key, thereby transforming its significance, and effecting a harmonious bridge between the passages. This same process may need to be effected several times in order to get from the original to the final desired key. Skilful composers may also smooth the transition by introducing already into the closing strains of the old passage melodic motifs which do not really belong there at all, but which point ahead of themselves to the new.

Moltmann's passing appeal to the model of 'conversion' indicates the need for the development of some such paradigm to set alongside that of crucifixion-resurrection in order to complement it dialectically, and hence accommodate the apparent evidence of God's skilful modulation from the key of death into the key

[46] Ibid., 45.

of life. There is no need to turn to musicology for such a paradigm however. It is there already in the Christological focus to which Moltmann himself directs us. But we need to cast our gaze back behind the event of the cross, and to remind ourselves that prior to this strikingly discontinuous irruption of the power of God's future into the present there had already been a whole life lived in which the power of this future was already perceptibly locked in a struggle to the death with the powers of evil. The transformation or *palingennesia* of humanity did not begin on Golgotha, that is to say, but precisely in the womb of the virgin, and was effected through Jesus' Spirit-filled and enabled responsiveness to his father from moment to waking moment of his life *culminating* in the self-offering to death on the cross. In the events of Jesus' messianic ministry we find constant foreshadowings of the new order which constitute a genuine presence of the kingdom or rule of God in the midst of this order. As the one who furnishes Yahweh for the first time with a satisfactory covenant partner the Messiah is himself an embodiment of this rule in the world. And yet, the cross and resurrection, the decisive anticipation of the shift from old to new, are still to come. In all this we have a valuable paradigm for reflecting on how the power of God's future can be genuinely present and effective in the midst of a world which, as yet, cannot bear it. This, perhaps, is part of the theological significance of the gospel story of Jesus' transfiguration on the mountain, an eschatological moment in which the true meaning of Jesus' present is revealed to the three disciples through a vision of his post-resurrection glory, a glory discontinuous with the conditions of his historical ministry, yet genuinely present under the form of anticipations of it, and visible for those granted eyes to see. It is no coincidence that it is in the light cast by this event that Peter's stumbling confession of Jesus as the Messiah comes. Messianic history, we might say, is the context for the modulation from the conditions and potentialities of death to those of life in this world.

Transfigured and Transfiguring Imagination

The power of the future to transform the present lies chiefly in the capacity of God's Spirit to capture our imagination and to open up for us a new vision of God's promise and the present which it illuminates, thereby stimulating alternative ways of being in the world in the present, living towards the future. Imagination is thus a vital category in eschatology as in theology more generally.

Imaginative forms are rendered necessary rather than merely useful or ornamental precisely by the dialectical relationship between present and future about which we have already spoken. On the one hand some level of continuity and commensurability between the old and new orders is vital if we are to be able to say or think anything meaningful about God's future at all. The *novum ultimum* cannot be wholly lacking in analogy to the here-and-now, otherwise we are driven to silence, and can have no hope precisely because we can expect nothing, look forward to nothing, fashion for ourselves no imaginative horizon towards which to move. It is in terms of a transfigured present that we are able to speak and

think about God's promised future. Yet the discontinuity and incommensurability about which we have said so much renders imagination absolutely necessary as the mode or capacity relevant to eschatological expectation and statement. Reason and science, the tools of *logos*, insofar as they are orientated and accommodated to the familiar, the regular, the continuous, have no means of penetrating beyond its limits.[47] It is precisely imagination, the capacity which is able to take the known and to modify it in striking and unexpected ways, which offers us the opportunity to think beyond the limits of the given, to explore states of affairs which, while they are earthed in radical and surprising modifications of the known, are so striking and surprising as to transcend the latent possibilities and potentialities of the known.

If, therefore, the promise of God is the source of hope, it may be that we must pursue the suggestion that it is the *imagination* of men and women to which that promise appeals, which it seizes and expands, and which is the primary locus of God's sanctifying activity in human life. That, though, is a topic for another volume.

[47] It would be unfortunate if this were taken to mean that reason and science had nothing whatever to do with the activity of imagination. Clearly this is not the case, and no such crude separation is intended. The point here, however, is simply that insofar as they are attending (as they often do) to the regularities and predictable orderliness of this world, working deliberately within the boundaries furnished by our shared experience of it, these tools as such are unable to take us beyond those self-set limits into the limitless beyond of the eschatological future. Here a different sort of imaginative activity is required. At times science itself (in constructing hypotheses for example, especially ones which involve moves towards a significant paradigm shift) is driven to utilize imagination in similar ways. But for the most part its reliance upon imaginative modes is of a more constrained sort, imagining within the limits (which might be described as a form of reasoning – inference? deduction?) rather than trespassing beyond them.

Index